A mind-blowing collection! With rich visual process descriptions, creators invite us into their workshops and let us look over their shoulders. You will discover both an exhibition of wonderful data-inspired works as well as the backstories of each of these pieces. Whether hand-made, machine-controlled, or created through natural processes, all the chapters show fascinating and bespoke creations of data objects. A much needed collection highlighting what is happening at the frontiers of art and sciences in this new field of data design.

— *Giorgia Lupi*, *partner at Pentagram and author of* Dear Data

What a much-needed book! Till, Sam, Lora, and Wes show us that data communication can be so much more than just visualization. There is a whole exciting world of data physicalization waiting to be explored, and the authors open the door for us and lead us through it with intelligent commentary. The book takes us to visit different artists, who explain their approaches and tools—from copper pipes to paper, from wood to electronics. It's a hugely inspiring tour. Reading this book will make you want to experiment with data in the realm of the physical.

— *Lisa Charlotte Muth*, *data vis designer and writer at* Datawrapper

This book has fresh inspirations from innovative artist-inventors who open up new possibilities for anyone who has data that tell a story. The screen is no longer the goal or the limit; freeing designers to explore more dimensions and shape deeper experiences to reach people with important messages about their health, communities, and climate. Data physicalizations break free into new dimensions where playful imaginations can use water, plastic, wood, or stone to fabricate data stories for public installations and private reflections. This book makes me want to turn on the laser cutter and restart the 3D printer to fabricate something startling, informative, and eye opening.

— *Ben Shneiderman*, *Professor of Computer Science, University of Maryland*

A collection of recent and diverse data-driven physical artifacts and sensorial experiences. Projects are beautifully illustrated and described in jargon-free language packed with practical information elucidating the design process, from the tools used to the context of their conception. Making with Data is an invaluable resource for educators and practitioners alike. It broadens our perspective of representing data by engaging all our senses.

— **Isabel Meirelles**, *Professor at OCAD University and author of* Design for Information

"Designing with Data" is one of today's key mantras. What next? Perhaps "Making with Data", as argued by professors Huron, Nagel, Oehlberg, and Willett. This timely book explores new ways data is penetrating our living environment and is crossing the boundary between the physical and the digital. Innovative fabrication methods lend materiality to data, as designers experiment with the use of laser cutters and 3D printers to transform maps and charts into tactile models and artworks. A compelling read for any data enthusiast!

— **Carlo Ratti**, *Director, MIT Senseable City Lab*

MAKING WITH DATA

Making with Data: Physical Design and Craft in a Data-Driven World provides a snapshot of the practices used by contemporary designers, researchers, and artists who are creating objects, spaces, and experiences imbued with data. Creators of physical representations of data draw from a range of domains and traditions, and represent a fascinating, inspiring, and revealing cross-section of contemporary maker and data culture.

To highlight the diversity of approaches, this book features a collection of first-hand accounts from 25+ international artists, designers, and scientists, documenting the process of designing and creating new physical representations and experiences with data. In each chapter, creators tell the story of how they created specific physical representations of data and illustrate that process via documentary sketches, photos, and other design artifacts. The book is divided into five themes (*Handcraft, Participation, Digital Production, Actuation,* and *the Environment*), each with an introduction that considers the broader social, scientific, and artistic implications of giving physical form to data. In particular, this book explores the process by which those artifacts are created, surfacing the design decisions, considerations, methods, and fabrication techniques that modern creatives use when making with data.

The first book to showcase physical representations of data, and discuss the creative process behind them, approaching the topic from a multidisciplinary perspective - from computer science, data science, graphic design, art, craft, and architecture - and beautifully illustrated throughout, ***Making with Data*** is accessible and inspiring for enthusiasts and experts alike.

AK Peters Visualization Series

Series Editors:
Tamara Munzner, University of British Columbia, Vancouver, Canada
Alberto Cairo, University of Miami, USA

Visualization Analysis and Design
Tamara Munzner

Information Theory Tools for Visualization
Min Chen, Miquel Feixas, Ivan Viola, Anton Bardera, Han-Wei Shen, Mateu Sbert

Data-Driven Storytelling
Nathalie Henry Riche, Christophe Hurter, Nicholas Diakopoulos, Sheelagh Carpendale

Interactive Visual Data Analysis
Christian Tominski, Heidrun Schumann

Data Sketches
Nadieh Bremer, Shirley Wu

Visualizing with Text
Richard Brath

Mobile Data Visualization
Bongshin Lee, Raimund Dachselt, Petra Isenberg, Eun Kyoung Choe

Questions in Dataviz
A Design-Driven Process for Data Visualisation
Neil Richards

Joyful Infographics
A Friendly, Human Approach to Data
Nigel Holmes

Making with Data
Physical Design and Craft in a Data-Driven World
Samuel Huron, Till Nagel, Lora Oehlberg, Wesley Willett

For more information about this series please visit:
https://routledge.com/AK-Peters-Visualization-Series/book-series/CRCVIS

MAKING WITH DATA

Physical Design and Craft in a Data-Driven World

Edited by

Samuel Huron | *Institut Polytechnique de Paris, France*

Till Nagel | *Mannheim University of Applied Sciences, Germany*

Lora Oehlberg | *University of Calgary, Canada*

Wesley Willett | *University of Calgary, Canada*

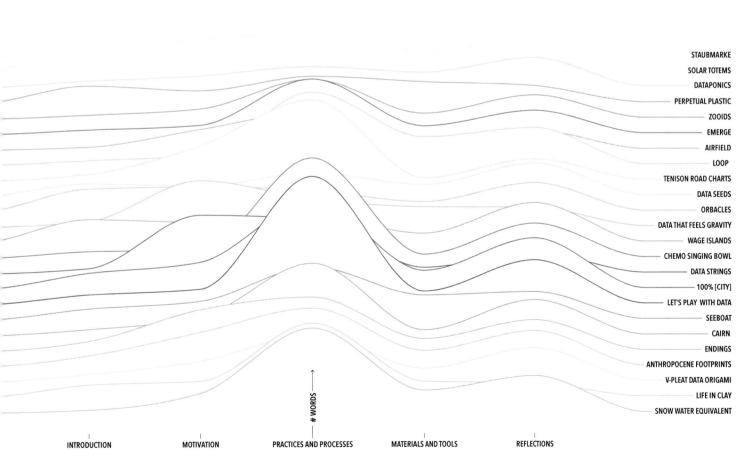

STAUBMARKE
SOLAR TOTEMS
DATAPONICS
PERPETUAL PLASTIC
ZOOIDS
EMERGE
AIRFIELD
LOOP
TENISON ROAD CHARTS
DATA SEEDS
ORBACLES
DATA THAT FEELS GRAVITY
WAGE ISLANDS
CHEMO SINGING BOWL
DATA STRINGS
100% [CITY]
LET'S PLAY WITH DATA
SEEBOAT
CAIRN
ENDINGS
ANTHROPOCENE FOOTPRINTS
V-PLEAT DATA ORIGAMI
LIFE IN CLAY
SNOW WATER EQUIVALENT

WORDS

INTRODUCTION MOTIVATION PRACTICES AND PROCESSES MATERIALS AND TOOLS REFLECTIONS

AK Peters | CRC Press
Boca Raton and London

First edition published 2023
by CRC Press
6000 Broken Sound Parkway NW, Suite 300, Boca Raton, FL 33487-2742

and by CRC Press
4 Park Square, Milton Park, Abingdon, Oxon, OX14 4RN

Library of Congress Cataloging-in-Publication Data
Names: Huron, Samuel, editor. | Nagel, Till, editor. | Oehlberg, Lora, editor. | Willett, Wesley, editor.
Title: Making with data : physical design and craft in a data-driven world / edited by Samuel Huron,
Institut Polytechnique de Paris, France; Till Nagel, Mannheim University of Applied Sciences, Germany;
Lora Oehlberg, University of Calgary, Canada; Wesley Willett, University of Calgary, Canada.
Description: First edition. | Boca Raton : AK Peters : CRC Press, 2023. | Series: AK Peters visualization series
| Includes bibliographical references and index. Identifiers: LCCN 2022025399 (print) | LCCN 2022025400
(ebook) | ISBN 9781032207223 (hardback) | ISBN 9781032182223 (paperback) | ISBN 9781003264903
(ebook) Subjects: LCSH: Information visualization--Social aspects. | Data structures (Computer science)
| Design and technology. Classification: LCC QA76.9.I52 M355 2022 (print) | LCC QA76.9.I52 (ebook)
| DDC 001.4/226--dc23/eng/20220725
LC record available at https://lccn.loc.gov/2022025399
LC ebook record available at https://lccn.loc.gov/2022025400

Publisher's note: This book has been prepared from camera-ready copy provided by the authors.

Design by Elodie Maigné.

Cover image by Betty Soliman.

Companion website: https://makingwithdata.org

For Anke, Azur, Iris, Rhys, and Tiphaine.

TABLE OF CONTENTS

13 **Series Foreword**
 by Alberto Cairo and Tamara Munzner

14 **Foreword**
 by Barbara Tversky

15 **Foreword**
 by Hiroshi Ishii

16 **Introduction**

28 # HANDCRAFT
 Introduction | Sheelagh Carpendale and Lora Oehlberg

36 **SNOW WATER EQUIVALENT**
 Adrien Segal

50 **LIFE IN CLAY**
 Alice Thudt

62 **V-PLEAT DATA ORIGAMI**
 Sarah Hayes

74 **ANTHROPOCENE FOOTPRINTS**
 Mieka West

86 **ENDINGS**
 Loren Madsen

98 # PARTICIPATION
 Introduction | Georgia Panagiotidou and Andrew Vande Moere

108 **CAIRN**
 Pauline Gourlet and Thierry Dassé

122 **SEEBOAT**
 Laura Perovich

132 **LET'S PLAY WITH DATA**
 Jose Duarte and EasyDataViz

146 **100% [CITY]**
 Rimini Protokoll
 (Helgard Haug, Stefan Kaegi, and Daniel Wetzel)

162 **DATA STRINGS**
 Domestic Data Streamers
 (Daniel Pearson, Pau Garcia, and Alexandra de Requesens)

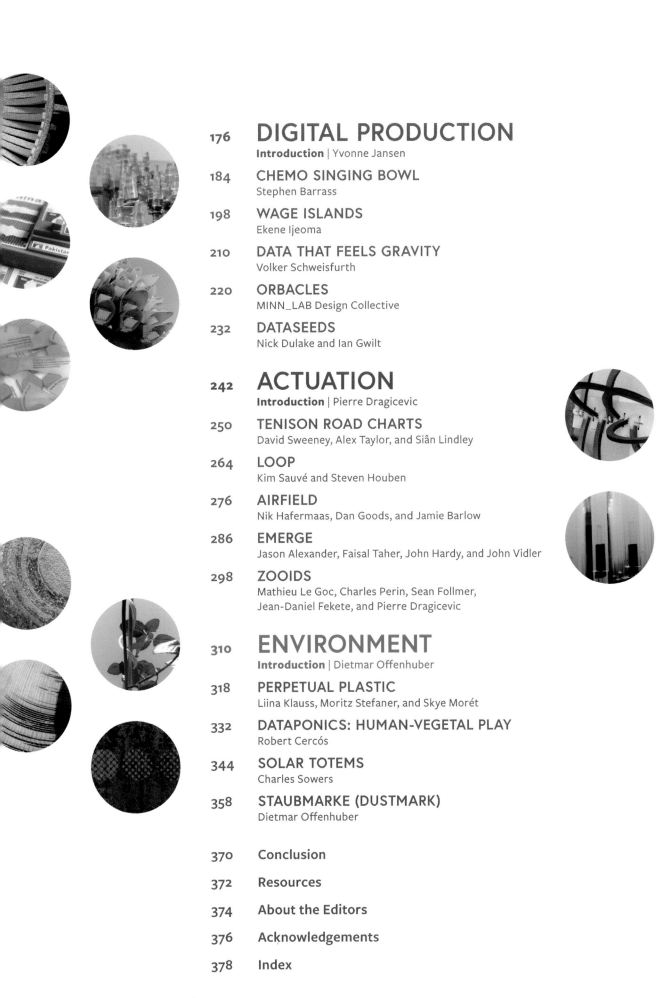

176 DIGITAL PRODUCTION
Introduction | Yvonne Jansen

184 CHEMO SINGING BOWL
Stephen Barrass

198 WAGE ISLANDS
Ekene Ijeoma

210 DATA THAT FEELS GRAVITY
Volker Schweisfurth

220 ORBACLES
MINN_LAB Design Collective

232 DATASEEDS
Nick Dulake and Ian Gwilt

242 ACTUATION
Introduction | Pierre Dragicevic

250 TENISON ROAD CHARTS
David Sweeney, Alex Taylor, and Siân Lindley

264 LOOP
Kim Sauvé and Steven Houben

276 AIRFIELD
Nik Hafermaas, Dan Goods, and Jamie Barlow

286 EMERGE
Jason Alexander, Faisal Taher, John Hardy, and John Vidler

298 ZOOIDS
Mathieu Le Goc, Charles Perin, Sean Follmer,
Jean-Daniel Fekete, and Pierre Dragicevic

310 ENVIRONMENT
Introduction | Dietmar Offenhuber

318 PERPETUAL PLASTIC
Liina Klauss, Moritz Stefaner, and Skye Morét

332 DATAPONICS: HUMAN-VEGETAL PLAY
Robert Cercós

344 SOLAR TOTEMS
Charles Sowers

358 STAUBMARKE (DUSTMARK)
Dietmar Offenhuber

370 Conclusion

372 Resources

374 About the Editors

376 Acknowledgements

378 Index

FOREWORDS

—

ALBERTO CAIRO AND TAMARA MUNZNER

**Editors,
AK Peters Visualization Series**

Data physicalization has a long history and a bright future. The vibrant and exuberant state of the art in creating physical representations of data is celebrated in this first-ever book on the subject. This book showcases the work of a diverse set of people from a broad swath of communities—designers, artists, architects, makers, crafters, researchers, engineers, and data scientists. It provides a guided tour through the creation, design, and fabrication processes and techniques for a fascinating collection of projects, situated within historical context and a rich intellectual landscape of considerations and implications.

This book is part of the AK Peters Visualization series, which aims to capture what visualization is today in all its variety and diversity, giving voice to researchers, practitioners, designers, and enthusiasts. Visualization plays an ever-more prominent role in the world, as we communicate about and analyze data. The series encompasses books from all subfields of visualization, including visual analytics, information visualization, scientific visualization, data journalism, infographics, and their connection to adjacent areas such as text analysis, digital humanities, data art, or augmented and virtual reality.

BARBARA TVERSKY

is a cognitive scientist intrigued by everything spatial, in the mind or in the world, natural or invented, in memory, language, events, gesture, visualizations, art, design, and creativity, working with artists, scientists, and engineers of many varieties. She wrote *Mind in Motion: How Action Shapes Thought.*

Credit: Roslyn Banish.

Why make data physical?

Data begin as physical, real stuff in real space and in real time: people, things, places, events, ticks in time, a birth, a death, an atom smashed, a price declined, dots in space that accumulate. Data are collected, combined, reduced, transformed, and mapped, typically to space and typically to sight, but also to time, to sound, to touch, to smell to enable extracting the general from the individual, finding meaning, and drawing implications.

Data, then, are created by a process, a process that occurs in time and space. Seeing and, even better, grasping, manipulating, or creating physical instantiations puts you in touch, literally and figuratively, with the processes that transform aspects of the world into data. Directly experiencing physical instantiations slows you down, makes you pause, to think and reflect. What is this representing? What is the mapping from the world to the artifact? It can make you sense the process. Sliding beads on an abacus corresponds far more directly to the actions of adding, subtracting, multiplying, and dividing real things than the formulaic writing of numbers and symbols in rows and columns. Knitting a row of a scarf each day where the color and length of a row corresponds to the number of deaths by overdose makes the terrible pace of unnecessary loss of life tangible. Hearing the bells count the hours, more chimes, for later, greater hours, does the same. We become aware of the individual and the particular, and of the process that accumulates and maps, that creates the mean, the curve, the equation.

Making data physical creates art, incidentally or intentionally. Art, too, abstracts. Traditional representational art abstracts the artist's conception of a person, a scene, an event; the person, scene, or event depicted is likely to be familiar and recognizable. Modern abstract art abstracts emotion or form, not just in visual art but also in music, literature, video, and more. Data physicalizations are a new kind of art form, a form that is both abstract and representational, but representing data about people, scenes, or events, not the entities themselves. In so doing, data physicalizations make the abstract concrete again, but the concrete has been transformed.

This wonderful book is packed with delightful examples of this new artscience form, examples that are inspired and inspiring and will bring joy to the senses and thought to the mind.

—

HIROSHI ISHII

is the Jerome B. Wiesner Professor of Media Arts and Sciences at the MIT Media Lab. Joining the Media Lab in 1995, he founded the Tangible Media Group to make digital tangible by giving physical and dynamic form to digital information and computation, pursuing his visions of "Tangible Bits" (1997) and "Radical Atoms" (2012) that will transcend the current dominant paradigm of Human-Computer Interaction: the "Painted Bits" of Graphical User Interfaces.

Credit: Junichi Otsuki.

We are tangible beings, not digital. Through human evolution, we have developed sophisticated skills for sensing and manipulating our physical environment through our hands, skins, bodies, and minds. However, most of these skills are not used when interacting with the digital world where interaction is largely confined to the painted bits of graphical user interfaces (GUIs).

The abundant data that we visualize, analyze, and consume today are primarily digital, stored in silicon memory, and represented as pixels on ubiquitous flat screens. However, the physical representation of abstract data has allowed people to record, compute, and reflect with their hands and minds. My favorite example is the ancient abacus that not only makes digits tangible with wooden beads, but also can be transformed into an imaginary toy train, musical instruments, or a back scratcher.

This beautiful and timely book *Making with Data* illustrates a seminal intellectual movement to bring abstract, digital data back to the physical world and into the hands of people who reflect and reason through the sense of touch, vision, and sound. As physical representations of data allow people to manipulate data, it becomes a powerful demonstration of "making the digital tangible", one of the overall goals of tangible user interface research in human-computer interaction and design.

The Tangible Media Group at the MIT Media Laboratory proposed the notion of "Tangible Bits" and tangible user interfaces (TUIs) in the mid-1990s to bring grasping hands and the sense of touch back to humans' interactions with data. TUIs offer a new way of embodying Mark Weiser's vision of *ubiquitous computing* by weaving digital technology into the fabric of the physical environment, rendering the technology invisible. Rather than melting data into a two-dimensional flat screen of pixels, TUIs give physical forms to data so that they can fit seamlessly into people's physical environment. TUIs aim to take advantage of haptic interaction skills, a significantly different approach from GUIs. TUIs make digital information directly manipulatable with our hands and perceptible through our peripheral senses through its physical embodiment.

When people have asked me how we came up with the ideas behind our tangible user interfaces over the years, it always requires a long answer. Sometimes the person asking hopes that there is a simple path they can follow to create something similarly inspirational – but there is no defined process, recipe, or protocol. This book reflects the unique stories behind physical data representations, the creators' relationships with data and the materials, and sources of inspiration for each piece. It connects the final physical objects and abstracted data back to the human inspiration and meanings behind them. It gives its readers a peek behind the unique processes behind each piece, and to forge their own path to "making the digital tangible".

INTRODUCTION

There is no *right* way to transform data into a physical object or experience. Instead, artists, designers, and researchers today are using a variety of approaches to give data physical form. The works they create run the gamut from personal to public to client-driven. Some incorporate massive datasets while others favor small, intimate ones. Their processes range from artisanal to casual, employing a diverse set of fabrication, construction, and craft techniques. Born at the intersection of data-driven culture and the maker movement, these contemporary projects and art pieces highlight how making data physical can inspire deeper experiences, with both the data itself and the larger world around it.

Rather than illustrating one correct approach, this book showcases the myriad ways in which people today are *making with data*—in the hope that these processes might inspire you to make something new.

A BRIEF HISTORY OF PHYSICAL DATA

Since long before recorded history, humans have created objects imbued with information. While our contemporary notion of *data* did not yet exist, early people externalized their memory by encoding quantitative or qualitative values into physical objects. Early examples, like the 40,000-year-old Lebombo bone and the 20,000-year-old Ishango bone, show people using tally marks to record information. Mesopotamian clay tokens, dating from roughly 10,000 years ago, suggest people had already begun to use objects to count, combine, and visually organize types and quantities of trade goods, as well as create durable physical records of transactions. Archaeologists like Denise Schmandt-Besserat have even hypothesized that these physical artifacts might have served as the genesis for writing systems.[1]

1 How Writing Came About.
Denise Schmandt-Besserat. 1997.
UT Press.

Over the following millennia, physical representations of data allowed people to record, reflect, and reason about the world in new and profound ways. Physical tools like sundials, water clocks, and hourglasses permitted the measurement of time. Voting via physical tokens provided the basis for collective decision making. Stones, shells, and metal coins facilitated trade, and likely gave rise to early currencies. Recording systems using portable technologies like knotted cords also emerged (likely independently) in cultures across the world and supported the emergence of new economic and administrative systems. This development has only intensified in recent centuries, with physical instruments like thermometers and seismographs helping facilitate the development of modern science. Similarly, physical models of cities, bodies, and ecosystems have allowed humans to reason about the world at new scales and complexities—provoking advances in fields such as planning, medicine, and ecology. Industrialization and an explosion of new fabrication technologies also introduced an ever-wider array of physical tools to support thinking and communication.

A BRIEF HISTORY
OF PHYSICAL DATA

Ishango Bones

The Ishango bone features a sequence of notches carved in groups, which have been interpreted as tally marks. There is no consensus on what data these tally marks represent. In David Darling's online encyclopedia, he speculates that a similar artifact, the Lebombo bone (35,000 BC), "may have been used as a lunar phase counter, in which case African women may have been the first mathematicians, because keeping track of menstrual cycles requires a lunar calendar."

Credit: Ben2 - Own work, CC BY-SA 3.0.

Clay Tokens

These clay tokens from the Uruk period represent the type and quantity of goods being exchanged. Clay tokens were used as a concrete counting system, and seem to be one of the earliest forms to count, combine, and visually represent trade data. When a transaction was completed the tokens were wrapped into sealed clay envelopes.

Credit: © RMN-Grand Palais (musée du Louvre) / Gérard Blot.

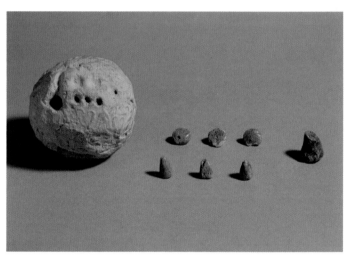

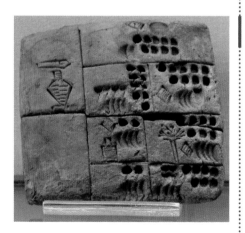

Clay Tablets

These clay tablets from the Uruk period were impressed with clay tokens to record accounts of commercial exchanges. Icons were added as pictorial representations to encode qualitative information. This clay tablet with pre-cuneiform writings is considered as the ancestor of our writing systems.

Credit: Poulpy, Public Domain.

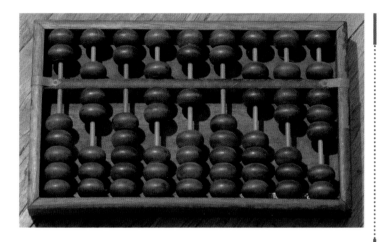

Abacus

An abacus is a simple mechanical calculation tool. The Chinese abacus (*Suanpan*) depicted consists of a frame with wooden beads threaded on rods. The beads can be moved up or down in the two sections in order to add, subtract, or multiply numbers. Abacuses have been found in different periods of history, and various parts of the world including Egypt, Greece, India, and Mexico.

Credit: ShieldforyoureyesDave Fischer - Own work, CC BY-SA 3.0.

Pebble Voting

This Greek wine cup from 490 B.C. shows one of the earliest graphical representations of a voting scene. In ancient Greece, dropping a pebble in an urn gave each (adult male) citizen an opportunity to express their opinions on political matters. Counting the stones provided the mechanism which anchored one of our earliest voting systems.

Credit: Courtesy of the Getty's Open Content Program, Public Domain.

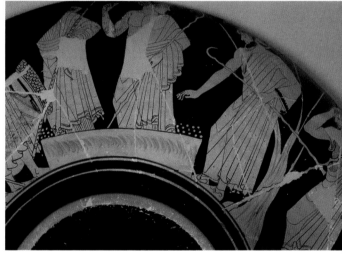

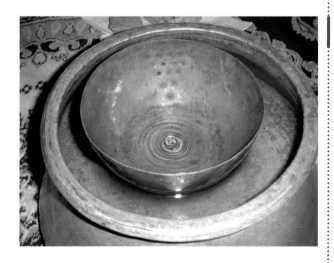

Water clock

Among the earliest ways that humans have tracked time was through water clocks. Depicted is a Persian water clock (a *Fenjaan* from 400 BC) which consisted of a larger vessel filled with water, and a smaller bowl floating in it having a tiny hole. The bowl would slowly fill with water, reaching the different marks signifying certain amounts of time. Finally, the bowl would sink, and the cycle began anew.

Credit: Maahmaah & Zeebad, CC BY-SA 3.0, https://parssea.blogspot.com/2012_01_01_archive.html

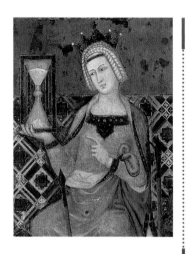

Hourglass

This is an excerpt from a cycle of frescoes, *The Allegory of the Good and Bad Government* (1338-1340), depicting a member of the government with a sand clock in his hand. With the emergence of clearer glass and glass blowing, people tracked time via hourglasses full of sand.

Credit: Ambrogio Lorenzetti—The Yorck Project (2002) 10.000 Meisterwerke der Malerei (DVD-ROM), Public Domain.

Plan-relief

This plan-relief presents the fortified town of Neuf-Brisach in France and was built between 1703 and 1706 at a 1:600 scale. Plan-relief models are small physical copies of landscapes, buildings, and battlefields, which have long been used to support building projects and military strategy.

Credit: Martin Leveneur—Collections du Musée des Plans-Reliefs de Paris, exposition *La France en relief* – Grand Palais. CC BY-SA 3.0.

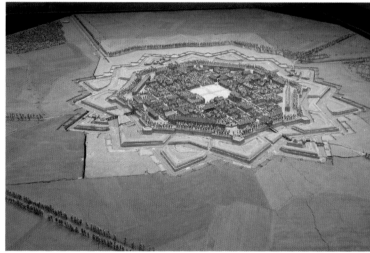

Gaudí's Hanging Model

Gaudí used this model made of weighted strings to simulate and compute the shape of the curves of the Sagrada Família. By using weights on the ropes, gravity and tension apply a force on each rope which curves the ropes and physically computes the correct arches in which the structure would hold.

Credit: Till Nagel, CC BY-NC-SA 2.0.

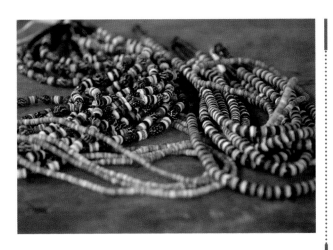

Shell Money

Stones, shells, and other physical tokens facilitated trade, and likely gave rise to early currencies. They have been used in many parts of the world including Africa, the Americas, Asia, and Australia. Today, coins and banknotes encode information (value and denomination) of a certain unit of money in much the same way.

Credit: Rob Maccoll for Australian Department of Foreign Affairs and Trade - SOLS0344, CC BY 2.0.

Mass Communication Tools

Otto & Marie Neurath and Gerd Arntz wanted to democratize statistics to encourage a more informed society. They created a visual system called Isotype, which used pictograms to communicate data, and displayed these as part of large-scale public exhibitions. To compose their graphics, they physically assembled sheets of paper with block printed pictograms that represent data.

Photo: Walter Pfitzner, 1930 Credit: Österreichisches Gesellschafts- und Wirtschaftsmuseum.

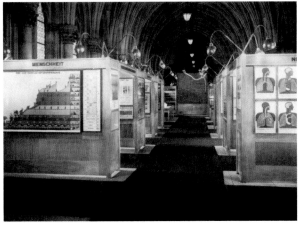

Analytical Tools

In the mid-20th century, cartographer Jacques Bertin and his team used physical matrices to analyze socio-demographic data. Small "dominoes" in the matrices each graphically encoded a single data value (for instance the number of young adults below the age of 20 in the city of Amsterdam). The teams then connected these dominoes with rods to form matrices that could be manually sorted and organized to help reveal patterns in the data.

Credit: Serge Bonin, Archive Nationales.

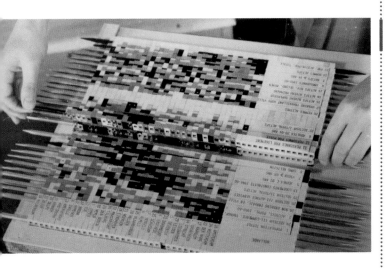

MAKING WITH DATA IN THE DIGITAL AGE

Of course, this practice of creating data objects is far from a lost art, and digital technologies have not replaced the practice of making physical objects. In an era where data is an increasingly visible part of our everyday existence, a growing number of artists, designers, makers, and everyday people are actively exploring the possibilities of making data physical. The explosion of new and accessible sources of data, combined with flourishing new craft and design disciplines, has led to a rich and growing space of data-rich physical artifacts and experiences.

If anything, digital tools have made it easier than ever to continue to make data physical. We now have new and accessible sources of personal and public data. Digital media helps designers coordinate how groups of people can create data representations together. Digital fabrication machines like 3D printers or CNC mills allow physical objects to be created with greater precision, based on digitally defined geometries from computer-aided design (CAD) software tools. Technologies like robot swarms or programmable circuits offer ways to computationally define and control objects' physical behaviors. As a result, the spectrum of people creating physical representations of data is more diverse than ever.

While the stories of exactly how and why most historical data objects were created have been lost to time, recent examples from designers, artists, and researchers around the world offer insight into the diversity and potential of new physical representations of data. Thus, this book offers a snapshot of contemporary data-driven making—examining the stories behind projects and unpacking the stories, tools, and decisions behind the designs.

THE LANGUAGE OF MAKING WITH DATA

There are perhaps as many ways of describing the process and potential of making with data as there are makers. Numerous practitioners and researchers, including some of the contributors to this book, have discussed the potential of physical representations of data—each offering their own overlapping (and sometimes contradictory) definitions. These descriptions range from abstract to specific, considering a variety of different senses, artifacts, and practices.

Throughout this book, we have tried to avoid academic jargon and use general inclusive language to describe each of the examples we showcase. However, the authors of individual chapters sometimes use more specific terminology to reflect their own approach and understanding of data-driven making.

PHYSICAL REPRESENTATION OF DATA

SENSES

ARTIFACTS

PROCESSES

▶
FOLLOWING PAGES

7 Embodiment in Data Sculpture: A Model of the Physical Visualization of Information. Jack Zhao and Andrew Vande Moere. 2008. In *Proceedings of the International Conference on Digital Interactive Media in Entertainment and Arts (DIMEA '08)*. Pages 343–350. ACM.

8 Opportunities and Challenges for Data Physicalization. Yvonne Jansen, Pierre Dragicevic, Petra Isenberg, Jason Alexander, Abhijit Karnik, Johan Kildal, Sriram Subramanian, and Kasper Hornbæk. 2015. In *Proceedings of the ACM Conference on Human Factors in Computing Systems (CHI '15)*. Pages 3227–3236. ACM.

9 Data Manifestation: Merging the Human World & Global Climate Change. Karin von Ompteda. 2019. In *IEEE VIS Arts Program (VISAP)*. IEEE.

10 Data Materialization: A Hybrid Process of Crafting a Teapot. Courtney Starrett, Susan Reiser, and Tom Pacio. 2018. In *ACM SIGGRAPH 2018 Art Gallery (SIGGRAPH '18)*. Pages 381–385. ACM.

11 Data by Proxy – Material Traces as Autographic Visualizations. Dietmar Offenhuber. 2019. In *IEEE Transactions on Visualization and Computer Graphics*. Volume 26, Issue 1. IEEE.

Data Visualization[1]

"The use of computer-supported, interactive, visual representations of abstract data to amplify cognition."

PHYSICAL REPRESENTATION OF DATA

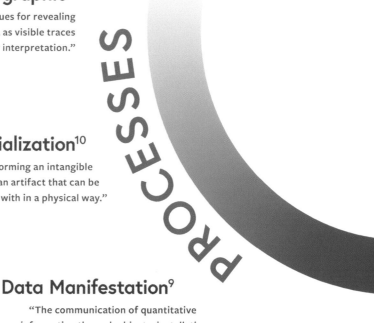

Autographic[11]

"A set of techniques for revealing material phenomena as visible traces and guiding their interpretation."

Data Materialization[10]

"The process of transforming an intangible object (data) in an artifact that can be interacted with in a physical way."

Data Manifestation[9]

"The communication of quantitative information through objects, installations, and sensory experiences."

Data Sonification[2]

"The mapping of data to sound parameters."

Data Edibilization[3]

"Encoding data with edible materials, as a novel approach to leverage multiple sensory channels to convey data stories."

SENSES

Information Olfactation[4]

"Harnessing scent to convey data."

Data Tactility[5]

"Giving a physical shape to the data collected over time in the form of a familiar and highly tactile functional object [...] to spur imagination, memory, and reflection."

Data Objects[6]

"Redesigning everyday objects—and not new objects—embodying data or as an interface to data services."

ARTIFACTS

Data Sculpture[7]

"The use of computer-supported, interactive, visual representations of abstract data to amplify cognition."

Data Physicalization[8]

"A physical artifact whose geometry or material properties encode data."

1 Readings in Information Visualization: Using Vision to Think. Stuart K. Card, Jock D. Mackinlay, Ben Shneiderman. 1999. Elsevier Science.

2 Data Sonification: Do You See What I Hear? Tara M. Madhyastha and Daniel A. Reed. 1995. *IEEE Software*. Volume 12, Issue 2. (March 1995). IEEE.

3 Data Edibilization: Representing Data with Food. Yun Wang, Xiaojuan Ma, Qiong Luo, and Huamin Qu. 2016. In *Proceedings of the 2016 CHI Conference Extended Abstracts on Human Factors in Computing Systems (CHI EA '16)*. Pages 409–422. ACM.

4 Scents and Sensibility: Evaluating Information Olfactation. Andrea Batch, Biswaksen Patnaik, Moses Akazue, and Niklas Elmqvist. 2020. In *Proceedings of the ACM Conference on Human Factors in Computing Systems (CHI '20)*. ACM.

5 ListeningCups: A Case of Data Tactility and Data Stories. Audrey Desjardins and Timea Tihanyi. 2019. In *Proceedings of the ACM Conference on Designing Interactive Systems Conference (DIS '19)*. Pages 147–160. ACM.

6 Data Objects: Design Principles for Data Physicalisation. Ricardo Sosa, Victoria Gerrard, Antonio Esparza, Rebeca Torres, and Robbie Napper. In *Proceedings of the DESIGN 2018 15th International Design Conference*. Pages 1685–1696. ACM.

DOCUMENTING THE MAKING PROCESS

Throughout the book, we highlight a cross-section of contemporary data-driven objects, art pieces, installations, artifacts, and performances that are provocative, interesting, and inspiring. These works, from more than two dozen designers, artists, and researchers emphasize the richness of contemporary data craft and design. Most importantly, however, they showcase the diversity of ways in which today's artisans are *making with data*.

We set out to let contemporary artists and designers at the forefront of data-driven making tell the stories of their pieces and reveal the rich and nuanced creative processes behind them. We invited a set of creators to contribute chapters that discuss the creation process behind a specific physical representation of data—avoiding generalization, and grounding discussions of their process in the specifics of a single piece. The result is by no means an exhaustive catalog of physical data representations. Instead, it represents a series of examples that begin to highlight the diversity of materials, expertise, datasets, fabrication techniques, and philosophies behind physical representations of data.

We have clustered these pieces into five themes, each introduced by researchers at the forefront of academic discussions at the intersection of data and making. *Handcraft* highlights how artists and designers imbue both unconventional and mundane objects with data. *Participation* showcases installations or events where communities and groups come together to collectively create physical representations of data. *Digital Production* collects pieces that use digital fabrication techniques like 3D printing or digital milling to produce unique and expressive physical forms. *Actuation* shows new systems that leverage automation and robotics to physically encode data in dynamic and interactive ways. And, finally, *Environment* explores systems in which people create opportunities for environmental forces to reveal data in physical media.

We hope that readers will take inspiration from the diverse set of approaches, styles, tools, and processes, as well as the emphasis on data-driven fabrication and communication. By bringing transparency to the making process, we hope to highlight the accessible nature of making with data, showing readers that they too can incorporate data into physical designs and engage with data by physically crafting it.

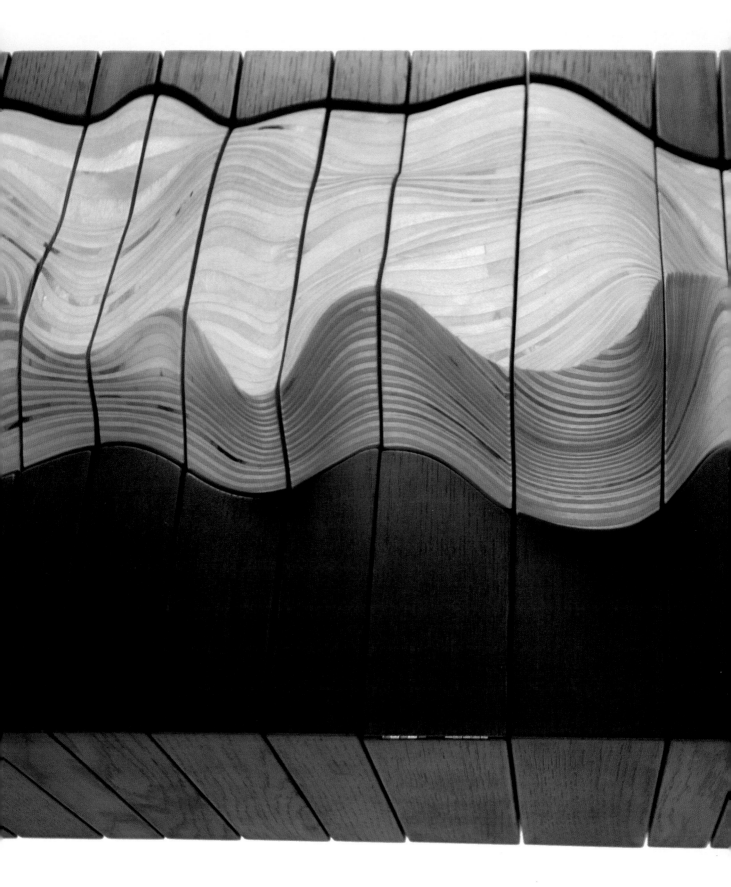

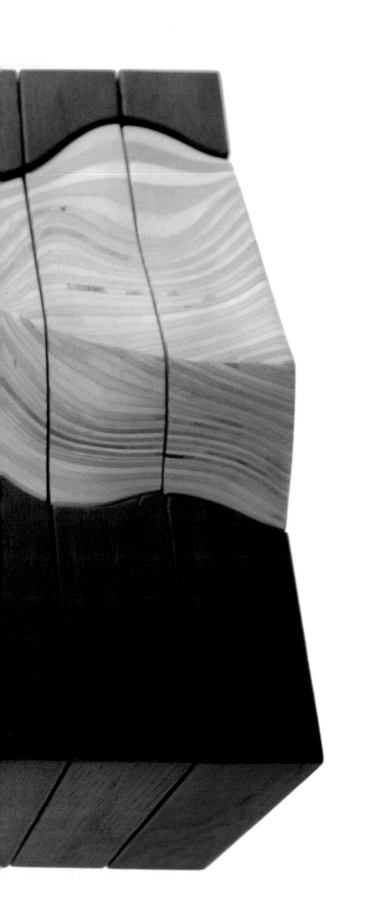

HANDCRAFT

SHEELAGH CARPENDALE

is a Canada Research Chair in Data Visualization in Computing Science at Simon Fraser University. Her research in data visualization and interaction design draws on her complex background in Computer Science and Visual Arts. She works with people who use data to move toward designing more natural, accessible, and understandable interactive visual representations of data.

LORA OEHLBERG

is an Associate Professor of Computer Science at the University of Calgary. Her research addresses interactive technology to support creativity, informed by her academic background in Mechanical Engineering, design theory, and design methods.

Discussions of data often treat it as something precise and mechanical—at odds with the flexible, adaptable, and expressive nature of handcraft. Yet many contemporary practitioners are choosing to blend the two, reflecting the rich history of recording and representing information by hand. Although handcraft has historically been the only way to create objects, today, handcrafting reflects a deliberate choice. Handcrafted representations of data communicate the care put into the object's creation. Each piece reflects the creator's manual labor or the way they used their own hands to bring the data into physical reality. Each creator has an inherently physical and personal experience with data; the object not only represents the data, but also the intimacy between the artifact, the data it represents, and its creator.

Yet, materials and handcrafting techniques from some of the earliest examples of physical representations of data have echoes in contemporary work. The fiber crafting techniques that used spun cord and knotted them into information representations called quipus are echoed in the textile art of Mieka West's *Anthropocene Footprints*. Mesopotamian clay tokens were an early form of an accounting system—echoed in the functional ceramics of Alice Thudt's *Life in Clay*.

◀

PREVIOUS PAGES
Snow Water Equivalent cabinet, by Adrien Segal.

FIGURE 1

Anthropocene Footprints, by Mieka West.
| Credit: Brian Harder.

FIGURE 2

Incan quipu from Peru. | Credit: NHB2013-02242, Department
of Anthropology, Smithsonian Institution.

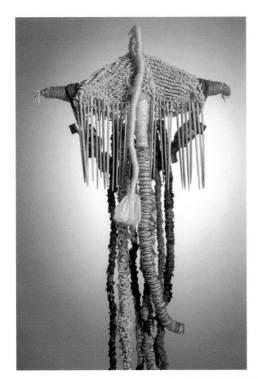

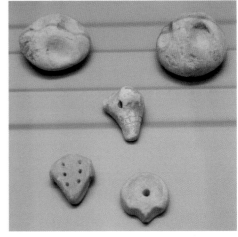

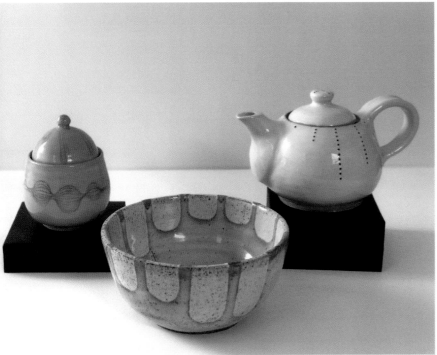

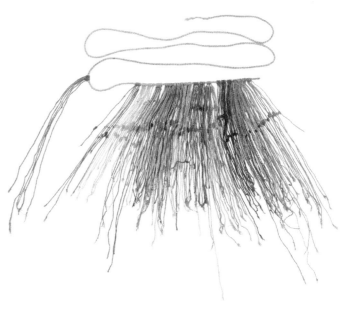

▲

FIGURE 3

Clay accounting tokens, Susa, Uruk period.
| Credit: Marie-Lan Ngyuen CC-BY 2.5.

◄

FIGURE 4

Life in Clay, by Alice Thudt. | Credit: Alice Thudt.

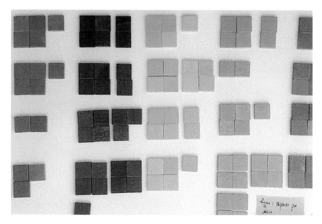

◄

FIGURE 5

Representing data by hand using laser-cut tiles, LEGO bricks, and modeling clay[1].

1 A Constructive Classroom Exercise for Teaching InfoVis. Wesley Willett and Samuel Huron. 2016. *Pedagogy of Data Visualization Workshop at IEEE VIS.*

◄

FIGURE 6

Of All the People in All the World. Stan's Cafe created data landscapes all over the world by mapping each grain of rice to a person in order to convey various statistics such as city populations or deaths in the Holocaust. The size and theme of the show change depending on the location. Rice is weighed manually in small quantities and manually poured over piles. This labor-intensive process is part of the show. | Credit: Graeme Braidwood.

However, just as historical examples used the available techniques of their eras and cultures, the artists, designers, and crafters making with data today often leverage modern tools to aid their hand creation process. For example, all of the authors in this section used computers to find and process datasets. In several cases, they even used computational tools to generate printed graphics that guided their manual fabrication. For example, to create his sculpture *Endings*, Loren Madsen first plotted and printed data using a computer, then manually bent copper piping to match—creating a piece that is simultaneously precise and bespoke.

————

The experience of creating a physical representation by hand is a deep and intrinsic part of the value of the piece.

————

The decision to hand craft a physical representation of data can be born of many different motivations. Often, this impulse reflects the creators' access to materials, equipment, or expertise, resulting in handcrafted data objects that showcase the deep knowledge and technical skill of an expert craftsperson. For example, Adrien Segal, the professional furniture maker whose *Snow Water Equivalent* cabinet appears later in this section, brings over a decade of technical woodworking skill to bear when creating her data-driven work. In other cases, handcrafting is simply the most approachable way to represent data physically, allowing creators to use everyday materials and requiring little to no prior experience. Approaches like Sarah Hayes' *V-Pleat Data Origami* highlight this, giving physical form to data using just ink, paper, and accessible folding techniques. This emphasis on accessibility has also driven the rise of "constructive" visualization techniques—physical representations of data assembled using everyday, prefabricated materials such as tiles or construction toys like LEGO bricks.

Regardless of expertise, the experience of creating a physical representation by hand can also be a deep and intrinsic part of the value of the piece. For example, in *Of All the People in All the World*, artist collective Stan's Cafe represented a variety of population statistics (including populations of various towns, the number of people with a given profession, daily births, and daily deaths) using piles of rice on a gallery floor, where

each grain represents one person. The assembly of the installation itself—the act of carefully counting or weighing out grains of rice—is a key part of the experience of the piece.

This kind of reflective handcrafting also lends itself to projects in which data collection is ongoing—and thus the design of the final object is unknown. In her performance piece, *Slumber*, artist Janine Antoni logged her daily sleep data between 1994 and 2000. During the day, she wove patterns of her rapid eye movement (REM) data into a blanket, which covered the bed where she slept at night—reinterpreting and reflecting on the nature of wakefulness and sleep. The relationship between crafting, awareness, and observation is also evident in the widespread practice of crafting "temperature blankets" where knitters or crocheters encode daily weather data bit-by-bit (either as a row of knitting or a crocheted granny square) into the growing piece. Most crafters approach these projects as "knit-a-longs" or "crochet-a-longs," adding to their blanket every day over the course of a year and ultimately creating an artifact that mirrors both meteorology and their own daily experiences.

Handcrafted representations of data communicate the care put into the object's creation.

The personal nature of many handcrafted data objects, and the constraints of artistic media and aesthetics, also have implications for how (or if) the data can be read in the final piece. In her chapter on *Anthropocene Footprints*, Mieka West describes her process of painstakingly and precisely measuring reused materials so that each bit of the materials explicitly represents a particular aspect of data before working them into unique, individual masks that reflect that data-informed set of materials. The resulting trio of masks offers its audience a holistic impression of our greenhouse gas emissions past, present, and future—embodying data while not asking viewers to read or compare specific values. Similarly, in Loren Madsen's *Endings*, the overall shape of the trend matters the most. Viewers can refer to an accompanying booklet if they are curious about specific data values.

Finally, handcrafted data representations can create opportunities for encounters with data in a range of settings. Two of the following chapters—Alice Thudt's ceramic tableware in *Life in Clay* and Adrien Segal's *Snow Water Equivalent* cabinet—involve domestic objects that can live in personal and social spaces and see day-to-day use, prompting everyday encounters that might trigger reminiscence and reflection. (In fact as we write this, several of Thudt's ceramic pieces continue to see regular use in our own research lab's kitchen.) Other examples from this section, like Loren Madsen's *Endings* and Mieka West's *Anthropocene Footprints*, were created for gallery settings that more overtly invite reflection and contemplation. Encounters with these objects—either at home among other objects or in a dedicated space—offer opportunities to examine our past in the present moment.

◄

FIGURE 7

A crocheted blanket by Heidi Filbert that encodes daily temperature and precipitation over one year (2018) | Credit: Heidi Filbert.

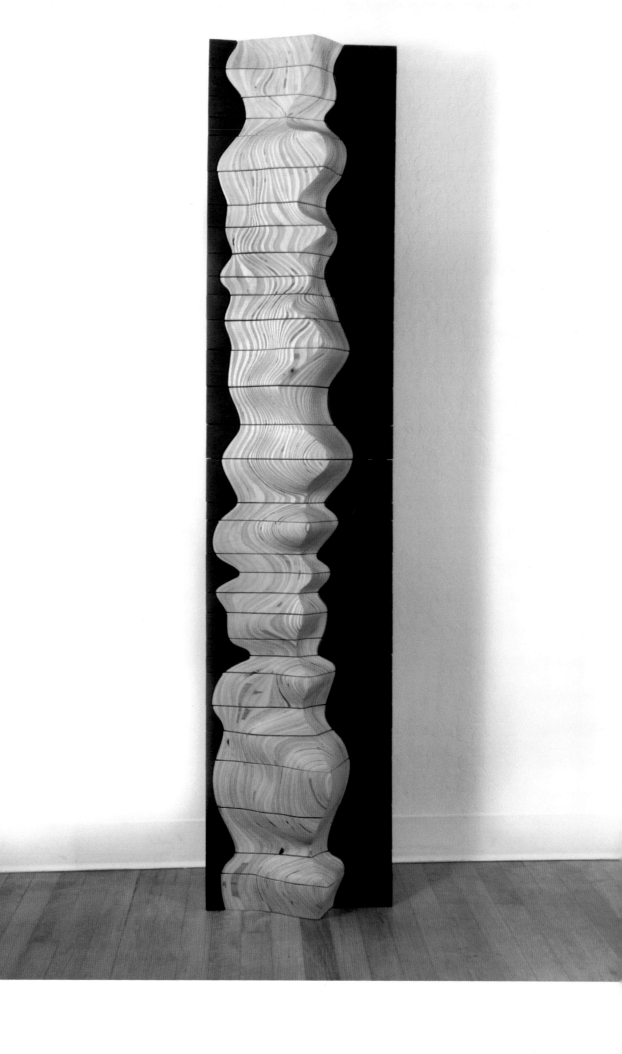

SNOW WATER EQUIVALENT

Adrien Segal

2011 (EBBETTS PASS),
2017 (SQUAW VALLEY)

Exhibited at *Innovations in Contemporary Crafts*, Richmond Art Center, Richmond, CA. March 23-June 1, 2013. Best of Show Award.

Published in *Conservation Magazine* (Spring 2013), *Arid Journal* (Fall 2015), and *American Craft Magazine* (June/July 2017).

Acknowledgments
Snow Water Equivalent is owned by a private collection
Data Source: Natural Resources Conservation Service (NRCS) / National Water and Climate Center / USDA

🔗 adriensegal.com/snow-water-equivalent

The *Snow Water Equivalent* cabinet is a functional data sculpture illustrating snowpack measurements recorded at Ebbetts Pass in the Sierra Nevadas of California, from 1980 to 2010.

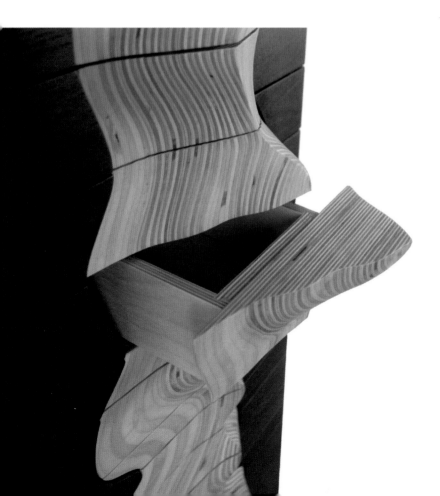

—

ADRIEN SEGAL

is an artist and writer based in Oakland, California. Drawing from landscape, science, history, emotion, and perception, her interdisciplinary work bridges the gap between scientific rationality and the emotional nature of human experience. Her work has been exhibited internationally since 2007, and is published in several books and journals. She has been awarded Artist Residencies across the US, Canada, and Europe.

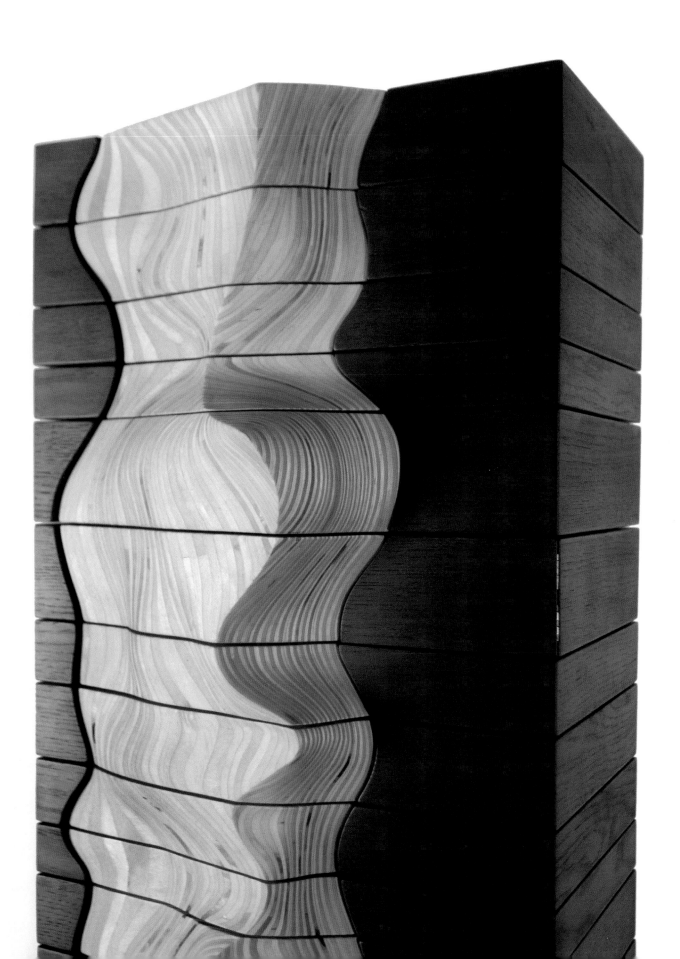

PROJECT MOTIVATION AND INSPIRATION

There is no formula that I use to create a sculpture using data—every piece is responsive to the source data, the concept, and the inspiration. The *Snow Water Equivalent* cabinet materialized from personal experience, rooted in my memories and nostalgia of growing up in the mountains in Colorado. The allure of snow and its quiet, all-encompassing beauty has always captivated me. This sculpture emerged from my love of the mountains, and my fond memories of experiencing snow from childhood.

Snow is the perfect seasonal water storage system, one that captures excess precipitation as frozen ice crystals during the winter months. The snowpack then slowly melts during the spring and summer months, feeding the streams and rivers that bring water to lower elevations. The natural landscape depends on this annual seasonal cycle, as do humans who rely on snowfall to be used for irrigation, industry, and public water needs in the dry summer months.

The inspiration leads to in-depth research to learn about how snowfall is studied and recorded as a way to better understand the long-term trends and patterns of natural phenomena, capturing changes in the landscape that occur in cycles or over longer periods of time.

▶

FIGURE 1

Water Year Graph showing the amount of snow water equivalent (inches) for one water year (September 2008-October 2009).

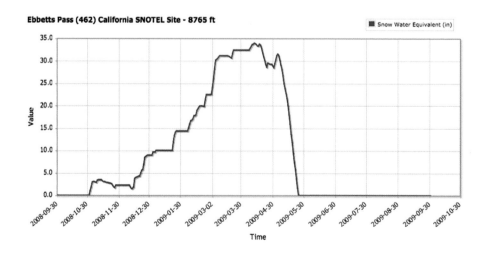

PRACTICES AND PROCESSES

 Sourcing the Data

Research into the study of snowfall led me to the website of the Natural Resources Conservation Service (NRCS), a division of the United States Department of Agriculture and the National Water and Climate Center. The NRCS operates and maintains an extensive automated system in the western United States. They established the SNOTEL program, which stands for SNOw TELemetry, to conduct snow surveys and to develop accurate and reliable water supply forecasts. Quantitative data such as air temperature, precipitation, snow depth, snow water equivalent, and soil moisture are available and easily searchable on their website. I found a number of sites in the Sierra Nevadas in California.

 Visual Iteration

My process is exploratory. I use drawing and sketching as a way to understand how the shapes, trends, and patterns in the data from year to year can be revealed and enhanced, and to envision how to transform the data into an aesthetically engaging physical form. Sketching allows me to ideate and experiment with different orientations and formats based loosely on the dataset, as I work my way through the process of 2D iteration to 3D forms. This sketch illustrates how source data can be visualized in three dimensions on the x, y, and z axes. During this stage, I am also considering what materials and fabrication methods I can utilize to make the sculpture.

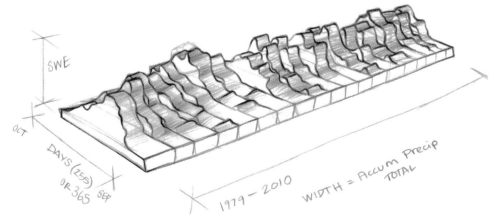

◄

FIGURE 2

Concept sketch showing 3D data visualization. x=water years (31 total), y=days, z=SWE, or snow water equivalent, measurement in inches.

FIGURE 3

Layout front view of sculpture showing 2D layer areas for cutting parts.

FIGURE 4

Export individual charts of SWE measurements for each water year.

FIGURE 5

Cutting, assembling, and laminating 2D plywood layers into a 3D stacked form.

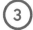

③ Applying the Data

The sculpture has continuity. The layers consist of 31 years of snowpack measurements from the data source, from 1980 through 2010 when the sculpture was made. Once I came to a form that worked well in terms of proportion and scale, I applied the actual data points to drive the form that would be fabricated. At this point I decided to orient the layers of data vertically. This is when I moved from sketching to using digital tools and programs to aid in design, which allowed me to represent the data as accurately as possible.

④ Digital Design of 2D Parts

To keep the design of the form as true to the dataset as possible, I entered each annual chart of snowpack into the computer program Adobe Illustrator and indexed them in relation to each other. The charts were used to drive the digital layout design that I later used as plans to cut the materials and begin to fabricate the sculptural form.

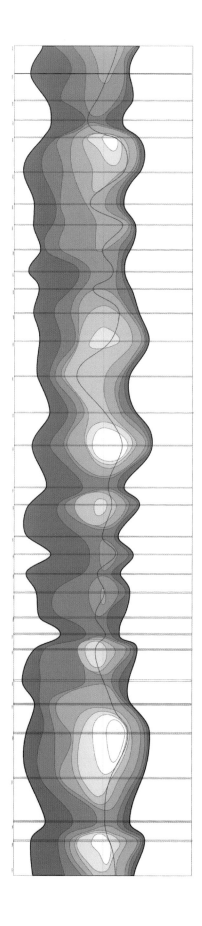

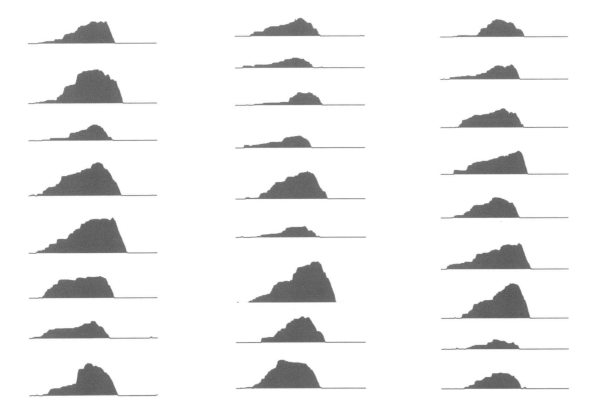

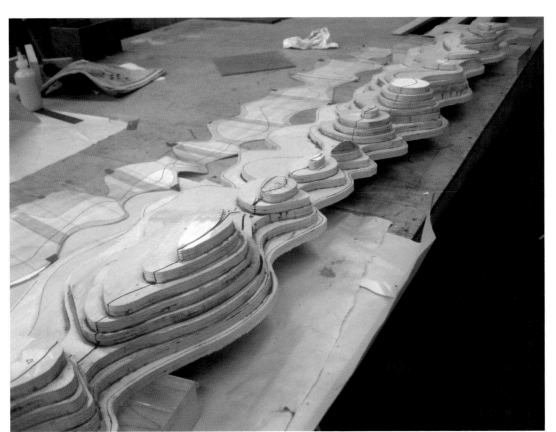

▶

FIGURE 6

Carving and shaping of the plywood form.

▼

FIGURE 7

Cutting the shaped plywood form into segments that will become the drawer fronts.

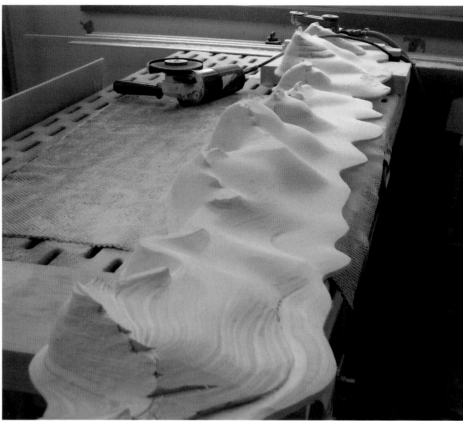

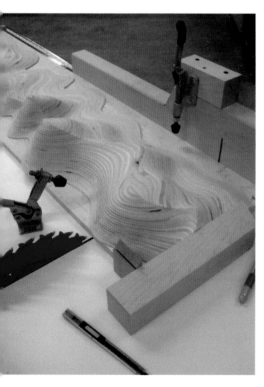

▶

FIGURE 8

Casework parts for the cabinet.

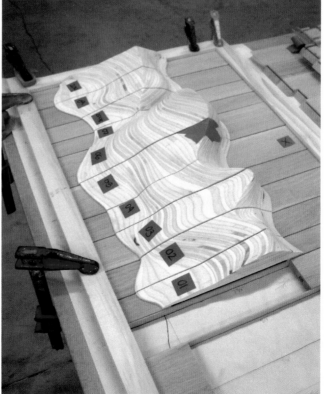

Stack Lamination

The plans for the parts design in Illustrator are used as templates to cut out the shapes in plywood on a bandsaw. They are stacked and glued together into one solid form, at which point they are ready to be carved.

Rough Shaping

Rough shaping of the plywood is done after the glue is fully set. The carving is done by hand with an angle grinder with an abrasive disk, in addition to hand-held shaping tools. I use safety equipment including a face shield, respirator, and hearing protection. It requires lots of practice to be able to control and use these tools safely and accurately. I grind away the plywood until it becomes a single fluid form.

Cutting and Fitting the Drawer Fronts

The sculpted plywood is cut into drawer segments using a table saw with a sled and toggle clamps to hold the parts in place while being cut on the machine. Each of the 31 drawers is custom cut to a dimension that correlates to the annual accumulated precipitation for each water year. The drawer fronts are then fit into each layer of the casework.

Fabricating the Casework

The framework for the cabinet is made out of solid wood, which requires advanced woodworking skills to fabricate. This image shows how each segment of the cabinet, each representing one year, was laid out and cut to size before being assembled with glue. Each section was a different dimension based on the annual precipitation data, which adds complexity to the fabrication process. I have a systematic method of labeling each piece to keep them organized.

▼

FIGURE 9

CAD (computer-aided design) model of a drawer slide and joinery.

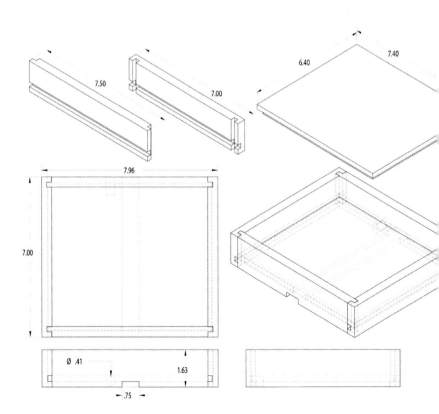

▼
FIGURE 10
Drawers with different sizes.

▼ ▶
FIGURE 11
Assembling and attaching the
sculpted plywood drawer fronts.

⑨ Building the Drawers

Every single drawer is a different size, following the variation in the annual water precipitation at the data site. This makes the drawers very labor-intensive to fabricate as well, since each one is cut individually, again referring to the spreadsheet with dimensions.

⑩ Assembling the Drawers

Once the drawers are built, the sculpted plywood sections are attached to the front of each drawer. They will reform the sculpted form once the drawers are assembled into the cabinet framework. The shallow, small drawers represent years where there was very little water available in the snowpack. The section of the carved plywood seen from the top of the drawer shows the graph of snow water equivalent for that particular year.

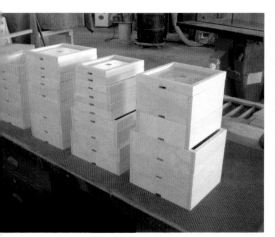

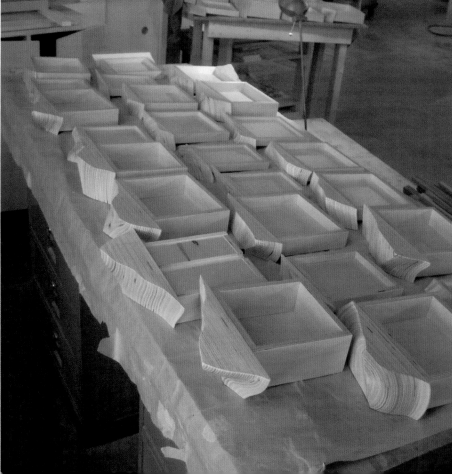

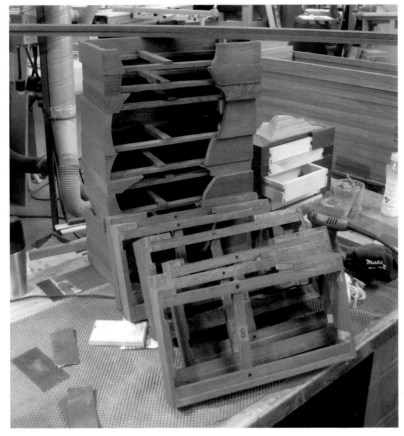

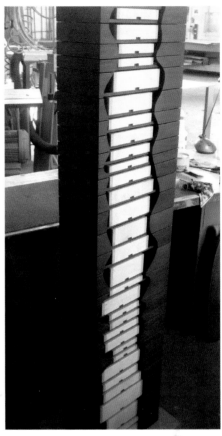

⑪ Ebonizing the Casework

The solid wood casework is made out of ash, a light-toned wood that I chose to ebonize, a process of black stain, to create a visual contrast with the carved plywood drawer fronts. Here each segment is ready for the final coat of a protective finish.

⑫ Final Assembly

Each finished segment of the casework is organized in consecutive order by year, from 1980 at the bottom to 2010 at the top.

▲◄
FIGURE 12
Assembling the casework.

▲
FIGURE 13
Final assembly of the casework with drawers fit in place.

MATERIALS AND TOOLS

Software

Excel
Spreadsheet software used to translate raw numerical data into line graphs and charts.

Adobe Illustrator
Used to layout vector drawings of the charts and the shapes in the design of the sculpture, which can be dimensioned and scaled, printed out as templates for cutting parts, or used to program a computer-controlled machine in some cases.

SolidWorks
CAD (computer-aided design) program used for 3D modeling, which was used to model the joinery and parts for the drawers and the casework for the cabinet.

Hardware

Woodshop
Equipment included a table saw, drill press, jointer, planer, handheld grinders, and shaping tools. Traditional woodworking techniques include milling raw lumber on a jointer and planer to make the wood flat, straight, and square so that one can cut out accurate parts with precise joinery to build a structure that is stable and sturdy.

Bandsaw
Used to cut curved shapes, in this case out of plywood which is then stacked, laminated with glue and then carved smooth with various handheld grinders and tools for shaping and sanding curvy shapes.

Material

Solid Wood
Ash was used to build the casework for the cabinet.

Water-Based Stain
The wood was ebonized with black stain.

Plywood
This was cut, stack laminated, and carved into the drawer fronts.

Hardware
The drawers have hardware that opens the drawer when it is pushed.

Wood Finish
Everything is coated with a protective wood finish.

REFLECTIONS

The concept behind the data drives every decision about what finished form the data will take. The *Snow Water Equivalent* sculpture ultimately took the form of a cabinet to make a connection between snow as a natural device for storing water and the devices humans use for storage. The size of each drawer is limited by the amount of annual precipitation and the cumulative amount of water contained in the snowpack; thus, for very dry years, the drawers are very small and there is very little space for storage. People can approach the concept from a number of perspectives. They may see a beautiful, evocative form. They may be drawn to the technical skill or material used. They may ask themselves, "What am I looking at and what is it telling me? Why is this drawer so small?" The piece is an invitation to investigate further and gain knowledge about the information embedded or contained in the artifact through a personal inquiry and subjective experience.

The process begins with finding the data and letting it reveal the form and materials that best represent the idea behind it as a refined artifact involving translation, interpretation, and creative license. As the artist, I direct the process of inquiry and translation using my unique skills, perspective, and creative vision. For some sculptures, the concept behind the data calls for a material or a technique with which I have little experience, or can require specialized tools or equipment in some cases, such as a kiln or a foundry. Those decisions push me to figure out new fabrication techniques, learn methods for using other materials, or to partner with other fabricators. The data, the story, and the inspiration drive that exploration. The iterative process from data to form can be very challenging, and evolves as it is developed and refined at each step in the process. Only when I feel that the concept and the design are fully resolved in a refined state do I begin fabrication to make the finished piece. Artifacts can be a creative expression that captures a particular time and place in the physical realm. They have the potential to raise awareness, bring about dialogue, tell a story, or change perceptions—they can be vessels embedded with layers of information, from which knowledge can be derived.

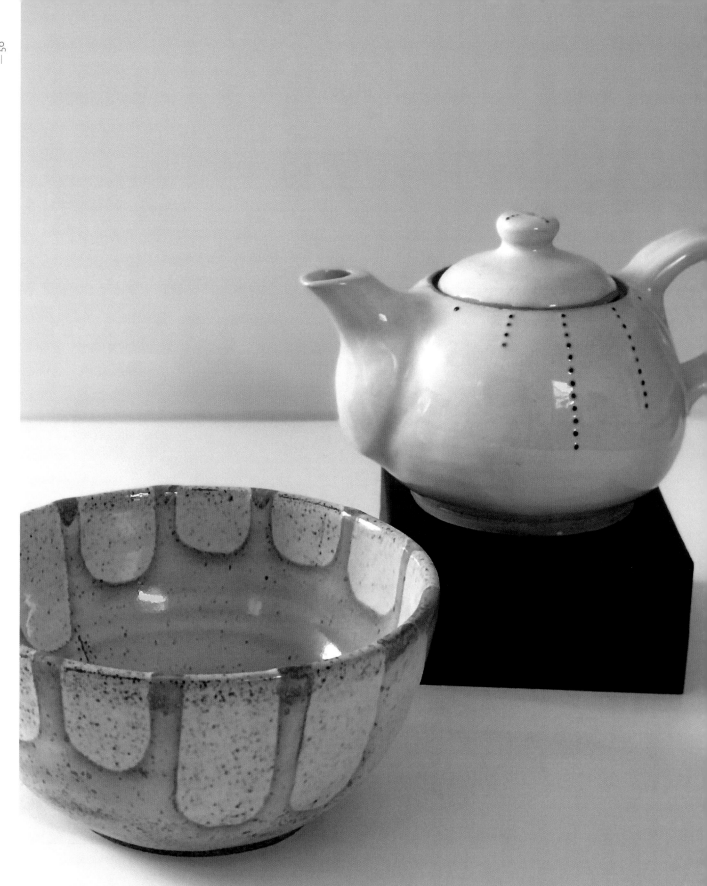

The teapot on the right shows a visualization of the same data in a different encoding. The bowl in the front represents my partner's productivity, to remind him of his accomplishments at work. The outside shows Git commits while the inside represents emails sent.

LIFE IN CLAY

Alice Thudt

2015

Acknowledgments

Thanks to Sheelagh Carpendale and Uta Hinrichs for their support and input on the project.

⟨⟩ alicethudt.de/projects/life-in-clay

Life in Clay is a series of functional ceramic pieces. Each piece is decorated with a visualization of personal data that reflects a precious memory, experience or relationship.

–

ALICE THUDT

has a Ph.D. in Computational Media Design. She pursued her research at the InnoVis group at the University of Calgary. Her research interest is to understand how people can use visualizations of personal data for personal reflection and expression. Creating personally meaningful artifacts from visualizations of personal data is both a focus of her research and her hobby.

▼
FIGURE 1

This set of bowls represents my Skype call history with my mom and dad during the time I lived in Canada. I made one bowl as a present for my parents and one for myself. When we eat our breakfast cereal, the bowls are a daily reminder to stay in touch and a symbol of how much we care about each other.

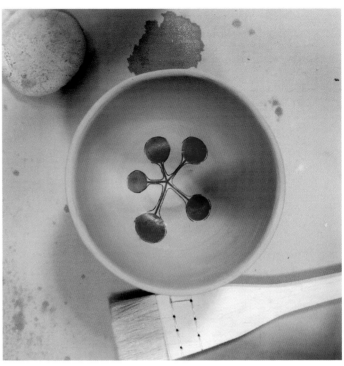

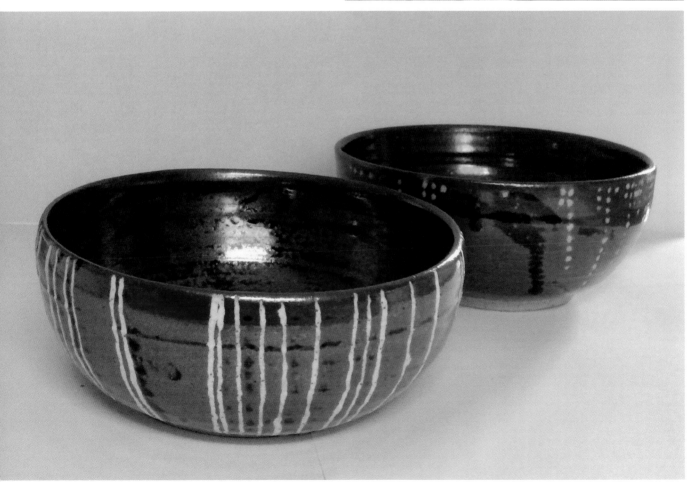

PROJECT MOTIVATION AND INSPIRATION

Life in Clay explores the act of turning data about my life and the lives of my loved ones into functional pottery. My goal is to give our elusive personal data a physical presence by creating objects that can be touched, loved and used every day. The pattern of each handcrafted artifact represents a precious memory, experience, or relationship that I want to remember or remind others of. The data pots create opportunities for the stories hidden in my data to be serendipitously reencountered, shared over dinner with friends, or silently reflected upon with a cup of coffee on the couch.

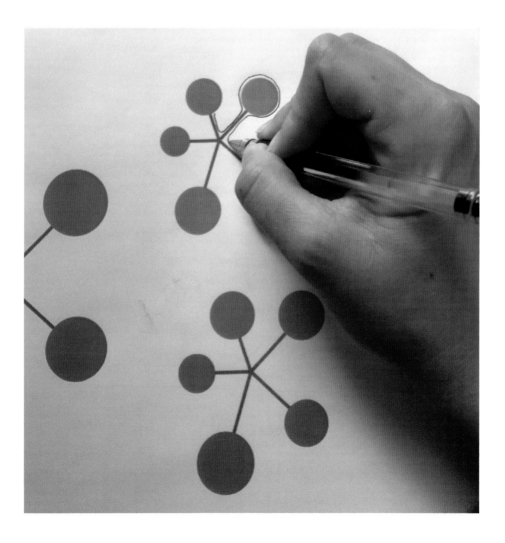

PRACTICES AND PROCESSES

Making a data pot is a very involved process that can take weeks or sometimes months to complete. The effort I invest in each artifact makes it precious to me and the act of making is my way of valuing the experience or the aspect of life an object represents. The design and making of each pot is an iterative process. I view it as an ongoing conversation between myself, the digital medium, data, and the physical medium, clay. Thus, the following steps are not always performed linearly but sometimes happen in parallel at the studio.

Decide on an Aspect of Life & Find a Data Source

I started the design process of each data pot by deciding on an aspect of my life or the life of a person close to me that I want to turn into a tangible memento. The aspect can be an activity, a specific accomplishment, or a relationship. Next, I decided on the data source that can represent this aspect. I have used calendars, email, text messages, location histories, and other activity logs as a basis for data pots. If I make the data pot for another person, gathering the data can involve asking them for an excerpt of their own records. Any dataset can be used in my process. However, for the manual, imprecise, and at times unpredictable clay decoration techniques, it can become necessary to reduce the level of complexity of large datasets.

POTTERY LEXICON

Throwing
The process of forming clay on a potter's wheel.

Slip Application
Applying colored clays on a piece before first firing with a brush or applicator.

Sgraffito
Applying a layer of colored slip on the object and then carving into it to reveal the color of the clay below.

Stains
Coloring oxides that can be applied to the glaze before firing.

Incising
Cutting patterns into the clay surface to create a relief.

Ideation

When I have found my data source, the next step involves playing with it, selecting aspects that are interesting or representative of the experience I want to capture, and creating initial graphs to get familiar with the general shape of the data. In this step, I already consider which decoration technique would work for the patterns in the data, or manipulate the data through aggregation, filtering, or selection of excerpts to adjust the level of complexity to a decoration technique I have in mind.

This process also involves sketching ideas for the design of the decorative pattern and the basic form of the object. Both the shape of the data and affordances of different clay decoration techniques influence this step.

Experimentation with Physical Materials

In parallel, in the studio, I start trying out some of the ideas and decoration techniques on test tiles. This gives me an idea of what ceramics techniques and materials work best for creating a pattern and, in turn, how the pattern needs to be adjusted based on the limitations of the physical materials. Thus, the process of choosing a data representation and decoration technique

have to go hand in hand. For instance, very detailed data patterns will not work reliably with techniques such as glazing, especially if the glazes tend to run. It might, however, be possible to create quite detailed patterns with sgraffito or on-glaze pencils.

The choice of what basic shape the object should have, whether I want to make a bowl, vase, mug, or teapot, is influenced by the topic, the person it is for, how I envision it being used and integrated into daily life, and how I hope it can best trigger reminiscing and reflection.

Assembling the Pattern

When I have decided on a form and pattern I map the data to simple visual marks such as circles, lines, and rectangles, which make up the pattern. I usually use standard software such as Excel or Tableau for this step, but I have also written my own software to more easily access and visualize common personal data sources such as calendars or GPS logs.

When I have created the visual marks, I use Adobe Illustrator to assemble them into a simplified version of my design. If necessary I print and manually adjust the pattern until I have created a version that can be transferred to clay. I use the measures of the physical object to determine the scale of the pattern in

Chapter	Pages	Pages
1	20	20
1.1		12
1.2		2
1.3		2
1.4		1
1.5		1
1.6		1
2	13	13
2.1		5
2.2		8
3	25	25
3.1		1
3.2		13
3.3		8
3.4		1
4	7	7
4.1		4
4.2		2
4.3		1
5	22	22
5.1		2
5.2		1
5.3		12
5.4		2
5.5		2
6	35	35
6.1		5
6.2		7
6.3		2
6.4		15
6.5		4
7	26	26
7.1		1
7.2		1

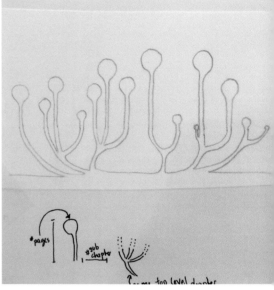

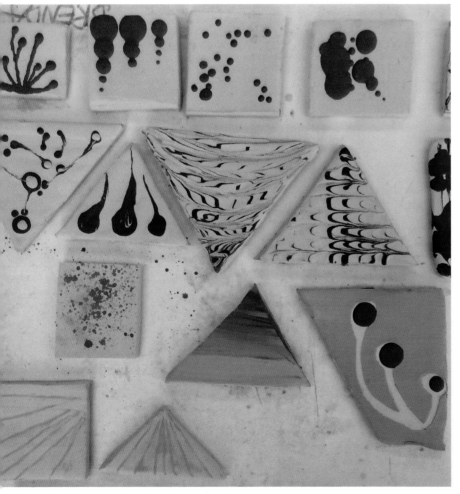

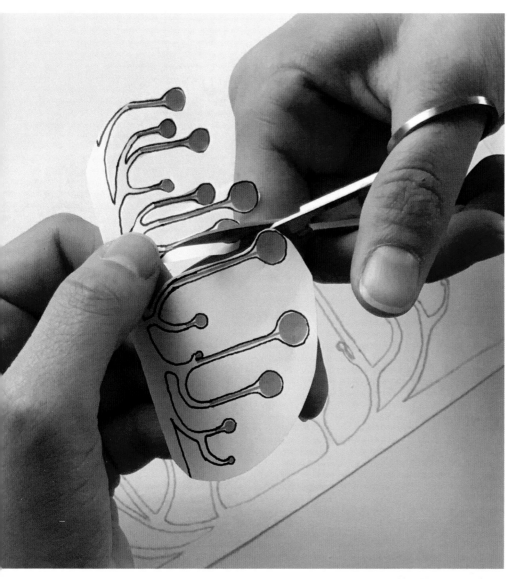

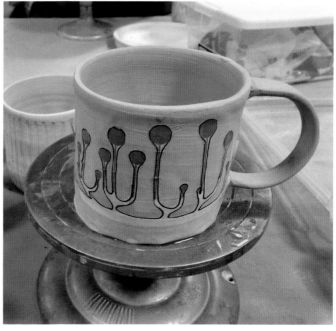

Illustrator or my own custom software. In the meantime, in the studio, I throw and refine the basic functional object.

Applying the Pattern to the Pot

For different clay decoration techniques, how a pattern is applied to the objects varies. What transfer method is most appropriate depends on the pattern, the form of the object and the decoration technique.

When using stencils, I either manually cut them out from the printed pattern or use a paper cutter that automatically cuts the stencil based on the input vector graphic. Using such digital fabrication is particularly useful for complex or fine-grained patterns. For simpler patterns the manual process is quicker.
If the pattern is one-dimensional, a simple measuring tape can be used to transfer the pattern to the pot. For more complex patterns that are painted onto the pot (for example by using techniques like slip application, sgraffito, stains, or incising), I use transfer paper to apply a printed pattern or project the pattern onto the pot using a setup with a pico projector.

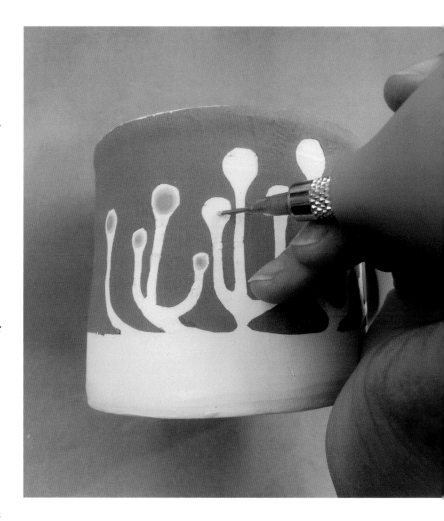

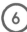

Finishing the Pot

After applying the pattern, I finish the decoration of the pot. As a last step, the pot is then glazed and fired. This process can sometimes be serendipitous and it is difficult to fully anticipate the results. Sometimes it can take many attempts until I am happy enough with the outcome to use it or give it away.

MATERIALS AND TOOLS

Microsoft Excel & Tableau

I use these tools to explore the data and create visualizations that form the basis of the data patterns that are applied to the pots.

Adobe Illustrator

For some pots, I assemble a version of the pattern in Illustrator.

Custom Software

I have written my own software to access common personal data sources such as location histories and calendar data. In the software, I create simple visualizations of this data.

Pen and Paper

I planned out my data patterns using pen and paper. For each pot, I created a variety of sketches before I decided on the final pattern.

Paper Cutter

I have used a paper cutter to create stencils for applying patterns to pots. However, if the pattern is not too intricate, ordinary scissors work as well.

Clay Manipulation Tools and Kiln

Working with clay involves a large variety of physical tools. These tools are used to throw and finish each pot. After this, the pots are fired in a kiln.

REFLECTIONS

Working with clay is a process that includes many failures and serendipitous outcomes. A big challenge is creating data patterns that work with the organic properties of the materials. The process thus involves a lot of experimentation, both digitally and in the studio. I find this experimentation with its failed attempts to be a big part of the reflectiveness of the making process. It requires looking at the data from different angles until a piece is finalized.

I have created my data pots with the intention of making objects that spark reflections and episodes of reminiscing. However, by making and living with these objects, I have noticed that the design and creation process is what makes me think deeply about the experiences hidden in the data. The creative process itself is more reflective than encountering the objects in my everyday life.

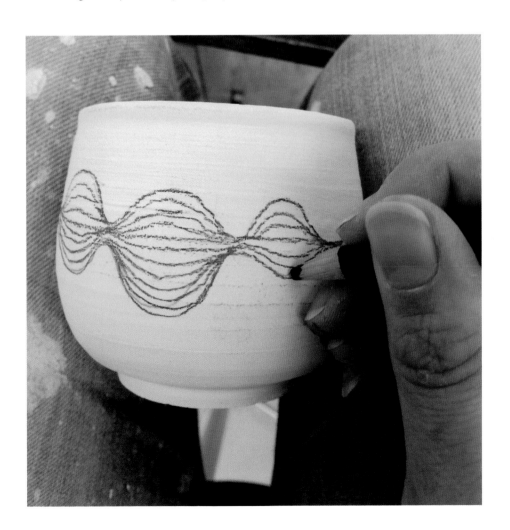

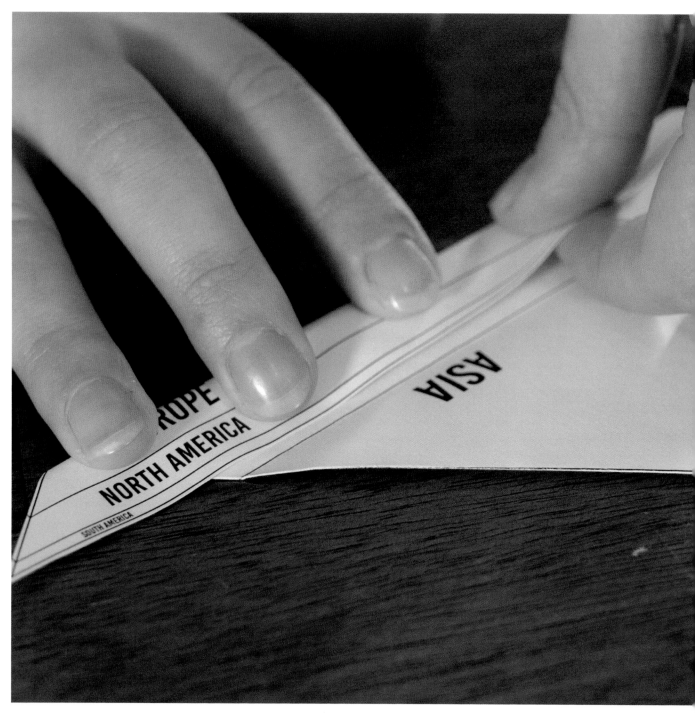

A person folding a V-Pleat pattern.

V-PLEAT DATA ORIGAMI

Sarah Hayes

2019

V-Pleat Data Origami is an origami pattern designed to encode data. It is constructed from regular printer paper, cut into a square shape and folded into a V-pleat, which is an origami pattern made up of zig-zagging pleats. The pattern can encode a one-dimensional dataset in the surface area of each of the folded pleats.

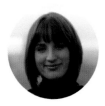

–

SARAH HAYES

is a Ph.D. student and UX designer living and working in Cork, Ireland. She earned a BA (Honors) in Multimedia from Cork Institute of Technology in 2015. Her Ph.D. research explores how low-cost, traditional crafting techniques can be used to encode data, and how people experience and engage with these designs.

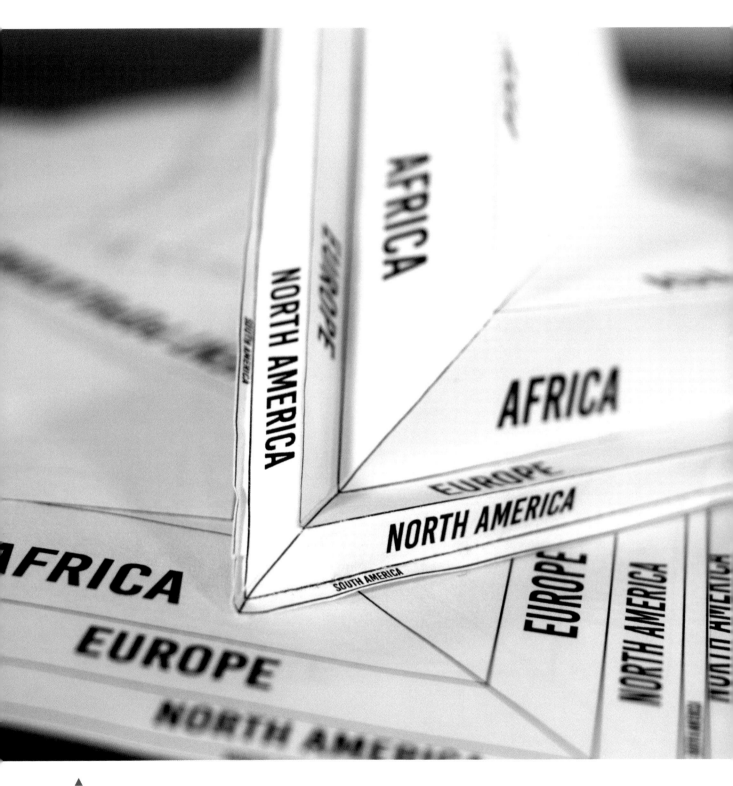

▲

FIGURE 1

A V-Pleat physicalization that encodes
continental population data.

PROJECT MOTIVATION AND INSPIRATION

I first became interested in using origami as a medium for data physicalization out of necessity. I was fairly restricted in the prototyping tools and materials to which I had access. As a student, cost was also an important consideration. I needed tools and materials that were affordable and readily accessible. Paper met these criteria—and furthermore, a rich history of paper crafting existed for me to tap into and explore in the context of physicalizing data. The work of practitioners such as Étienne Cliquet and Paul Jackson served as further inspiration. I conducted an open-ended design exploration, which involved quickly folding many established origami patterns as well as developing design modifications of existing patterns, and attempting to encode these with simple datasets. Through my engagement with this process, I became convinced of the potential of origami as a medium for physicalization. This practice offers designers a huge range of opportunities for encoding data in physical form, due to the existence of a massive library of origami patterns that is readily accessible online, as well as the vast range of approaches and methods within the practice as a whole. Additionally, the accessibility and relative affordability of paper as a material means that casual or non expert designers can participate in this design space.

PRACTICES AND PROCESSES

① Design Exploration

My design exploration began with a general inquiry into the ways paper can be shaped by hand. Initial sketches allowed me to map out some of these construction methods, and to begin exploring how they might be used to create variables in the paper object that could encode data. Length, width, height, angle, distance, surface area, volume, and number of folds were all identified and explored as physical attributes that could be varied within origami patterns to represent data. To simplify the data mapping process and to allow me to focus on developing origami designs, I decided to constrain myself to a one-dimensional dataset for my first design. After playing around with several origami patterns, both traditional and modern, I selected the V-pleat pattern.

② Adapting V-Pleat Techniques to Datasets

The V-pleat design comes from Paul Jackson's book *Folding for Designers*. In it, he demonstrates a method for varying the width of each of the folded pleats. I adapted this approach by developing a simple mathematical formula that could calculate the surface area of the two arrow-like shapes that make up each pleat. In this way, a dataset in the form of percentages could be encoded into the V-pleat pattern. For the purposes of this design, I selected simple one-dimensional datasets, such as continental population data. Datasets were converted into ratios, as this allowed me to easily encode the data by applying the percentage ratio to the surface area ratio of each of the pleats. This would then provide the position of each of the fold lines for the origami pattern.

OPEN-ENDED EXPLORATION OF SHAPING PAPER

ORIGAMI PATTERN EXPLORATION

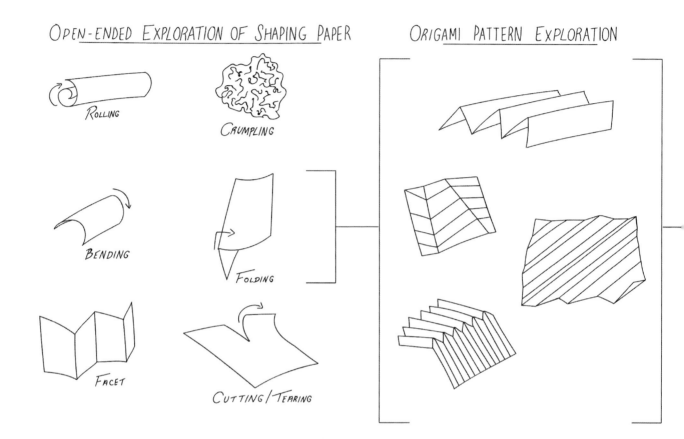

ROLLING

CRUMPLING

BENDING

FOLDING

FACET

CUTTING / TEARING

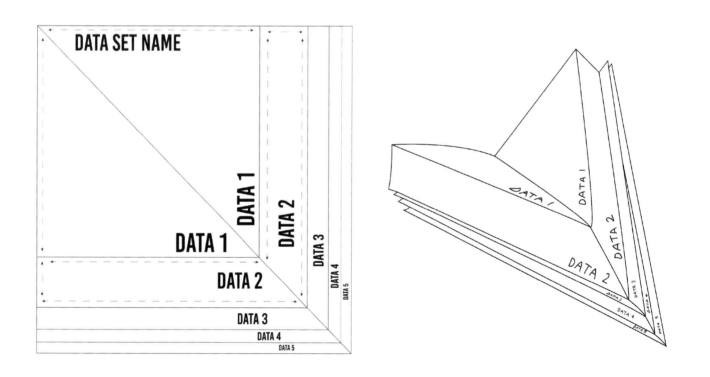

DATA SET NAME

DATA 1

DATA 2

DATA 1

DATA 2

DATA 3

DATA 3

DATA 4

DATA 4

DATA 5

DATA 5

APPLYING DATA TO ORIGAMI

(3)
From Web App
to Paper

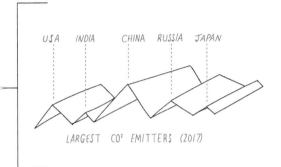

USA INDIA CHINA RUSSIA JAPAN

LARGEST CO² EMITTERS (2017)

▲

FIGURE 2

An overview of the process I
followed to generate paper-
folded data physicalization
patterns.

◀

FIGURE 3

The V-Pleat pattern, unfolded
and folded.

Producing the V-pleat pattern meant
calculating the pattern ratios by
hand with pen and paper—a time-
consuming process that often led to
errors. In response to this, I developed
a web application using JavaScript
that automatically generates the
V-pleat pattern based on an entered
dataset. Although this web application
simplified the production process, it
does have its restrictions. The data must
be in the form of percentages, and it
can currently only take up to six values.
My aim is to expand the abilities of
the application to handle increasingly
complex data, and to produce new
physicalization patterns as I develop
them. Once completed, I will make this
web application and its code available to
use and modify online.

▼

FIGURE 4

The process for generating
and constructing V-Pleat
physicalizations.

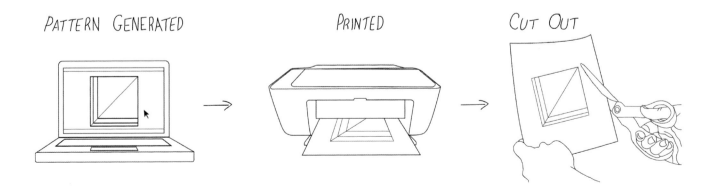

PATTERN GENERATED PRINTED CUT OUT

Origami Pattern Is Folded By Hand

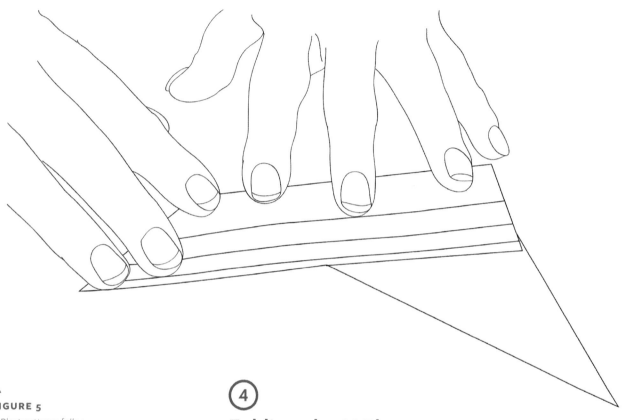

▲

FIGURE 5

V-Pleat patterns follow
traditional origami practice in
that they are folded by hand.

④

Folding the V-Pleats

V-Pleat Data Origami was designed
so that it can be replicated as easily as
possible by anyone who cares to do so.
It is printed on regular printer paper.
The pattern is then cut to its square
edges, and folded by hand along the
printed lines. The pattern is relatively
simple to fold, with no complicated
techniques involved. It can take people
a couple of tries to get it right; however,
I consider these failures to be part of the
experience of creating origami. They
seem to increase your satisfaction with
the finished piece when all your folds
eventually line up.

MATERIALS AND TOOLS

Printer Paper

I originally started designing in origami paper, but quickly switched to printer paper, as I realized that the latter is more widely accessible, lower-cost, allows for home printing, and has no effect on the folding of the design.

Bespoke V-Pleat Pattern Generator

Using JavaScript and HTML, I developed a simple web application that maps an inputted dataset against the V-Pleat design, and generates a corresponding physicalization pattern.

Printer

The V-Pleat pattern can be printed from the application using a standard laser or inkjet printer.

Paper Cutter

I used a paper cutter to cut the paper. This was perhaps the most specialized piece of equipment involved in the process. It is extremely useful for achieving straight edges and quickly cutting multiple patterns, although scissors could be used if a cutter isn't available.

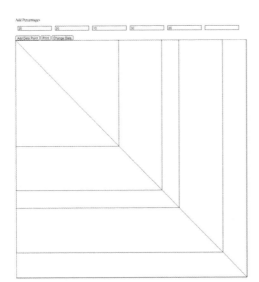

▲

FIGURE 6

Screenshot of the V-Pleat pattern generator.

REFLECTIONS

As a first foray into adapting an existing origami pattern for physicalizing data, I am happy with *V-Pleat Data Origami*. However, the pattern is restricted in the type of data it can encode, and supports relatively limited user interaction. The main interaction people have with *V-Pleat Data Origami* is folding the pattern. Once folded, the design can be opened and closed to examine the different pleats and compare the size of the different areas. I am not satisfied with the level of engagement afforded by these interactions, and am eager to move beyond this design to more elaborate origami patterns that support richer user interactions. During my initial design exploration, I identified several patterns that I believe could produce interesting and compelling physicalizations. For instance, I am deeply interested in shape-changing origami, and how it can be used to dynamically encode data.

Reflecting on the origami data object I have created, and the types of designs I plan to investigate next, has made me consider my expectations and intentions for my work. While the *V-Pleat Data Origami* pattern is relatively straightforward to construct and fold, the patterns I am interested in moving toward next are significantly more complicated. This raises a number of questions around the function and purpose of my data origami. Is it sufficient for me to be able to build one version of my design, or should they be replicable? What is the value of using low-cost and accessible materials and tools if the patterns themselves are too complex for the casual user to create? There is a tension between the complexity of the origami patterns I select, and the accessibility of the design. Ultimately, the answers to these questions depend on the application of each pattern. Thus far, I have been focused on developing the design space of data origami, and exploring its boundaries. Moving forward, my efforts will shift toward investigating and establishing specific application scenarios for my patterns, for instance, in schools, museums, and industry. I envision that designing toward specific usage contexts will provide guidance to the future direction of my work.

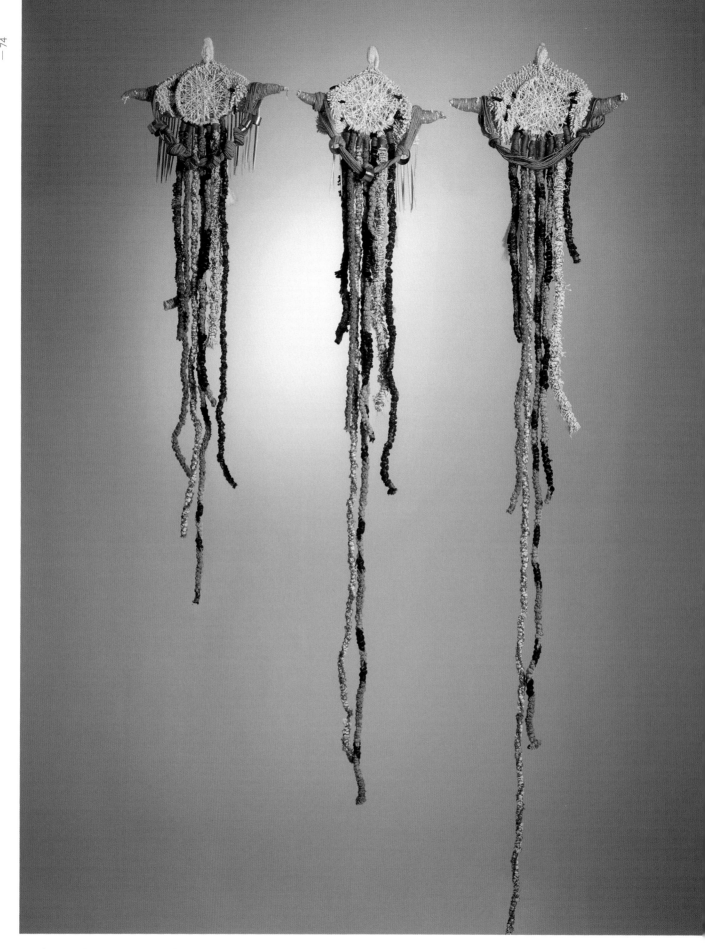

Canada's Greenhouse Gas Emissions for 1990 (left),
2010 (center) and 2030 (right).

ANTHRO-POCENE FOOTPRINTS

Mieka West

2017

Data Effect (Ottawa, Canada), CEM10 (Vancouver, Canada),
IEEEVIS 2018 (Berlin, Germany), Festival Cervantino (Guanajuato,
Mexico), Spark2019 (Edmonton, Canada)

Acknowledgments

Sheelagh Carpendale (Supervisor), Simon Fraser University

Glasha Obrekht and Alexandre Dumas (Data Experts), Environment Canada

Anthropocene Footprints is a handmade visualization of Canada's actual greenhouse gas emissions for 1990 and 2010 and projected greenhouse gas emissions for 2030. Long woven ropes encode the emissions from each sector of the economy with the longest, in 2030, showing oil and gas emissions. The data comes from Environment Canada's Reference Case for 2016.

—

MIEKA WEST

is a Canadian data designer, artist and maker of data sculptures using repurposed materials.

▶

FIGURE 1

Creature back; here you can see the tail which shows Canada's per capita emissions (in magenta yarn) versus the world's (in ivory yarn).

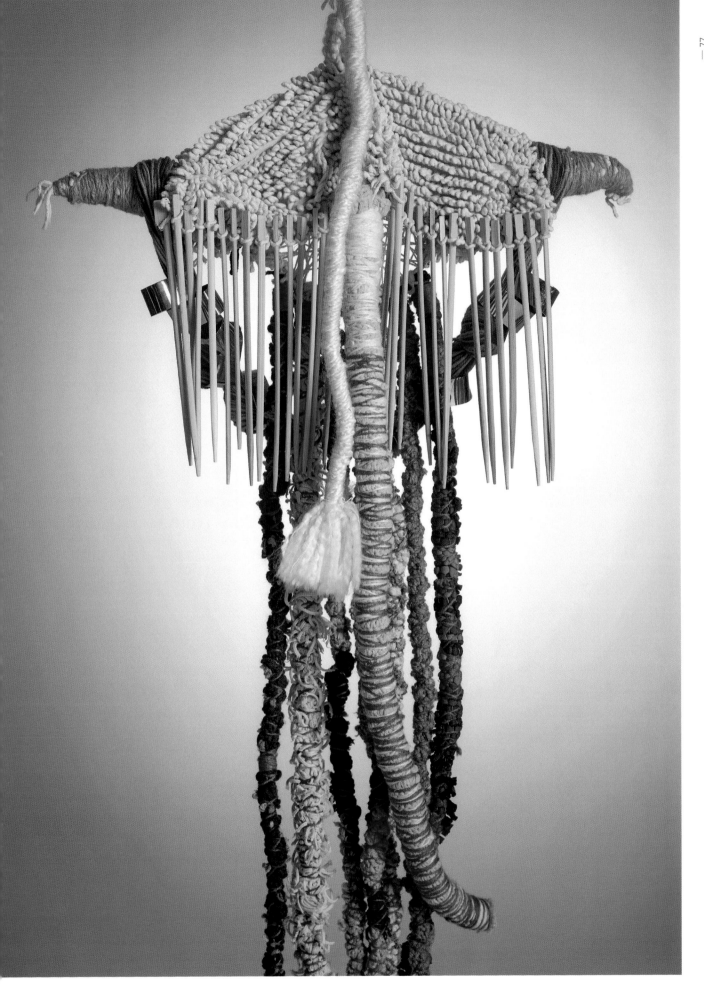

▼

FIGURE 2

Chopstick fringe of the creature showing pounds per person per day of emissions. The wooden fringe also has an auditory quality when the chopsticks move.

▲

FIGURE 3

Detail of the tail. The tail uses repurposed baby blankets wrapped tightly with yarn.

PROJECT MOTIVATION AND INSPIRATION

While working as a designer at the University of Calgary's Interactions Lab on a research project visualizing energy data for Canada Energy Regulator (CER), I also took an evening course on data visualization. I made this project as my first physicalization. I spent a great deal of time thinking about how Canada's greenhouse gas emissions data might be experienced by someone face to face, and how that artifact might have an effect on them. I walked through different scenarios in various spaces; in staircases, galleries, hallways. I was motivated to sidestep any visualization software and make the artifact by hand, doing all the calculations by hand. I wanted to question what appears to be an accepted standard in data visualization about efficiency: namely, that people should be able to understand data visualizations quickly and that visualizations should use an efficient amount of ink to get the point across. I gave myself the license to express the data in very non efficient ways. Making this project by hand would give me a slow and tangible way of learning about the data. Because we often think of emissions as being in the air, I was drawn to smog masks and masks in general. This became the first inspiration, and how masks form personalities, or creatures. Because Canada's projected emissions are set to increase, the masks would have to grow considerably. I then studied early examples of physicalization, going back thousands of years. I came upon one of the earliest forms of data visualization, the *quipu*, or "talking knots." This was a highly portable set of knotted strings used by a number of cultures to record demographic data such as census, taxes, and calendars. The quipu became the second source of inspiration because, as a set of knotted strings, it is very accessible from a maker perspective and a viewer perspective. I imagined how the quipu was made, how it could be touched, hung, and easily transported. Yarn and string are very forgiving materials because they can be so easily manipulated and repaired. In addition, I set the constraint of only using repurposed materials. These constraints were the creative starting point to begin making the work.

PRACTICES AND PROCESSES

FIGURE 4

I assembled the repurposed materials and stitched them together in Adobe Illustrator to get a sense of what the project might look like. I did go ahead with this version but then disassembled it because the materials behaved unexpectedly together.

① Data Selection

My challenge with the data was figuring out how to represent very small changes over time with huge variation between categories. I chose a very small subset of the data, three years—1990, 2010, and 2030—that would tell a story and show our past, present, and future.

② Find Suitable Repurposed Materials

I had to find sufficient textiles to represent the largest emissions. This led to establishing the overall scale of the work, making the pieces roughly human scale, so as to maximize the relatability of the data. Large works create very different experiences for viewers than small work. I didn't want to create a larger work that might make the viewer feel less powerful, nor did I want to make the work very small,

or diminutive. My feeling was that if viewers can relate to the emissions, at a relatable scale, it might have more impact emotionally and they might take more ownership of their emissions. I then took pictures of potential material combinations and stitched together the pieces in Adobe Illustrator.

③ Measure Materials

When I had amassed a small mountain of textiles, I began measuring out in length and width what was available to me to work with and began cutting. At this stage in the project, I was using a per capita calculation for all emissions, where one metric ton was equal to one inch of fabric.

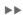
FIGURE 5

Simple tools, repurposed materials and a small slice of the data. The first step is to figure out how much material is required for the largest data point. The next step is to figure out how to join sometimes disparate materials.

▶▶
FIGURE 6

Turning woven blankets into "tentacles" by wrapping yarn tightly around large pieces. To make a rope such as the one on the left, I needed a wide swath of textile. Depending on the weave and how it is held during fabrication, it can stretch in length.

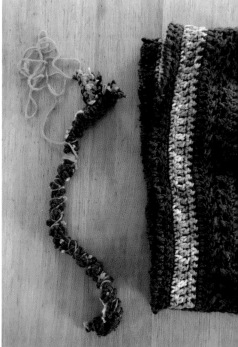

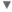

FIGURE 7

An example of creating a heavy rope using repurposed textiles. In this case, I used a baby blanket to make the tails of the creatures. To make a 1-inch-diameter rope, I used approximately 6-inch-wide material.

FIGURE 8

Depending on how the materials are manipulated, there can be unexpected shrinkage, stretch, or unravelling with textiles. With this first iteration of the project, the materials didn't behave as expected, so I dismantled the work.

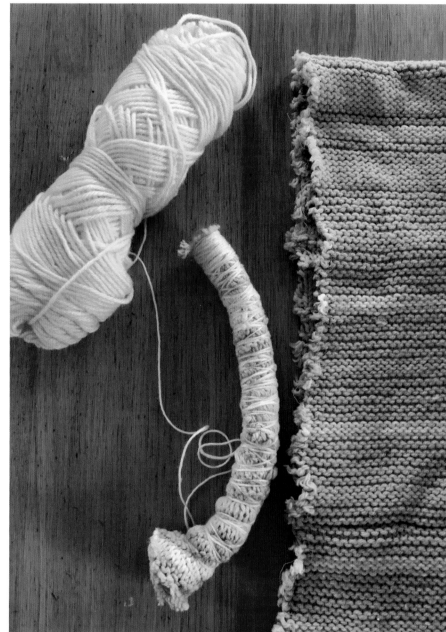

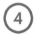

Explore Ways to Attach Materials

Because I was using a wide array of domestic repurposed materials, cutting into them and figuring out how to join them was an interesting challenge. I used simple and wide stitches at first, like a basting stitch. Silk, cotton, wool, and synthetic fibers can behave differently, and there may be surprises depending on the density of the weave and the grain of the fabric. When I cut into a woven mat, there were synthetic fibers that popped out but had given the mat structure. It is important to know how to react on the spot to the challenges that materials pose. In this situation, each material responded in a different way, sometimes shrinking, stretching, or unraveling depending on the join.

Re-evaluate Progress

At every step in the process, it was necessary to take a step back and assess whether the combined materials were reading as intended. I finished all three pieces and concluded that they weren't behaving how I had anticipated, and chose to take it all apart. In fact, the weight of the combined fabrics, one pulling on the other, was stretching the piece and exaggerating the data, so that the loosest weave unintentionally became the largest segment! This was a useful point in the creative process, because it led me to discover new territory, as nothing had been mapped out for me and there were no guidelines.

Iterate

Then, with a stack of deconstructed repurposed materials, I went back to the data and decided to concentrate on the total reported emissions, rather than per capita. The differences between the largest emissions—for oil and gas, for instance—and another sector of the economy was really noticeable. I turned those total emissions for each sector of the economy into long handmade bar charts. I hand-stitched and wrapped the materials (see Process3 image) tightly in yarn, in a similar way to making rope, with an inner core and yarn wrapped tightly around the outside. As I was making these segments they started feeling in my hands like creature "parts": long tentacles, horns, hair. I have used metaphors in design as a way to see the design through, and in this case, the metaphor was also tactile. As it turns out, I was making creatures with a large mask with moving parts.

MATERIALS AND TOOLS

Software

Microsoft Excel
I first received the data in Microsoft Excel spreadsheets from Environment Canada. The tabular data became useful for framing the narrative; focusing on binning the data according to years rather than regions.

Adobe Illustrator
In Adobe Illustrator, I did quick sketches of potential shapes to construct, using different textures and configurations. This could have easily been done by hand sketching; however, I was able to use photos of the actual materials to do a composite sketch.

Tools

Measuring Tape

Scissors
Nothing beats a good pair of scissors when using textiles for a repurposing project.

Pen, Paper
As I aimed to do the calculations by hand, I had numerous sheets on the go.

Large Sewing Needle

Resources

Reclaimed Materials
Sourced from local thrift stores, reclaimed materials included yarn, embroidery hoops, chopsticks, baby blankets, bath mats, napkin rings, and thread.

Time: 140 hours
Time and labor to assess, deconstruct, and fabricate different materials with different elastic properties was key.

REFLECTIONS

Taking the project apart led to the notion that the work didn't need to be precious. It could be touched and compared by a viewer, and that was a really interesting revelation. If something unraveled slightly, it could be easily repaired. This allowance for imperfection and tactility has in turn made the work accessible for people to learn about visualization.

Anthropomorphizing the data or making the data into creatures is a way for people to see themselves in the data. When I now explain the finished piece in person to viewers, I often use the same language to explain the data mapping: creatures, tentacles, horns, hair. The language makes the data more relatable. Because I was drawn to the quipu and how it could be touched, this informed the interaction with the work.

What was interesting for me personally in making these large pieces by hand was that I felt akin to those who make work with few tools and an incredible amount of manual labor. The canvas for exploration, when you are using very few tools, is vast, and it holds very few barriers. I realized after the fact that I had made work that is accessible to younger audiences, to people who might know very little about data, to people who normally don't have access to online data visualizations, and to the sight-impaired. This last point, making data visualization universally accessible, is the reason I continue to create physicalizations.

Anthropocene Footprints has been well received. However, when it is exhibited, I am next to the pieces to explain the encoding. There is a great deal of complexity in understanding the work, which can be both a negative and a real positive. It challenges the accepted notion that all visualizations should be easily understood. People have to work at understanding it, but when they do, the visualization is something they remember. They remember that the longest tentacle is oil and gas and that Canada's oil and gas emissions are set to increase dramatically in 2030. When people take the time to understand the work, the reaction is excitement about the potential of physicalization, the impact of touching the emissions, and surprise that data can be visualized in non traditional formats.

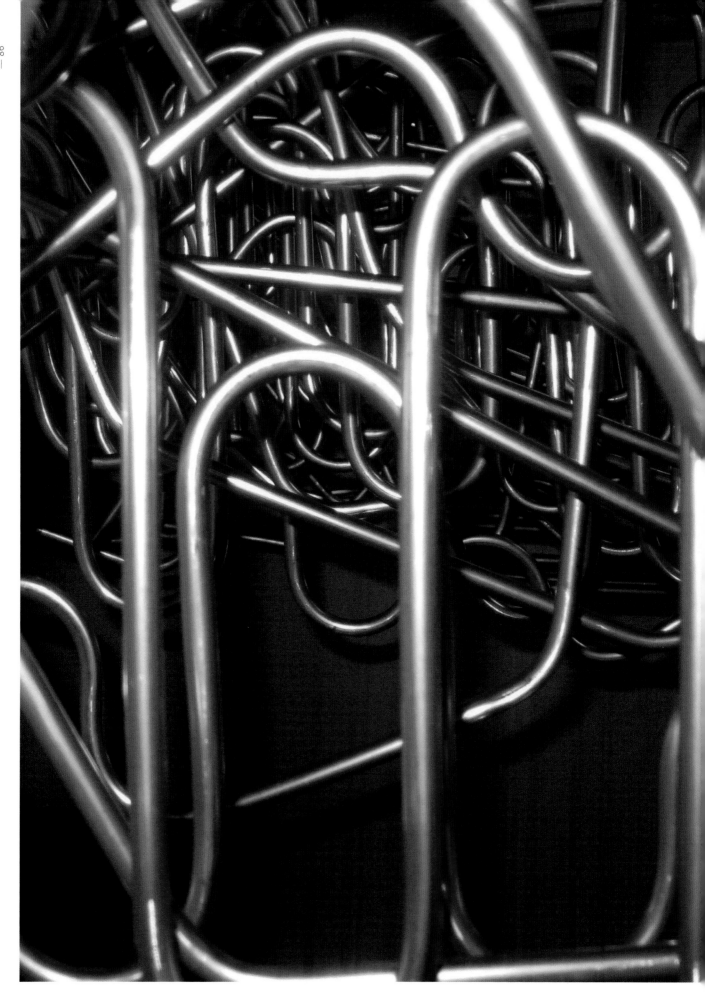

ENDINGS

Loren Madsen

2011

Exhibited at Data Deluge, Marfa, Texas, 2011

Acknowledgments

Endings is currently privately owned by Beyoncé Knowles-Carter.

🔗 lorenmadsen.com/data_art.html

The subject of *Endings* is "happy endings"—like the end of smallpox or airborne lead pollution. Each tubular piece is an abstraction of a graph representing a generally desirable ending: polio has been nearly eliminated; wars—counterintuitively—are less frequent, less deadly, and far less expensive since the end of the Cold War. The sculpture is, in short, a random catalog of good news should a viewer be interested.

Each tube has a small number stamped in its end, and a printed guide shows both the original graph and a representation of its sculptural abstraction, as well as dimensions and sources.

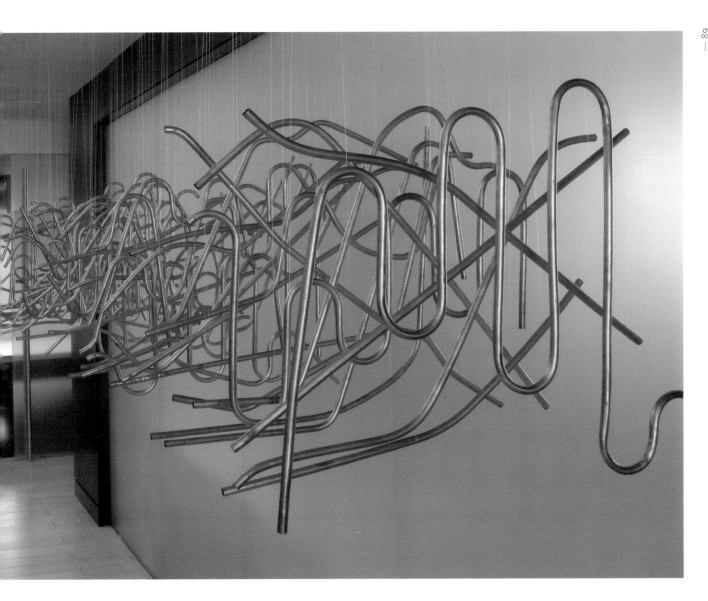

–

LOREN MADSEN

is an artist whose first solo exhibition, in 1973, consisted of precariously balanced bricks rooted in gravity and friction. An earthquake destroyed the show before it opened. Despite this divine critique he continued with these early sculptures, which mutated into large site-specific installations of which the only record is photographs.

He found that sculptural theater was not enough. He wanted narrative. In 1991 he made a large installation titled *Missing Matter* that summarized what he knew and felt about issues of cosmology. By 1994 he was using the Statistical Abstract of the U.S. and many other sources to turn data into sculpture and prints. These are broadly historical if the viewer chooses to engage with the information, and abstract if the viewer does not.

In 2005 he moved from New York City to Mendocino County, California, where he still quixotically transforms understanding into art, now accompanied by grand views and wonderful wine.

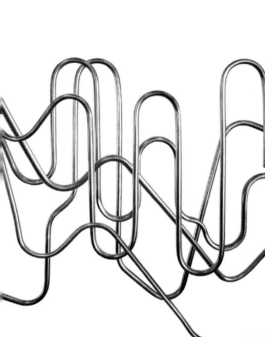

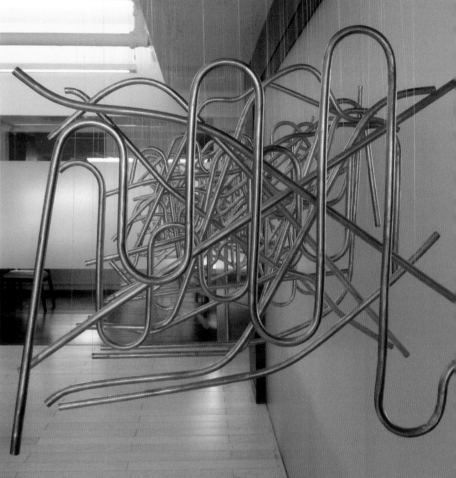

▲

FIGURE 1

On a white background, abstract.

▲

FIGURE 2

Endings, viewed from the side.

PROJECT MOTIVATION AND INSPIRATION

I had done a number of pieces about things that were very negative—including one about the 9/11 disaster in New York City. At that time, we lived about a mile from the World Trade Center Towers. But ultimately I got tired of tracking down terrorists' activities. I sought more positive views. It seemed remarkable to me how many people are eager for termination. When termination is not provided by our deities, people make it happen themselves, as with the Brothers of the Red Death (1900), Jim Jones (People's Temple 1978), and the Branch Davidians (1993). I felt that there is much going on that is very positive, and that should be addressed as well; *Endings* is a counter-sculpture to those narratives of termination. When I did *Endings*, crime and other adverse issues in America had decreased substantially.

I had lived in Los Angeles, where I could not see the mountains because of smog. New regulations took effect, cars got cleaner, and one could see the mountains again. In Pittsburgh, Pennsylvania—which used to be one of the centers of steelmaking in the United States—the air pollution chart over time went up and up, and then it went dramatically down. By the 1990s, there is even more good news: 295,000 people have gained access to electricity and 305,000 accessed clean drinking water for the first time. In the 1980s, 44 percent of the world's population lived in extreme poverty ($2 a person per day). Now, fewer than 10 percent do. In the post-World War II era, around half a million people died annually through direct violence in wars; in 2016, the number of all battle-related deaths was 87,432. US homicides were almost 10 per 100,000 in 1990; in 1994 the rate was about 4.5 per 100,000. In 1900, average life expectancy was 41 years; today it is 78. We work 50% less now than our ancestors did in the 19th century.

Endings was an attempt to emphasize the positive aspects of cultural change.
I chose datasets that covered all of society's concerns—medicine, law, environment—all the sea that we swim in was covered by that data. I'm perpetually stunned by peoples' negative expectations in the face of more and better health/longevity/diet and safety than at any other time in human history. It is these "happy endings" (like the end of smallpox or airborne lead pollution) that are the subject of the piece. It is also amazing to me how ignorant most people are of the workings of the world. If you take the big issues that people respond to, like crime or disease, then you get their attention. Hence my ambition to embed information in a seductive sculptural form.

PRACTICES AND PROCESSES

1

Find a Pipe Bender

When I lived in New York City you could pick up the phone and someone would make a metal thing for you, or cast something in glass, clay, or ceramics. I now live way out in the country where my access to fabricators is limited and I need to find ways of making things on my own. I got three or four bending machines and started bending copper pipes, and found the machine that worked the best.

2

Find Data

I found the datasets on Google. I have eight or ten books that address the issue of good news, and perhaps contrary to our feelings, we have made huge social advances. I started with Steven Pinker's *Better Angels of Our Nature*, which is full of charts. Those pointed me in a direction to search for the actual datasets.

3

Plot Data

I entered all the data into Excel, which then produced the charts. I imported the chart into CAD and abstracted it using CAD tools. The graphs tend to be pretty jagged—with peaks and valleys—but the pipes can only bend to a minimum diameter of three inches, so I needed to abstract those features. I made line drawings using CAD. These would be printed on a large scale, and I taped the individual sheets together to make a rough template.

4

Bend Pipe

I used the full-scale drawings—two feet by two feet—as a guide. Bending the pipe was a question of getting it to be accurate to the chart. It's a plumber's pipe bender—without a jig to control the angles. I do a bend, and then respond to what happened. I could bend a pipe in a half hour, to do it properly, but I had to throw many away because they were incorrect. I drilled holes in each one so that they could be suspended from the ceiling using a fishing line. Ultimately, there are 76 elements of ½-inch-diameter copper

▲
FIGURE 3

Manual pipe bender used to create *Endings*.

Battle Deaths in International Conflicts, 1946-2008

▲
FIGURE 4

Chart of the average number of reported battle deaths with the planned pipe bend overlaid.

▲
FIGURE 5

Simulation of *Endings* in CAD.

▲
FIGURE 6

Side view of all of the individual pipes in *Endings*, simulated in CAD.

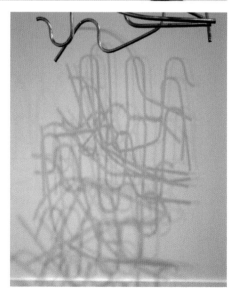

▶

FIGURE 7

Shadows cast on the
gallery wall by *Endings*.

tubing. Each element is 24 inches deep and approximately 24 inches high and is suspended at eye level 4 to 6 inches apart. The total weight is less than 50 pounds, and the length is about 30 feet (variable).

Don't Worry about the Layout

I was impressed when I had each element in my studio just stacked up. I liked the end view where they all criss cross and the angles complement or cancel each other. I realized that I didn't have to come up with any layout. I cleared a corner of our living room and hung them from the ceiling in no particular order. They looked the way I wanted them to. When I showed them in Texas, it was a different order; at Beyoncé's it's in yet another order.

Don't Worry about Finish

The tubing cutter compresses the ends and eliminates sharp edges. As we finished each piece in the shop, we cleaned them up. I haven't finished them since. When I hung them in the gallery in Texas, I'd get fingerprints all over them. I liked the different colors and shadings. When I took it to New York to install it in Beyoncé's office, I took brass cleaner with me but didn't use it.

Manual Leaflet

Each tube has a number stamped at its end. A printed guide depicts both the original graph and a representation of its sculptural abstraction (in red) along with extent and data sources. The guide sits next to the sculpture so that viewers can find it and find what a particular pipe might represent.

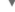

FIGURE 8

One of the pages from the leaflet, showing the number of smoky days in Pittsburgh.

Sources:
Cliff I. Davidson, "Air Pollution in Pittsburg: A Historical Perspective, *Journal of Air Pollution Control Association 29* (1979) 1035-11
Council on Environmental Quality, *Annual Report* (various years)

MATERIALS AND TOOLS

Materials

Copper Pipe
Pipes of ½-inch diameter, to represent the data.

Fishing Line
Lines are used to suspend the copper pipes from the ceiling.

Software

Microsoft Excel
Excel spreadsheet software is used for entering data and making line charts.

Computer-Aided Design Software
CAD software is used to make 3D models of the pipes, based on line charts.

Tools

Pipe Bender
A standard tool for plumbers, to bend pipe to specific angles. Manipulated by hand. Does not have any jigs or guides to limit bends to a particular place.

Printer and Paper
Printed paper is used for making templates to use during the pipe bending process.

Drill
A drill is used to make holes in the final bent copper pieces for the fishing line.

REFLECTIONS

The piece was installed at an exhibition called Data Deluge in Marfa, Texas. Beyoncé —whose family all lived in Texas—saw the exhibition, liked it, and bought it. Her assistant said that she was drawn to the piece because of the positive message embedded in it. I'd like the copper to turn green with a patina over time. However, because Beyoncé owns a lot of art, the piece will no doubt be taken down and put into storage before it corrodes. It will be very well cared for!

I have done data art since 1994 or so, but I also make non-referential abstract sculptures at the same time. With the abstract pieces I can be very loose and intuitive, but with data art I feel an obligation to the facts, to the data. Many artists will tell you they only make art for themselves and don't care about viewer response; I'm not one of those people. I make art in part to communicate.

A long time ago, I was in Paris looking at impressionist art—alone, standing in front of a Degas painting. I had an experience that validated for me the potential power of art. I thought, "if I could do that one time to one person in my life, that would be worthwhile." I've had feedback that suggested that might have happened, which is very gratifying.

I hoped that communication through data art would bring people close to the reality in which we all live, which we share. Some of it would be frightening and some of it would be calming, but it would have some kind of effect. The truth is, it doesn't really do that. I think people go into an art gallery and they see the art as an abstraction, and they either like it or they don't. Very few look at the information. My hopes for a shared reality, especially in these highly politicized days, seem to recede ever further away.

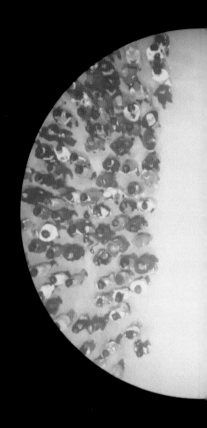

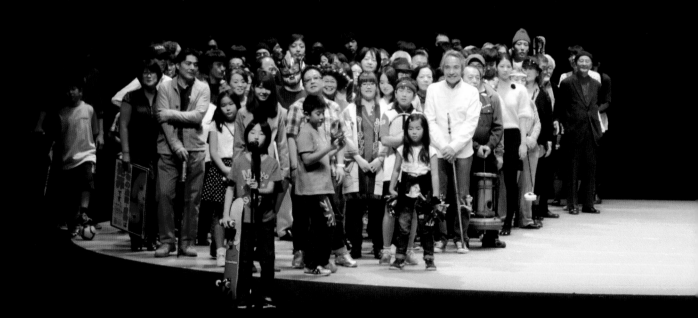

いいえ

PARTICIPATION

–

GEORGIA PANAGIOTIDOU

is a Ph.D. researcher at Research[x] Design and the Sagalassos Project at KU Leuven. Her research focuses on making human-data interactions more transparent by examining how people handle ambiguity when interacting with data and by making that process more participatory.

–

ANDREW VANDE MOERE

is a Professor in Design Informatics at KU Leuven (Belgium), where he co-directs the research group Research[x]Design (RxD). He was one of the first people to recognize the potential of representing data in physical form. He conducts design-oriented research with a focus on emerging technologies.

Participatory data implies the act of multiple individuals supplying discrete pieces of data and merging them into a single dataset. It is perhaps best exemplified by citizen science projects, which enlist many individuals to gather information about environmental phenomena. These bits of data are collected by individuals at disparate locations and at different points in time, but the participatory process aligns each individual's effort towards a shared goal, creating aggregated datasets that are much more valuable than the sum of their parts.

Similarly, *participatory physicalizations* involve the collaborative *physical* representation of data by multiple people. This collaboration can take many forms, from the act of collecting many individual bits of data, to choosing the appropriate physical encodings that represent them, to physically assembling them together into a meaningful whole. The resulting physical representation can take many forms as well, including tangible objects, whole spaces, or even experiences.

The upcoming chapters highlight a variety of participatory approaches. First, Rimini Protokoll's *100% [City]* turns data into a collective performance during which a representative sample of 100 people act out data as a live statistical infographic on stage. Meanwhile, Jose Duarte and EasyDataViz's *Let's Play with Data* kit uses panels

◀

PREVIOUS PAGES
100% Tokyo (2013) by Rimini Protokoll. | Credit: Yohta Kataoka.

positioned in public spaces to invite passersby to collaboratively create graphics that respond to questions about their neighborhood. Pauline Gourlet and Thierry Dassé's *Cairn* table surveyed visitors to a fab lab by asking them to assemble colorful physical tokens that record activities during their visits. In Domestic Data Streamers' *Data Strings*, passersby are given the chance to answer questions by weaving a colorful string across a set of physical axes that correspond to their personal opinions. Finally, Laura Perovich's *SeeBoat* is a collective endeavor in which participants steer miniature boats that measure and visualize water pollution levels using ambient lights.

The choices made in these and other participatory projects showcase diverse approaches to data input, construction, and orchestration. Moreover, these pieces highlight ways in which the design of participatory data-driven design connects to notions of shared ownership as well as the social and ethical implications of asking participants to contribute.

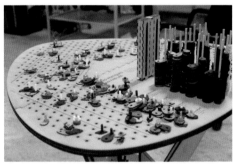

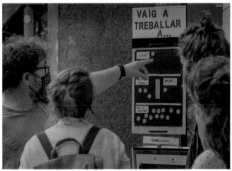

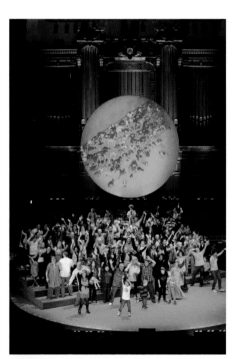

◄◄

FIGURE 1
Cairn, Pauline Gourlet and Thierry Dassé.

◄

FIGURE 3
100% [City], Rimini Protokoll.

▼

FIGURE 5
SeeBoat, Laura Perovich.

▲

FIGURE 2
Let's Play with Data, Jose Duarte.

►

FIGURE 4
Data Strings, Domestic Data Streamers.

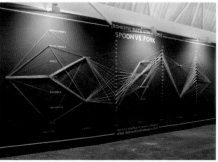

►

FIGURE 6

Physical Bar Charts by Lucy
Kimbell and Andrew Barry in the
Declining Democracy exhibition
at Palazzo Strozzi, Florence, 2011.
| Credit: Lucy Kimbell.

▼

FIGURE 7

A mental landscape
representing a group's
perception of the concept of
interdisciplinarity. | Credit:
Dan Lockton - CC BY 4.0.

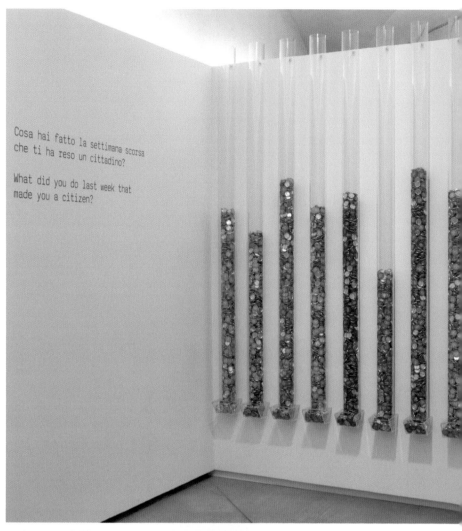

DATA INPUT

Individual participants in these kinds of projects typically contribute the data that drives the piece, often by physically adding it themselves. As a result, these works often serve as examples of what Samuel Huron and Wesley Willett call *input visualizations*—visual representations that are designed to collect (and represent) new data rather than encode pre-existing datasets.[1] Collecting "new" and more "personal" data is especially meaningful when the resulting object, performance, or piece tells a collective story that could not be told by observing its individual parts. For instance, in both *Data Strings* and *Cairn*, it is only through the aggregation of data from multiple people that meaningful visual patterns appear.

1 Visualizations as Data Input? Samuel Huron and Wesley Willett. 2021. In *alt.VIS Workshop at IEEE VIS 2021.*

> When individual contributions are explicitly visible, the intrinsic motivation to participate increases.

The kinds of data that participants can contribute vary considerably. Projects like *Data Strings* or Lucy Kimbell and Andrew Barry's *Physical Bar Charts* (Figure 6) collect and represent mostly categorical and quantitative data. *Cairn* and *100% [City]*, on the other hand, represent a whole series of data events ranging from categorical to ordinal to numeric.

Even qualitative and subjective data can be captured. For example, in Ricketts and Lockton's *Mental Landscapes*[2] (Figure 7) participants used craft materials like paper, strings, and glue to freely externalize and physicalize their collective understanding of complex concepts such as interdisciplinarity. This participatory, craft-oriented approach allows concepts to be mapped out in physical, metaphorical, and collaborative ways, allowing people to progressively construct meaning. Metaphorical and visual abstraction can also make it possible to reveal complex or abstract types of data from which people may shy away—such as the water pollution levels visualized by the *See-Boat* project.

2 Mental Landscapes: Externalizing Mental Models through Metaphors. Delanie Ricketts and Dan Lockton. 2019. In *ACM Interactions Magazine.*

▶

FIGURE 8
Workshop participants collect
the tokens required to create
their own *Data Badges*. | Credit:
Till Nagel.

▶▶

FIGURE 9
A Data Badge, placed on top of
its instruction manual. | Credit:
Georgia Panagiotidou.

CONSTRUCTION PROCESS

The shared construction of a physical representation of data requires the active involvement of multiple people, which can often be as valuable as the piece itself. To emphasize the communal process, many projects rely on synchronous construction in a co-located setting, while others, like *Let's Play with Data*, reward ongoing asynchronous construction by many people.

These acts of making have the potential to bring people together, creating a shared experience that focuses attention on the data and nudges people to engage with one another. In projects like *Cairn*, continuous negotiation about what data to include or exclude, how to encode it, and how to physically assemble the resulting piece encourages discussions, reflections, and collaboration. Other participatory projects, such as *100% [City]*, avoid creating a physical object entirely, and instead focus on sharing data as a collective event for a larger audience.

ORCHESTRATION

To ensure that a piece is readable, its encoding needs to be consistent and interpretable. As such, most participatory projects rely on concrete sets of instructions, or even a physical toolkit, which determines how data should be translated into a physical outcome. Notably, the readability of the work is important not only for the people involved in its construction, but also for anyone who wants to interpret the outcome.

**3 Data Badges: Making
an Academic Profile
through a DIY Wearable
Physicalization.** Georgia
Panagiotidou, Sinem Gorucu,
Andrew Vande Moere. 2020. In
*IEEE Computer Graphics and
Applications*.

For example, in our own *Data Badges*[3] workshops (Figure 8), attendees followed a set of instructions and used modular tokens to assemble a physical representation of their professional expertise—creating a wearable badge that aimed to spur personal discussions with other attendees. Here, the shared but flexible encodings allowed attendees to create unique personal objects that represented themselves, while also providing a representation that fellow participants could interpret.

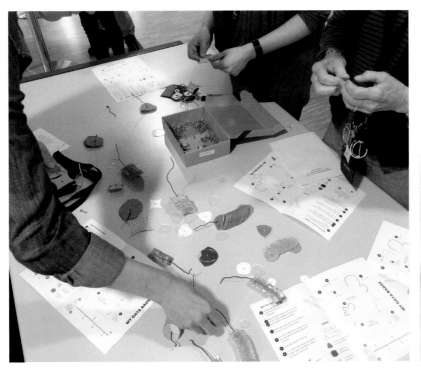

the story | *The data say that for many people food is not affordable and accessible because of the number of people living in poverty (or undocumented). We want to tell this story because there are resources in Somerville to help.*

The hands alternate showing factoids about food security and resources in our community that can help.

We selected quotes to concretize the ways that food is neither affordable nor accessible for many community members.

The circle of hands represents a human connection offering and accepting support of different types.

We choose the icons around the central circle to present places and groups within the Coalition and Somerville.

We included a few specific contacts for audiences in need - a phone number and website that have more information and lists of resources to help.

The house, broccoli and pencil represent that the data showed housing, education and food all being connected in the struggle to achieve food security.

The rings on the outside are a more abstract representation, showing the percentage of Somerville living in poverty over time. The wider the ring, the more people living in poverty that year.

▲ ▶

FIGURES 10 – 11

An example *Data Mural* on the topic of food security. The Somerville community collectively discussed the data, created the story, and painted the negotiated outcome. | Credit: Rahul and Emily Bhargava.

Other projects use the physical affordances of their media to more gently suggest ways of including and encoding data. For instance, the familiar magnetic shapes like circles, bars, and wedges in the *Let's Play with Data* toolkit can be combined to collect or depict data using common chart types like pies and bars. However, it can also be appropriated in creative and even unpredictable ways to serve new communities.

The physical presence of a moderator or director can also facilitate more complex types of construction and organization, particularly when a sequence of consecutive steps is required. These facilitators can directly guide participants (as in *100% [City]*), join in the process alongside them, or simply observe from the sidelines (as in *SeeBoat*).

SHARED OWNERSHIP

Throughout, participatory approaches provide the unique experience of sharing the construction process with other individuals. In cases where participants encode data into a piece directly, each element of the final piece can often be directly attributed to an individual, ensuring a certain degree of both accountability and ownership. Researchers Eric Gilbert and Karrie Karahalios[4] found that when individual contributions to data visualizations are explicitly made visible, intrinsic motivation to participate increases. This effect of "psychological ownership"[5] also makes contributing individuals feel that the final outcome is "theirs," making them feel more emotionally attached, responsible, or proud.

4 Using Social Visualization to Motivate Social Production. Eric Gilbert and Karrie Karahalios. 2009. In *IEEE Transactions on Multimedia.*

5 On the Social Nature of Nonsocial Perception: The Mere Ownership Effect. James K. Beggan. 1992. In *Journal of Personality and Social Psychology.*

6 Data Murals: Using the Arts to Build Data Literacy. Rahul Bhargava, Ricardo Kadouaki, Emily Bhargava, Guilherme Castro, and Catherine D'Ignazio. 2016. In *The Journal of Community Informatics.*

For example, in Rahul Bhargava and colleagues' *Data Murals*[6] project (Figures 10 and 11), local community members engaged in a participatory design process in which they translated their data into visual stories that were collectively painted and displayed in public spaces. Community members reported a strong sense of ownership of the design, a theme that extends to many other participatory projects.

In some cases, like *Data Badges* and *100% [City]*, constructing a shared data representation can help people feel so involved or connected that they might identify themselves as being part of a new community. The physical data outcomes of *Data Badges*, for example, identify people who wear them as co-participants in the same shared construction process. These kinds of individual representations of data can also serve as memorabilia or souvenirs that evoke the shared process and experience.

ETHICS

However, participatory approaches are not without their challenges. In fact, the progressive construction process itself can bring new insights that in turn influence later participation. In *Let's Play with Data* polls, early responses may well encourage or discourage others from participating, changing the final result. Public and shared creation processes also have the potential to make participants' contributions extremely visible to others. For instance, the audiences of *100% [City]* performances can see the personal opinions of the performers directly as they perform, and bystanders to *Data Strings* or *Let's Play with Data* can observe others' personal sentiments or their feelings on civic issues. Because their underlying construction processes are not fully anonymous, these projects' outcomes should not be used as truly representative samples, but rather as data-driven triggers and sparks that can elicit further discussions through democratic means.

physical experiences with data have the potential to be more diverse and more representative

When anonymity is required, well-considered data encodings can offer some level of privacy. In *100% [City]*, sensitive replies are anonymized by simply turning off the lights. Similarly, the data encodings of *Mental Landscapes* and *Data Badges* were designed to be flexible and adaptable, with participants given explicit permission to bypass or re-interpret sensitive questions.

By reducing barriers to participation, physical experiences with data have the potential to be more diverse and more representative than more technical forms of civic engagement. As a result, the principles of participatory physicalization align nicely with the tenets of Catherine D'Ignazio and Lauren F. Klein's *Data Feminism*,[7] such as providing accessible ways to participate and co-create with data. Yet, participatory data projects still need to consider who gets the chance to participate. Using creative and physical ways to bring in those traditionally excluded from "data practices" opens up new possibilities for people to engage with data on their own terms, even for those who do not possess extensive visualization literacy or technical abilities.

7 Data Feminism. Catherine D'Ignazio and Lauren F. Klein. 2020. MIT Press.

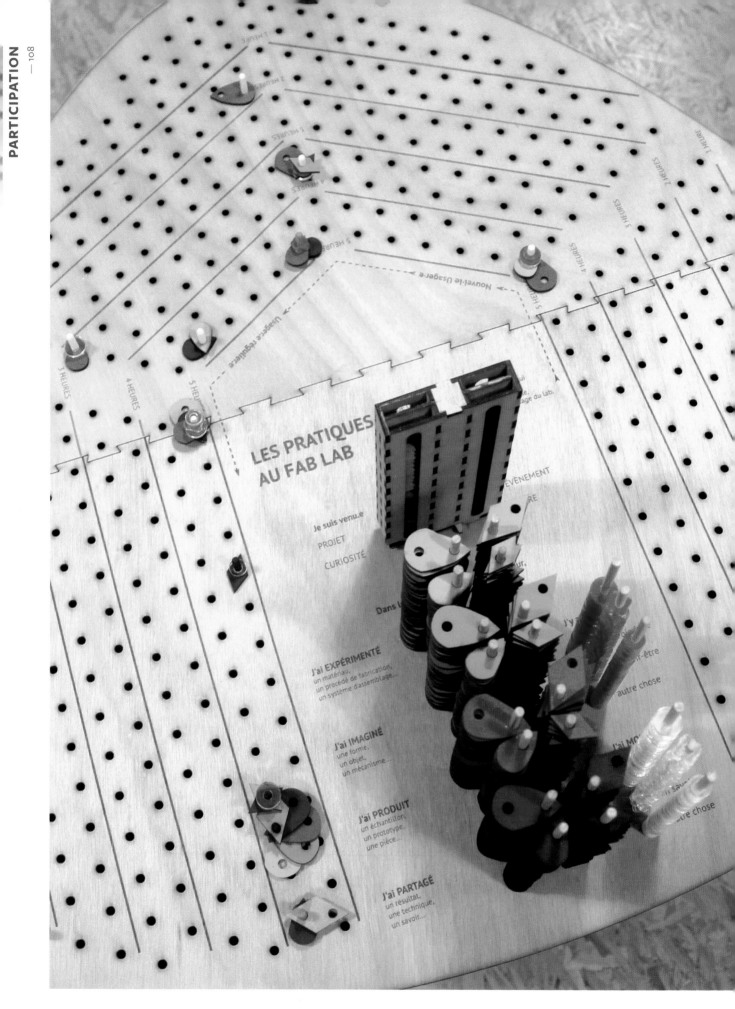

CAIRN

Pauline Gourlet
Thierry Dassé

2017

**Carrefour Numérique,
Saint Etienne Design Biennale,
Kantar Information is Beautiful Awards**

🔗 paulinegourlet.com/products.html

Cairn is a tangible tabletop that explores experiential alternatives to questionnaires and other traditional survey techniques. It enables data collection, visualization, and analysis within a community of practice in a French fab lab.

—

PAULINE GOURLET

Ph.D., works as a designer, researcher, and teacher. She is also the co-founder of l'Atelier des chercheurs. Currently, she has a post-doctoral position at médialab Sciences Po, where she investigates artificial intelligence (AI) controversies with a focus on participation.
https://paulinegourlet.com

—

THIERRY DASSÉ

has a background in engineering and has worked as a math teacher and scientific facilitator. Today, he is a Fabmanager at the Cité des sciences et de l'industrie in Paris. He is fascinated by technical systems, from ancient techniques to digital technologies, and has developed numerous projects bridging fabrication, science, and art.

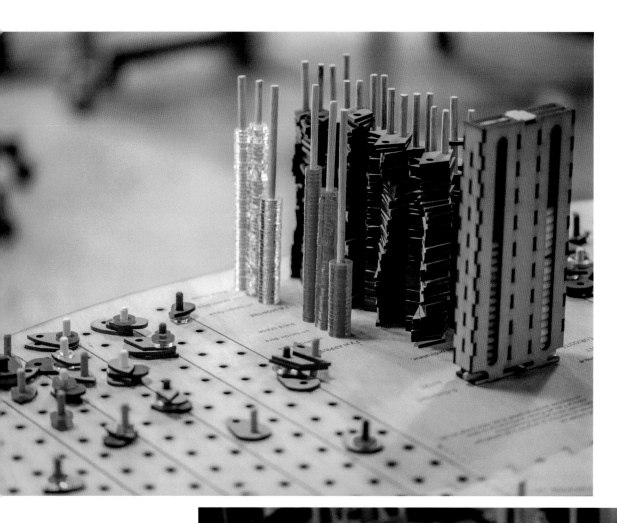

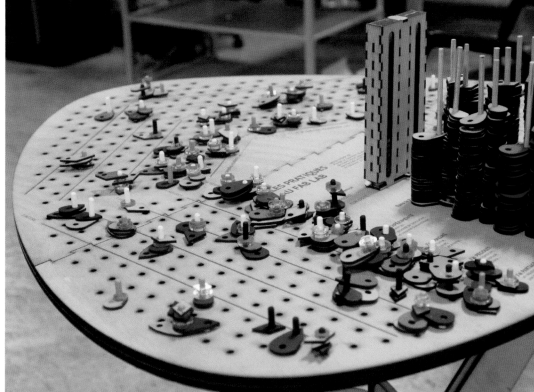

▲
FIGURE 1
View of *Cairn* with pin
dispenser and piled
tokens.

▶
FIGURE 2
Overview of *Cairn* after
three days of use.

▼
FIGURE 3
Close-up of the tabletop, showing
some individual cairns.

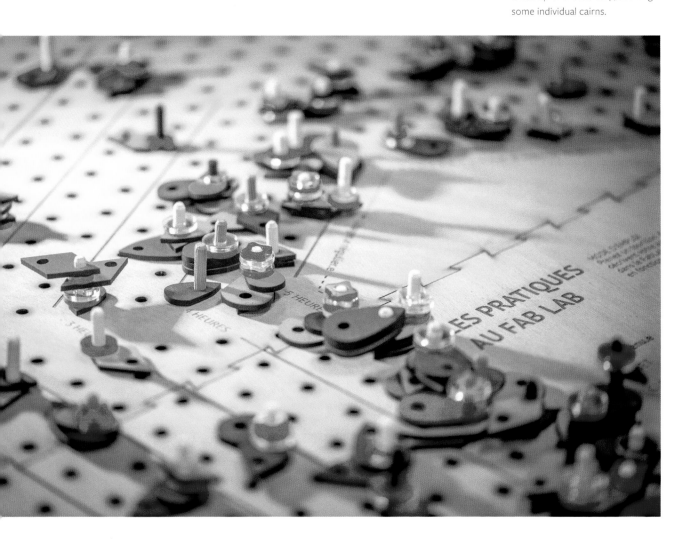

PROJECT MOTIVATION AND INSPIRATION

CAIRN [kairn] noun. *From Scottish Gaelic: càrn (plural càirn). A human-made pile or stack of stones. In modern times, cairns are often erected as landmarks.*

Created together with the managers and makers at a fab lab located inside a famous Paris museum, the *Cairn* table addresses assumptions about making practices and activities in third places (social spaces outside of home and work). Dissatisfied with traditional surveys and evaluation tools, we looked for ways to create a survey apparatus that could be accessible to both visitors and regular fab lab members. Taking inspiration from many different sources, from ancient traditions to contemporary construction systems, we created a table that invites people to play with and assemble tokens that represent their experience in the space. What type of landscape forms the fab lab community? What does it care about and value? The installation uses aesthetic properties, such as touch, shape, color, and layout to engage visitors in data collection processes to trigger a participatory inquiry. The shape of the table itself encouraged people to gather around it to form an "assembly" and discuss the data displayed on the tabletop.

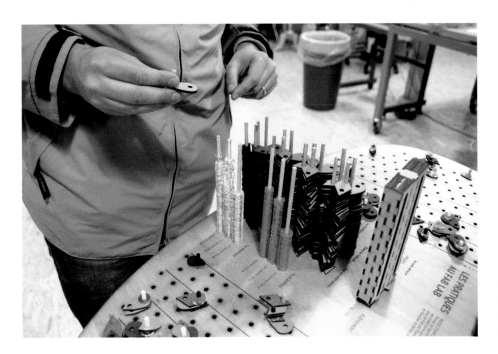

◄

FIGURE 4

Someone choosing tokens to assemble a cairn.

PRACTICES AND PROCESSES

Cairn was designed through a situated and participatory approach. Situated, because both Pauline and Thierry were part of the fab lab—Pauline as a regular member and Thierry working there as part of the Fabmanagers Team. Both knew the space, its vibe, its organization, and its implicit rules. The design of the table therefore reflects the questioning that emerges from inhabiting this particular space and encapsulates a desire among the fab lab members to better understand their community. This collective desire was translated through material practices specific to both Pauline and Thierry and conditioned by the space (the available machines and materials and the ways of using them). Participatory in this case means that other fab lab members were part of the design process, both in formulating the questions ("How can we account for what we are and what we do here?") and in designing this experiment to gain insights on this collective inquiry.

Design Principles

Two main design principles guided the design of *Cairn*—manipulation and visualization. First, manipulation as an individual elicitation technique. We formulated the hypothesis that the interaction with and creation of "things" to describe one's activity would trigger greater care in the reflection and finer elicitation than an oral response or writing, for example. So, we tested several ways of assembling pieces of materials (straps, magnets, wood, acrylic, piling), as in Figure 6. As a constraint, we wanted to simultaneously represent unitary and aggregated views on people's practices in the space, so the apparatus had to reflect individual responses, as well as to offer an overview of all the responses. We chose a subtractive system: people would take tokens from dispensers and assemble them to form individual sculptures (little cairns). As they emptied, the dispensers could be read as inverted bar charts visible in Figure 5, while the little cairns represented individual experiences, as can be seen in Figure 7.

Second, visualization and discussion of the data to make sense collectively. To foster collective inquiry about what the data meant, we wondered how to best display the little cairns to offer a data landscape that would represent the community's activities. We opted for a round shape for the table to enable gatherings and discussions over the data landscape; this design was inspired by Jean Prouvé. This was also an opportunity to showcase what could be achieved in a fab lab in terms of aesthetics and design po-

▶

FIGURE 5

View of the dispenser that works as a subtractive bar chart.

▼

FIGURE 6

Experimenting with shapes and materials to assemble tokens.

◀

FIGURE 7

Little cairns representing individual experiences.

◄
FIGURE 8
View of the tabletop.

▼
FIGURE 9
Close-up of the mounting
of the table.

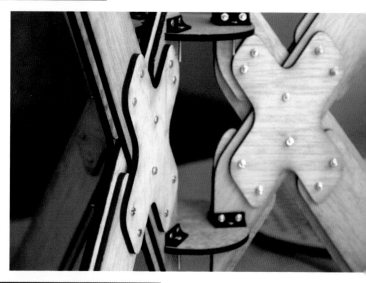

▼
FIGURE 10
3D image of the table.

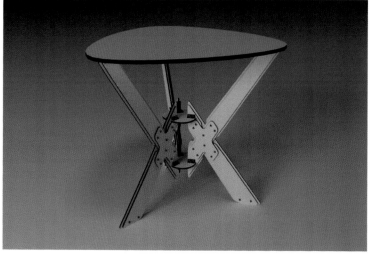

tential, as can be seen in Figure 10. Little cairns, once assembled, could then be placed on the tabletop according to a code (time spent and visit frequency) engraved on the tabletop.

We iterated over all components, from the table shape to the pins and token dispenser. We paid specific attention to the way the activities that we could observe in the fab lab were encoded into colorful tokens to be assembled. The typology of activities and the words chosen to describe them were brainstormed with the fab lab community, a process that was repeated even after the display of the first version of *Cairn* in the space (see Reflections section).

Cairn is replicable, and all of its components—including the tabletop, table base, tokens and dispensers—are documented and open-source under creative commons.[1] Fabrication takes three to four days for one person.

1 https://carrefour-numerique. cite-sciences.fr/wiki/doku. php?id=projets:table_t35

▲

FIGURE 11

View of the tabletop code engraved.

▶

FIGURE 12

Descriptions of *Cairn*'s elements.

Design and Fabrication Steps

Identifying a Common Problem

We first defined our line of inquiry through genuinely living and discussing with fab lab members.

Observing Situated Activities

We then built an understanding of practices in the space by observing and discussing with makers, reflecting on their activities and what matters to them.

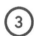

Looking for References

For inspiration, we looked to references and examples of both participatory questionnaires and assemblage systems that allow for manipulation and combinations.

Low-Fi Testing of Assemblage Techniques

Next, we explored the encoding of activities into tokens and positions on the table via multiple iterations with fab lab members. This involved testing token shapes, colors, and materials, as well as manipulation and placement principles.

Final Design and Fabrication

We created the final version using laser-cut medium-density fiberboard (MDF) and plexiglass for the tabletop, dispenser, and tokens, along with 3D-printed brackets. This step cannot be underestimated in terms of time and material consumption. Paint is applied on the tokens before laser-cutting.

Assembly

With the help of fab lab members, we installed all components on the tabletop.

 7

In the Fab Lab

After construction, we placed the design in the fab lab where members could begin adding cairns and having conversations about them.

 8

Documenting and Sharing

Finally, we documented and shared the project on a wiki and via the fab lab newsletter.

MATERIALS AND TOOLS

Inkscape
For drawing for the tabletop.

Blender
For creating the 3D model of the table's brackets.

Laser Cutter
To cut and engrave all the wood pieces (tokens, tabletop, table elements).

3-mm Wood Panel
Painted for the tokens and dispensers.

3-mm Plexiglass Panel
For the tokens.

6-mm Wood Panel
For the tabletop.

6-mm Wood Pins
To assemble the cairns.

3D Printed Brackets
To assemble the table.

▶

FIGURE 13

Top view of *Cairn* in the fab lab in the first moments of its use.

REFLECTIONS

Although this was not its primary objective, we discovered *Cairn's* ability to trigger discussions in the fab lab among people from diverse backgrounds. These discussions concerned both people's introspective experience when interacting with *Cairn* and broader questions about the fab lab community. The verbal code that we inscribed on the tabletop to categorize and qualify people's activities was subject to redefinitions, which addressed the space ethos. (*What is learning? Can I say that talking to you is sharing in a fab lab context? What is a soft skill?*). Some started to write their thoughts and proposals for adaptation directly on the tabletop: for example, the word "Project" was crossed out and several words were proposed instead, such as "create" or "work."

Over five months in the fab lab, we observed the development of unexpected uses: it became a mediation tool for the fab managers to present the fab lab, a discussion spot, as well as an incentive for newcomers to get started. We also gained insights into the table's use as a methodological tool to conduct qualitative interviews. It is a promising way of eliciting one's experience, like an experience sampling tool that encourages people to reflect and verbalize while negotiating the creation of an individual little cairn. One of the most interesting and unexpected outcomes is that *Cairn* became a symbol, an iconic production of the fab lab. Today, pictures of *Cairn* are displayed on computer screens and it is presented as a major piece produced in the space.

2 *La Table Dataviz pour la Cité des enfants.* https://carrefour-numerique. cite-sciences.fr/wiki/doku. php?id=projets:la_table_dataviz_ pour_la_cite_des_enfants

3 *CAIRN: A Tangible Research Tool to Materially Visualize Practices in a Makerspace.* Anne-Laure Fayard, Victoria Bill, Srishti Kush, and Madeleine Nicolas. 2018. In *The International Symposium on Academic Makerspaces (ISAM).* https://makerspace.engineering. nyu.edu/makerspace/cairn-an-interactive-design-research-tool-madeinnyumakerspace

Later, *Cairn* inspired other researchers and makers and several versions were built. Here, we briefly present three instances. One was built and displayed during the exhibition We Fork the World at the Design Biennale in 2017 (Saint-Étienne, France), which enabled interesting discussions around the concept of *Commoning* with a community of makers and activists. *Cairn* was indeed seen as an interesting design proposition to accompany communities who wish to materialize their collective practices, reflections, and negotiations. *Cairn* was also adapted for pedagogical purposes. The Cité des Sciences Mediation team worked closely with Thierry to imagine a new version that would help children grasp the concept of personal data.[2] Lastly, another version was elaborated by a research team at New York University (NYU) Tandon School of Engineering, specifically designed for their newly launched Makerspace.[3]

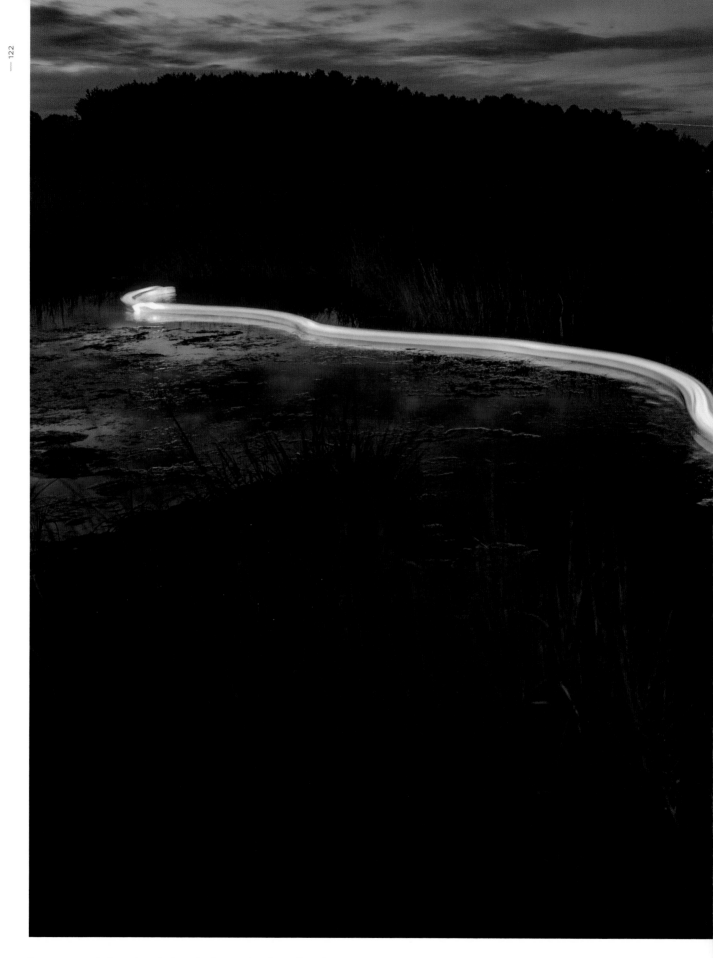

Long exposure photograph capturing water temperature data collected
by *SeeBoat* in a salt marsh in southern Maine. | Credit: © Jen Burton.

SEEBOAT

Laura Perovich

2014 — ONGOING

Water bodies in New England, USA

Acknowledgments

Sara Wylie, Talia Spitz, Rima Rebei, Rod Bayliss, Sophia Struckman, Robert Henning, Claudia Chen, Don Blair, Brian Mayton, Jorge Valdez, Jen Burton, Tyler Schoeppner, Dan Novy, Sam Costa, GreenRoots' ECO, Public Labs, MIT Media Lab Object Based Media group, Casco Bay Estuary Partnership

🔗 seeboatscience.com

SeeBoat is a tool for identifying and understanding water pollution and environmental systems in communities. Water quality sensors on a remote-controlled boat measure four pollution markers on-site and in real time and display the data using color-changing lights.

—

LAURA PEROVICH

is an Assistant Professor in Art + Design at Northeastern University. Her research focuses on developing physical ways for individuals and communities to interact with information and explore social issues.

PROJECT MOTIVATION AND INSPIRATION

Modern-day pollution is often invisible in our day-to-day life, though its impacts remain harmful to our health, environment, and collective future. *SeeBoat* makes water pollution visible and present in our public waterways to help communities and researchers use science to answer important civic questions and explore local pollution sources and environmental phenomena. This includes groups that understand the impacts of road salt on local streams, or the mixing of salt and fresh water in coastal water bodies. Water quality sensors on a remote-controlled boat control LEDs that change color in response to water quality parameters (temperature, conductivity, turbidity, and pH) to indicate potential pollution sources or the dynamics of water systems. *SeeBoat* builds from the Thermal Fishing Bob project[1] developed by Sara Wylie and Public Lab, which focuses on visualizing thermal pollution using color-changing fishing bobs that could be dragged through the water by hand and documented through long exposure photography. By visualizing water quality data on-site and in real time and capturing the data, we are better positioned to understand the complex human systems that contribute to water pollution and create positive change on these issues.

▼

FIGURE 1

The final *SeeBoat* prototype has water quality sensors coming out of the bottom of the boat and an LED strip inside the boat that changes color in real time based on the measured water quality values. Sensors measure water temperature, turbidity, conductivity, and pH, which are common water quality indicators.

1 https://publiclab.org/wiki/thermal-fishing-bob

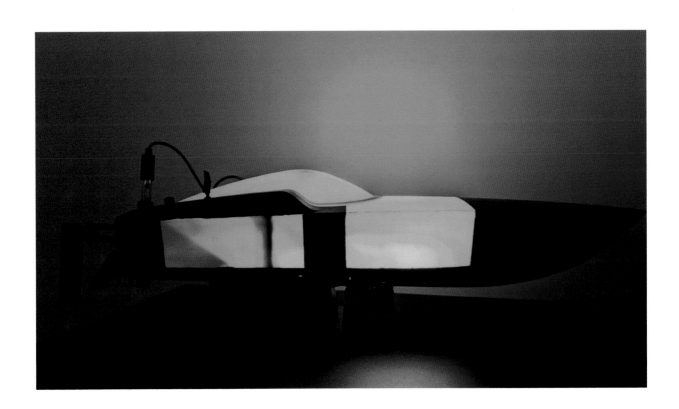

▼
FIGURE 3
The first remote control
boat-based prototype.

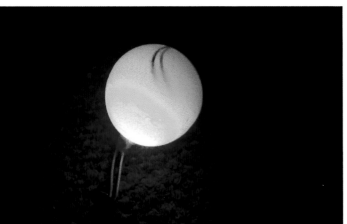

▲
FIGURE 2
An early prototype casted
the electronics in a wax
sphere.

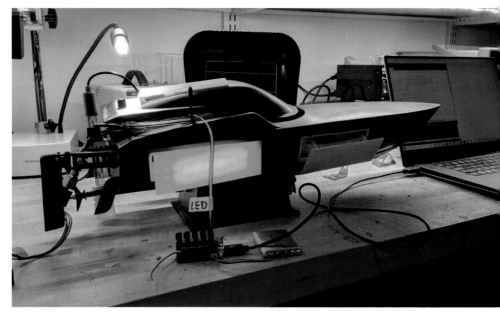

▲
FIGURE 4
One of the final in-progress prototypes
using hobbyist remote-control boats.

PRACTICES AND PROCESSES

① Data Encoding

SeeBoat displays water quality data through color-changing LEDs. We programmed the lights to change on a green to red scale with red values indicating high measurements, relative to the baseline values of the water quality parameters we measured in the particular waterbody. We measured temperature, conductivity, turbidity, and pH using a combination of off-the-shelf and custom-made sensors. The color scale follows a "traffic light" pattern that is familiar to a general audience. Large changes in color indicate a potential pollution source or natural phenomena that can be further examined in context—are the sensors near an outflow pipe when the lights change color? Are there variations in the landscape that could impact the dynamics of the environmental system?

② Design

We created many iterations of *SeeBoat*, particularly around the form factors and the electronics. Our iterations aimed to increase the robustness and functionality of *SeeBoat* so it could be used in a wide variety of waterbodies that had different environmental challenges. Yet we also aimed to keep the cost of the tool as low as possible and ensure that it could be easily used and understood by the general public. We tested many form factors in creating *SeeBoat*, including wax spheres visible in Figure 2, bathtub remote-control boats pictured in Figure 3, and finally, larger hobbyist remote-controlled boats in Figure 4. Incorporating the sensors into a remote-controlled boat allowed us to navigate through large areas of water bodies and led to a tool that was fun and easy to use.

▼

FIGURE 5

Exploring water quality near industry outflows with *SeeBoat* during the day (LED colors not visible). | Credit: © Talia Spitz.

1 https://github.com/lperovich/
seeboat

Electronics

The electronics of *SeeBoat* evolved from an Arduino mini with a digital temperature sensor and an SD card for data logging, as seen in Figure 6, to a custom designed board with a digital temperature sensor and an SD card, pictured in Figure 7, to an Adafruit Feather with radio plus individually addressable LED strip, custom designed conductivity, temperature, and turbidity sensors and an off-the-shelf pH sensor, shown in Figure 8. Our iterations were motivated by a desire to sense additional water quality indicators and to more reliably capture both the numeric sensor data and the data expressed by the LEDs.

Documentation

We created and shared significant documentation on *SeeBoat* so that hobbyists, makers, and other communities are able to use, build on, and adapt it to their needs. The documentation[1] includes parts lists, written tutorials, code samples, and videos. *SeeBoat* is also designed to be fun for a broad audience by giving control to community members and combining social experiences with data gathering. The color-changing lights are aesthetically pleasing and give people an immediate intuition for the data that positions them to ask questions both about the data itself and the social systems behind the data. On-site visualizations of water quality data can surface, questions on the intertwined nature of the environmental systems, social systems, and infrastructure—such as the impacts of road salt from highways on stream health and the ways in which water bodies are or aren't visible in the communities they may impact—that are equally important in creating change around environmental issues.

SENSOR INTEGRATION TUTORIAL
W/O LED PANELS

BOAT PREP

1. Test drive the boat.
 i. Set everything to a slow speed.
 ii. Make sure the boat can turn and go backwards.
 iii. Watch for how low/high the boat sits in the water.

This was a test drive of the boat to see how much of the boat is in the water while it's driving. The image on the right shows the settings which allowed us to drive at a reasonable speed, turn, and move forwards and backwards.

2. Remove the stickers from the boat. Peel them off, then remove the sticker residue.
 i. The best way we came up with was to use rubbing alcohol. Let the sticker residue soak in the rubbing alcohol for a few minutes before removing the glue goop.

 ▲

FIGURE 6

Online Documentation of the project.

| Credit: Talia Spitz.

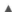 ▲▲

FIGURE 7

Arduino mini with a digital
temperature sensor and an SD card.

▲

FIGURE 8

Electronics of the final prototype.

MATERIALS AND TOOLS

Hobbyist Electronics Platforms:
Physical hardware platforms (including Arduino and Adafruit), board fabrication services, and online tutorials and forums are central to the physical implementation of the systems.

Adhesives and Sealants:
Epoxy, silicone glue, hot glue—and even tape!—played a critical role in sealing and securing the water-based tools so that they don't sink and the electronics stay safe.

Interaction and Photography:
Data from *SeeBoat* is documented numerically through data logging and visually through both a real-time plot and the colors of the LEDs on the boat. The LED outputs often attracted people to *SeeBoat*. We also captured the cumulative data trails through long exposure photography which allows people to situate the water quality data onsite and can lead to productive tension between the beauty of photography and potential environmental harms captured in some images.

Community Knowledge:
Community groups, open data websites, government officials, and field experts are critical to finding good locations for activities using these tools. What are the potential water pollution challenges that we should explore? What do they mean for the community? Where and how can we access the waterfront to use these tools? Some open data websites hosted by government organizations—for example, the United States Environmental Protection Agency[2] or the National Water Quality Monitoring Council[3]—share water quality data. Data from these sources and expert advice from community groups and water ecologists helped us identify areas with potential water quality issues, access the waterfront, and determine the kind of sensors that could detect the relevant water quality parameters at a particular location.

2 https://echo.epa.gov

3 https://waterqualitydata.us

REFLECTIONS

While using *SeeBoat* in the world, we realized how difficult it can be to get the information needed to hold a successful public installation, underscoring the importance of citizen science tools in creating community-driven information. Many outflows were difficult to locate from publicly available documents. Narrowing down possible areas for further testing is important in coastal areas where there may be many rivers, lakes, and streams, and it would be too time-consuming to explore all the local water bodies. Physical phenomena, such recent rain events, can also impact the conditions of a water body and the amount of outflow from industries, sewers, or other systems into water bodies, which means that the outcomes can vary greatly from day to day or even hour to hour.

The many iterations of *SeeBoat* strike different balances between accessibility, expense, robustness, and versatility. These tensions are common in citizen science and require reflection on the aims and audiences for the tool. For example, while *SeeBoat* senses a wider variety of water quality parameters than the Thermal Fishing Bob and provides both numeric and visual data, it is also more expensive (approximately $500 compared to approximately $50) and requires makerspace tools to build. Therefore, it may be better suited to hobbyists than to a general audience. Sets of citizen science tools of varying aims and complexity may help introduce broad groups of people to citizen science, build curiosity, and create an intuitive understanding of water quality data. With *SeeBoat* we have tried to find a balance between these demands to create a tool that spans a spectrum of use cases and helps surface community knowledge and energy to create positive environmental change.

1 Ideas for Change (https://
ideasforchange.com), working
on the project WeCount,
aims to empower citizens
to take a leading role in the
production of data, evidence,
and knowledge around mobility
in their own neighborhoods,
and at street level. Ideas
for Change has contributed
to the implementation and
development of the projects'
pilots in Barcelona and Madrid,
following a participatory citizen
science method to co-create
and use traffic-counting sensors.
This project has received funding
from the European Union's
Horizon 2020 research and
innovation programme under
grant agreement No 872743.

2 https://lichenis.com

LET'S PLAY WITH DATA

Jose Duarte
EasyDataViz

2021

Barcelona, Madrid (Spain)
Leuven (Belgium)

Client
Ideas for Change, working on the project WeCount[1]

Collaborators
Lichen Innovación Social[2]
Jhon Peña
Diego Almanza
Martha Perea

🔗 easydataviz.co

Let's Play with Data is a kit designed for people to show data and ask their neighbors questions about a specific topic. Ultimately, we seek to trigger deeper conversations to get the citizen's perspective about important community issues.

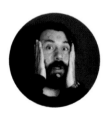

—

JOSE DUARTE

is a Colombian designer, co-founder of TELL - Business Storytelling, director of The Visual Thinking School Colombia, and principal of EasyDataViz, a data visualization initiative based in Bogota, Colombia.

EasyDataViz relates citizenship with information through a playful experience, making interventions with data in public spaces to encourage citizen participation and trigger conversations around issues that interest citizens. When people fall in love with data, it brings them closer to information that can be complex so they can make better decisions.

FIGURE 1
A panel to probes passerby about their means of transportation to go to work.

▼
FIGURE 2
A passerby is expressing what transportation she is using to go to work.

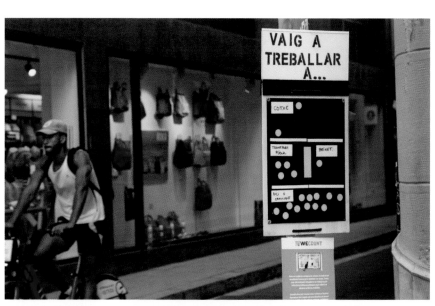

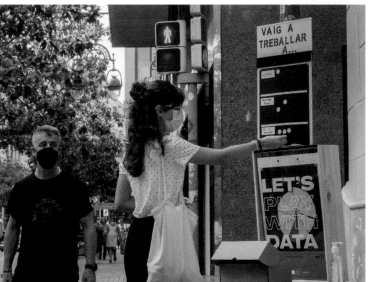

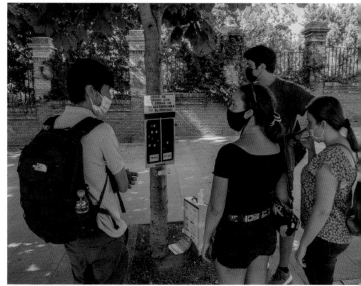

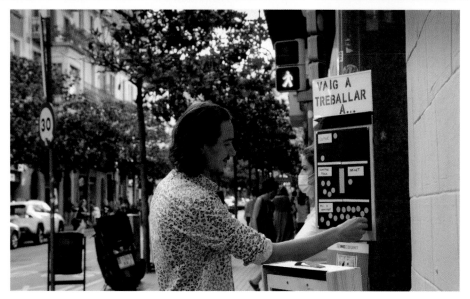

FIGURE 3
A group of people with a facilitator in front of a panel asking "do you agree with the low emission zones in the center?"

◀

FIGURE 4
A passerby is expressing what transportation he uses to go to work.

PROJECT MOTIVATION AND INSPIRATION

Our client, Ideas for Change, had been working on a project called We Count which installs digital devices in some houses around Barcelona and Madrid to collect data about mobility in front of those houses. They saw our earlier work with data visualization kits and liked the playful, portable approach to data. Ideas for Change wanted to take their data from the digital world outside into the neighborhood, because people don't usually read the existing webpage showing these data. They also liked that the projects we make are not expensive; it's important for anyone to be able to find the materials to make a data visualization. The information is very local, and collects data from someone's personal surroundings. After meeting with the client and understanding their requirements, my team at EasyDataViz wrote down a clear challenge to understand whether we had achieved it at the end of the process:

How can we connect people with mobility data through a playful experience in public space?

▶

FIGURE 5
Closeup shot of someone replying using the public transportation.

PRACTICES AND PROCESSES

Listening to the Client

The first part of our process was to listen to our clients and understand the project itself: who are the people who will work with the kits? Where are they? We found out that the people who will interact with the kits are collecting data, but they think it's boring and don't know what to do with it.

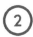

Understanding the Design Challenges

Our client wanted to help people to be happy to share their data. Their requirements were for us to create a visualization kit that would be:

- Easy to use
- Easy to carry
- Accessible to a broad age range (15–85 years old)
- Small budget
- Fun to use
- Easy to access

We phrased these requirements as a challenge: *How can we connect people with mobility data through a playful experience in public space?* We always have a clearly stated challenge; it is important to understand whether we have reached our goal at the end of the process. For about one week, we reflected upon the design conditions and things that could make this project different. For this project, it was important to use public areas and take the information outside, because the data was about mobility activity occurring in the street. If you carry out interventions in public areas, they have to trigger a conversation about the topic. That was our mantra.

Drawing Possibilities

In this part of the process, we started to draw possibilities around the kit. These sketches imagine possible solutions to this challenge that also address the conditions. We initially called this kit a "Data Experience in One Kit." We brought two final options to the client. One option was a kit that could display and represent all kinds of data, secured to the base of a lamp post using a bungee cord. The second option was the "big small data kit." This kit just had materials to make three kinds of graphics: histograms, graphics of comparisons, and pie charts. The second option was on a larger scale: it wasn't for

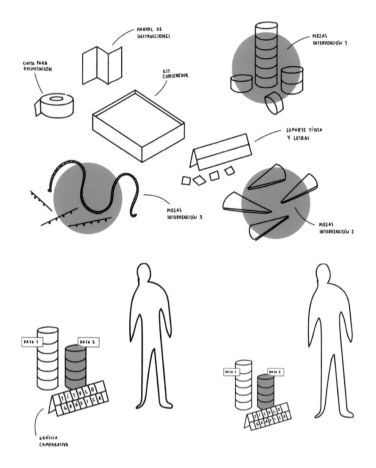

▲

FIGURE 6

Sketches of the different
design options.

▶

FIGURE 10

The principles of
participation according to
easydataviz.co.

lamp posts, it was for the street. Our
clients were more interested in the first
option.

④ Designing and Defining

During Design and Define (De-De),
we took the client's selected option and
started to define how it would work. For
example, we started to understand what
kinds of materials we could use, what
kind of visualization configurations
people could use, and how many pieces
we needed in order to make those
configurations. We started to imagine
all the ways that someone could use the

kit, including how the data could be
shown—*Mostrandos Datos* (showing
the data)—and what shape could be
made with a *Fichas de Formas* (shape
sheet), in Figure 8.

⑤ Personalization and Data Interactions

We were working with two modes:
people could use the kit to collect data,
or could use it to display data. The
kit pieces are colorful and in different
shapes, but we wanted people to be
able to intervene or write on some of
these pieces to personalize their own
intervention. That way, people could
feel that the system was their own. If
someone has clear instructions, they can
do whatever they want with the system.

⑥ Considerations for Interaction

Based on our experience with
other projects, we had in mind 20
considerations for interactions with
devices to collect data. These are
conditions for any project that we do
in public areas. For example: when
are you going to put the intervention
on the street? At what time? On what
day? Some days are easier for people to
participate than others. Or, where are
you going to put it? Some people think
the best place to put an intervention is

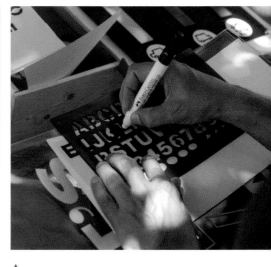

▲
FIGURE 7
Sketches of the kit.

▲
FIGURE 8
Fichas de Formas.

▲
FIGURE 9
Tools to support personalization.

LOCATION
Where, which height, which and in which direction should the system be placed? Does the location give me confidence?

LEVELS OF INFORMATION
Does the system guide my participation?

QUALITY OF MATERIALS
What difference does it make wood or paper?

QUESTION
How does the wording of the question alter participation? Is it well phrased? Does it require context?

INTERACTION TIME
How long should system participation last?
Is the interaction time clear?

TIME
What is the best time to set up the system? How does participation vary by time?

DAY
Which days work best?

MATRIX TYPE
Which matrices produce the participation? Does the matrix answer the question?

INSTRUCTIONS
Is the interaction clear to the participants, is there a step-by-step and is it clearly marked?

PURPOSE
Is the purpose of participation clear to the citizen?

POST-PARTICIPATION
Is the invitation clear for the citizen once he/she participates? Do you want to see the results?

VARIABLE INCREASE OF POINT
When should the variables of participation increase and what effect does it have? What is the effect of increasing variables with the points?

CALL TO ATENTION
Is the system visible, does it stand out well in the environment, and is it easy to differentiate?

CLIMATE
How does climate affect participation? What alternatives are there to modify the system according to the climate?

REWARD
What is the impact of materially rewarding participation? What type of reward can be given?

VISUAL LANGUAGE
Is it convenient to use emoticons or icons in the systems?

IMPULSE
How relevant are the mechanisms to increase participation?

GRID
How does the grid affect the mode of participation? Is it easier for users to interact if an order of participation is defined? Where do I put my point?

PARTICIPATION SYSTEM
Are points, balls or ropes better?

STORYTELLING
What is the story that the system tells me? What is the big story that I am part of through my participation?

FIGURE 11

An instruction manual for the kit can be found on the back of the box.

FIGURE 12

Colored small magnets.

FIGURE 13

Different visual encodings that could be made with the kit.

where there are a lot of passersby, but that's not true. You want people who are standing, not walking by, like at a bus or train station. What is the reward that people will get when they participate in the system?

Once we defined the design—this is what we're going to do, how big the device is, how it will be installed, how it will be weatherproofed from sun or rain, what kind of pieces it has—we conducted focus groups with five people. We did a small exercise to understand whether the interactions would work.

⑦ Testing

We had to be sure that the panel could be put on a pole and support the information. If it was too heavy, it wouldn't work. We did a lot of experimentation and testing to make sure we got the materials right. Initially,

we used Velcro to place pieces on the panel. But when we did the testing, it wasn't the best choice. Instead, metal with magnetic pieces worked best: a metal panel covered in black adhesive paper, with laser-cut pieces of MDF (medium-density fiberboard) with small magnets.

⑧ Production and Shipping

We send the kits with one dataset already represented on it so that people could see what you can do with it. We made the kits in Colombia, and then sent them to Barcelona. However, the client wanted to introduce kits in another country (Poland), and requested some additional ones. We think the best approach is to produce them there, so we are looking for a partner to make the kits in Europe.

Instructions

The instructions indicate the parts
included the kit, and the kinds of
visualizations you can make, how to
place and install the device, how to
ask questions, and how to deliver data.
And that's it! They are very simple
instructions.

We created examples of how we
recommend putting the device on
the post in the instructions. We
recommended using tape on the
ground to call people's attention to
the installations. Some people used
arrows or circles or lines in other
configurations. We also made a video
with instructions and recommendations
for what to do with the kit. The
budget was small, so we had to do it
in our homes, and it is just a video of
me talking. Still, it worked for our
purposes.

Workshop

We had a three-hour workshop;
the original idea was to hold the
workshop in-person, but because of
the COVID-19 pandemic, we had to
do it virtually. During the workshop
we showed examples of how to use the
kit, including three kinds of graphics
(histogram, comparison, pie chart) with
some variations. Then, participants
chose a type of graphic they felt
comfortable using to share their data,

▼

FIGURE 14

A passerby sharing a picture of the urban intervention.

▶

FIGURE 15

Screenshot of the #easydataviz social media presence on Twitter.

with freedom to explore other ways to represent that same data. While we provided recommendations and examples, ultimately the most important thing was for people to understand the ways they can use the kit and then feel free to use it however they are most comfortable.

The youngest workshop participant was 19 years old, and the oldest was 75. Usually, the older participants found it difficult to use the kits, but when they practiced in the workshop they started to feel comfortable and find ways to use it. The younger participants—some were designers—were very excited about the kits. All of them enjoyed the possibility of visualizing their own collected data. People could show neighbors their own work, and show that they were doing something good for their neighborhood.

⑪ Community Dissemination

Usually, these kinds of devices work by themselves if you just leave them on the street, but it's better if there are people near the device who can call on others to participate. We also gave people instructions on how to bring more people into the interaction and increase participation.

When you do an intervention in public spaces, usually 50, 100, or 200 people may participate each day. But if you share that information through social networks like Instagram or Facebook, more people can amplify the scope of the intervention—you can reach 10,000 people! For us, it was important to tell people how they could share the photos of the devices: in the workshops, we gave

recommendations for taking a photo, and what kind of message to put next to the photos. We also recommended using hashtags—*#wecount* and *#easydataviz*—to make it easier to follow the intervention. Sometimes I ask the people organizing the intervention to send me pictures afterward. This is part of the digital strategy to make this interaction with data more visible. It's not just about visualizing information, but making information visible.

MATERIALS AND TOOLS

Pen and Paper
For sketching and exploring design possibilities.

Vector Graphics Software
For preparing the laser cutting profile and for the instructions.

Laser Cutter
A laser cutter for cutting the pieces.
The visual marks were composed of 4-mm-thick MDF, colored adhesive paper coating, and magnetic pieces.

Tape
Use tape on the ground to call people's attention to the piece.

Video
To send instructions and examples to the organizers.

Printed Paper
For instruction inside the kit box.

Bungee Cord
For attaching the kit where it is to be deployed.

Bags and Elastics
For organizing the magnets by colors and shapes.

Markers
For writing the titles and legend on the board.

Letter and Number Templates
For helping boardwork.

Twitter/Social Networks
To advertise the action and keep track of people's participation, we used the hashtag #wecount.

REFLECTIONS

A lot of people used the kit to visualize personal data, and this is not because they just want to experiment with analog data visualization, but because they want to express something and maybe they haven't found a way to do it. So, when they find a way—maybe it's handmade with simple items from their home—it's a door that opens for the first time. They realize, "Okay, I don't have to be a developer. I can use spoons and glasses from my kitchen." This analog approach is a revival of analog approaches from 15 years ago. Millennial culture values things from the past.

At the beginning of my journey as a data artist and data visualization designer, before I understood the potential of public spaces and participation, handmade approaches were important to me. It was important for the visualization to look good, and for the picture to be beautiful. This is still important for a lot of people: to create an analog visualization, take a good picture, and share it on social media.

However, that's no longer the most important thing to me. Now it's most important to trigger conversations, to get people to participate as a group to share data, and to make data visible. My motivation is different—it's not about how good it looks, but how well it works. And for me, a great intervention triggers a conversation, not just data that looks good and that you can photograph.

Sometimes people see the visualizations from the kits and think, "oh, I can do research with this..." But that's not the purpose of this kit. You can use it to understand people's perception of any topic, but there are a lot of limitations: the data is very local, and may not be representative. It's important for the bars to be proportional, but it doesn't matter if they're not exact. What matters is that, as a visitor, you get the main idea of the graphic. These graphics are not precise or intended for decision making, but meant to trigger passersby to discuss and think about local issues.

My advice for people making their own kits is to GO and DO it. It doesn't matter if you don't have a budget, you can work with the things around you. It can be frustrating if you have a big idea and you don't have the materials or the money, but it doesn't matter. You can make a world-class data visualization using the things you have in front of you. If the project is more complex, alliances are more important. If you are going to make an intervention in a public space, it's important that the people in that space feel the intervention is part of themselves. They will not only care about your intervention, but will also invite people to participate in it and create a network.

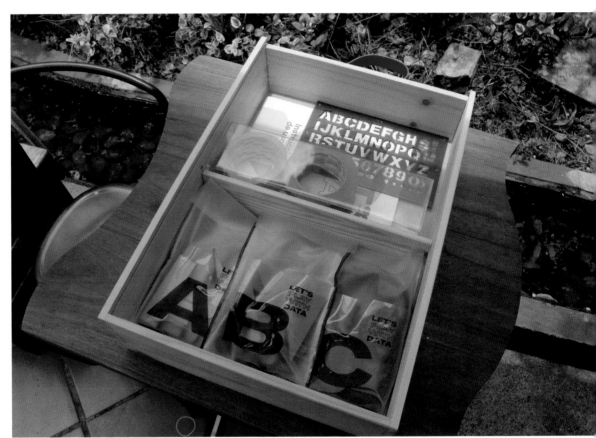

▲

FIGURE 16

View of the elements inside
the *Let's Play with Data*
toolkit box.

나에게 스마트폰이 없다면…

무력감을 느낍니다 외롭습니다 지루합니다
자유로워집니다 그런 순간은 상상할 수 없습니다

How do you feel without your smartphone? Green=helpless, yellow=lonely, blue=bored, red=free,
white=can't imagine that. *100% Gwangju*, South Korea (2014). | Credit: © Ahn Gab Joo.

100% [CITY]

Rimini Protokoll

2008 — ONGOING

Since its original staging at Hebbel Theater Berlin in 2008, *100% [City]* has been staged in more than 40 cities on five continents, including Amsterdam, Brussels, Riga, Kraków, Voronezh, Montreal, Gwangju, Yogyakarta, Tokyo, Paris, Montreal, Philadelphia, Stellenbosch, San Diego, São Paulo, Kaohsiung, Hong Kong.

Concept, Text, Direction, Sound
Helgard Haug, Stefan Kaegi, Daniel Wetzel

Original Set Design
Mascha Mazur

Original Dramaturgy
Cornelius Puschke

Video and stage (alternating)
Marc Jungreithmeier, Andreas Mihan, Wolfram Sander

🔗 rimini-protokoll.de/website/en/projects/100-stadt-7-1
🔗 vimeo.com/showcase/2904800

100% [City] is a theater performance that presents 100 inhabitants of the city in which it is being staged. The cast is chosen using socio-demographic statistics, so the performers represent the population, and hence, on stage, can claim that they are performing as their entire city.

▶

FIGURE 1

ME / NOT ME Section. Question: Who eats fish? 1% states: NOT ME. *100% Tokyo*, Japan (2013). | Credit: © Yohta Kataoka.

RIMINI PROTOKOLL

was founded by author-directors Helgard Haug, Stefan Kaegi and Daniel Wetzel in 2000. Their works in the realms of theater, sound, radio plays, film, and installations have emerged in constellations of two or three, as well as solo. Since 2002, all their works have been collectively attributed under the label Rimini Protokoll. At the heart of their work is the continuous development of the tools of theater to allow unusual perspectives on reality and to rework the operating system (OS) of theater. (rimini-protokoll.de)

| Credit: © David von Becker.

▶

FIGURE 2

WE Section. 20% who wanted to make the statement that night stand together. *100% San Diego*, California (2013). | Credit: © Pigi. Psimenou.

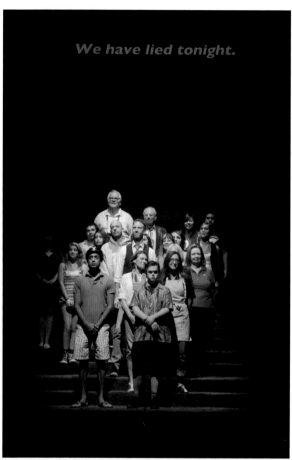

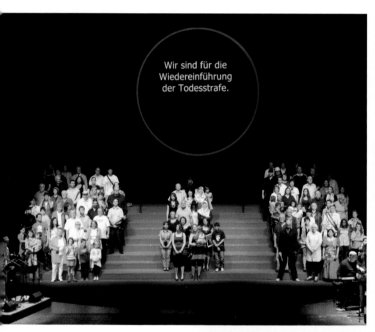

▲

FIGURE 3

"We are in favor of reinstatement of the death penalty." Group Pictures Section—those who want to make the statement that night stand together. *100% Braunschweig*, Germany (2012). | Credit: © Pigi. Psimenou.

▶

FIGURE 4

Anonymous Section with flashlights pointing at the top view camera. 14% of the adult section of the cast state that they have paid for sex. *100% São Paulo* (2016). | Credit: © Yohta Kataoka.

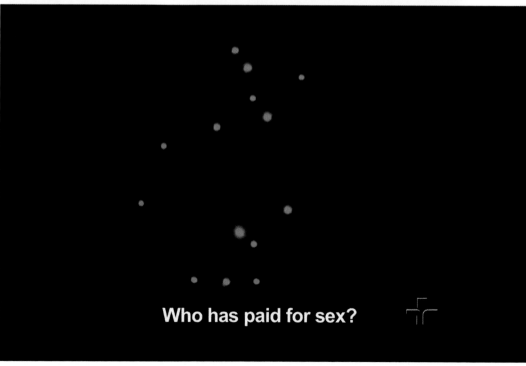

PROJECT MOTIVATION AND INSPIRATION

We have done numerous previous projects based on and focusing on the experiences and biographies of what we call "experts in their own kind", presenting them on stage, developing original pieces around and with them. We use the term *"Expertentheater"* (theater of experts) to describe this work, in contrast to amateur theater.

100% [City] was an opportunity for us to go beyond the individual and to explore the appearance of individual narratives in a more diverse context—and to cast, so to speak, "one performer with 100 heads."

The birthplace of the piece was the Hebbel Theater in Berlin, on the 100th anniversary of its opening in 1908. Inside the Hebbel Theater we found a round, revolving turntable stage. We discovered that 100 people could stand in a circle around the turntable on the stage. We then asked ourselves, *who should these 100 people be*? Perhaps 100 people, each born in each of the last 100 years, the eldest 100 years old and born in the year of the opening? We asked the local Bureau of Statistics how we could compose a group of 100 that would represent the population of Berlin in the year 2008. In their eyes, a group of 100 people selected along five statistical values— gender, age, district of residence, nationality, and marital status—could then represent the population of Berlin accurately. Hence, if this group were asked questions, their statements on stage would be a mirror of what the population would state as a whole.

We invite the audience to have a complex, emotional experience of who we are as humans, beyond our individual bubbles. They may also think about the general public's responses and the limitations and paradoxes of representation.

PRACTICES AND PROCESSES

① How to Make a City Appear on Stage

We developed a grid of 500 empty boxes to define the overall casting criteria and to guide the casting process. The entire process starts by gathering statistical material. For *100% [City]* performances, we always aim for a direct collaboration with the local Bureau of Statistics to define the five parameters we will apply during the process of casting. The second step with the local team is to define any additional criteria that should be taken into account. These criteria are applied less strictly and in a smoother manner, but are nevertheless essential: professions, minorities, ethnic background, various genders, income classes, or supporters of different political parties.

② Chain Reaction— to Convert Numbers into People

About four months before rehearsals begin, we start to generate the cast of 100 people, step by step, on a daily basis. The first person in the cast often works for the city or the government and can say "I am involved with the data that the city generates about itself." Often it is even the Head of Statistics herself (for instance, in Zurich, Riga, and Kraków). This person also represents 1% of the population and then invites another 1%—number 2—to participate. This process continues in a chain—1% number 2 identifies 1% number 3, who identifies 1% number 4, and so forth. The casting process not only follows the grid and the additional hidden criteria, but also invites every participant to announce the next member of the cast. As a city also consists of social clusters, we also create a cast that has at least fragments of circles of acquaintances. The further down the casting timeline, the more complex it gets for the local casting team to find people who fill the gaps in the grid.

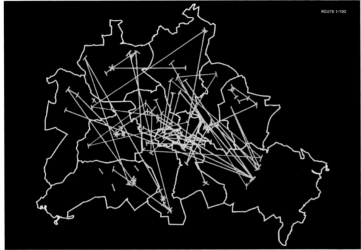

ROUTE 1-100

FIGURE 5

All 100 Berliners: who suggested whom based on residential location. Excerpt from Programme Book "*100% Berlin*" (2008). | Graphics: Katja Strempel, Phillip Zwanzig.

FIGURE 6

Casting grid of *100% Cologne* (2011), anonymous worksheet giving an overview of the entire grid in check boxes for the criteria gender, age groups, district of residence, number of household members, and nationality.

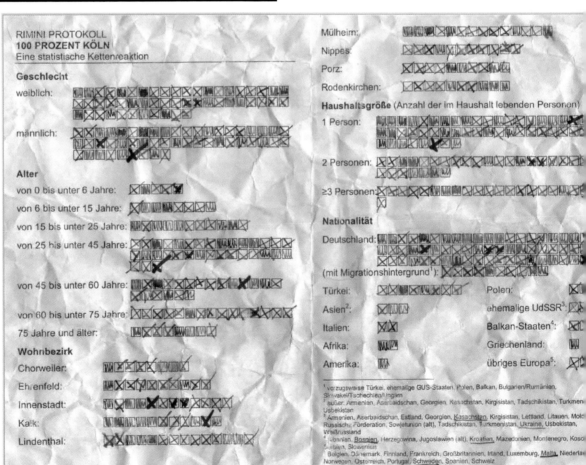

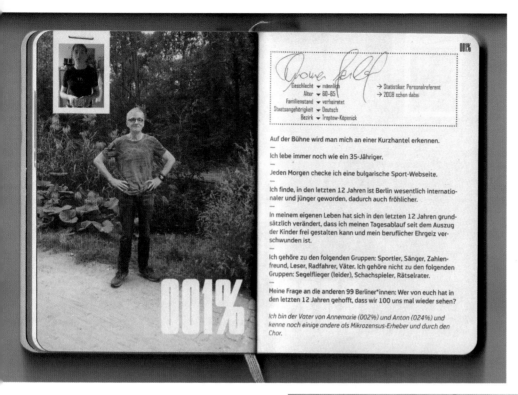

Auf der Bühne wird man mich an einer Kurzhantel erkennen.

Ich lebe immer noch wie ein 35-Jähriger.

Jeden Morgen checke ich eine bulgarische Sport-Webseite.

Ich finde, in den letzten 12 Jahren ist Berlin wesentlich internationaler und jünger geworden, dadurch auch fröhlicher.

In meinem eigenen Leben hat sich in den letzten 12 Jahren grundsätzlich verändert, dass ich meinen Tagesablauf seit dem Auszug der Kinder frei gestalten kann und mein beruflicher Ehrgeiz verschwunden ist.

Ich gehöre zu den folgenden Gruppen: Sportler, Sänger, Zahlenfreund, Leser, Radfahrer, Väter. Ich gehöre nicht zu den folgenden Gruppen: Segelflieger (leider), Schachspieler, Rätselrater.

Meine Frage an die anderen 99 Berliner*innen: Wer von euch hat in den letzten 12 Jahren gehofft, dass wir 100 uns mal wieder sehen?

Ich bin der Vater von Annemarie (002%) und Anton (024%) und kenne noch einige andere als Mikrozensus-Erheber und durch den Chor.

◄ **FIGURE 7**

%1 of the very first *100% [City]* program book introducing Thomas Gerlach.

▶ **FIGURE 8**

A collection of various 100% program books.

▼ **FIGURE 9**

One of the 438 slides of the prompted script of *100% Stellenbosch*, South Africa (2018). #12 indicates that participant 12% is supposed to say this sentence as well as the sentence on the following slide. Participants choose their language and are interpreted via headphones.

#12 Nou is dit julle beurt, die gehoor. Wie voel ons verteenwoordig julle? Steek julle hande op, asseblief! >>#12

#12 Now it's up to you, the audience. Who feels represented by us? Raise your hands, please! >>#12

(3)

Booklet

The casting process also normally leads to a booklet in which each participant is portrayed with a double page. The basis for this is the questionnaire-based interview with every participant. We modify and adapt the questionnaire from city to city in collaboration with the local team. In general, we ask what makes people unique, unlike the other 99 cast members: what groups and categories they associate and dissociate with, what their relationship with the city is like, what they see from their windows, what smells and sounds make the city special, issues on which they would join a demonstration—and what could make them leave the city. The interviews are run by the local team that processes the entire casting. The interviews make it possible for us to follow and to monitor the process remotely, to learn about the participants and about their themes—as a key resource for preparing the city-specific script and rehearsals in advance.

(4)

Converting 100 People into an Ensemble

We start with a profile with a photo of everyone. Each individual "counts" in a specific way as soon as we start the process of making the 100 become a temporary ensemble representing the population of their city. We base our work on conversations with individual members, regarding who could highlight which aspects, who would disappear into the crowd if not given a special task, etc. The script is actually a presentation document providing the participants with all the information they need—both directions as well as things to be said. Essentially, no one needs to memorize their lines. For those adults and kids who cannot read, other solutions are provided, mainly among the cast. However, the training makes it possible for most performers to achieve some independence from the prompter.

⑤ Scenes from a *100% [City]* Performance

- **Prologue**
 Introduction monologue by Number 1.

- **Self-Introduction**
 The 99 following participants introduce themselves (average 12 seconds).

- **"We are the City"**
 Presentation of the age groups, gender split, nationalities, districts.

- **24 Hours**
 People miming the course of an average day in their lives.

- **ME / NOT ME**
 Cast members ask questions and make their statements by moving across the stage to one of the two sides.

- **Voters**
 Cast members with a right to vote ask questions from a preformulated set, and make their statements by moving across the stage to one of the two sides.

- **Anonymous Section**
 With the lights off, cast members hold flashlights on top of their heads, and turn them on to respond "yes" to questions on sensitive topics (such as "who has had an abortion?", "who watches porn?"). The audience is shown an overhead video of the stage that has also been rotated to preserve the anonymity of the respondents.

- **Open Mic**
 Members of the cast are invited to improvise statements that allow other members of the cast to position themselves.

- **Kids Section**
 Preformulated questions by and for those younger than 18.

- **Physical Section**
 Includes questions like: Who is the fastest? Who can do the most push-ups? Who would dance to different types of music? Who would like to moon the audience? Who would like to perform a dramatic death scene?

- **Group Picture Section**
 The participants ask questions to the audience and they respond by raising their hands.

- **Audience Questions Section**
 The participants allow the audience to ask questions directly and respond with hand signals (me / not me).

- **Demonstration**
 All participants unfold papers with handwritten one-word statements responding to one specific question (who is your local hero, what superpower would you like to have, etc.) and try to show theirs to everyone in the audience, preferably by entering the auditorium.

- **WE section**
 All participants are on a staircase and present themselves in constantly changing sub-groups under the appropriate headings.

- **Closing dance to final song**

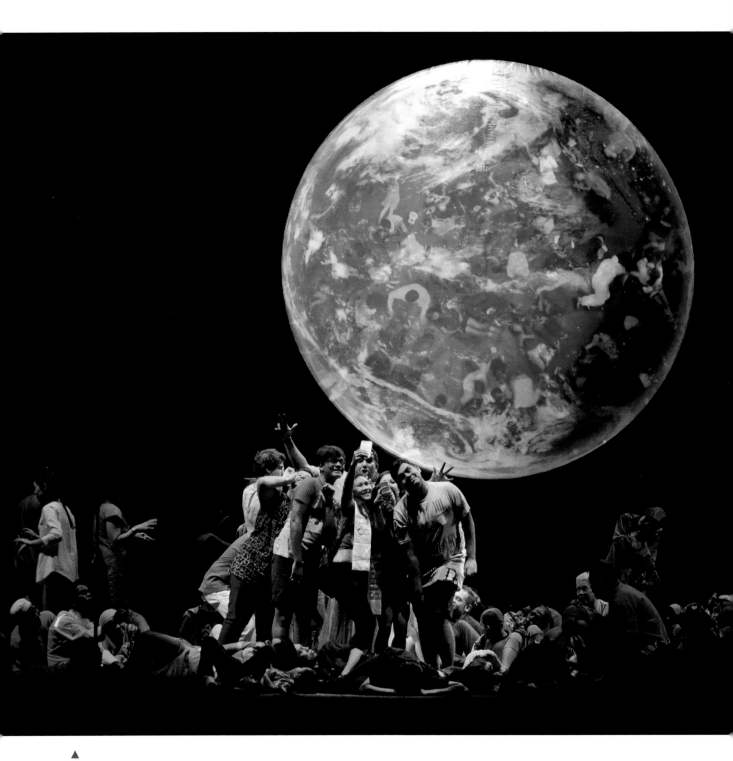

▲
FIGURE 10

Performing at the scene 24 hours in Penang.
At 1 a.m.—some are online, some take selfies at a party,
and about 80% are asleep. *100% Georgetown*, Malaysia
(2015). | Credit: © Yew Kok Hong.

MATERIALS AND TOOLS

Staging

A Large Stage

A Large Round Projection Screen

Live Top-Down Video Cameras
For a microscopic perspective on the hundred.

Live Frontal Video Camera
For close-ups of the individuals.

Two Microphones
On stands that are easily adjustable to accommodate people of varying heights (including kids).

Video Teleprompter
Visible to everyone involved on stage.

Prerecorded Sound Effects
For the first part of the show.

Live Band
For the second part of the show.

Team

Research Team
For the casting and interviews—duration 100 days minimum.

Directing Team
For handling the script, dramaturgy, rehearsals.

Stage Team
Monitors the cast's responses to questions and provides special assistance where needed.

Community Team
From the local theatre; responsible for hosting and promoting the event.

Participants

Funds for Participant Compensation
Essential, as this is far from being a piece for potential theater enthusiasts.

100 Participants
Each brings an item that makes them stand out from the rest of the crowd and helps them to introduce themselves.

100 Books
With pages in various colors for the multiple-choice section.

100 Large Sheets
For the participants presenting the names of locally relevant heroes, dishes, and other items (category depends on the city).

▶

FIGURE 11

The stage rotates one last time with the closing song. *100% Melbourne* (2012). | Credit: © Pigi Psimenou.

REFLECTIONS

For every city, we refer to what we have developed so far and work on a city-specific adaptation. Performances of *100% [City]* do "work," ideally, in the sense that the material is accurate—that the cast appears to the audience to be an appropriate mirror of the city's population. This is a big challenge for the local teams. Ideally, the discussion about it does not stop. In some cities, restrictions are insurmountable and hence need to be thematized within the piece as best possible. For example, sexual orientation cannot be addressed in the same way irrespective of the project venue. Thus, *100% [City]* is a site-specific mirror, and it is a special task to mark this point so that both the cast and the audience are aware of the restrictions imposed by the cultural mainstream, or even by laws that might have to be respected, to keep everyone on board in a cast that is as diverse as possible.

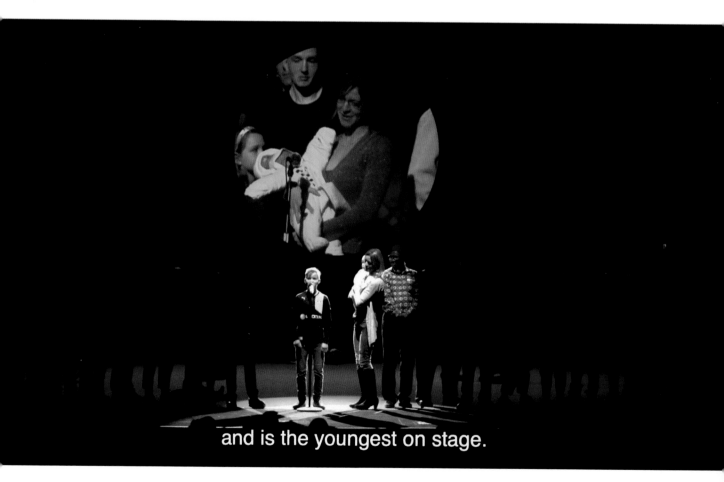

and is the youngest on stage.

It is both an aim and a challenge to extend the diversity of the cast, especially toward the "right wings" or more "phobic" corners of society. This sometimes leads to a paradox: we'd like to show this diversity, but the process of spending time together working toward a mutual goal—producing the shows—makes people change their minds at times. We have often seen people with clearly racist or anti-LGBTI+ statements explain a few rehearsals later that they would not like to maintain their statements. A significant proportion of the cast in Darwin (Australia) initially stood on the "Me" side when responding to the question, "Who thinks that only heterosexual couples should be permitted to adopt children?" which clearly mirrored the stance on this topic in Darwin in the year 2015. However, by the dress rehearsal, nobody was standing there any longer. The rehearsal process had "falsified" the results in terms of representation, but had generated an amazing social result within the sample of 100 out of 142,000 inhabitants of Darwin. As theater makers, we were faced with a choice: should we erase the question because it could make all other statements appear equally inappropriate? In this case, we highlighted what happened to emphasize to everyone that theater—and *100% [City]*—is a process of visualizing what is normally in the domain of politics, science, and media, but that through the dynamic process of us being alive together we have the potential to change our minds, to discover our prejudices and to reconsider our actions.

Twelve years after the initial *100% Berlin* shows, the number one of that time stood again on stage and introduced the audience to *100% Berlin Reloaded* (2021). Thirty-seven people from the first shows came back on stage together with 63 others—the cast also had to be younger on average, more international, and the average household income had risen by 40% over the previous 12 years, as had the risk of poverty (15%) and the number of single households. In 2008, participant number 100 entered the stage as a newborn, just a few weeks old, in the arms of his mother. This time, he was twelve years old and came along with his newborn sister.

◀

FIGURE 12

"...and is the youngest on stage" is what the boy
at the microphone says in *100% Berlin Reloaded*
(2020) about his little sister—just a few weeks
old—carried by their mother. She is also visible on
the round projection screen holding a baby boy
saying the same thing about him—the same boy
12 years earlier in *100% Berlin* (2008).
| Credit: © Video Still, Rimini Apparat.

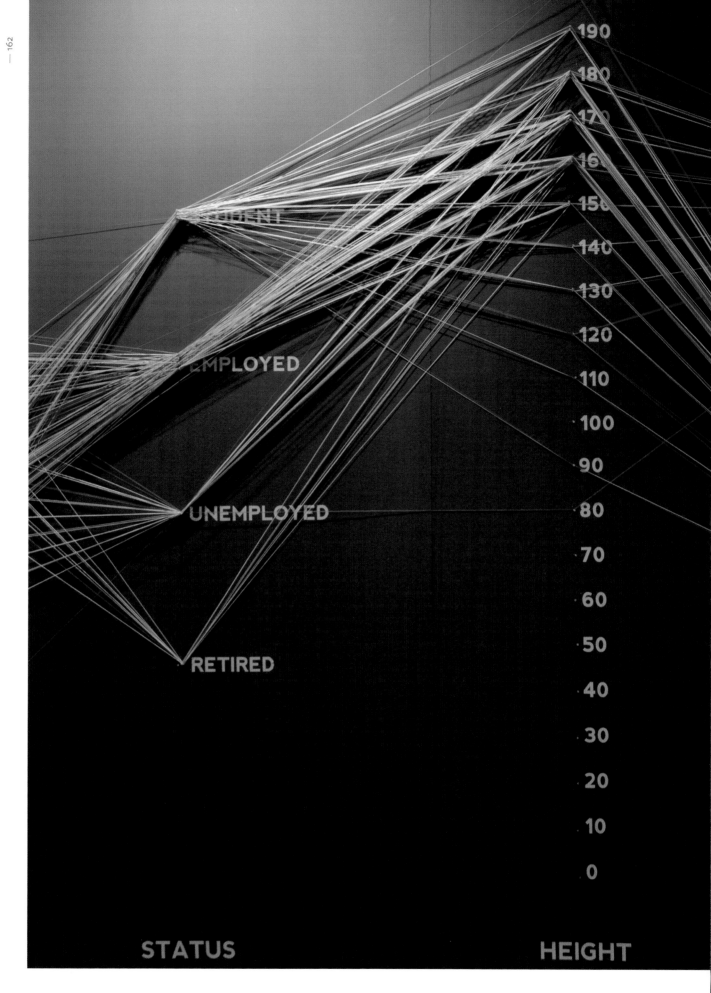

DATA STRINGS

Domestic Data Streamers

Daniel Pearson

Pau Garcia

Alexandra de Requesens

2013

Contemporary Art Fair, Barcelona 2013
Game Developers Conference, San Francisco 2014
Innovation Summit, Doha 2014
Jumeirah Towers, Dubai 2015
Casual Connect, Amsterdam 2015
Design Museum of Barcelona 2015
PMQ Hong Kong 2015
Science Museum, Barcelona 2016
Design Week, Jerusalem 2016
Fondation EDF Paris 2017
World Bank Organization, Washington DC 2018
TED Talks Edinburgh 2018
Design Museum of Barcelona 2019
Palau Robert 2019
Chevy Magazine 2020

Acknowledgments

Contemporary Art Fair of Barcelona / Hong Kong Design Week

🔗 vimeo.com/638992823

Our *Data Strings* installation is an analog collective and living graphic that aims to make people participate and visualize the audience's thoughts around various topics. It is an engaging, fun and relatable way of showing information.

—

**DOMESTIC
DATA STREAMERS**

are a communication studio that believes in the power of data explained through storytelling, action, technology, and the arts. Founded in 2013, they have worked around the world, sparking dialogue, interaction, and action for change, and collaborating with companies and organizations like Spotify, Nike, the California Academy of Sciences, the United Nations, and many more.

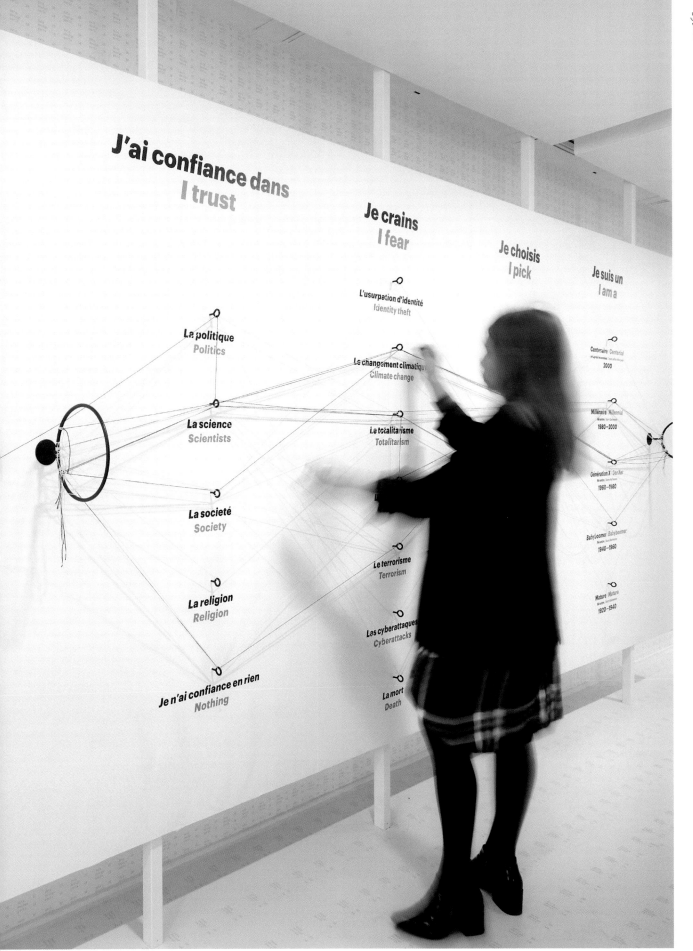

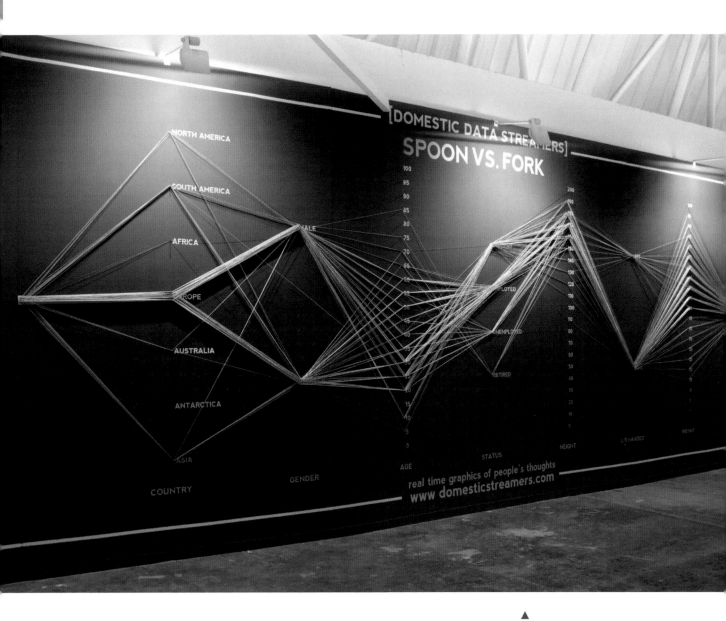

▲

FIGURE 1

*Data String*s at the Contemporary
Art Fair of Barcelona (2013).

PROJECT MOTIVATION AND INSPIRATION

Data Strings was a project that, far from being commissioned, was born out of our own artistic exploration. The first time we did it we had been invited to take part in the Barcelona Contemporary Art Fair. The director had seen some previous work of ours in an urban art festival and he asked us if we would like some space at the fair for free.

Our previous work was totally bidimensional, but we were using thread to draw circumferences on a wall with an audience, so we thought about how to improve the experience and transform the visualization tool within the visualization itself: instead of using the pencil to draw a visualization, the pencil would be the visualization. In this case, instead of a pencil we used thread.

We started thinking about how we could bring a more plastic and sculptural approach to the bidimensional aspect of most infographics, and how we could transform something that needs to be read in two dimensions into a three-dimensional experience. Also, it had to be something cheap to produce due to the lack of time and the low budget we had at that time. That is why we chose thread and nails to create *Data Strings*;

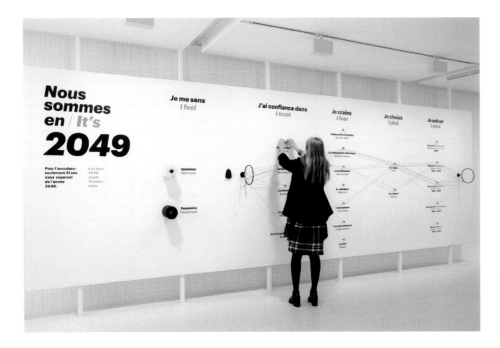

◄

FIGURE 2

Data Strings at Fondation EDF
Paris (2018).

they were easily accessible for us, and this is the main reason why we have repeated this installation in so many places. It is simple and hassle-free, in terms of both resources and know-how. All the material is accessible in almost any place in the world. After eight years, *Data Strings* has come to more than 20 countries, in museums, streets, convention centers, and even religious spaces.

We have been asked so many times why we create participative visualizations. Our answer is always the same. It's only when you are part of the data that you really connect with it; if you see yourself represented in a data visualization, you will empathize much more with the meaning behind it. You will invest much more time and brainpower in understanding what this data means.

We understand the world through numbers and information, but not through numbers and information alone. We need to look at reality and compare it with something we already understand. We need to feel represented in what we witness, otherwise, connecting with it is much harder; we need to feel part of something to relate to it. This is why the *Data Strings* installation was born; to show aspects of our world and the future made by people themselves in a way that was collaborative.

We must emphasize that the success of an installation like this one is not only due to the format, which can be beautiful and engaging, but what really makes a difference is the content, the questions we ask the audience. Even though our first test installation was really an experiment and we were asking very stupid stuff, like do you prefer a fork or a spoon, we have constantly learned how to improve our questions. They have to be deep and personal because this is the only way to make it relevant to people—it is about placing the audience in situations that trigger feelings that are connected to the goal or context in which this *Data Strings* is placed. For example, if we talk about the future, we could ask something like: How long do you think you will be remembered after you die? With this question, we are already causing people to think about a future that is farther off in their timeline and, at the same time, to reflect on their acts and their loved ones.

The installation design is half of the project; without doubt, the other half is the content.

PRACTICES AND PROCESSES

Identifying the Objectives

To initiate the creation of a *Data Strings*, we first identify what kind of discussion we want people to have, given that the universal objective of this installation is always to generate debate, share opinions, and understand the audience. Let's say that *Data Strings* enables institutions to trigger questions that are meaningful to them, making people reflect on them, and opening a dialogue between them and the audience.

What Needs to Be Said

We normally work hand in hand with the institutions that want to exhibit this artwork to define the questions and the potential answers. We focus on nailing the tone with humor and a language that will connect with the public. We try to never exceed more than nine questions, as it can be a bit tedious to repeat the same process and we would need a lot of space for the installation to really look good.

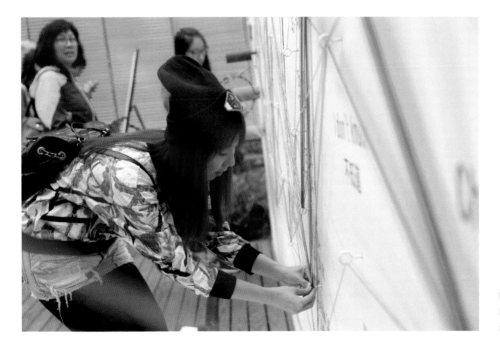

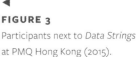

FIGURE 3

Participants next to *Data Strings* at PMQ Hong Kong (2015).

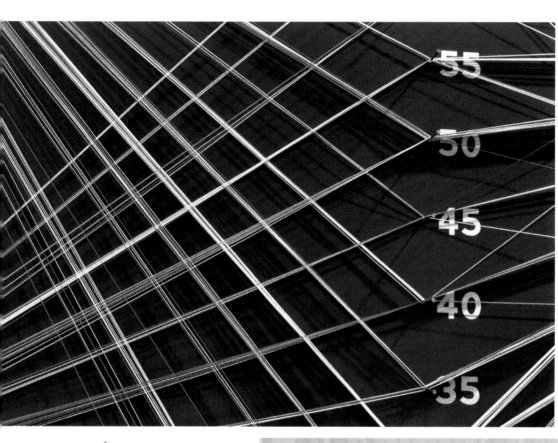

◄

FIGURE 4

Close-up of *Data Strings*
at the Contemporary Art
Fair of Barcelona (2013).

▶

FIGURE 5

Data Strings at the
Contemporary Art Fair of
Barcelona (2013).

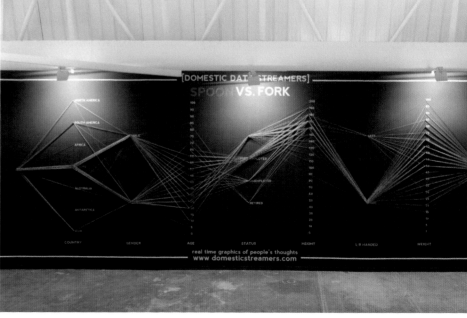

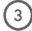

Content Design

Once the content has been validated, we design *Data Strings* following the visual guidelines of the brand and merging it with the signature *Data Strings* look and feel. In the meantime, the final graphics for the vinyls are prepared. If necessary, we also create the plans to build a wall to suspend it on, which is normally made of wood and is then painted.

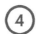

It's Material Time

We prepare the packaging to be sent, which includes the corresponding color threads and the fixing brackets, the hoops for the answers and the thread cutters. If the client is responsible for assembling it, we also include a very easy-to-follow instruction manual. We send the packaging with all the material to our destination.

▲

FIGURE 6

Participant pointing to a value on a
Data Strings at PMQ Center Hong Kong (2015).

⑤ Assembly

To assemble a *Data Strings* piece, it's necessary to have a wall into which all the thread holders and the hoops for the answers can easily be screwed. The most commonly used tool is an electric screwdriver. A *Data Strings* installation is simple to assemble, but you need to be precise. First of all, the background needs to be painted or covered with a vinyl that fits the design. Second, it's extremely important to place the vinyls correctly, as they will mark the places where the hoops need to be screwed in. After that, all the 3D-printed pieces are screwed into the wall and, finally, the interaction with each of the color threads needs to be tested.

⑥ The Experience

As a general rule, *Data Strings* installations don't last for more than a day or two, but in some cases they can stay up for a week or even months, for example, if the installation is part of an exhibition. In such cases, it needs regular maintenance and cleaning, cutting parts of the thread and resetting the whole project from time to time. When the interaction begins, participants usually understand how it works due to the simplicity of the interaction design, but a person may be in support to help if necessary; this person can also facilitate debate and encourage more people to try the experience. As more people interact, the installation grows and the information that can be read starts to show patterns of answers or conclusions in real time, which is the final result of a *Data Strings*.

Most of the time, as our main focus is to trigger debate we don't record all the data generated; it can be understood from a simple glance at the artwork. However, sometimes we also capture it digitally, enabling us to perform deeper research into the results and their potential correlations.

MATERIALS AND TOOLS

3D Printers
Printing the fixing brackets for the wall and the thread cutters.

Inkscape
Open-source software to design all graphics.

Screwdriver
Screwing in the fixing brackets and the assembly of *Data Strings*.

Vinyl Cutting Machine
Adding all the content to the wall.

Colored Thread
Visualizing and interacting with *Data Strings*.

Metal Hangers
For the thread support.

▼
FIGURE 7
Participant adding a record in *Data Strings* at PMK Center Hong Kong (2015).

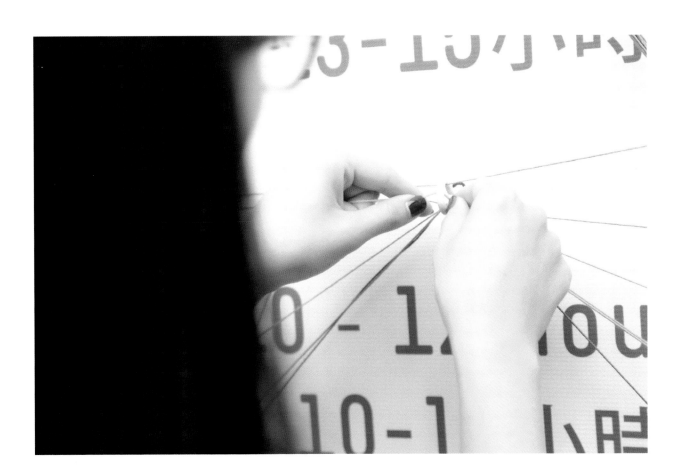

REFLECTIONS

We've been creating *Data Strings* installations for eight years now. They've generated lots of conversations around topics such as mobility, dystopian technologies, sense of belonging, environment, life in 2049, and so forth. We first created it with the idea of making data tangible, but we discovered a trick that went much further than this, brought people together and made them reflect on their differences and similarities, and organized ways of thinking to visualize not only the choices we have, but also the possibility that there are others.

At the end, the audience have their say. They create a collective piece of information. This is a way for people to understand themselves, their place in the world, and for the organizations to see and embrace the plurality of ways of thinking.

It works because it turns the audience into the main character of the experience; unexpectedly, all eyes are on them and they become part of a beautiful shared artwork. It brings people to a space of individual expression with their thread, but what makes it beautiful is the divergence of thoughts. It is in our oppositions and quirks that we create both change and critical thinking; if you look at this installation, that's what you see most of the time. People discuss their opinions and how they understand what other people think.

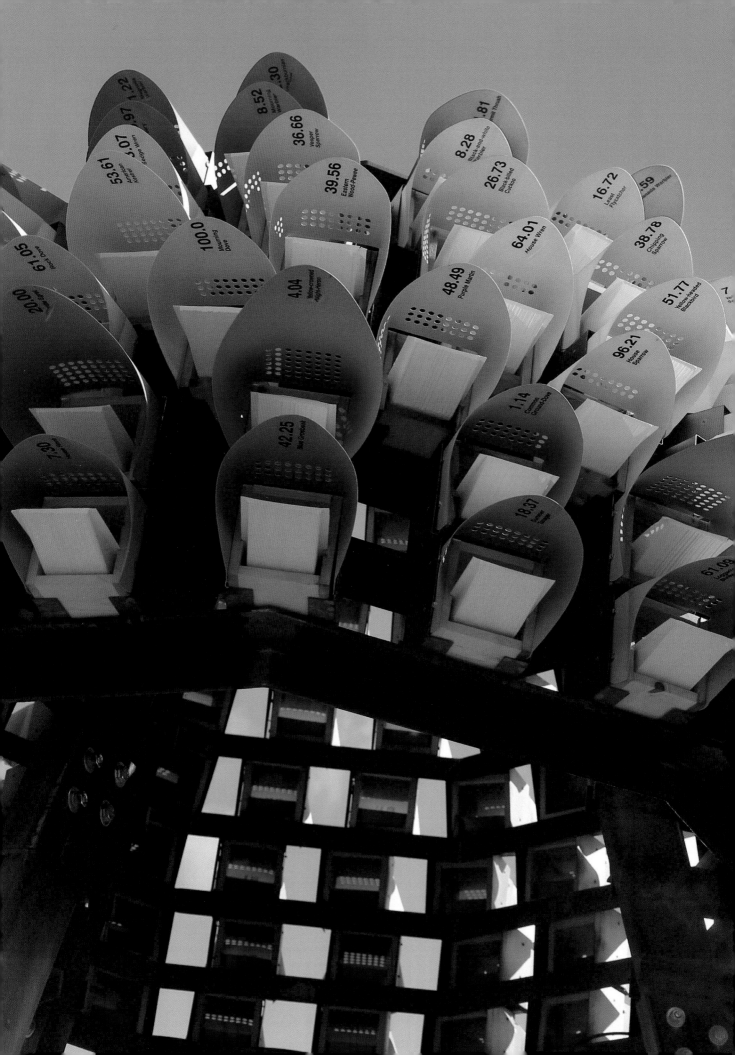

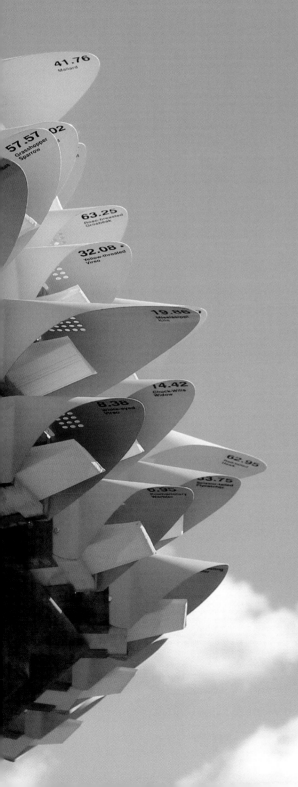

DIGITAL
PRODUCTION

DIGITAL PRODUCTION

–

YVONNE JANSEN

is a permanent research scientist with the French National Center for Scientific Research. Her Ph.D. thesis focused on physical data representations, and her research interests now center more broadly around how visualizations may help people make better decisions or generally improve their lives.

Digital production has changed the practice of physical data representations tremendously. The first section of this book included works that relied on manual crafting, which requires a mastery of "traditional" tools, such as chisels to do woodcarving (like Adrien Segal's *Snow Water Equivalent*), or machines such as pipe benders or various saws to bend and cut materials into the required shape (as in Loren Madsen's *Endings*). This section shows how the emergence of *digital production* shifted from mastery of tools to mastery of *software* controlling the machines. It includes a selection of five works that have, to different degrees, relied on digital production mechanisms to produce the desired physical artifacts.

While it may be tempting to think that not much mastery is required when machines do all the work, creating physical data representations using digital production is not as straightforward as it may seem. Yes, machines do the actual carving, bending, or cutting, and in many cases probably more accurately than a human would be able to, but telling a machine what to do requires a different kind of ingenuity. One has to generate the unique code that can tell a machine how to make the specific physical instantiation of data that one has in mind. And in most cases, there are no apps for that. Sometimes, even the machine is not something one can just buy in a store. For example, Figure 1 shows a printed 3D model of a mathematical object (a D2 dihedral symmetry group) created with a home-built custom 3D printer which uses sugar as its printing material and was dubbed *CandyFab4000* by its inventors. Finally, there is more than one way

◀

PREVIOUS PAGES
Orbacles by the MINN_LAB
Design Collective. | Credit:
Chris Savage

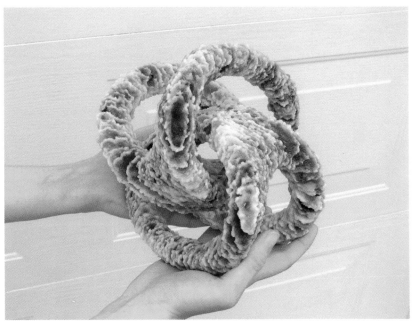

◀

FIGURE 1

A 3D model called Sugar Soliton, created by Windell Oskay after the original model by Batsheba Grossman, and printed using sugar that partially turned into caramel giving it the appearance of a coral. | Credit: CC-BY 2.0 Windell H. Oskay, www.evilmadscientist.com

▼

FIGURE 2

emoto data sculpture showing timelines of Twitter sentiments during the Olympic games in 2012. It consisted of 17 plates milled with a CNC machine. | Credit: Moritz Stefaner, Drew Hemment, and Studio NAND. www.emoto2012.org

▶

FIGURE 3
Credit: Rohit Khot.

▼

FIGURE 4
3D-printed data sculptures encode
data about an individual's physical
activity. | Credit: Simon Stusak.

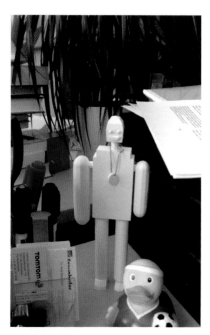

to go about physicalizing particular data and often many paths need to be explored and many decisions made until an object finally emerges. Due to the intrinsic physics of a desired geometry and a chosen fabrication process, the resulting artifact does not necessarily come out as expected (as Stephen Barass discusses in his chapter on the *Chemo Singing Bowl*). In most cases, some additional manual intervention is needed, most commonly to assemble or paint what comes out of a machine. The five chapters in this section all rely on digital production, and each one tells a different story combining different levels of manual and digital craft.

The emergence of digital production shifted from mastery of tools to mastery of software controlling the machines.

A high level of manual craft is involved in pieces where machines cut dozens to hundreds or sometimes even thousands of components into a particular shape which then need to be assembled (often manually). Machines can very accurately produce an abundant number of pieces which then need to be put together to make sense and show the actual data, which can be a very painstaking process. Ekene Ijeona's chapter introducing his *Wage Islands* sculpture is an example of such an approach, and the artist details the minutious effort that went into it. Similarly, Volker Schweisfurth describes how he cuts, assembles, and glues 3D printed elements to create *Data That Feels Gravity*. Another example is the *emoto* data sculpture created by Moritz Stefaner (whose *Perpetual Plastic* project appears later in the book), Drew Hemment, and Studio NAND which shows timelines of Twitter sentiments captured during the summer Olympic Games in 2012. Figure 2 shows a closeup of the sculpture and the detailed peaks that represent the volume of tweets about the 2012 Olympics grouped into columns for each day and separated into rows by the level of positivity of the sentiment expressed (positive to negative). A computer numerical control, or CNC, machine made sure that the sculpture accurately showed the data, but much preparatory work went into the collection and processing of the data, the editing of the 3D design files, and the final assembly of the different pieces. A different laborious process involving many different steps and combinations of support structures and data-encoding parts

Additional manual
intervention might be needed;
to assemble or paint what
comes out of a machine.

is described in detail in the MINN_LAB Design Collective's chapter detailing their *Orbacles* project.

The above are very specific examples, where a unique physical representation was conceived explicitly for a specific data set. At the other extreme, one can find examples where the digital production process is almost entirely automated so that anyone, without prior experience in digital design or fabrication, could insert their data—for example, from their personal activity tracker—and get a personalized 3D printed artifact at the end. There are multiple examples (Figures 3 and 4) of predefined designs, which are parameterized such that someone's data determines specific features, like the length or width of spikes on a graph or toes on a frog. The motivation behind these designs is to make these kinds of objects accessible to anyone who would like to see their data in physical form, for instance, as a memento.

Objects that encode data can also simply serve the interests of personal curiosity, such as the ones shown in Figure 5, made by Nathan Yau, who generated physical charts based on 2018 shot data for key NBA players. He wrote code to transform NBA data from a player into a physical shape and—similar to the personal data objects above—ran the same code for different players to generate many physical charts that can be physically organized and compared.

While many digitally produced data objects encode data solely in their geometrical shape (as seen above), some also encode data in the non-visual properties of the final physical object. For instance, Stephen Barrass's chapter describing his *Chemo Singing Bowl* sculpture examines how objects can sonify data. Here, the fabricated object is meant to be played like an instrument so that it makes the encoded data perceivable. Many different kinds of physical properties can be adjusted based on the data used to generate the object, including properties such as mass, buoyancy, and even taste. For instance, in their chapter on *Dataseeds,* Nick Dulake and Ian Gwilt detail how adjusting the shape and mass of artificial seeds results in objects that fall at different speeds. The relationship between shape and falling speed is complex and encoding data in such ways depends very much on the availability of mathematical models to transform the data. Creating such data physicalizations would not be possible without the support of digital production.

◀

FIGURE 5

Nathan Yau's physical charts showing per-player NBA shot selection data. | Credit: Nathan Yau.

Weekly measurements of blood pressure are mapped
to spokes that connect the top to the bottom of the bowl.

CHEMO SINGING BOWL

Stephen Barrass

2016

Out of Hand Exhibition,
Museum of Applied Arts and Sciences,
Sydney, Australia, 2017
🔗 **maas.museum/event/out-of-hand-materialising-the-digital**

Acknowledgments
Data set provided by Maja Kuzmanovic
Photos by Maja Kuzmanovic

🔗 sonification.com/2016/01/18/chemo-singing-bowl

Blood pressure readings from a year of chemotherapy modify the shape of a Tibetan Singing Bowl so that it both physicalizes and sonifies the dataset due to the intrinsic link between shape and acoustics.

—

STEPHEN BARRASS

has a Doctorate in Auditory Information
Design from the Australian National
University (1998) and a Bachelor of
Electrical Engineering from the University
of New South Wales (1986). He was a
Postdoc in the Virtual Environments
group at GMD in Bonn (1998), Senior
Researcher at CSIRO in Canberra (2000),
and Associate Professor of Media
Arts and Design at the University of
Canberra (2005). He is the founder of
SONIFICATION.COM.

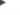

FIGURE 1

More extreme data values
cause more extreme variations
in the curves of the spoke.

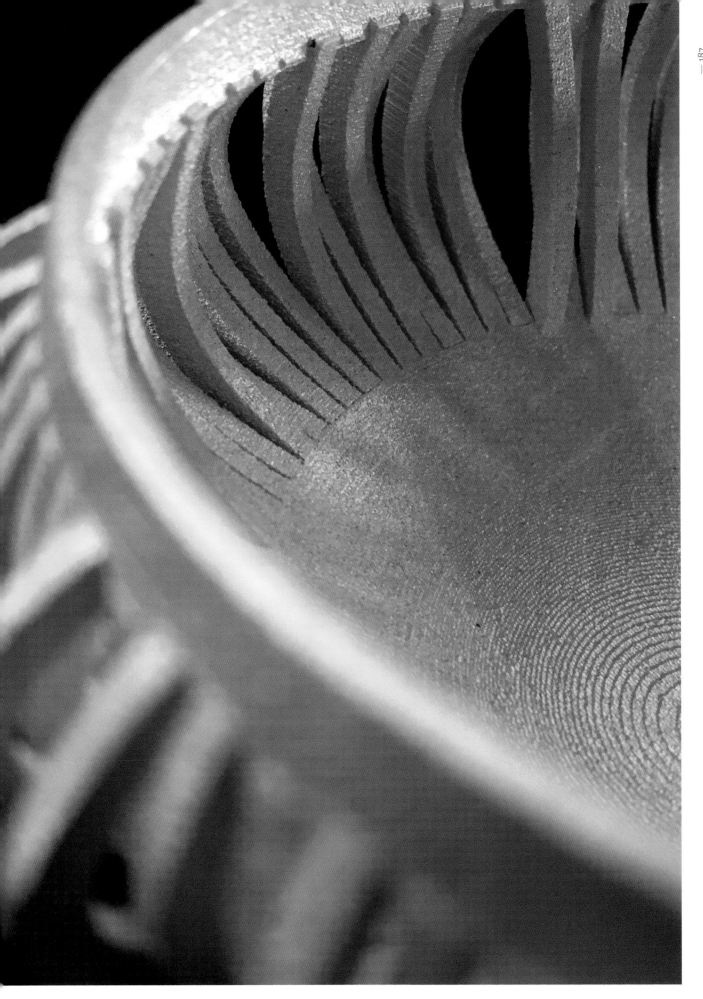

PROJECT MOTIVATION AND INSPIRATION

Sonification is the use of sound to represent data. Like physicalization, sonification provides an alternative to visualization that may allow different perceptions and insights. Sonification is usually done by digitally mapping data values onto sound parameters using computer music software. However, when I heard about recent experiments with 3D-printed musical instruments, I wondered whether it might be possible to map data onto the shape of a 3D-printed musical instrument to create a data physicalization that produces sounds that also sonify the dataset.

The *Chemo Singing Bowl* is a Tibetan singing bowl shaped by blood pressure data measured during a year of chemotherapy. When my friend and collaborator Maja Kuzmanovic offered her health records for the project, I realized that although datasets are usually considered to be objective measurements, a health dataset like this can actually be very personal. I chose the Tibetan Singing Bowl as the musical shape and metaphor for this project because of its association with health and well-being, reflective meditation, and alternative therapies.

▼

FIGURE 2
Each systolic/diastolic data
pair controls a spline curve
shaping the spoke.

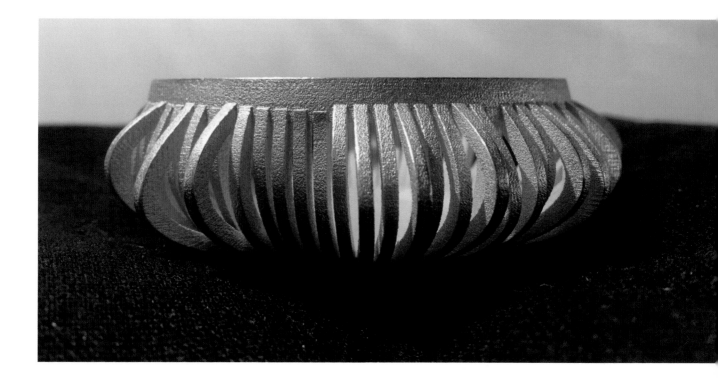

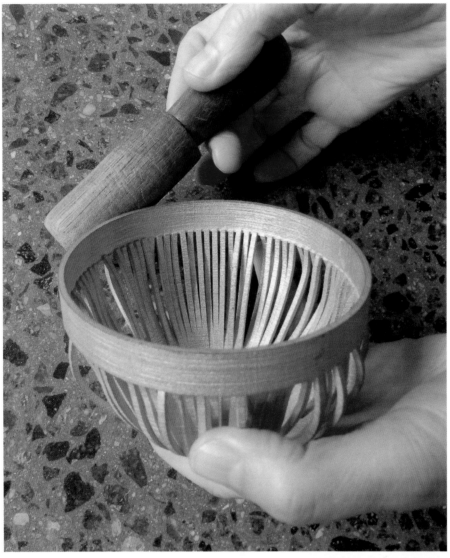

▲

FIGURE 3
The *Chemo Singing Bowl* is played by ringing with a Puja stick.

▶

FIGURE 4
The variations in the shape of the spokes also cause variations in the sound of the singing bowl.

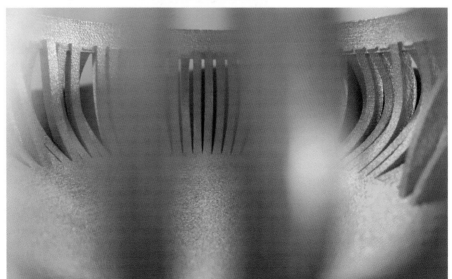

PRACTICES AND PROCESSES

My process for creating the *Chemo Singing Bowl* takes a design research approach with stages of data characterization, sound design, data shaping, 3D printing, and testing.

Data Characterization

Blood pressure data values consist of readings in the form of systolic/diastolic pairs, where systolic pressure occurs when the heart contracts, and diastolic pressure occurs when it relaxes. A normal blood pressure reading for a healthy person is 120/80 millimeters of Mercury (mmHg). When you visit the doctor your blood pressure is typically diagnosed by categories of increasing risk, as shown in Figure 5.

A graph of Maja's blood pressure, in Figure 6, shows readings taken during a year of chemotherapy. Notice how the effects of chemo cause the measurements to veer erratically from hypotension to hypertension and back again.

Sound Design

The graph in Figure 2 is a familiar way to represent data that we are taught to understand at school. A physicalization of the graph as a 3D-printed object allows you to hold it and feel the shape as well. This object could make a sound if you tap on it, but it would not be very audible because the shape and material are not very resonant. Musical instruments are specifically designed to resonate and make sounds in various ways. In 2009, when a 3D-printed whistle was uploaded to the Thingaverse.com site by Zaggo, it attracted a lot of attention because it actually made a sound when you blew it. This first example of a working musical instrument inspired others to create 3D-printed flutes, guitars, violins, trumpets, percussion blocks, and interesting innovations in CAD musical instrument design. CAD instruments can be customized; for example, there is an app that allows you to change the shape parameters of a whistle to produce a range of whistles with different notes and timbres. This

Category	Systolic, mmHg	Diastolic, mmHg
Hypotension	< 90	< 60
Normal	90–119	60–79
Prehypertension	120–129	60–79
Stage 1 hypertension	130–139	80–89
Stage 2 hypertension	>140	>90
Hypertensive crisis	≥ 180	≥ 120

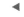

FIGURE 5
Categories of risk from blood pressure readings.

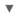

FIGURE 6
Graph of blood pressure readings from a year of chemotherapy treatments.

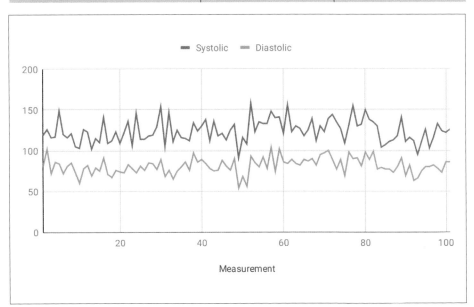

idea of parameterizing a simple musical instrument inspired me to experiment with the most fundamental acoustic object of all—the tuning fork. The tone of a tuning fork is a pure sine wave with a specific frequency that depends on the length, cross-sectional shape and diameter of the tines, and the density of the metal it is made from. In my experiments I expanded on these parameters to also include the number of tines and the shape profile along the tine, I printed a set of nine different tuning forks in stainless steel, shown in Figure 7, that produce vibratos, amplitude modulations, and other acoustic effects.

Parametric tuning forks could be used to represent small datasets by mapping data values onto them to hear differences in the tones they produce as acoustic sonifications of the data. However, the size of the dataset is limited by the handful of parameters that can be mapped onto a single tuning

▶

FIGURE 7

Variations on the shape of
a tuning fork that produce
different acoustic effects.

▼

FIGURE 8

Programming the 3D model
of the *Chemo Singing Bowl* in
OpenSCAD.

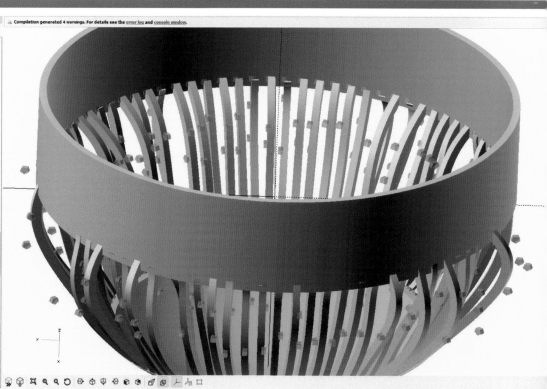

fork. Nevertheless, the tuning fork could provide a fundamental building block for a sonic data physicalization in the shape of a musical instrument that could represent larger datasets.

I chose the Tibetan Singing Bowl for this project because of its association with meditation, wellbeing, and alternative medicine. Antique singing bowls were hand-beaten from metals that could include gold, silver, copper, brass and bronze. Today, 3D printing services allow you to make jewelry and other small objects in a range of metals that include gold, silver, bronze, brass, copper and steel. The challenge for this project was to work out how my experiments with the tuning forks could inform the design of a singing bowl that could acoustically sonify a larger dataset.

(3) Data Shaping

Maja provided her chemo blood pressure measurements as an Excel spreadsheet. At the start of her treatment the readings were taken five times per week and gradually reduced in frequency, resulting in 102 pairs of systolic / diastolic data points over the period of a year. The graph in Figure 6 shows how erratic the measurements were in the early stages, shifting to more consistent readings as the chemotherapy takes effect, and stabilizing as she recovered. The design challenge is to map the series of measurements over time onto the circular shape of the singing bowl, which does not have a timeline. I chose to map time around the circumference, which, although it joins the start and end points, still allows the perception of the erratic variations through shape. However, my main objective was to produce an overall impression of the entire dataset in a single sound, rather than a linear sequence of notes like most common sonifications of time series data. The bowl has to be 3D-printed in metal to resonate acoustically, which limits the maximum size to 80x80x80 mm and the minimum thickness to 1 mm. These physical limits constrain the number of data pairs to 90, spaced at four-degree intervals around the 80-mm circumference. I chose to concentrate on the treatment period of the first 90 values, leaving off the last 12 readings from the recovery phase.

I imported the data into the OpenSCAD software, which is an open-source and freely available environment for coding 3D shapes. I made a bowl by subtracting an inner sphere from an outer sphere and cutting off the top to form a rim. I then made a gap between the rim and the bottom by subtracting a rectangular block. I programmed a wall of spline curves and mapped each systolic / diastolic measurement to two control points for each spline to produce smooth 3D curves with ends on the rim and base. The systolic value controlled the upper part of the spline and the diastolic value controlled the lower part. Data values that were in the hypotension category push the curve inwards, while those in the

▼

FIGURE 9
Uploading the 3D model to
Shapeways 3D printing service.

▶

FIGURE 10
You can see and feel the
variation between spokes, which
represents the variation in blood
pressure.

hypertension range push it outwards.
The programming environment made
it possible to rapidly iterate the mapping
to accommodate for the extremes of the
dataset, and ensure that the splines were
separated and the shape looked good.
I then exported the CAD model as an
STL file for 3D printing.

3D Printing

I uploaded the STL file to the
Shapeways online 3D printing service
which has tools for checking mesh
integrity and printability, and ordered
an initial prototype in plastic to
check for production problems. Two
weeks later when I received the print
everything looked fine, but plastic does
not resonate much, so I could not test
the sound at this stage. I then ordered
the final version in steel, which is a
cost-effective metal that does resonate
acoustically.

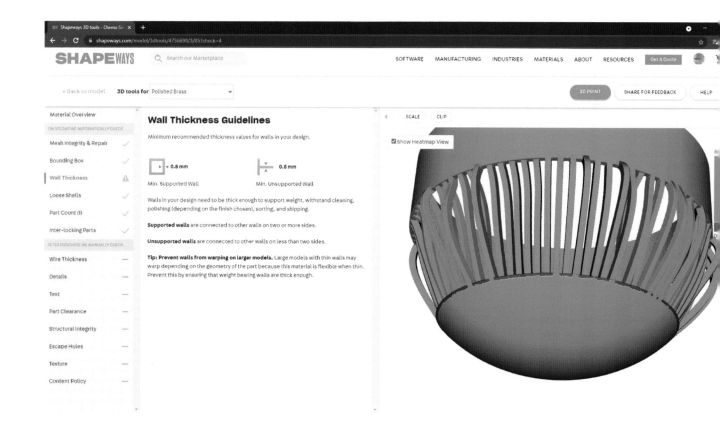

MATERIALS AND TOOLS

LibreOffice Calc
Spreadsheet for graphing, formatting and exporting data.

OpenSCAD
Programming environment for creating solid 3D CAD objects.

Shapeways
Online 3D printing service.

Puja stick
Ready-made from another singing bowl.

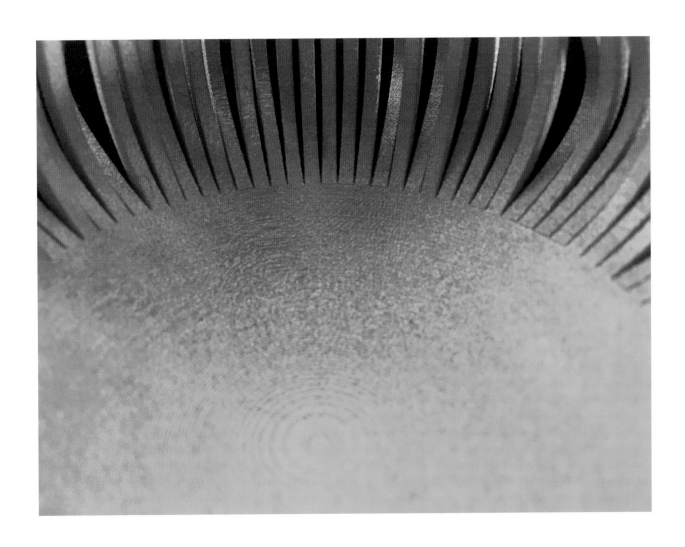

REFLECTIONS

I gave a *Chemo Singing Bowl* to Maja as thanks for providing her health dataset for the project. When she tried playing it she said:

"It sounds exactly as I imagine to have sounded while having chemo! It's painful to experience it, but quite accurate—the sound is dry and heavy, without much resonance, just like I felt!"

I had initially hoped the *Chemo Singing Bowl* would make a beautiful and unique sound like an antique singing bowl, due to its shaping by a personal dataset, but in actuality it clanks like a tin can, and rasps rather than sings. I think the rough and dissonant effects may be due to the erratic quality of the spokes causing inharmonic vibrations. It would be great if there was a way to model the acoustics of a 3D object so that you could tell how it would sound before it is 3D printed. There is a technique called modal synthesis for modeling the acoustics of simple vibrating objects, such as strings, bars, and plates, but the *Chemo Singing Bowl* is too complicated. In the future a personal 3D metal printer could be a way to more rapidly iterate the design of acoustic sonifications, using physical acoustics rather than digital simulations. This bottleneck highlights the potential power of acoustic sonification as an alternative to conventional computational methods by allowing an entire dataset to be heard instantly without any delay. The physicalization also has the advantage of allowing you to manually interact with the sonified dataset by striking it in different places and with different forces, or rubbing it with the Puja stick at different rates, rather than simply triggering the sonification on a computer desktop. The singing bowl is a familiar metaphor that provides cues for how to interact with the sonic data physicalization to make it ring or sing. Familiarity with the instrument may help the listener to understand the effect of the dataset on the sound, and interpret meaning from it. Just like the soundtrack moved film out of the silent era, acoustic sonification can enable emotional, narrative and aesthetic sound effects that open up a new era of sonic data physicalization.

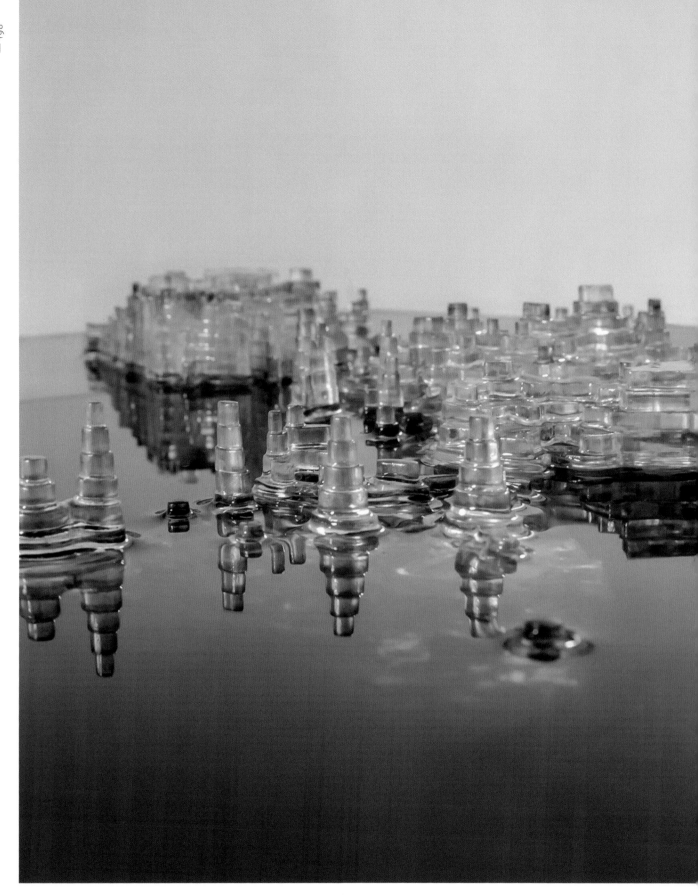

Detail shot of the first edition for Measure (2015) at Storefront for Art and Architecture, showing the peaks of the map emerging from the water as a visitor held down the button to increase the wages. When the visitor released the button, the map would submerge one level at a time until only the top level was above the water—returning the map to its inactive state. This edition had 19 levels, and at 19, all levels were above the water.

WAGE ISLANDS

Ekene Ijeoma

2014— ONGOING

**Storefront for Art and Architecture,
Pratt Manhattan Gallery,
Museum of the City of New York**

Acknowledgments

Storefront for Art and Architecture,
Pratt Manhattan Gallery,
Museum of the City of New York

🔗 ekeneijeoma.com

Wage Islands is a series of data-driven sculptures that visualize the drowning costs of housing for low-wage workers in New York by submerging a topographic map in a water tank based on income data. Each sculpture is composed of a clear topographic map of NYC based on housing costs, in a clear tank with dark water, filled to just below their peaks; the few areas where low-wage workers can afford housing. The editions vary in data sources, map levels, dimensions, and interactive components, allowing viewers to interact with the map by increasing wages and lifting more housing areas from the water.

—

EKENE IJEOMA

is an artist who uses poetic and computational strategies to produce sound, video, sculptures, installations, and performances that expose our social, political and environmental realities and engage people in enacting alternatives. His work have been presented through exhibitions and initiatives at the Bemis Center for Contemporary Art, Museum of Contemporary Art Denver, Contemporary Art Museum of Houston, Annenberg Space for Photography, and The Kennedy Center. He is an Assistant Professor of Media Arts and Sciences at MIT and the founder and Director of the Poetic Justice group at the MIT Media Lab.

▼

FIGURE 1

Installation view of the most recent edition for Who We Are: Visualizing NYC by the Numbers (2019) at the Museum of the City of New York. For this edition, when a visitor held down the button, the map would emerge one level at a time and pause at every level based on the percentage of the population who could afford to live within each level.

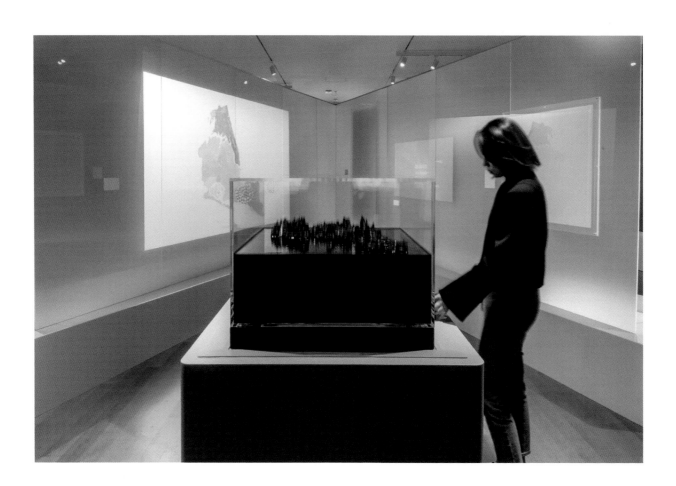

▼
FIGURE 2
Detailed shot of the first edition for Measure (2015) at Storefront for Art and Architecture, showing the increase in wages and area after a visitor held the red button for a few seconds.

PROJECT MOTIVATION AND INSPIRATION

I was a few months away from releasing *The Refugee Project* in January 2014, in collaboration with Hyperakt, a design studio. It was my first independently produced, sociopolitically focused, research-based project and would later become my first project to feature in international galleries and museums. Like *The Refugee Project*, *Wage Islands* came from meeting like-minded people within the design and technology communities interested in social issues and civic communication as opposed to technical problems and commercial solutions. I had met a few of these people, including Deroy Peraza, the co-founder of Hyperakt, at their Lunch Talks throughout 2012 and later their Re3 StoryHack event in October 2013. It was there that I met an organizer from the Fast Food Forward movement in NYC (that later became Fight for 15). They had been fighting to raise the minimum hourly wage for fast-food workers in the city to $15 and would later win that for all workers by 2019. New York City was and is one of the most expensive cities, and I had so many questions about how those workers were staying afloat. We were all living on the same physical island but within various actual and metaphorical socio-economic islands, some of which were below sea level, and I wanted to portray that.

◄

FIGURE 3

Installation view of the most recent edition for Who We Are: Visualizing NYC by the Numbers (2019) at the Museum of the City of New York.

PRACTICES AND PROCESSES

1 Find a making-of video at https://vimeo.com/145239064

Wage Islands has become an ongoing series, and as new editions have been commissioned for various exhibitions, we've worked with my team to re design the topographic map and re engineer the electromechanical lift to create a more truthful and beautiful experience. Here, I'll focus on our process for creating the topographic maps.[1]

Data Collection

For each edition, we started by researching data on median household income from the Census Bureau's American Community Survey (ACS) or Public Use Microdata Sample (PUMS) and developing more legible and relatable ways of segmenting them into various "wage islands." For the first edition, we started at the minimum wage of $8.25 and then increased by increments of $3.75. For the most recent editions, I wanted the increments to be more personal to viewers. So we tried starting at the poverty wage of $5.84, increasing it based on minimum wages from 2015–2019, then ending with increases of $5 and then $10 increments. However, using increments based on previous minimum wages along with MIT's Living Wage household wages categories felt the most meaningful (Figure 5).

Gradient Maps

Next, we developed gradient maps that were smooth yet discrete using QGIS (Figure 6), trying various interpolation types and settings but using inverse distance weighting (IDW). We used the 30% rule of how much income should be spent on housing to determine how affordable each area was based on median housing costs.

▶

FIGURE 4

Screenshot of spreadsheet of wage levels for the most recent edition of Who We Are: Visualizing NYC by the Numbers (2019) at the Museum of the City of New York.

▼

FIGURE 5

Gradient map for the most recent edition of Who We Are: Visualizing NYC by the Numbers (2019) at the Museum of the City of New York. The light areas have higher median housing costs and the darker ones lower. The darkest areas become the peaks of the topographic map.

OPTION A - Minimum wage and living wage increments			
Level	Hourly Wage	Category	% of Total Population
1	$5.84	Poverty level wage: New York County	8%
2	$8.75	Minimum wage: New York State, 2015	5%
3	$11.00	Minimum wage: New York City, 2017	4%
4	$12.10	Living wage: 2 adults (both working)	2%
5	$13.00	Minimum wage: New York City, 2018	1%
6	$15.00	Minimum wage: New York City, 2019	3%
7	$17.46	Living wage: 1 adult	4%
8	$22.15	Living wage: 2 adults, 2 children	7%
9	$24.19	Living wage: 2 adults, 1 working	3%
10	$28.23	Living wage: 2 adults (1 working), 1 child	6%
11	$30.85	Living wage: 2 adults (1 working), 2 children	3%
12	$31.99	Living wage: 1 adults, 1 child	2%
13	$35.23	Living wage: 2 adults (1 working), 3 children	4%
14	$41.54	Living wage: 1 adults, 2 children	6%
15	$54.98	Living wage: 1 adults, 3 children	12%
~~ignore this segment~~			~~30%~~

▼

FIGURE 6

Rendering of the top view of the topographic map for the most recent edition for Who We Are: Visualizing NYC by the Numbers (2019) at the Museum of the City of New York.

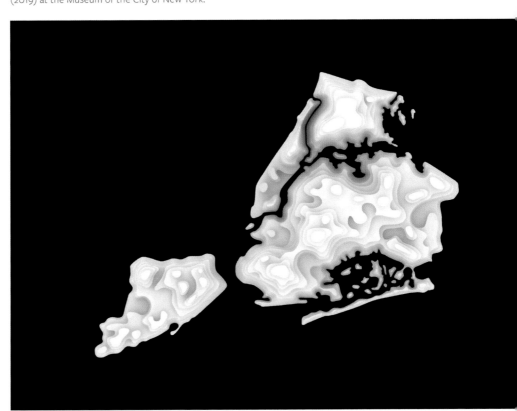

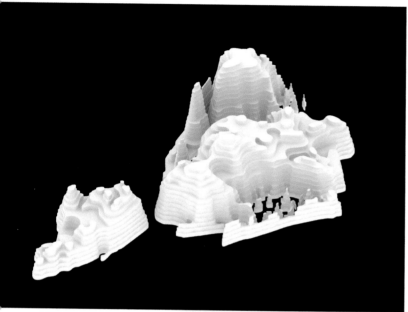

FIGURE 7

Rendering of the topographic map for the most recent edition of Who We Are: Visualizing NYC by the Numbers (2019) at the Museum of the City of New York.)

FIGURE 8

In-progress topographic model for the first edition (2015).

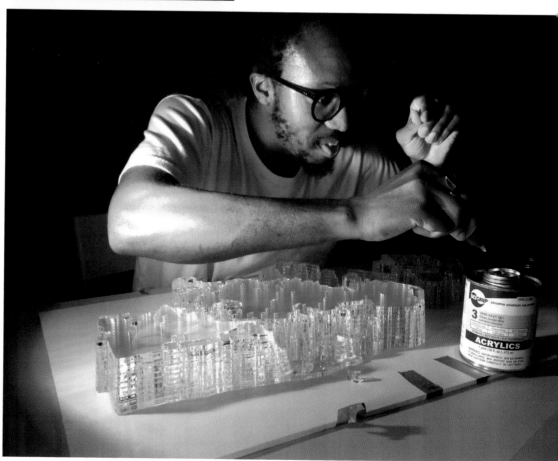

Topographic Maps

Afterward, we created topographic maps using Rhino and Grasshopper with various settings to create well-proportioned, formed curves.

Physical Model

Last, we created the physical topographic map by laser-cutting hundreds of pieces and hand-assembling them using acrylic glue.

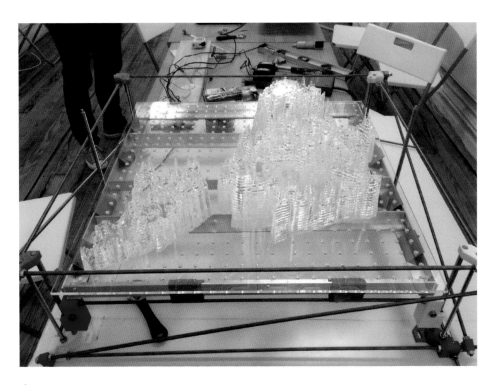

▲

FIGURE 9

The completed topographic model
for the first edition (2015).

MATERIALS AND TOOLS

Google Docs and Sheets
Used for editing data.

QGIS
For creating gradient maps.

Rhino and Grasshopper
For creating topographic maps and cut sheets.

Laser Cutter
For creating hundreds of acrylic parts that were hand-assembled with acrylic glue to create the topographic model.

Ink-Dyed Water
For hiding the submerged levels of the model.

Aluminum and Wood

Solidworks and Autodesk Fusion 360
Used for creating the **electromechanical components** (LED display, push button, timing pulley, servo motor, custom mechanics, and electronics) for viewers to interact with it (as seen in Figure 2).

REFLECTIONS

Wage Islands was an early crossroad in my practice at which I turned away from didactics and moved toward poetics. In my previous work, *The Refugee Project*, I'd thought about how data could capture stories outside the frames of photos and reveal the hidden patterns and relationships of the refugee crisis. The project succeeded in answering data-specific questions such as how many refugees migrated where, when, and why. However, the data mapping was so straightforward, closed-ended, and non-opinionated that it failed to expand on those questions.

At that time, I hadn't seen many open-ended data mappings that were not abstract and illegible; they were either information design or data art. I wanted to bridge the gap between facts and feelings in a way that felt familiar and intuitive. I created both information design and data art while working at design studios, newsrooms, and labs and knew that if I were to create anything new and different, I'd need to work outside their needs for screen-based content or user metrics. A commission from Eva Franch i Gilabert at The Storefront for Art and Architecture (a non-profit gallery in SoHo) and a residency with Gary Chou at Orbital (a coworking community space in LES) gave me the space and resources to produce the first edition of *Wage Islands* with a small team of designers and engineers.

Throughout my design career, before *The Refugee Project*, I can't remember one project for which I used any of my cultural knowledge or personal experience. I wanted to see what it could look like if I applied musical techniques such as call and response to storytelling with data through wordplay. So in a call and response with myself, I started with keywords—low wages and affordable housing—and went from "in deep water," "out of depth," and "keep your head above water," to "drowning in debt" and underwater mortgages. I went through a few key objects and images, including icebergs (most of whose mass is underwater) and the *New York Magazine* cover photo of Manhattan after Hurricane Sandy (in which most of downtown was out of power). Through this journey, I arrived at using the geographic features of NYC in a symbolic way to bring the data into conversation with the many textual and visual metaphors for money, water, land, and access. I would go on to use *Wage Islands* as a guide for remixing cultural artifacts using data for artworks such as *Deconstructed Anthems* and *Pan-African AIDS*.

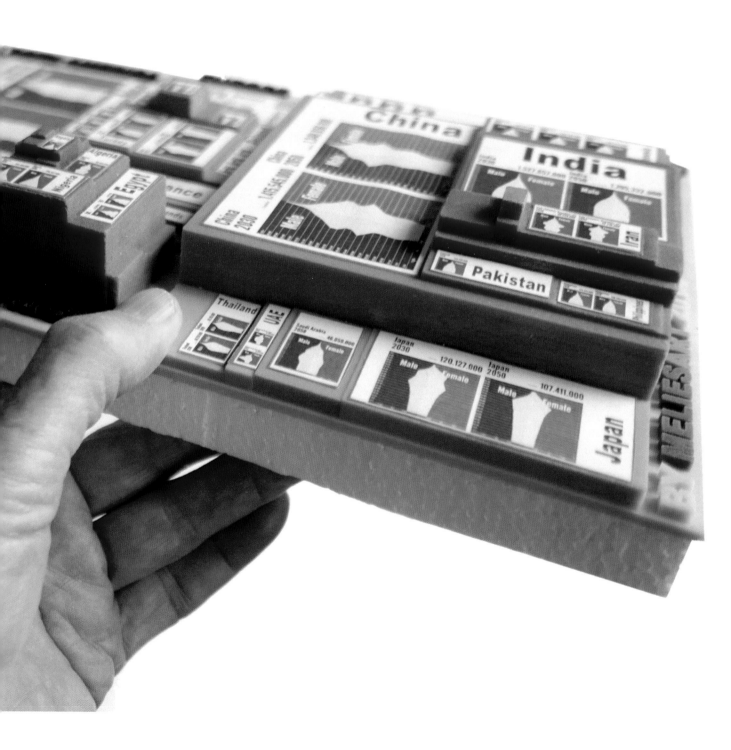

DATA THAT FEELS GRAVITY

Volker Schweisfurth

2017

The data sculpture presents key economic data for 130 countries to understand investment opportunities and challenges. Through its shape, the multicolor 3D-printed treemap acts as a decision support landscape. In this way, the physical object offers "statistics at your fingertips," makes the data more exciting, and makes the objects worth remembering and circulating.

–

VOLKER SCHWEISFURTH

is a data artist from Düsseldorf, Germany. As an industrial engineer by training he has worked on digital technologies and visualization methods since 1965, when he learned about data processing in a missile battalion. He aims to slow down the act of seeing, understanding and communicating by making digital data and situations physical. In addition, he explores ways of "breathing life" into physical forms by embedding them into mixed reality environments.

PROJECT MOTIVATION AND INSPIRATION

I have been in development policy and industry for over 35 years, and have consulted for companies wanting to invest abroad, and bodies that act as investment agencies. A major goal has always been to come to a common understanding of the use of investments.

Most of the statistical data that we read on a weekly basis does not really stick with us, and we often forget most of it quickly. So when 3D printing became readily available I decided to use it to make digital data tangible, so that it could be held and felt. In this way, 3D-printed data sculptures can support understanding and memorization and accompany PowerPoint slides or any other presentation. Given the fact that "detailed, durable, long-term memory representations are stored as a natural product of haptic perception,"[1] these sculptures help people remember the characteristics of the data as well as their spatial arrangement. One could imagine wandering through the data as through one's own apartment.

Thus, the sculptures act as an invitation for dialogue, and create an opportunity for decision makers to discuss the various matters at hand.

1 Long-Term Memory for Haptically Explored Objects: Fidelity, Durability, Incidental Encoding, and Cross-Modal Transfer. Fabian Hutmacher, and Christof Kuhbandner. 2018. In *Psychological Science*. Volume 29, Issue 12.

▼

FIGURE 1

3D printed prototype of the decision support landscape.

The sculpture represents 130 countries with their key economic data, grouped by continent. You can see the Americas on the left, Europe and Africa in the middle, and Asia on the right. From above, you see the sizes of the different economies; each box represents the Gross National Income of the different countries (GNI in Purchasing Power Parity (PPP)). Take these as the countries' potentials.

Now, if you tilt the sculpture, and look from the side, you see the height of the country boxes. These heights indicate the ranking from the *Doing Business Flagship Report* by the World Bank.[2] Each year, for 190 countries, they compare the ease of doing business in each country. Thus, a tall block is a country with difficult investment conditions. One can see that nearly all of the African countries rank high in difficulty; these are some of the more difficult countries to invest in. The colors encode this same difficulty, and help to identify similarly ranked countries.

Taken together, you have the opportunities from above, and the challenges from the side. On the upper surfaces of each 3D-printed box, I added graphics showing the countries' future population pyramids for the year 2030, and in some cases also for 2050. The combination of these three incorporated types of information (namely economy, investment hurdles, future population) delivers a vivid narrative of the nations' situation and fate.

This impression is even stronger if you use VR glasses, see https://youtu.be/9DSYXegs21E)

Grouping the countries by continent allows viewers to identify outliers in a region. In Europe, for instance, France, Germany, and the United Kingdom become apparent as countries to invest in, so to speak. But you can also see higher boxes representing places with more difficult business conditions, such as Ukraine, or Georgia. Now, you have a sort of landscape before you, supporting decisions on where to invest—I call it a "decision support landscape." It invites people to walk around virtually—searching and understanding places.

PRACTICES AND PROCESSES

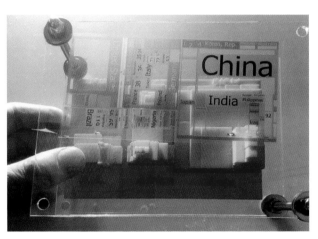

① Choosing a Physical Form

After thinking about suitable physicalizations for the task on hand, I construct my pieces through a combination of manual and digital production. In the following, I describe the process for the case of the "decision support landscape."

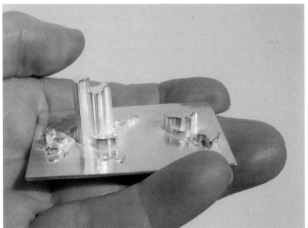

② Clean and Prepare Data

First, I checked the dataset for suitability, as well as consistency. I also verified whether its license allowed me to use it and combine it with other sources.

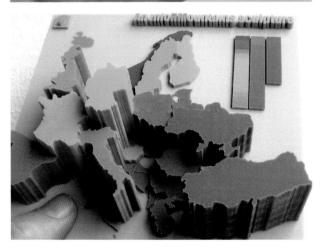

③ Create Treemap

After carefully checking the raw data, I grouped the countries by continent, generated a treemap diagram, and exported it to Photoshop for clean-up. I then transferred it to the 3D program Blender, where the actual construction took place. The treemap acts as a

▶

FIGURE 2

World Bank. *Doing Business 2016: Measuring Regulatory Quality and Efficiency.* CC-BY 3.0 IGO

TABLE 1.1	Ease of doing business ranking									
Rank	Economy	DTF score		Rank	Economy	DTF score		Rank	Economy	DTF score
1	Singapore	87.34		64	Jamaica	67.27 ↑		127	Cambodia	55.22 ↑
2	New Zealand	86.79 ↑		65	Bahrain	66.81 ↑		128	Maldives	55.04
3	Denmark	84.40 ↑		66	Kosovo	66.22 ↑		129	West Bank and Gaza	54.83 ↑
4	Korea, Rep.	83.88		67	Kyrgyz Republic	66.01 ↑		130	India	54.68 ↑
5	Hong Kong SAR, China	83.67 ↑		68	Qatar	65.97 ↑		131	Egypt, Arab Rep.	54.43 ↑
6	United Kingdom	82.46 ↑		69	Panama	65.74		132	Tajikistan	54.19 ↑
7	United States	82.15		70	Oman	65.40 ↑		133	Mozambique	53.98 ↑
8	Sweden	81.72 ↑		71	Bhutan	65.21 ↑		134	Lao PDR	53.77 ↑
9	Norway	81.61 ↑		72	Botswana	64.98 ↑		135	Grenada	53.46 ↑
10	Finland	81.05 ↑		73	South Africa	64.89		136	Palau	53.43
11	Taiwan, China	80.55 ↑		74	Tunisia	64.88 ↑		137	Guyana	51.83
12	Macedonia, FYR	80.18 ↑		75	Morocco	64.51 ↑		138	Pakistan	51.69 ↑
13	Australia	80.08		76	San Marino	64.21 ↑		139	Tanzania	51.62 ↑
14	Canada	80.07 ↑		77	St. Lucia	64.20 ↑		140	Marshall Islands	51.58
15	Germany	79.87 ↑		78	Tonga	64.13		141	Malawi	51.03 ↑
16	Estonia	79.49 ↑		79	Bosnia and Herzegovina	63.71 ↑		142	Côte d'Ivoire	50.93 ↑
17	Ireland	79.15 ↑		80	Malta	63.70 ↑		143	Burkina Faso	50.81 ↑
18	Malaysia	79.13 ↑		81	Guatemala	63.49 ↑		143	Mali	50.81 ↑
19	Iceland	78.93 ↑		82	Saudi Arabia	63.17 ↑		145	Papua New Guinea	50.74 ↑
20	Lithuania	78.88 ↑		83	Ukraine	63.04 ↑		146	Ethiopia	49.73 ↑
21	Austria	78.38 ↑		84	Brunei Darussalam	62.93 ↑		147	Sierra Leone	49.69 ↑
22	Latvia	78.06 ↑		84	China	62.93 ↑		148	Micronesia, Fed. Sts.	49.67
23	Portugal	77.57 ↑		86	El Salvador	62.76 ↑		149	Kiribati	49.50
24	Georgia	77.45 ↑		87	Uzbekistan	62.60 ↑		150	Togo	49.03 ↑
25	Poland	76.45 ↑		88	Fiji	62.58 ↑		151	Gambia, The	48.99 ↑
26	Switzerland	76.04 ↑		88	Trinidad and Tobago	62.58		152	Burundi	48.82 ↑
27	France	75.96 ↑		90	Vietnam	62.10 ↑		153	Senegal	48.57 ↑
28	Netherlands	75.94		91	Dominica	61.44 ↑		154	Comoros	48.22 ↑
29	Slovak Republic	75.62 ↑		92	Uruguay	61.21 ↑		155	Zimbabwe	48.17 ↑
29	Slovenia	75.62 ↑		93	Dominican Republic	61.16 ↑		156	Suriname	47.69 ↑
31	United Arab Emirates	75.10 ↑		94	Vanuatu	61.08 ↑		157	Bolivia	47.47 ↑
32	Mauritius	75.05 ↑		95	Seychelles	61.05 ↑		158	Benin	47.15 ↑
33	Spain	74.86 ↑		96	Samoa	60.70 ↑		159	Sudan	46.97 ↑
34	Japan	74.72		97	Albania	60.50 ↑		160	Niger	46.37 ↑
35	Armenia	74.22 ↑		97	Zambia	60.50 ↑		161	Iraq	46.06
36	Czech Republic	73.95 ↑		99	Nepal	60.41 ↑		162	Gabon	45.99
37	Romania	73.78 ↑		100	Paraguay	60.19 ↑		163	Algeria	45.72 ↑
38	Bulgaria	73.72 ↑		101	Kuwait	60.17 ↑		164	Madagascar	45.68 ↑
38	Mexico	73.72 ↑		101	Namibia	60.17 ↑		165	Guinea	45.54 ↑
40	Croatia	72.71 ↑		103	Philippines	60.07 ↑		166	São Tomé and Príncipe	45.50 ↑
41	Kazakhstan	72.68 ↑		104	Antigua and Barbuda	59.70 ↑		167	Myanmar	45.27 ↑
42	Hungary	72.57 ↑		105	Swaziland	59.10 ↑		168	Mauritania	44.74 ↑
43	Belgium	72.50 ↑		106	Bahamas, The	59.00 ↑		169	Nigeria	44.69 ↑
44	Belarus	72.33 ↑		107	Sri Lanka	58.96 ↑		170	Yemen, Rep.	44.54 ↑
45	Italy	72.07 ↑		108	Kenya	58.24 ↑		171	Djibouti	44.25 ↑
46	Montenegro	71.85 ↑		109	Indonesia	58.12 ↑		172	Cameroon	44.11 ↑
47	Cyprus	71.78 ↑		110	Honduras	58.06 ↑		173	Timor-Leste	44.02
48	Chile	71.49 ↑		111	St. Vincent and the Grenadines	57.91 ↑		174	Bangladesh	43.10 ↑
49	Thailand	71.42 ↑		112	Solomon Islands	57.86 ↑		175	Syrian Arab Republic	42.56
50	Peru	71.33 ↑		113	Jordan	57.84 ↑		176	Congo, Rep.	41.88 ↑
51	Russian Federation	70.99 ↑		114	Ghana	57.69 ↑		177	Afghanistan	40.58
52	Moldova	70.97 ↑		114	Lesotho	57.69 ↑		178	Guinea-Bissau	40.56 ↑
53	Israel	70.56 ↑		116	Brazil	57.67 ↑		179	Liberia	40.19 ↑
54	Colombia	70.43 ↑		117	Ecuador	57.47 ↑		180	Equatorial Guinea	40.03
55	Turkey	69.16 ↑		118	Iran, Islamic Rep.	57.44 ↑		181	Angola	39.64 ↑
56	Mongolia	68.83 ↑		119	Barbados	56.85		182	Haiti	39.56 ↑
57	Puerto Rico (U.S.)	68.73		120	Belize	56.83 ↑		183	Chad	38.22 ↑
58	Costa Rica	68.55 ↑		121	Argentina	56.78		184	Congo, Dem. Rep.	38.14 ↑
59	Serbia	68.41 ↑		122	Uganda	56.64 ↑		185	Central African Republic	36.26 ↑
60	Greece	68.38 ↑		123	Lebanon	56.39		186	Venezuela, RB	35.51
61	Luxembourg	68.31		124	St. Kitts and Nevis	55.83 ↑		187	South Sudan	34.78
62	Rwanda	68.12 ↑		125	Nicaragua	55.78 ↑		188	Libya	31.77
63	Azerbaijan	67.80 ↑		126	Cabo Verde	55.54 ↑		189	Eritrea	27.61 ↑

Source: Doing Business database.

Note: The rankings are benchmarked to June 2015 and based on the average of each economy's distance to frontier (DTF) scores for the 10 topics included in this year's aggregate ranking. For the economies for which the data cover two cities, scores are a population-weighted average for the two cities. An arrow indicates an improvement in the score between 2014 and 2015 (and therefore an improvement in the overall business environment as measured by *Doing Business*), while the absence of one indicates either no improvement or a deterioration in the score. The score for both years is based on the new methodology.

two-dimensional bottom layer, and is extruded according to the "difficulty" ranking.

Prepare 3D Printing

Next, I had to refine the CAD models. This is sometimes tedious because 3D printing requires more than simply rendering the data in 3D. I had to keep an eye on the resulting solid objects so that there were no overlapping sections and no protruding corners.

3D Printing

As usual in my works, I used commercial 3D printing services in this step. Major weak points in the printing process so far are surfaces with fonts, photo textures, and predefined color settings.

Inspect Quality

After getting the 3D object back from the commercial printing service, I inspected it with a magnifying glass to check for quality.

Label and Assemble

Finally, I cut and assembled all the pieces to create the final sculpture. I glued color-printed population pyramids for the countries on top of their surfaces. Lastly, I adhered the whole sculpture to a foam surface, so that people can hold it in their hands and look at it from all sides.

MATERIALS AND TOOLS

Data Sources
In Figure 3 (left), I list some of my data sources, such as the World Bank, Transparency International, or Wikipedia.

Computers
Next, I name the computer hardware used to create the models, including my iPad and my Mac computers.

Schemas
In my practice, I use a wide range of different methods which I show in the third panel. These include visualization techniques such as timelines, flow diagrams and heatmaps, business analytic techniques such as the Boston matrix or the Gartner hype cycle, and management tools such as Greek risk measures or the cause-and-effect diagram.

Software and Tools
In Figure 3 (center), I show the software and tools, as well as their interplay. These range from tools used in the early concept phase such as SketchUp and X-Mind, to data analysis software such as Deltagraphs and Excel, to graphic software such as Photoshop and Illustrator, and finally 3D software such as Blender and Meshlab.

Output and Related Production
Next are three groups of output, and further tools for each group. I distinguish between data sculptures, smart data sculptures, and AR/VR versions.

Dissemination
In Figure 3 (right), I describe the ways in which I disseminate the pieces, be it via my personal website, on social media, or to the press.

REFLECTIONS

Data physicalization can provide haptic pleasure, better group experiences, and deeper engagement. Instead of having to browse through endless studies or read through long tables, more senses are addressed.

In my work, I mostly use multicolor 3D printing. This is suitable for small print runs and is promising for the display of additional parameters. If, for example, the surface roughness can be varied in the future, visually impaired people will also have improved tactile experiences in addition to the spatial haptics.

Let me emphasize that physical data modeling as a "slow" and permanent information carrier must not be left to architects and urban planners. Data modeling can offer insights and additional sensory values. People can touch them, feel the surface haptics, watch them at eye level, and pass them around. Or, as Robert Polidori, Canadian photographer stated: "Digital data is made to forget, analog is made to remember."

Smart data sculptures.

Plenty of options exist to extend static data sculptures to active ones. A prototype I developed plays a sound bite giving details about the data when tapped. Another possibility is to equip the surfaces with OLED or AMOLED screens, which would allow short explanatory videos to be played directly on the model.

◀

FIGURE 3

Hand-drawn overview of my design and construction process. In this schematic diagram I collect the inputs, materials and tools, and outcomes used in my practice.

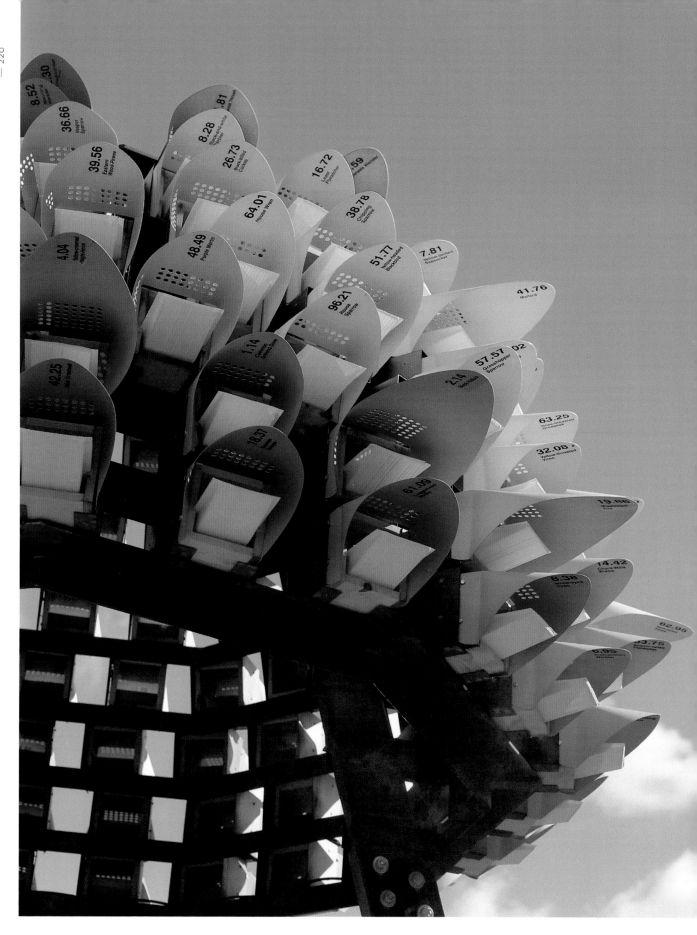

The final piece installed at The Commons. This orb holds one module for each bird species in Minnesota, 147 in total. The length of each hood varies in response to the average size of the species, and the color is based on the prevalence of the species in Minnesota. | Credit: Chris Savage.

ORBACLES

MINN_LAB Design Collective

Daniel F. Keefe

Ross Altheimer

Andrea J. Johnson

Mahdieh Mahmoudi

Patrick Moe

Maura Rockcastle

Marc Swackhamer

Aaron Wittkamper

2017

Minneapolis, MN

Acknowledgments

Orbacles was supported by the annual Creative City Challenge commission, which is made possible by the Arts, Culture and the Creative Economy program of the City of Minneapolis, hosted in collaboration with The Commons and Northern Lights.mn and the Northern Spark festival. Additional support was provided by the University of Minnesota Digital Design Center. The 2017 commission was based on the theme Climate Chaos, Climate Rising.

Additional support was provided by the Arts, Culture and the Creative Economy, City of Minneapolis, the University of Minnesota Digital Design Center, MG McGrath, 3M Design (signage materials sponsor), and Grain Millers.

🔗 ivlab.github.io/minnlab/orbacles.html

Orbacles makes scientific data tangible via a site-specific triad of sculptures that connect visitors to the reality of climate change through the story of changing Minnesota bird populations given current and future predicted climate scenarios.

—

MINN_LAB

is a design collective composed of architects, landscape architects, and computer scientists. We engage in and facilitate cross-disciplinary dialogue through the collective creation of site-based installations that foster awareness and critical inquiry into the nature of our cities, and imagine their possible futures. Our projects challenge the conventional notions of design agency through our plurality of design voices, use of data, and user integration.

▼

FIGURE 1
The color white represents the current state. So, the "Current" orb in the foreground contains all white modules, showing the bird species currently present in Minnesota. | Credit: Chris Savage.

◀

FIGURE 2

The two colored "Future" orbs shown here represent scientific simulations of Minnesota 100 years from now under two possible scenarios. The low-emissions scenario (left orb) models a future that would require us to make aggressive changes in our policies to limit greenhouse gas emissions. The high-emissions scenario (right orb) models a future based on continuing current policies. If the species decreases in prevalence within the state, the color of the hood tends toward orange, and if it increases in prevalence (for instance, some species will migrate north to enter Minnesota) it tends toward blue. The sculptures include a didactic explaining the underlying data, including a link to our website that includes an interactive web visualization using the same data mappings. | Credit: Chris Savage.

PROJECT MOTIVATION AND INSPIRATION

After designing site-specific installations for three annual Northern Spark one-night arts festivals in Minneapolis, Postography (2014), Cityscope (2015), and Weather Report (2016), our design collective of architects, landscape architects, and computer scientists wished to create a more permanent and impactful work. We designed *Orbacles* in response to the 2017 Creative City Challenge, a competition that asked artists to explore the effects of climate change on the city and its residents via an installation at The Commons park, Minneapolis. The design's intentional connection to the city and its residents builds upon our earlier installations, and the themes of data physicalization and changing climate are a direct extension of *Weather Report*, a tunnel of interactive balloon pixels installed on the banks of the Mississippi River at the 2016 Northern Spark festival.

Recognizing that the timescale and underlying data-intensive evidence for climate change often feel out of reach to the average citizen—either too complex to interpret or only accessible by supercomputer—we thought, how can we make climate data and the local impact tangible?

Inspired by the city's birds, we thought, here is an aspect of the city that the changing climate will surely impact. What will it be like to visit this park 100 years from now? Which birds will be here? Which ones will have disappeared or moved in? And, how can we tell this story using the same, real numerical data that scientists use to answer these questions?

The data visualized come primarily from a spatial database of 147 bird species.[1,2] Typical lengths and wingspans were retrieved from the Patuxent Bird Identification Infocenter.[3]

1 Climate Change Bird Atlas (A Spatial Database of 147 Bird Species of the Eastern USA). Steve Matthews, Louis R. Iverson, Anantha M. Prasad, and Matt Peters. 2007-ongoing. Northern Research Station, USDA Forest Service.

2 Changes in potential habitat of 147 North American breeding bird species in response to redistribution of trees and climate following predicted climate change. Stephen N. Matthews. Louis R. Iverson, Anantha M. Prasad, and Matthew P. Peters. 2011. In *Ecography*. Volume 34.

3 Patuxent Bird Identification Infocenter. G.A. Gough, J.R. Sauer, M. Iliff. 1998. Version 97.1. Patuxent Wildlife Research Center, Laurel, MD. https://www.mbr-pwrc.usgs.gov/infocenter.html

PRACTICES
AND PROCESSES

① Concept Sketches

We explored the concept of a modular habitat for birds with concept sketches and mockups. The modules needed to be functional, acting as a habitat for birds, while also being held aloft so that visitors could not climb on them, and being robust enough to withstand the elements.

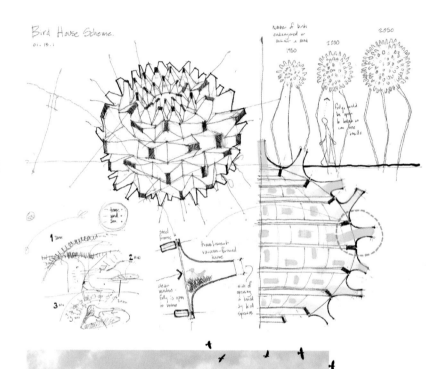

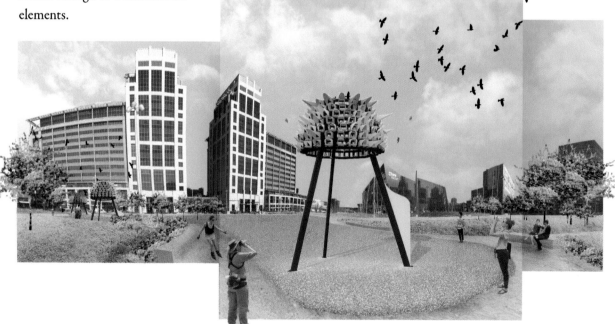

② Paper Mockups

While exploring various winged forms, we discovered several ways (hood length, hood tilt, color, placement within the "nest") to parameterize the design of each module, making it possible to tune each one based on underlying data for each bird species.

③ Digital Modeling

We created digital models and renderings using Rhinoceros and Grasshopper to understand how the modules would fit within each orb and how the final piece might feel when installed on-site.

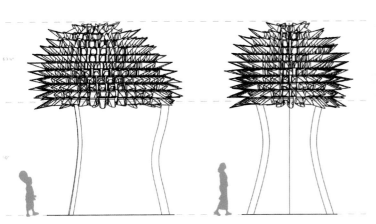

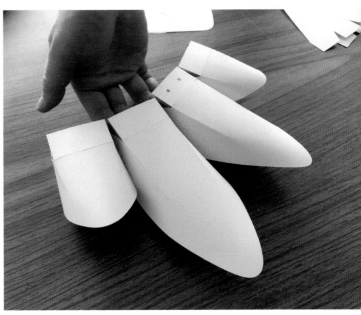

4

Fabrication Shop

The metal hoods and frames were fabricated by our partners at MG McGrath, while the wooden module boxes and formed plastic inserts for baths were fabricated by hand in the UMN School of Architecture workshops.

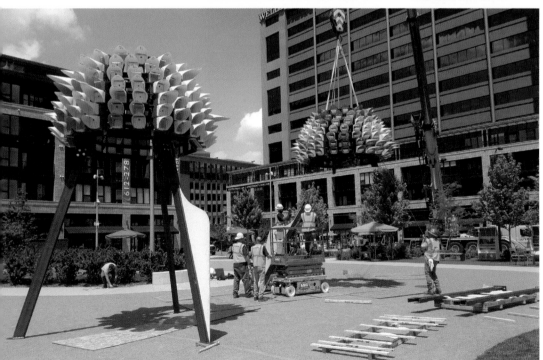

5

Installation Onsite

Installation on-site required some heavy machinery.

Projection

A flocking simulation written in Processing and an interactive webpage written in D3 brought the sculptures to life on opening night at the Northern Spark Festival.

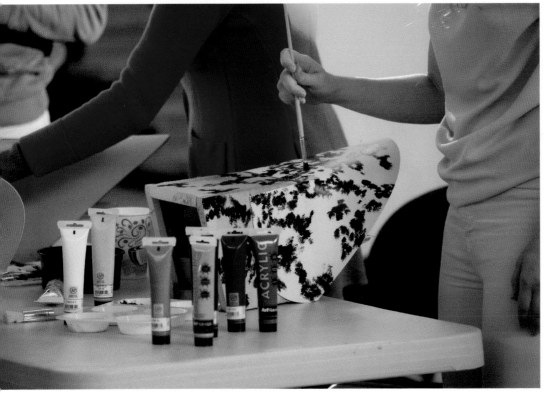

Afterlife

The installation in downtown Minneapolis was temporary, but the modules have an afterlife, providing a habitat for birds around the city.

MATERIALS AND TOOLS

Sketching
Early ideation and site planning.

Paper Folding
Designing and refining the modules, especially the specific shape of the hoods.

Woodworking Tools
Prototyping and constructing the module boxes.

Sheet Metal Bender
Prototyping and constructing the final form of the module hoods.

Vacuum Forming Machine
Prototyping and constructing plastic trays for the water-holding modules.

Processing.org and D3
Data processing, designing data mappings and color schemes, developing the complementary interactive projection component for opening night, developing the complementary interactive website.

Rhinoceros and Grasshopper
Parametric digital modeling to design the physical structures and translate data mappings into forms that can be fabricated.

REFLECTIONS

The MINN_LAB design collective brings together researchers and practitioners from multiple disciplines. Communication and building consensus will be a challenge in any such situation, but this project managed some great successes on these fronts and resulted in a design that pushes the boundaries of research in multiple disciplines.

Within the field of data visualization, the project asks us to consider what it takes to make scientific data more accessible and relevant to the average person. In a context where even our most scientifically robust climate data and conclusions are routinely called into question in the public sphere, these data and the science behind them can feel aloof, mysterious, and hopelessly uninterpretable to many in society. *Orbacles* asks us to reflect on how the way we "visualize" such data might change this. How will people react to climate data when, rather than stuck within a database, the data becomes so real that we can touch, smell, or taste them?

Similarly, within the field of architecture, *Orbacles* prompts us to consider how we might legibly incorporate various kinds of data into the design of our built environment to not only shape the forms we see and inhabit, but to also influence how we relate to these data-informed places and the broader implications of the data. *Orbacles* explores a model where housing accommodates rather than resists, shelters rather than defends, and partners rather than fights with local animals and plants. Additionally, the project outlines an expanded agency of the architect, taking control of the full lifecycle of a structure in order to plan its future material use after disassembly. How does a structure bring users into dialogue with place, and how do we plan for its reintegration into systems of materials use once its current manifestation is no longer relevant?

A pile of *Dataseeds* scattered on the ground after use.

DATASEEDS

Nick Dulake
Ian Gwilt

2015

**Design 4 Health Conference,
Sheffield, UK**

Acknowledgments

Sheffield Hallam University, Design Futures, Art & Design Research Centre

University of South Australia, School of Art Architecture and Design

⟳ digital.nhs.uk (data source)

⟳ behance.net/gallery/28146927/dataseeds-Nick-Dulake-Ian-Gwilt-2015

The *Dataseeds* are a physical translation of statistics about falls. Using the sycamore seed as a metaphor, the *Dataseeds* show the frequency of falls in people aged 50 to 90. Different wing sizes represent how the data affect the fall rates when seeds are thrown in the air.

—

IAN GWILT

is a Professor of Design at the University of South Australia. He is interested in the role that design can play in healthcare and wellbeing environments as a means of knowledge mobilization, and uses co-design to create hybrid digital/physical experiences and novel information design strategies that cater to a range of people and communities.

—

NICK DULAKE

is a senior industrial designer at Design Futures at Sheffield Hallam University. He has extensive experience in production design for industry, taking many products through from concept design to production, from one-off and low volume products to mass-produced goods. Nick's experiences include designing and developing products and managing new product development projects across consumer, medical, and consumer goods.

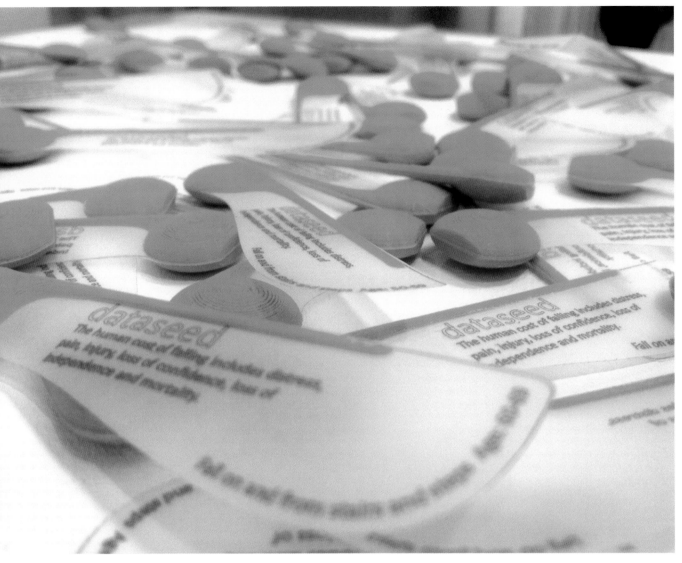

▲
FIGURE 1

Dataseeds on display. The base of each Dataseed has the same size and weight, with the size of the wings reflecting the frequency of falls in different age brackets. The age bracket is printed on the side of the wings, and fine lines indicate the number of falls for the lower age brackets.

◀
FIGURE 2

Dataseeds caught in flight. The surface area of the wings dictates the spin and the rate at which the seeds fall when thrown.

PROJECT MOTIVATION AND INSPIRATION

The *Dataseeds* concept was developed to explore a more engaging way of communicating important healthcare statistics to audiences who might find conventional ways of representing data such as statistical lists and graphs confusing or uninteresting. A 3D printing technique was used to visualize statistical data in an interactive and memorable way. When thrown in the air, data on the number of falls in different age groups is shown by the speed at which the seeds fall to the ground. The *Dataseeds* could be used in a healthcare management or education context where multilevel stakeholders are required to think about and discuss the data.

PRACTICES AND PROCESSES

To accurately represent the data as a data-driven object, we needed to make a physical representation of a sycamore seed that could drop and spin at different rates to visually and dynamically interpret the data. To achieve this goal, we produced a standard seed body and spine with an adaptable wing profile that would parametrically alter based on the data instance it represented (data amount to wing surface area/size). To change the descent and spin characteristics of the data objects, a number of prototypes were created to replicate the angle and pitch of flight from a natural seed.

① Inspiration

A natural sycamore seed; the visual metaphor for the Dataseed objects.

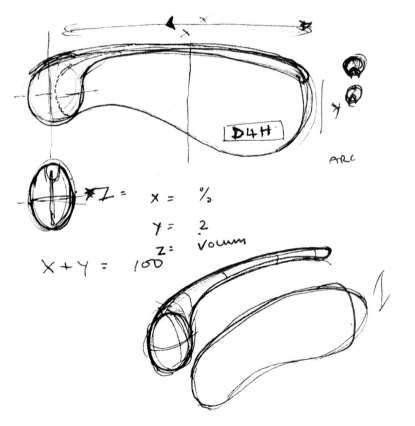

② Design Sketches

Paper sketches were used to conceive of the physical design the data object and to calculate the correlation between data and form—in this case, frequency to surface area of the wing.

③

Prototype Physical Models

Different materials were prototyped to test how they would spin and fall.

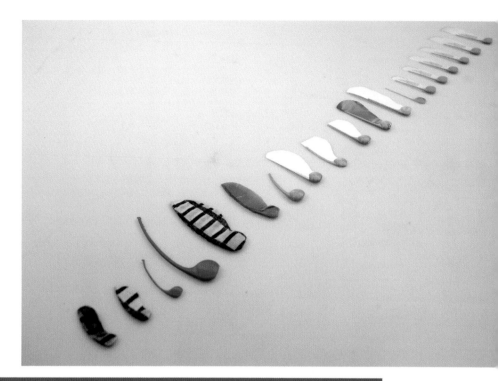

④

Computer Aided Design

Using design tables allowed the wing to be changed dynamically to change the surface area of the wing in line with the data.

⑤ Batch Production

A 3D printing process was used to produce multiple standard versions of the Dataseed body, to which different wing sizes could be attached (representing a range of data values).

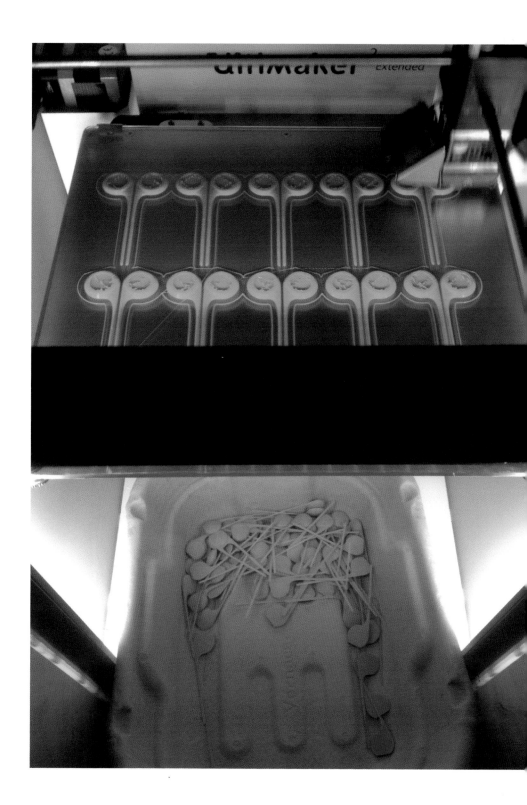

⑥
Final Prototype with Varying Wing Sizes

Dataseeds representing different data values were made and tested. Each wing size represented the number of falls in a 10-year age bracket.

MATERIALS AND TOOLS

Sketching Tools
Used to ideate and develop / plan the technical details of the project.

A Range of Different Physical Materials
Used to physically prototype the performance and production details of the data physicalization.

3D Computer Modeling Software
Used to create a 3D CAD model that could be used by the 3D printer to create the body of the *Dataseeds*.

3D Printer
Used to produce a short run of Dataseed bodies that could be quickly fabricated.

2D Laser Cutter
Used to create different wing sizes that could be attached to the 3D-printed Dataseed body to represent different instances from the dataset.

Laser Printer
Used to print contextual information about the dataset on the Dataseed wings.

REFLECTIONS

The *Dataseeds* are an example of the data objects concept that utilize a mixture of contemporary digital and hand-made fabrication methods. They translate complex digital data into physical objects that can be used to aid understanding and stimulate conversation around complex information. The *Dataseeds* were designed with a specific dataset and audience in mind, and the use of the sycamore seed metaphor only makes sense for this or a similar dataset. Every data physicalization should be approached in a way that best expresses the underlying data to aid cognition for the intended audience. Hence it is important to both know how to correctly read the data and have a good understanding of the needs and expectations of the users of the data.

Locally, people need to understand the content of the underlying data and know how to read it. We achieved this by printing the name of the data set and the value of the data on the wing of each Dataseed. More generally, there is no collective public recognition of data physicalizations and how to interpret them. Therefore, in this interim period as the rules and conventions of data physicalization become socialized, the overall concept also usually needs to be introduced.

Research has shown that data objects are particularly effective for communicating with non-specialist audiences with varying interests and levels of subject knowledge. However, they should not be seen as a substitute for graphs or statistical lists, and more as another mechanism for adding to the understanding of complex data. Creating data as a physical object that can be easily passed between people is very effective. Moreover, the material choices such as plastic, wood, and metal, and the quality of the materials' weight, roughness, smoothness, size, and shape, all appear to have an impact on how people read and value the underlying data. Therefore, when designing a data physicalization it is important to take material choices into consideration.

ACTUATION

ACTUATION

–
PIERRE DRAGICEVIC

is a permanent research scientist at Inria Bordeaux, France. He does research on data visualizations beyond the desktop, and on judgment and decision-making with visualizations.

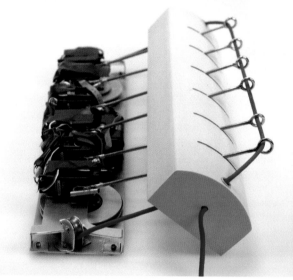

◄

PREVIOUS PAGES

EMERGE tabletop by Jason Alexander, Faisal Taher, John Hardy, and John Vidler.

►

FIGURES 1 – 2

A physical line chart consisting of a string whose shape is controlled by six servo motors. | Credit: Jon McTaggart and Christian Ferrara.

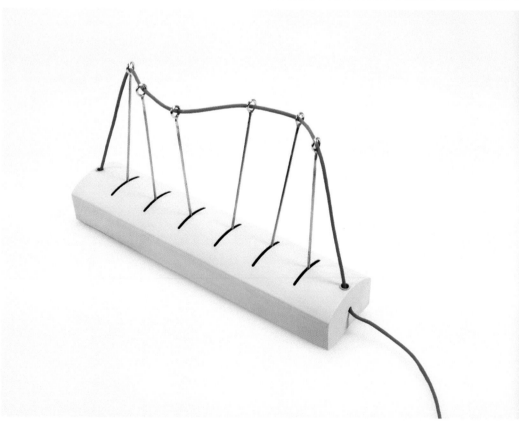

While many physical data artifacts are either static or need to be updated manually to reflect changes in the data, this section covers physical data artifacts that can update themselves without human intervention. For example, Figures 1 and 2 show a physical line chart whose shape can change with data, thanks to the presence of servo motors. Similarly, Figure 3 shows a map of Italy where the height of each region can be computer-controlled to encode particular data.

The possibilities for physical data artifacts that support actuation are endless. Later in this section, David Sweeney and colleagues discuss the design of complex mechanical versions of classic chart types in the *Tenison Road Charts* project. Other artists and designers, meanwhile, take more artistic approaches—as in Markus Kison's *Pulse* (Figure 4) where servo motors deform a heart-shaped latex object based on emotions inferred from a real-time sentiment analysis of blogs. In this book, Kim Sauvé and Steven Houben also discuss the design of *LOOP*, another example of non conventional physical data representation employing servo motors. But data actuation does not necessarily have to rely on motors—take Figure 5, for example, where the pressure of water jets varies in real time according to the value of a currency, and Figure 6, where the concentration of ozone in plant enclosures varies according to the pollution levels in different cities. Later in this section, Nik Hafermaas, Dan Goods, and Jamie Barlow discuss their *AirFIELD* installation, which employs liquid crystal to change the appearance of myriads of discs suspended in the air. Many other examples can be found online in the list of physical visualizations.[1]

1 http://dataphys.org/list/categories/active-physicalvisualization

◄

FIGURE 3

A motorized map of Italy where the height of each region is computer-controlled. | Credit: Dotdotdot with Michele Ferretti.

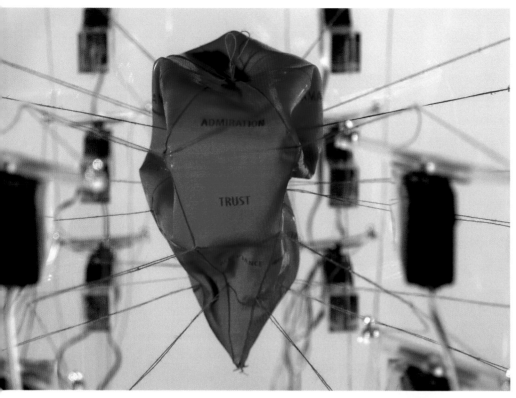

◀

FIGURE 4

An art installation where servo motors control the shape of a heart-looking object depending on a real-time sentiment analysis of blogs. | Credit: Markus Kison, Pulse, 2008 © MARKUS KISON / SOCAN (2022)

▼

FIGURE 5

A fountain made of three water jets whose pressure is updated every five seconds according to the value of a currency. | Credit: Koert van Mensvoort, Benjamin Voss, Charles Mignot, Rik Wesselink, Ronald Schipperen, Roy Damgrave, Koert van Mensvoort, Arian van Dorsten, and Jan Willem Nienhuis.

▶

FIGURE 6

An installation consisting of eight lettuces, each of which is enclosed in its own airtight Plexiglas box and represents a major city. The concentration of ozone in each box is controlled in real time to reflect the current pollution level in the city. | Credit: Timm-Oliver Wilks, Thorsten Kiesl, and Harald Moser.

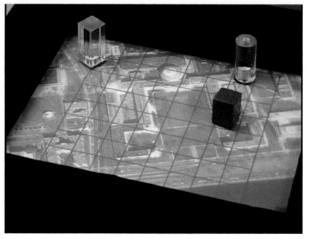

▶

FIGURE 7

The PSyBench moves objects with an electromagnet placed on a 2-axis positioning mechanism under the surface. | Credit: Scott Brave, Colyn Bulthaup, and Hiroshi Ishii.

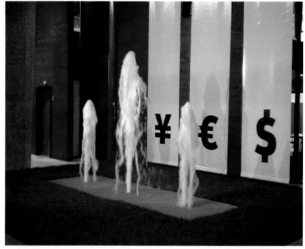

The designs shown in Figures 4, 5, and 6 as well as those used in *LOOP* and *Air-FIELD* are very expressive and effective at conveying their message, but they have the drawback of being highly specialized and thus hard to reuse. A designer who wishes to convey the same data differently or tell the story of an entirely different dataset needs to design and build a new device from scratch. The Italy map in Figure 3 is a bit more versatile because it can be used to convey arbitrary data about Italian regions, including their population, gross domestic product, or proportion of people vaccinated against COVID-19. The physical line chart Figures 1 and 2 is even more versatile because it can show any dataset that can be visualized as a simple line. However, it isn't nearly as versatile as a computer screen. If there was a computer screen that could only display line charts, most people would consider such a device as largely useless.

The possibilities for physical data artifacts that support actuation are endless.

There have been efforts to design highly versatile physical displays, dating back to the late 1990s and originating in large part from the Tangible Media Group at the MIT Media Lab. At the time, several research projects demonstrated so-called *tabletop tangible user interfaces* that involved manipulating and rearranging physical objects on a table instead of operating a keyboard and a mouse. However, because computers were unable to move those objects, the range of applications and features (such as saving and restoring work) that could be supported was limited. This issue was addressed with electromagnet-based designs allowing tangible objects to rearrange themselves without human assistance (as seen in Figure 7). These designs went on to inspire robot-based systems such as the *Zooids* system by Mathieu Le Goc and colleagues, showcased at the end of this section. Because all such systems can freely arrange multiple objects on a surface, they can be used to create physical versions of charts that represent data using collections of dots on a plane, such as two-dimensional scatterplots. Meanwhile, the third dimension is within reach, with experimental systems already capable of positioning physical objects in mid-air (as seen in Figures 8 and 9).

In parallel with developments in computer-controlled positioning of physical objects, research on new user interfaces has explored so-called *shape displays*, physical devices whose shape can be controlled by a computer. Perhaps the most common approach is assembling an array of motorized pins, which can be used to create physical versions of 3D bar charts and 3D surfaces (see Figure 10). Pin-based shape displays have also been used by artists to create kinetic art installations. Jason Alexander and colleagues' *EMERGE* installation, discussed later in this section, demonstrates a tabletop pin-based shape display specifically designed for data exploration.

All of the physical display designs we have seen so far focus on controlling the geometry (arrangement or shape) of physical entities, but geometry is only one way data can be conveyed physically. A range of material and perceptual properties (such as weight, texture, stiffness, reflectivity, temperature, smell, taste) can be used to encode information physically, and can in principle be "actuated" to reflect changing data. However, controlling such material properties is often not trivial, and little research has been done in this area.

Much of the research on versatile physical displays takes inspiration from a vision of the future broadly referred to as *programmable matter*, according to which, physical displays that can adopt any shape, color, and material properties will exist. This vision is far out of reach but is increasingly prevalent in popular culture (for example, the 2013 movie *Man of Steel* or the 2021 TV Series *Foundation*), and is being pursued in several disciplines such as physics, robotics, and computer science. The prospect of such a technology is probably as disturbing as it is exciting, as conveyed by this 1965 quote from the famous computer scientist Ivan Sutherland:

> *The ultimate display would, of course, be a room within which the computer can control the existence of matter. A chair displayed in such a room would be good enough to sit in. Handcuffs displayed in such a room would be confining, and a bullet displayed in such a room would be fatal. With appropriate programming such a display could literally be the Wonderland into which Alice walked.*

1 The Ultimate Display.
Ivan E. Sutherland. 1968. In *Proceedings of IFIP Congress.* Pages 506–508. ACM.

Although the safety and ethics of programmable matter will be important to consider, such a technology will be an unprecedented creative tool in the hands of infographic designers, data journalists, educators, and data artists. Not only will it allow them to re-create all the data artifacts we have discussed, it will also allow them to create radically new types of interactive data experiences that are beyond our current imagination.

▼
FIGURE 8
Research prototypes like BitDrones use small rotor-driven drones to position physical objects in three-dimensional space. | Credit: Calvin Rubens, Sean Braley, Antonio Gomes, Daniel Goc, Xujing Zhang, Juan-Pablo Carrascal, and Roel Vertegaal.

The ultimate display would, of course, be a room within which the computer can control the existence of matter.

Ivan Sutherland

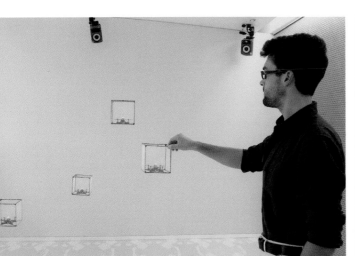

▲
FIGURE 9
The *Floating Charts* prototype uses acoustic levitation to move objects in ways that represent data. | Credit: Themis Omirou, Asier Marzo Perez, Sriram Subramanian, and Anne Roudaut.

◄
FIGURE 10
inFORM is a tabletop interactive shape display made of 900 motorized pins (30 x 30). | Credit: Daniel Leithinger, Sean Follmer, and Hiroshi Ishii.

TENISON ROAD CHARTS

David Sweeney

Alex Taylor

Siân Lindley

2014

Tenison Road, Cambridge, UK

Acknowledgments

Microsoft Research.
The residents of Tenison Road

⊘ microsoft.com/en-us/research/project/data-street-life

The *Tenison Road Charts* project visualizes data generated within a residential community in Cambridge, UK, using robotic versions of familiar pie and bar charts.

–

DAVID SWEENEY

is an industrial design engineer working at Microsoft Research in Cambridge. He is a designer of robotic systems, a builder of interactive experiences, and a developer of AI-enabled design tools for creatives. A common theme in his work has been digitally configurable surfaces, and novel digital displays.

–

ALEX TAYLOR

is a sociologist working in the Centre for Human Centred Design, at City, University of London. He draws on feminist technoscience to ask questions about the roles human-machine composites play in ways of knowing and being, and how they present possibilities for fundamental transformations in society.

–

SIÂN LINDLEY

is a social scientist at Microsoft Research in Cambridge. In her research, she focuses on developing a rich understanding of how technology fits into and can shape everyday life, in order to inform design.

A side view of a Pie Chart device shows
the mechanics hidden from the front view.

◀

FIGURE 1
The Physical Charts
displaying no data.

▼

FIGURE 2
The Physical Charts
displaying street data.

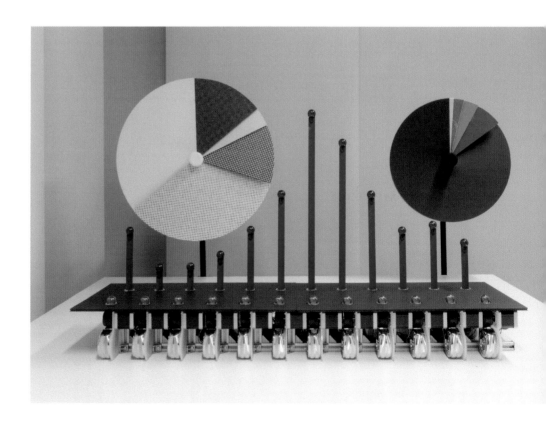

PROJECT MOTIVATION AND INSPIRATION

Data, it seems, is everywhere. Data's proliferation is presented as a new horizon in our understanding of ourselves and the world we live in. The associated datasets are vast and varied, encompassing census results, national statistics on crime, education, property prices, but also shopping habits, tweets, Facebook likes, and other measures that "quantify" the self and all that surrounds us. The scale and heterogeneity of this data are enabling unprecedented access to who we are as individuals and citizens, what we want, and even the nature of knowledge.

How, though, has data helped the ordinary person on the street? Beyond it being used to monitor and surveil people, what does data really do for the many who produce it? What immediate purpose or value does data have, not for governments, scientists, or corporate tech firms, but for individuals and citizens?

The instruments and physical charts below came out of a project we undertook to engage a community—quite literally the people living on a street—in this line of questioning. Working with the residents of Tenison Road in Cambridge (UK), we invited questions about the role and value of data in daily life. We used diaries, notebooks, workshops, and neighborhood meetings to explore how data might matter for a street and its people.

What arose from working with residents on Tenison Road for almost a year was an interest in using data to engage with local issues and local histories. Residents wanted access to air quality measurements and pedestrian and car traffic to talk to their local councilors about traffic calming. They wanted a means of collating data about the history of their neighborhood to protect buildings and homes. And they wanted ways to build a sense of a communal or collective spirit through polls, and in turn produce and visualize their own data.

The physical charts we detail below were installed on Tenison Road to invite residents to poll their neighbors in real time on topics they decided were important. Displaying real-time results for polls that were shared locally, the charts offered a highly visual means to present data back to the street's residents. They, if you like, performed data and its value for those on the street.

PRACTICES AND PROCESSES

Data of the Street

The data describing Tenison Road comes in many forms. It was produced in sensors deployed throughout the street, hidden signals important to the residents such as changing traffic patterns and air quality. It came in the form of polling data, pulled from interactive signage placed along the street, from bespoke devices deployed in resident's homes, and submitted through Twitter and texts, or SMS (Short Message Service).

A focal point was needed for communicating the various data streams back to the residents. Something embedded within the very environment that it describes. Physical data artifacts have an appealing presence; they stand out from the background noise of screens and digital devices that pollute our built environments.

Paper Prototyping

We searched for forms that could be reconfigured to represent the street's many datasets, yet were legible to all residents. Pie charts are instantly recognizable and widely interpretable, but generally unloved due to their ubiquity and association with dull financial reports. We considered whether a robotic version might refresh their image.

We began by making paper maquettes of configurable charts to understand the basics and convince ourselves that interlocked pieces of card could be moved relative to each other to fill different proportions of a circle. The aesthetics of the paper model were so pleasing that we worked hard to transfer it to the final piece. Digitally controlled artifacts, but with a craft aesthetic.

③

Experimenting with Mechanisms

The challenge was how to actuate the individual sectors without compromising the simple graphic aesthetic. The visibility of any mechanical workings would distract from the data being displayed and would be analogous to "chart noise," superfluous elements added to 2D data visualizations.

▼
FIGURE 3
Thermal sensor installed to
sense changing traffic patterns
on Tenison Road.

▶
FIGURE 4
Paper prototyping a movable
pie chart.

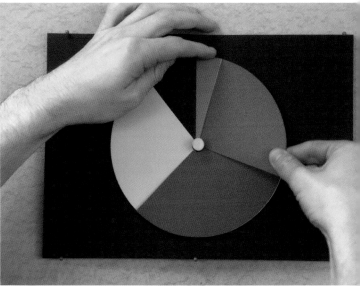

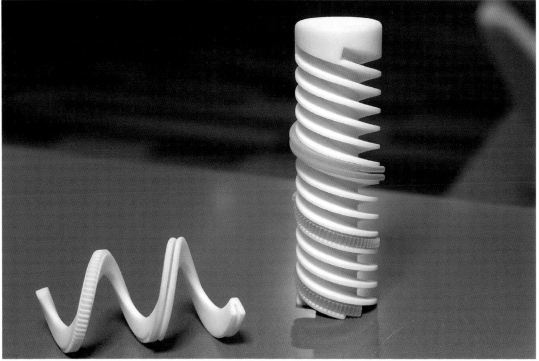

▲
FIGURE 5
3D-printed helix and geared
runner mechanism.

FIGURE 6

Creating a stop motion animation of a moving pie chart. | Credit: Robert Corish.

◄

FIGURE 7

Automating the pie chart using stepper motors. | Credit: Robert Corish.

▼

FIGURE 8

Pie chart legend device.

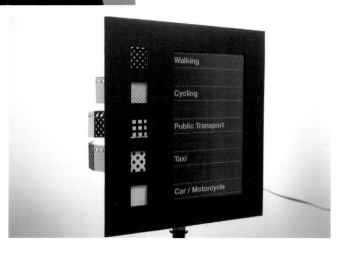

To maintain the characteristic circular outline of a pie chart, it was clear that the sectors needed to be actuated from the central shaft, rather than from their outer circumference. To achieve this, we prototyped a bespoke mechanism, a helix with 4 "starts," each holding a geared runner that holds a sector of the card. These prototypes were 3D-printed in nylon using the selective laser sintering (SLS) process, which produces strong parts that are self-lubricating.

4

Motion Studies

Before we began work on automation and specified motors and electronics, we explored potential dynamics of the piece using stop motion photography. This helped us validate that the aesthetic of the chart in motion is appealing, is something that can draw attention and is worth automating. We experimented with how the sectors accelerated, decelerated, and moved together. This helped us set some targets for the performance of the motors that would be needed.

5

Automation

We iterated on the basic mechanism to improve performance and prepare it for mounting on a sturdy structure. A stepper motor was needed to drive each of the sectors and these were also mounted to the same structure.

3D-printed mounts provided the pitch angle necessary for driving the guides along the helix.

The motors are driven by a bespoke Printed Circuit Board (PCB), which connects to our control software running on a PC. As is good practice with any automated mechanism, we added some sensors to allow the device to self-calibrate its position, to ensure that it displayed the data accurately.

6

Chart Legends

The pie chart can display datasets composed of a maximum of five categories, using four controllable sectors and the background. For datasets fully described using fewer categories, only 1, 2, or 3 of the movable sectors need to be used. To enable the chart to display the various datasets from the street, a legend device was created to associate each of their categories with a different sector. The labels were displayed using an e-ink panel, chosen for its paper-like, non-emissive aesthetic. The mapping was achieved by displaying a matching swatch of material beside each label—these swatches were mounted on small carousels, rotated by tiny servo motors and appeared through small apertures in the foam-board panel.

⑦ Time Series

Many of the datasets from the street cannot be described meaningfully using a pie chart, or some may have more than five categories. Many of the datasets were sensor data over time, such as traffic aggregated over the day, week, month, or year. Typically these would be charted on two-dimensional graphs such as a bar chart, so we created one using similar aesthetic principles and magical mechanisms.

This chart can compare two datasets simultaneously using red and blue bars. The bars themselves are tape measures that are covered with coloured masking tape. The horizontal width was chosen to be 12 bars as it maps nicely to the 24-hour day and months in the year.

⑧ Labeling

The bar graph is also accompanied by a legend device that indicates which dataset the sets of red and blue bars are currently visualizing. The bar graph has an additional need for individual labels for each of the bars. These labels can indicate the location of each set of bars along the dataset's "x-axis" (usually time) or indicate some arbitrary category. Once again, these labels are e-ink to maintain the "non-digital" aesthetic as much as possible. Once the set of charts move to display a new dataset and all the e-ink displays refresh, maintaining this visualization requires no power consumption.

▲

FIGURE 9

An e-ink label annotated each of the coloured bars.

◄

FIGURE 10

Stepper motors actuated the tape measures using a rubber wheel.

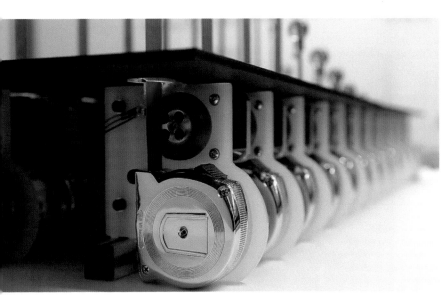

MATERIALS AND TOOLS

Craft Materials: Card, Foamboard, and Colored Styrene
3D Printed Mechanics
E-ink Displays
Stepper and Servo Motors, Sensors, Measuring Tapes
Shared Database

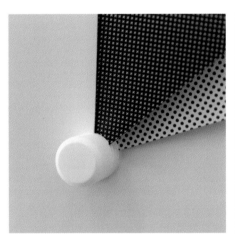

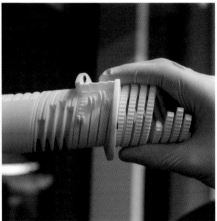

▲▲ **FIGURE 11**
Close-up of a pair of sectors
emerging out from behind the
background.

▲ **FIGURE 12**
A view of the back of the pie
chart legend device, showing the
swatch carousels, e-ink panel,
and control electronics.

▲▲ **FIGURE 13**
The helix and runners were 3D
printed in SLS nylon. | Credit: Robert
Corish.

▲ **FIGURE 14**
Various parts and materials that were
used to build the physical charts.
| Credit: Robert Corish.

REFLECTIONS

The objective of the physical charts was to grab the attention of passing residents, but there was always the danger that the contraptions themselves might overshadow the data they were visualizing. Stripping back these artifacts to simple graphic forms and concealing the control mechanics and hardware wherever possible were efforts to push the devices into the background. This highlighted the trade-offs that need to be made when displaying data using physical means.

The visualization of different kinds of datasets on a single, shape-shifting device is much more difficult than using screen-based methods, due to the challenge of digitally reformatting an object in physical space. Pie charts and bar charts were chosen as they are both familiar and adaptable, but there is a limit to their flexibility—these formats impose constraints on what can be displayed and how it has to be communicated. All data visualization requires some amount of "cleaning" of the data, filtering outliers, grouping categories, and so on, but due to the mechanical limitations of the physical charts, this process is particularly important. Our intention was that we would be an impartial facilitator of the residents' data, but this was active participation. Sorting through suitable datasets for display, arranging categories, and tweaking for clarity, shows that it is difficult to be truly neutral when supporting this type of installation.

▶

FIGURE 15

The Charts were installed for viewing by the community in a window at the end of Tenison Road.

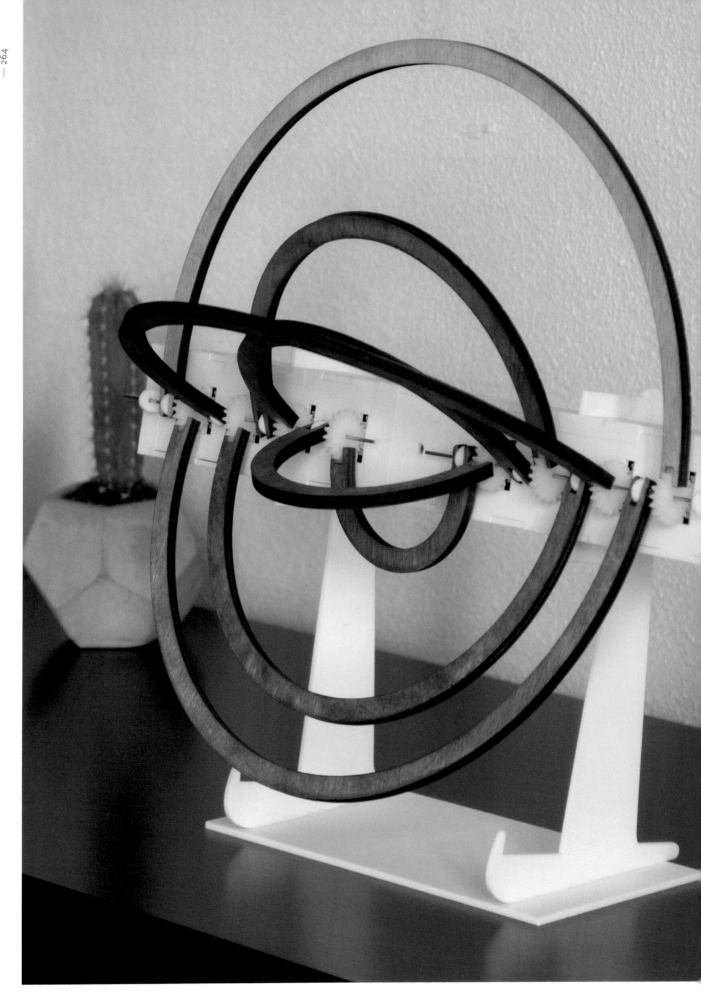

LOOP

Kim Sauvé
Steven Houben

2017

Acknowledgments

Saskia Bakker, Nicolai Marquardt, and Yvonne Rogers

🔗 kimsauve.nl/loop

LOOP, which in Dutch means "walk," is a physical artifact that visualizes personal step data. The daily steps made show in the seven weekday rings (dark brown) moving up, and can be compared to the step goal ring (light brown).

–

KIM SAUVÉ

is a Ph.D. candidate in Human-Computer Interaction (HCI) at Lancaster University, UK. Her research focuses on exploring the underlying principles of physicalization design. She specializes in Research through Design, applying design practice and developing interactive research prototypes to generate new insights for human-data interaction.

–

STEVEN HOUBEN

is an Assistant Professor in Human-Computer Interaction at Eindhoven University of Technology. His research focuses on physical and ubiquitous computing systems. His work explores physicalizing human-data interaction to support "from sensor to physicalization" and study new co-creation processes, concepts, interaction paradigms, and data embodiments for non-expert human-data/AI interaction.

▶

FIGURE 1

Detail of final prototype of *LOOP.*

PROJECT MOTIVATION AND INSPIRATION

While people increasingly have more access to data about themselves and the environment, engaging with that data in a meaningful way is challenging. Our work explores how an abstract data sculpture can represent personal activity data and goals in an aesthetically meaningful, embodied, and peripheral interface. *LOOP* is a data sculpture for the home that encodes physical activity in the motion of rings of increasing size. When the owner is active, the ring representing the current weekday moves upward and positions itself relative to the step goal ring. Over time, *LOOP* provides an overview of the physical activity at a glance.

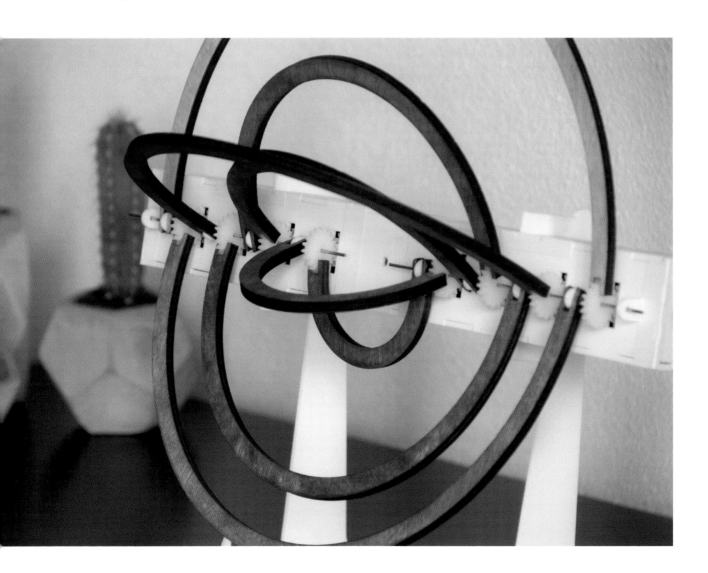

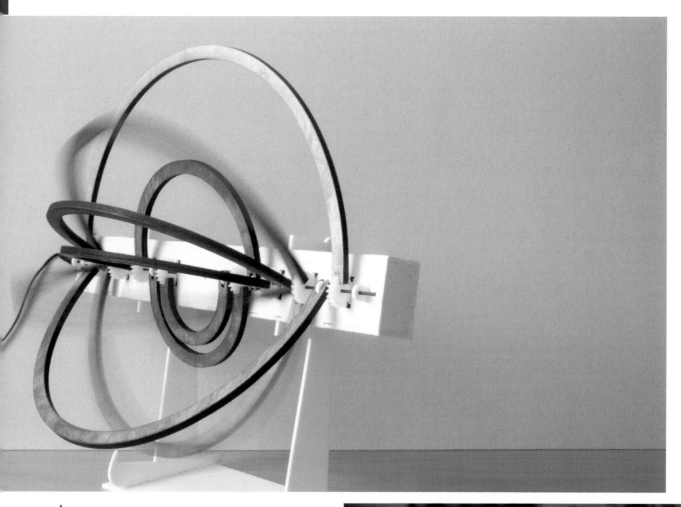

▲

FIGURE 2

Example of the Saturday step ring moving upward, closer to the goal ring.

▶

FIGURE 3

Creating multiple prototypes to establish the final design of *LOOP*.

PRACTICES AND PROCESSES

① Interviews

We interviewed 11 users of different types of activity trackers to collect personal experiences with these systems and extract opportunities for improvement. The interviews revealed that the users had different ways of explaining the meaning of the data from the activity trackers, though overall it seemed that no clear interpretation was made. While the numbers themselves (for example, the step count) did not necessarily make sense, the ability to compare them across days and weeks helped users reflect on their data. This convinced us that designing for comparison, rather than absolute numbers, could facilitate the sense-making of personal data.

② Shape Explorations

To introduce users to the concept and possibilities of physically representing data, we designed a range of low-fidelity "data objects" that were used in brainstorms. The creation of these prototypes was a semi-structured process, as we wanted to both embody the topics that were raised during the interviews and leave room for arbitrary designs that could trigger the imagination of the users. We designed the final collection of prototypes by analyzing existing devices/projects and reviewing guidelines on the design of shape-changing interfaces.

③ Design Critique Sessions

We organized two design critique sessions with three participants each, in which we used the collection of prototypes to generate ideas. During the session, we gave one prototype to each of the participants and asked them to imagine it as a digital device in their home showing data from their activity tracker. In this way, the prototypes functioned as generative tools to trigger the participants to think about what information it would show them exactly and in what way, where they would place it in their home, and when they would use it.

▼
FIGURE 4
Example of a current activity tracking device.

▼▼
FIGURE 5
Collection of shape explorations for the design critique sessions.

▼▼▼
FIGURE 6
Impression of a design critique session.

▼

FIGURE 7

First low-fidelity prototype using cardboard.

▼▼

FIGURE 8

High-fidelity prototype embodying the final design and construction for *LOOP*.

Design Principles

From the interviews and design critique sessions, it became clear that firstly, because the visualization would become part of someone's home, it had to blend into the environment and be aesthetically pleasing. Second, it would be beneficial to create an abstract representation that can be "read" by the owner, but provides privacy when observed by others. Lastly, rather than providing absolute numbers, facilitating the ability to compare data is really important, as this allows the user to make sense of it. One of the shape explorations for the design critique strongly inspired the final design of *LOOP* (Figure 9).

Material and Form Prototyping

To develop the ring concept into a fully working prototype, we started the process of creating multiple prototypes (Figure 3) to define the size, material, and construction of the final artifact. The first prototypes (Figure 7) were of low fidelity; they were made of cardboard and first sketched in 3D drawing software, after which we laser cut and assembled them. We repeated this process a couple of times until we came to a final design and construction. The final size (Figure 8) was based on the average size of a wall clock and the final materials used were white acrylic and wood to fit the home context.

Data Mapping

We did several brainstorms to establish the mapping of *LOOP* and explore what mapping of steps would provide an aesthetically pleasing artifact yet also convey enough information. Eventually, we chose a mapping that would scale itself according to the step range of the particular user, because example data showed that creating a fixed range would result in changes that were too small or too big, and would not create aesthetically appealing visuals. As the visualization became scalable, it was important to introduce the step goal ring, as this would be the only way in which the user could obtain an indication of absolute values from the visualization.

Designing Interactivity

As well as the exterior and the construction of the rings, we also had to consider the software and mechanics that were necessary for the rings to move. Therefore, we did multiple explorations (Figures 10 and 11) with different gear combinations, sizes, and materials to test functionality and

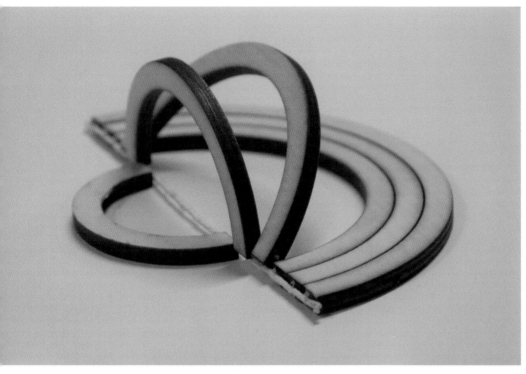

FIGURE 9

The shape exploration that strongly inspired the final design of *LOOP*.

▼

FIGURES 10 – 11

Exploration with different materials and gear designs to test functionality and strength.

strength. To make *LOOP* interactive, we used a Wi-Fi-enabled microcontroller that would extract the activity data from the activity tracker of the user. This microcontroller (Figure 19) powered eight servo motors to allow each of the rings to move independently, according to the activity data of the user.

(8)

Final Assembly

After multiple design activities had taken place in parallel, such as establishing the data mapping, construction, mechanics, and interactivity, we brought it all together in one working prototype (Figures 12 and 13). For the creation of the rings, we laser cut plain plywood, which we stained with different colors for a finished look (Figure 20) and to provide a subtle distinction between the weekday rings (dark brown) and the step goal ring (light brown).

▲
FIGURE 12
Assembly of the final prototype.

▶
FIGURE 13
Interior of the final prototype, showing the organization of electronics.

MATERIALS AND TOOLS

Sketching

We used sketching throughout the process to brainstorm and document ideas, but also to communicate them to others. For example, when determining the data mapping, we used sketches to play out scenarios of different mappings, to reveal how example data would show in the visualization.

Handcraft

For the shape explorations we used a mix of methods, such as laser-cutting plastic and paper origami. Combining machine-made elements with handicrafts allowed us to create a broad range of prototypes, with different textures, movements, and materials.

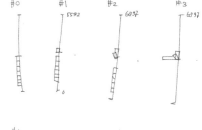

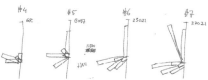

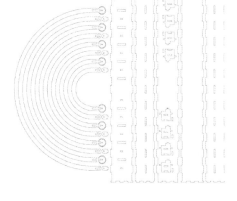

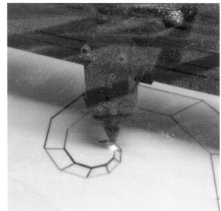

▲▲ **FIGURE 14**
Sketches to explore the data mapping of the visualization.

▲ **FIGURE 15**
Example of hand craft/origami.

▲▲ **FIGURE 16**
Digital drawing of the 2D components that together form the 3D prototype.

▲ **FIGURE 17**
Laser cutting one of the shape explorations.

Drawing Software

Throughout the process, we used drawing software to develop the construction of the final prototype in 2D, which we could laser cut directly to test the designs in 3D and adapt them along the process.

Laser Cutter

For the final prototype, but also throughout the design process, we made regular use of a laser cutter machine to do small test designs, which allowed us to iterate quickly on ideas.

Mixed Materials

The final prototype consists of a mix of materials; the white acrylic and wood exterior have an aesthetic purpose, but also more practical uses. Using solid acrylic allowed us to keep the electronic components, such as the motors, in place and protected. The rings are made of wood as it is a lighter material and therefore easier for the motors to lift and rotate. Lastly, the gears are laser cut from POM, which is a strong plastic material often used to give precision parts more stiffness and stability.

Programming Software

For the final prototype of *LOOP* to move its rings according to a person's activity data, we had to program this behavior and establish a connection between our prototype and an activity-tracking device.

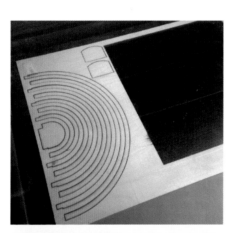

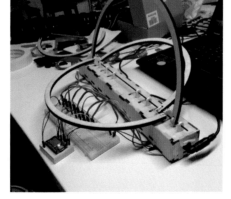

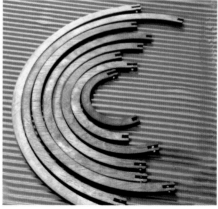

▲▲ **FIGURE 18**
Laser cutting one of the shape explorations.

▲ **FIGURE 19**
Integrating the microcontroller and motors into the prototype.

▲ **FIGURE 20**
The use of different finishes to provide subtle meaning to the different rings.

REFLECTIONS

Process and Tools. Throughout our design process, factors such as the materials, electronic components, and construction all influenced one another and we needed several iterations to balance and align the different elements into one prototype. Therefore, it was important for us to be able to continuously shift between materials and tools, adapted to the current activities. Whereas in the initial phases we would use materials more in a practical sense (for example to test mechanisms), in later stages it became more important to pay attention to the appearance of materials as well.

Visualization. The main challenge we encountered in our work was how to map data from numbers toward shapes and movement. Currently, there are no general design principles on how to create a meaningful translation, so it requires a custom process for each design. In our work, we aimed to facilitate this translation of personal data by applying a user-centered design process, involving current users of these devices. We let them critique our shape explorations to reveal opportunities for shape and movement. Rather than using a more conventional mapping of increase in physical activity to increase in size of the artifact, we explored how motion in space of different-sized elements could visualize personal progress.

Aesthetics. Our work opens up questions on how otherwise intangible personal data can be designed for everyday use and home integration. We explored how personal data could be represented in an informative yet aesthetically pleasing form for it to be understood by the owner and allow for reflection on personal progress, but also for it to blend into the home context and provide privacy when seen by others. Future work could further utilize interior design strategies in the development of these kinds of devices to make their appearance match current interior styles.

Integration and interaction. *LOOP* is one alternative way to represent personal data and, due to its abstract visualization, it could function as a platform system to visualize any time-based data. Direct or indirect user intervention could allow for the reconfiguration of the visualization and/or allow for a household to share the device. To conclude, it could be further explored how the physical presence of *LOOP* fits into the wider ecosystem of artifacts and people in the home, and how it could become part of future everyday life which is more and more involved with (personal) data.

AIRFIELD

Nik Hafermaas
Dan Goods
Jamie Barlow

2012

**Hartsfield-Jackson International Airport,
Atlanta, Georgia, USA**

Acknowledgments
Project Management: Jamie Barlow
Custom Software: Daniel Massey
Fabrication and Installation: Jim Hetherington
Technical Direction: Gustavo Huber
Engineering: Simon Franklyn / Anderson and Associates
Parametric Design: Andrew Kudless / Matsys
Clients: Katherine Marbury and David Vogt
Department of Aviation-Art Program
Real-time data feed provided by FlightAware.

⬦ ueberall.us/portfolio/airfield

The *AirFIELD* is a dynamic sculpture synced to real-time flight data reflecting the heartbeat of the world's busiest air travel hub, Hartsfield-Jackson Atlanta International Airport.

– NIK HAFERMAAS

is an international award-winning artist, designer, and educational leader. He is the founder of the artist platform Ueberall International, specializing in exhibitions and dynamic public art installations that converge digital media and spatial experiences. As the Graphic Design Department Chair at the ArtCenter College of Design in Pasadena, California, Nik has created a revolutionary transmedia curriculum, by fusing print, packaging, motion and visual interaction design.

– DAN GOODS

runs The Studio at NASA's Jet Propulsion Laboratory, a team that develops creative ways of communicating and working to transform complex concepts into meaningful stories that can be universally understood. After hours, he works on creative projects around the world. He also developed the *Museum of Awe*, an experience of art, science, theater, and surprise. In 2002 Goods graduated as valedictorian from the ArtCenter College of Design.

– JAMIE BARLOW

specializes in creating experiences at the intersection of physical space and storytelling. As a designer, he creates digital and physical installations for leading brands; as an artist, he merges data and narrative with experimental and innovative materials and electronics. Jamie received his education at ArtCenter College of Design in Pasadena and graduated with distinction in 2005 with a B.S. in Environmental Design.

PROJECT MOTIVATION AND INSPIRATION

Hartsfield-Jackson Atlanta International Airport is the world's busiest air travel hub. To the regular traveler, however, this superlative traffic is not apparent when visiting any of the concourse buildings.

Making the invisible visible is the key motivation behind many of our dynamic artworks, and the *AirFIELD* visualized in real time all flight movements at the Atlanta airport. As a data-driven art piece, the *AirFIELD* was connected to a live stream of Atlanta flight traffic data that triggered visual ripples throughout the sculpture with each takeoff and landing. The 90-foot-long by 30-foot-wide by 21-foot-tall (27.4m x 9.1m x 6.4m) sculpture was composed of more than 1,500 custom-made Liquid Crystal discs with the ability to individually fade from a clear state to white opaque. All discs appeared clear until triggered by a real-time data impulse, which would send a wave of white up or down the two swooping shapes of the sculpture.

Algorithms using fluid dynamics translated the flight data into custom animations: planes traveling a short distance created small ripples in the sculpture while planes traveling a longer distance caused greater activity. The visual activity caused by a single takeoff or landing would reverberate for several seconds, sometimes overlapping with the next movement, reflecting Atlanta airport's rapid-fire flight movements during rush hours.

PRACTICES AND PROCESSES

① Inspiration

The trajectories made by airplanes taking off and landing inspired us to create the two sweeping shapes that make up the sculpture. We took a long-exposure photo of several starts and landings at night superimposed on each other, which we then translated into the initial sketches for *AirFIELD*.

② 3D Modeling

Our design ambition was to create a dynamic visual shape to hover within the double height space of the concourse atrium. Over the course of several

weeks, we conducted extensive 3D modeling tests to optimize the overall arrangement. The finalized design of two intersecting shapes consisted of a total of 1,500 circular tiles, each disc with the diameter of a typical runway light. Different viewing angles allowed for a visually complex interplay of perspective, form, transparency, light, and shadow. When seen straight-on from the side, the sculpture was reminiscent of a bird in flight.

Data Mapping

The *AirFIELD* received real-time information about flights coming and going from the Atlanta airport. The real-time flight data feed was provided by FlightAware connected to our computer server. The software constantly monitored a live stream of Atlanta flight traffic data, which triggered generative motion behavior based on the specific size of each aircraft. The master computer sent data to a set of distributed circuit boards, which in turn sent an electrical charge to each disc in the sculpture. The simple synchronized fade in and out with a gradient opacity change was sequenced to produce on-and-off sweeps of movement chasing from back to front.

Prototyping

Prior to the onsite installation, we tested the discs, the mounting system, and the programming in a spatially compressed array at our fabricator's facilities. Our main objective was to ensure reliable performance of the discs and also to test and fine-tune the visual effect of the animations to make them appear fluid and organic: we wanted it to feel as if you were standing at the end of the runway and these flights are flying over you and you're physically seeing the fluid dynamics of the aircraft as they go by.

Rigging

The sculpture was mounted to a hidden structure above a drop ceiling via threaded rods that connected to 15-foot (4.5-meter) sections of aluminum "V" channel, serving as a structure and wire management for the 3,000 wires attached to the 1,500 circular tiles, connected to 81 circuit boards all linked back to a single computer server below.

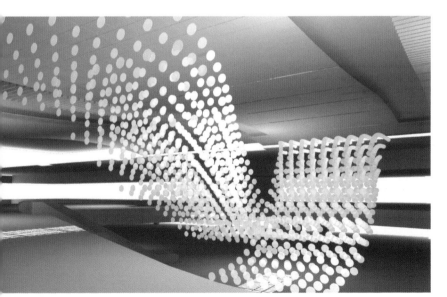

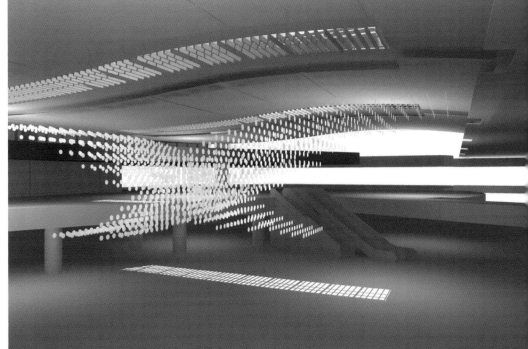

MATERIALS AND TOOLS

Liquid Crystal
Each of *AirFIELD*'s 10-inch circles was made of a liquid crystal switchable film laminated between two layers of polycarbonate to create large acrylic pixels. The LCD discs were prototyped and produced by Citala–LCD Display Products Manufacturer, now acquired by Glass Apps.

Wiring
We used 100,000 feet of tinned copper 26 AWG wire with clear silicone to provide electrical and data connectivity to each disc.

Software
The 3D form development of the sculpture was refined in Rhinoceros 3D and animated in Grasshopper. The custom software powering *AirFIELD* was written in C++ and built upon the innovative art programming library called Cinder.

Data Feed
The real-time flight data feed of up to 2500 flight movements a day was provided by FlightAware, a global aviation software and data services company.

REFLECTIONS

The *AirFIELD* project has been a highly complex installation on many levels. Unlike a static sculpture comporised of static materials, the *AirFIELD* sculpture consisted of dynamic components that have to constantly perform while relying on outside sources, in this case the flight data stream. Fatigue of dynamic materials, like some early types of LCD glass becoming cloudy, oxidized, and unresponsive, necessary hardware and software updates, and lapses in permanent data connectivity can all lead to performance issues. Therefore, points of potential failure have to be monitored and—if necessary—serviced on a regular basis. Especially for a multiyear installation, this requires a certain level of collaborative effort between the artist team and the artwork host. Our data-driven *eCLOUD* project (seen below) at Norman Y. Mineta International Airport, San Jose, California—comparable to *AirFIELD* in complexity and performance—is a great example of possible longevity of such a dynamic artwork. With the proper maintenance support (which includes regular software updates, data source management, and periodic computer hardware upgrades) in collaboration with the City of San Jose Public Art Program, the *eCLOUD* sculpture has been performing flawlessly ever since its inauguration in summer 2010.

EMERGE

Jason Alexander
Faisal Taher
John Hardy
John Vidler

2015

Acknowledgments
This work was supported by the European Commission's FET-open GHOST project (grant #309191) and the EPSRC's MORPHED project (grant #EP/M016528/1).
The authors would also like to acknowledge Christian Weichel and Abhijit Karnik whose time and input were invaluable in the construction of *EMERGE*.

🔗 jasonalexander.kiwi/EMERGE

EMERGE is an interactive, physically dynamic bar chart. Its 10×10 grid of illuminated, vertically actuating rods encodes values in the same manner as traditional bar charts. Each bar is touch- and position-sensitive to facilitate interaction alongside horizontal touchscreens that provide axis information.

—

JASON ALEXANDER

is a Professor of Human-Computer Interaction at the University of Bath, UK. His primary research interests are in the development of novel physical-digital systems with his recent work investigating shape-changing interfaces (surfaces with dynamically physical geometry) and data physicalization.

—

FAISAL TAHER

is a front-end software developer at AO, UK. His interests extend from software development that focuses on client-side applications, to design and user research.

—

JOHN HARDY

is a founder and director of HE Inventions LTD, UK. The business was founded to integrate the physical and digital worlds through novel products.

—

JOHN VIDLER

is a Senior Research Associate at the School of Computing and Communications, Lancaster University. His research interests cover communications applications in all areas of computing, energy and natural language processing. He is currently working with Internet of Things (IoT) orchestration technologies, and develops and administers the EASY-RES multi-site testbed.

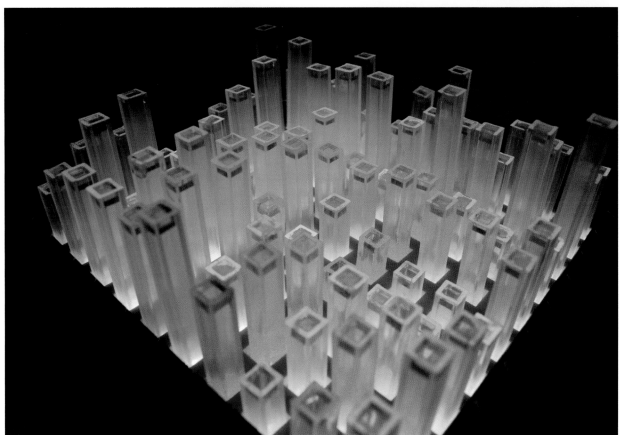

PROJECT MOTIVATION AND INSPIRATION

1 Evaluating the Efficiency of Physical Visualizations. Yvonne Jansen, Pierre Dragicevic, and Jean-Daniel Fekete. 2013. In *Proceedings of the SIGCHI Conference on Human Factors in Computing Systems (CHI '13)*. Pages 2593–2602. ACM.

Our goal with *EMERGE* was to provide a platform for exploring *dynamic* physical datasets. We were inspired by Yvonne Jansen's early work on handheld physical bar charts—indeed the shape and scale of bars was directly informed by her physical bar charts.[1] We set out to build a system that replicated the features of traditional visualizations to learn about the potential and power of dynamic data in the physical world. *EMERGE*'s interactive capabilities allow us to make direct comparisons with digital counterparts for both single users and groups of users.

▼

FIGURE 1

An interactive handheld bar chart created by Yvonne Jansen.

▶
FIGURE 2
A user pulls on a data bar to highlight that bar for later reference. When they let go, the bar returns to its original value.

▼
FIGURE 3
Datasets larger than the 10x10 grid of physical bars are navigated using the adjoining touchscreens.

PRACTICES AND PROCESSES

While the construction of *EMERGE* largely followed the six steps outlined below, like most innovative design projects, it was an iterative and evolving design. In many instances we iterated several times to produce a working solution. For example, our original linkage design included LEDs powered through wires inside the linkages; when this proved ineffective, we reverted to a simpler approach.

Ideation and Early Prototyping

The overall form of *EMERGE* was set early, with the core goal of producing a platform that represented a physical 3D bar chart. Early sketches and ideation focused on understanding the core components required for construction, how they would interact together, and how to assemble them. Key to this process was understanding how to situate the 100 linear actuators that would provide the physical movement for each of the bars.

Control Electronics

The control electronics played a significant role in enabling the dynamic interaction desired in *EMERGE*. We designed these first to ensure we could overcome the technical challenges in supporting the interactive capabilities.

There were three key components: (1) motor control and position sensing, (2) LED illumination, and (3) communication. We designed custom motor controller boards, each responsible for six linear actuators. These communicated back to a master Arduino microcontroller that receives commands from a PC. Power is provided by an off-the-shelf ATX power supply.

Physical Design

Once the overall system components and control electronics were understood, we created a physical design that supported the mechanical and electronic requirements. The linkages required to position and control each of the bars meant that *EMERGE* would be most suitable as a "stand around" display, with interaction occurring between waist and shoulder height for an average person.

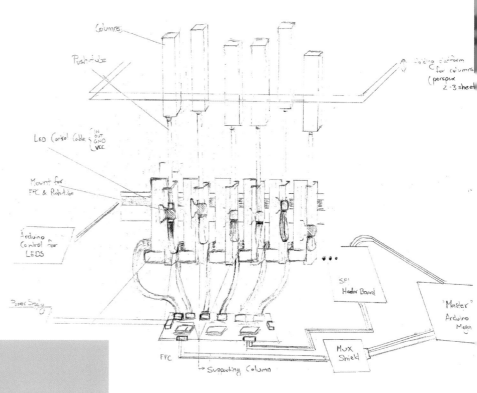

Columns

Push-tube

Folding platform
for columns
(perspex
2-3 sheet)

LED Control Cable { IN
OUT
GND
VCC

Mount for
FFC & Push-tube

Arduino
Control for
LEDS

Power Supply

SPI
Header Board

'Master'
Arduino
Mega

MUX
Shield

FFC

→ Supporting Column

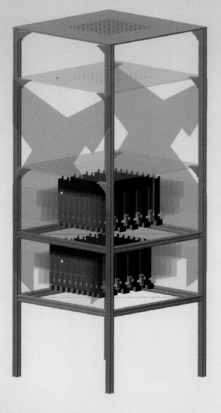

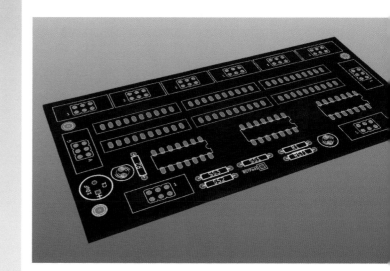

▶

FIGURE 4

Detailed view of *EMERGE*'s linear actuators, push-rods, and supporting plates.

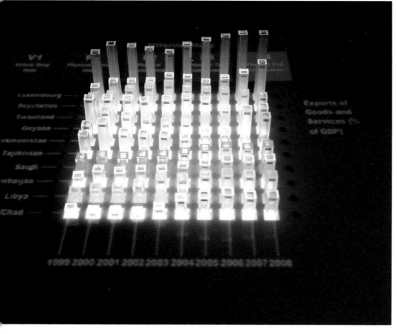

Fabrication and Construction

The main support structure of aluminum beams was pre ordered and arrived cut to specification. Our custom-made circuit boards were fabricated off-site, while we soldered the through-hole components together. In-house fabrication consisted of laser-cut supports, 3D printed parts, and the cutting of bars and linkages. The square-tube bars were also sprayed with frosted paint to diffuse the LED lighting. We began by constructing the frame, followed by slotting the soldered electronics into the laser-cut supports. Adding mechanical linkages, additional supports, and vanity paneling concluded the physical build.

Control Software and Data Encoding

We built four core software components. The first was the firmware that runs on the microcontroller chips on our custom circuit boards. These boards are responsible for reading and controlling the positions of the linear actuators. Second, communication software on the master Arduino microcontroller handles communication with the PC and delegates control tasks to each of the motor and LED controllers. Third, simulation software on the PC reads-in data files and maps values onto the current view shown on *EMERGE*. Finally, to display visual information around the interactive bar chart, we initially used the projection, but this later evolved into a web application used on tablet displays.

Interaction Technique Design and Evolution

EMERGE originally used projected interactive displays to show label data and receive commands. However, during user testing, we found this to be less accurate and responsive than desired. We re-engineered the top surface of *EMERGE* to instead use four tablets as the axis displays. This also meant re designing the control software: each tablet uses a web browser to render pages hosted on a web server on the PC. The tablets gave the interaction the smoothness and performance that users expected. This did not change the physical interaction with the bars.

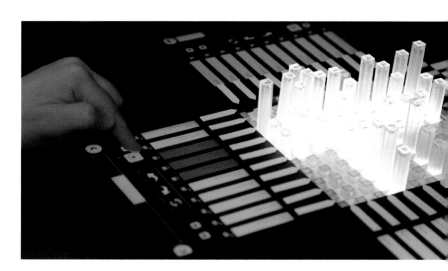

MATERIALS AND TOOLS

AutoDesk Inventor
Mechanical and structural design of *EMERGE*.

KiCAD EDA
PCB design for custom driver boards.

ATMEL AVR Programmer
Uploading software onto micro controllers.

Visual Studio
Developing and deploying PC-side software.

Arduino Boards and Software
High-level control, handling input and output from the PC.

Laser Cutter
Cutting sheet material to build *EMERGE* surrounds.

3D Printer
Printing custom parts for mounting a variety of *EMERGE* components.

HTML/CSS/JavaScript
Building the visual displays and interaction on the tablets that form the graph axis.

REFLECTIONS

EMERGE provides a platform for exploring human interactions with dynamic physical data. While our goal of constructing a generic platform for displaying dynamic datasets significantly increased the complexity of design and construction, it did allow us to demonstrate the power of reusable and reconfigurable data physicalizations. *EMERGE* went beyond other current systems by supporting interactivity directly with the dataset (by pushing and pulling bars) and allowed us to study and understand the power of direct data manipulation.

This complexity of implementation meant we had to bring together expertise in electrical and mechanical engineering, software engineering, and human-computer interaction. This is not a common skillset found in laboratories or design studios; we see the requirement for knowledge across these diverse fields as one of the key challenges faced by designers creating dynamic physical tools for interacting with data. There is, therefore a strong need for practical tools and toolkits that can allow a broad audience to engage with these approaches.

EMERGE has shown us the huge potential of interactive physical charts, but it has also opened numerous directions for further investigation. These avenues include understanding where and when physical representations are beneficial to their digital counterparts, what shape and form interactive charts should take, how digital and physical representations can be combined, and how groups of users can exploit their physical nature. We see *EMERGE* as a powerful platform for beginning to understand the world of dynamic physical manifestations of data.

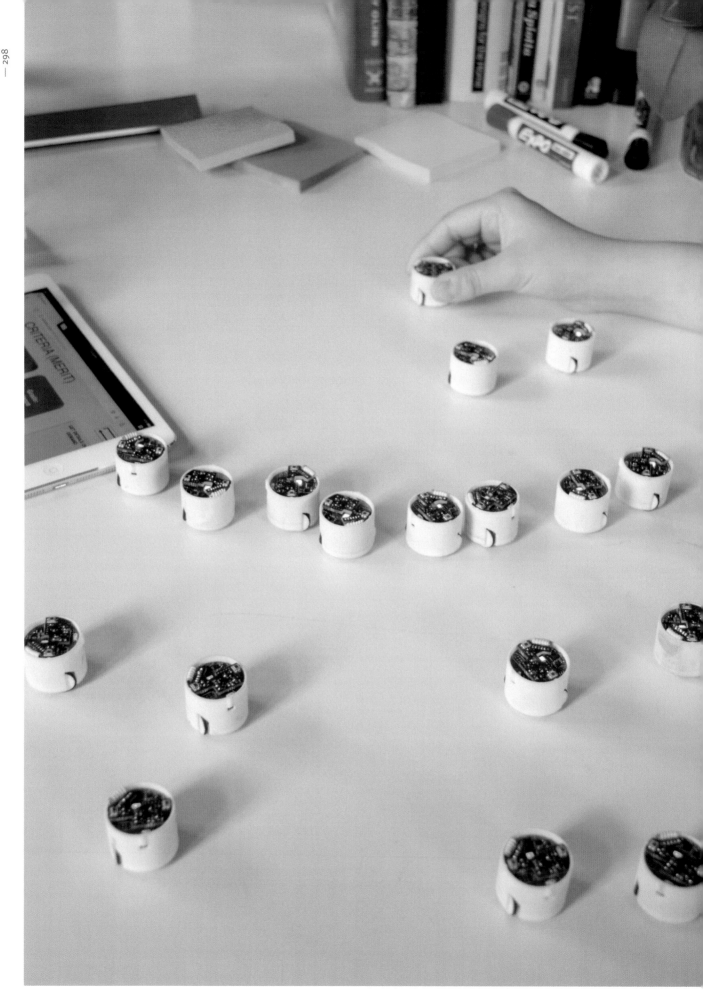

ZOOIDS

Mathieu Le Goc

Charles Perin

Sean Follmer

Jean-Daniel Fekete

Pierre Dragicevic

2018

IEEE VIS 2018

🔗 mathieulegoc.me/dynamic-composite-physicalizations

Zooids are small wheeled robots that can coordinate to create physical charts and interfaces. Working together, *Zooids* can give physical form to well-known interactive visualizations and also let us explore new visualization and interaction paradigms.

—

MATHIEU LE GOC

is an R&D engineer at Google ATAP, exploring technologies at the intersection of physical interaction and ambient computing to create future interactive technologies.

—

CHARLES PERIN

is an Assistant Professor of Computer Science at the University of Victoria, Canada, and co-founder of the VIXI lab. His research lies at the intersection of Information Visualization and Human-Computer Interaction.

—

SEAN FOLLMER

is an Assistant Professor of Mechanical Engineering and Computer Science (by courtesy) at Stanford University. Dr. Follmer directs the Stanford Shape Lab and is a faculty member of the Stanford HCI Group. He is a core faculty member of the Design Impact master's program focusing on innovation and human-centered design at Stanford.

—

JEAN-DANIEL FEKETE

is a Senior Research Scientist at Inria, France, and head of the Aviz Lab. His research areas are Visual Analytics, Information Visualization, and Human Computer Interaction. He has been granted the IEEE VGTC Visualization Career Award and is a member of the IEEE VGTC Visualization Academy and ACM SIGCHI Academy.

—

PIERRE DRAGICEVIC

is a permanent research scientist at Inria Bordeaux, France. He does research on data visualizations beyond the desktop, and on judgment and decision-making with visualizations.

▲ **FIGURE 1 AND PREVIOUS PAGE**

Credit: © 2019 IEEE. Reprinted, with permission, from **Dynamic Composite Data Physicalization Using Wheeled Micro-Robots**. Mathieu Le Goc, Charles Perin, Sean Follmer, Jean-Daniel Fekete, and Pierre Dragicevic. 2019. In *IEEE Transactions on Visualization and Computer Graphics*. Volume 25, Issue 1 (January 2019) IEEE.

PROJECT MOTIVATION AND INSPIRATION

Physical data visualizations tap into our lifelong experience of perceiving and manipulating the physical world, either alone or with other people. However, most physical visualizations are either monolithic and static, or require human intervention to be rearranged. We drew inspiration from existing physical interactive systems and data storytelling practices with physical tokens (like those of the influential Swedish professor Hans Rosling) to develop *Zooids*, tiny wheeled robots that can move rapidly on any horizontal surface. We used *Zooids* to explore physical data visualizations that can (1) be manipulated by humans, and (2) update themselves through computerized mechanisms.

PRACTICES AND PROCESSES

①

Looking at Token Manipulation

To better understand how people manipulate collections of small items and the possible benefits of tangible tokens over touch interfaces, we ran a study where we asked participants to quickly sort and arrange dozens of colored tokens. Tokens were provided in two versions: thick graspable objects, and flat objects meant to emulate touch interfaces. Our experiments suggested that people found the task more enjoyable and efficient when the tokens could be grasped. We also saw that the way people grasped objects was often indicative of the action that was going to follow.

►

FIGURE 2
Credit: **SmartTokens: Embedding Motion and Grip Sensing in Small Tangible Objects**. Mathieu Le Goc, Pierre Dragicevic, Samuel Huron, Jeremy Boy, and Jean-Daniel Fekete. 2015. In *Proceedings of the ACM Symposium on User Interface Software & Technology* (*UIST '15*). Pages 357-362. ACM.

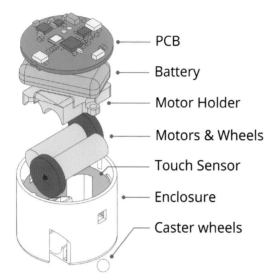

PCB

Battery

Motor Holder

Motors & Wheels

Touch Sensor

Enclosure

Caster wheels

▲▲
FIGURES 3-4
Credit: **Zooids: Building Blocks for Swarm User Interfaces**. Mathieu Le Goc, Lawrence H. Kim, Ali Parsaei, Jean-Daniel Fekete, Pierre Dragicevic, and Sean Follmer. 2016. In *Proceedings of the ACM Symposium on User Interface Software & Technology* (*UIST '16*). Pages 97-109. ACM.

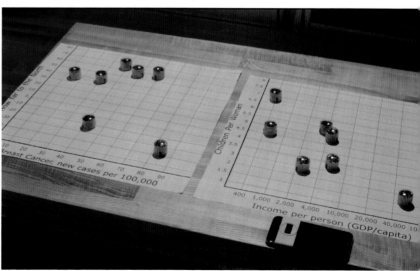

Adding Sensing to Tokens

Based on the insights from our study, we created SmartTokens, tokens with embedded electronics that could sense how people touched, moved, and manipulated them. Each SmartToken included a 3D-printed cylinder, a custom circuit board, a small battery, six sensors for detecting touches, and a wireless transmitter for reporting inputs to a computer. The form factor of SmartTokens was chosen so that they could be easily grasped, and roughly five of them could fit comfortably in one hand.

Adding Movement to Tokens

Next we augmented our SmartTokens with wheels to create small self-propelled robots we called *Zooids*. These robots can act as physical pixels that can change color and rapidly reposition themselves to create shapes. *Zooids* are also compact enough for people to grasp, lift, and manipulate several of them simultaneously. Their small size also lets them blend into existing environments and move other objects.

A First Prototype

We first explored how *Zooids* could be used to create basic physical graphics such as dynamic line charts and scatterplots. However, people had a hard time understanding what the charts showed until we added additional visual information such as titles, axes, and labels. They were also missing "details-on-demand" mechanisms that people could use to get more information about the data points. To address this, we added paper backgrounds to some charts, as well as small screens that viewers could use to inspect data from individual *Zooids*.

Richer Interactive Charts

We then used *Zooids* to create more complex interactive visualizations based on a "dust and magnet" metaphor, which viewers could use to explore multi dimensional data. For example, some *Zooids* may represent individual countries (the "dust"), while others represent data dimensions (the "magnets") such as population or average income. Placing a population magnet would cause all of the *Zooids* representing countries to move toward it, attracted by a force proportional to their population. By adding and moving additional magnets, viewers

could quickly rearrange the *Zooids*, dynamically revealing relationships between countries.

Just as particles of iron react to surrounding magnets, our grains of dust react to the presence of magnets and move at a distance that reflects their value in the dimension of each of the surrounding magnets.

Because the *Zooids* are physical, viewers could also use everyday objects like sticky notes to organize and annotate the space.

Adding Context

Viewers could also use the companion app to configure the *Zooids* or see the raw data for each individual element. For example, when using *Zooids* to examine a dataset of student records, a viewer could place individual robots on the tablet to see precise details such as name, age, or grades.

▼

FIGURE 5

(7)

Scatterplots
On-Demand

Our dust and magnets visualizations made it easier to explore trends and relationships, but hard to read exact values. As an alternative, we also built a physical scatterplot frame that let viewers place magnets on either of its axes. Assigning a data dimension to an axis would cause all of the dust *Zooids* in the frame to organize along it, creating dynamic scatterplots and making data points easier to compare.

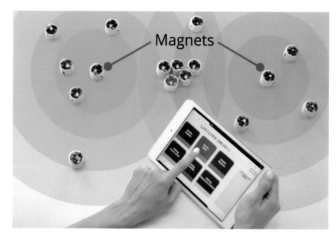

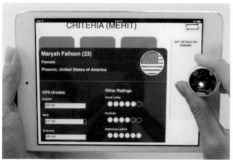

▲ ▶

FIGURES 6-7-8

Credit: © 2019 IEEE. Reprinted, with permission, from **Dynamic Composite Data Physicalization Using Wheeled Micro-Robots**. Mathieu Le Goc, Charles Perin, Sean Follmer, Jean-Daniel Fekete, and Pierre Dragicevic. 2019. In *IEEE Transactions on Visualization and Computer Graphics*. Volume 25, Issue 1 (January 2019) IEEE.

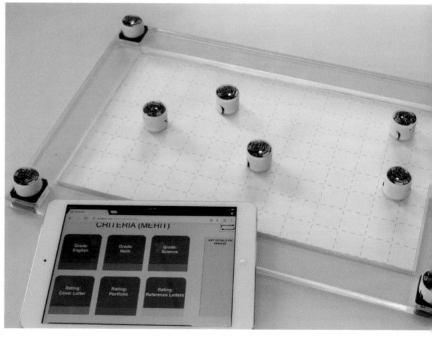

MATERIALS AND TOOLS

Microsoft PowerPoint and Paper Sketching
UX prototyping and Wizard-of-Oz prototypes

Altium Designer
Electronics design

SolidWorks
3D modeling

Crossworks Studio
Embedded software programing (C for ARM microcontrollers)

XCode, OpenFrameworks (C++), and JavaScript
Software development and user interfaces

Open source code and components for the project are available at:
https://github.com/ShapeLab/SwarmUI
https://github.com/ShapeLab/ZooidsCompositePhysicalizations

REFLECTIONS

The physical charts presented here are proofs of concepts, illustrating how dynamic physical objects could become common for users to collaboratively explore data. Many challenges emerged during this exploration, and we had to compromise on several factors. In our quest to create a versatile, tangible user interface, we designed our system to create homogeneous collections of *Zooids*. They are all indistinguishable from one another, making it difficult to distinguish "dust" *Zooids* from "magnet" *Zooids*. Their circular shape also limits the types of representations to "dot-based" visualizations.

Our prototypes also highlight the value of designing interactions that avoid creating more hassle and repetitive tasks. As datasets can become rather large, the last thing we want is to have to move dozens and dozens of *Zooids* by hand. Interaction techniques such as Dust and Magnets can help manipulate many *Zooids* at once, yet for now, most data exploration involves manipulating *Zooids* one by one.

Large datasets also require large numbers of *Zooids*. The robotics and sensing technologies we use are becoming smaller and smaller. However, in their current form, it remains challenging—both in terms of real estate and cost—to accommodate datasets with hundreds of data points. Scalability, providing context, and showing detail remain challenges for *Zooids* and for most physical charts. However, in a world where data is becoming ubiquitous, we see great opportunities for interactive physical charts to become more pervasive, maybe even part of our everyday lives at home.

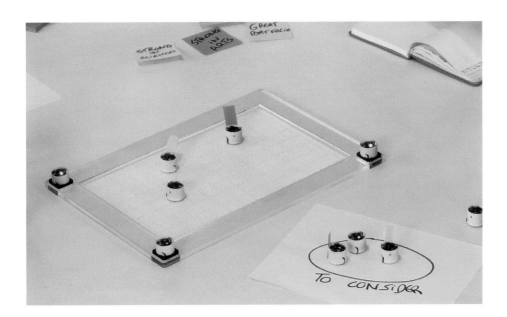

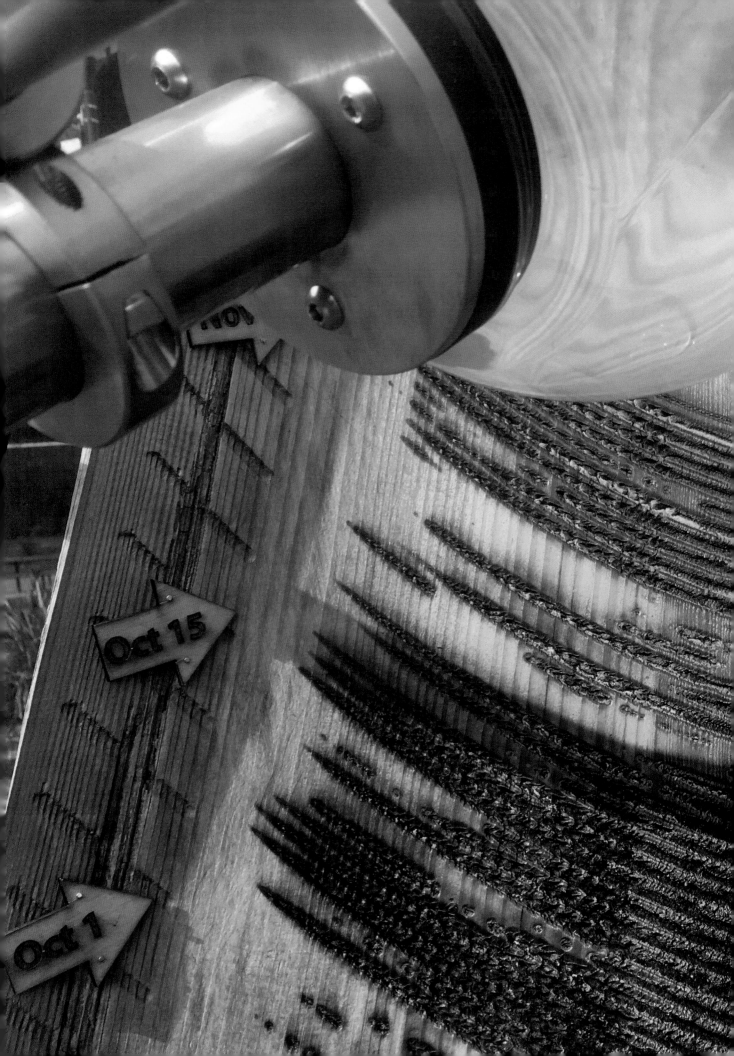

ENVIRONMENT

—

DIETMAR OFFENHUBER

is a Associate Professor at Northeastern University in information design and urban affairs. He holds a Ph.D. in Urban Planning from MIT. His research focuses on the relationship between design, technology, and urban governance. Dietmar is the author of the award-winning monograph *Waste is Information* (MIT Press) and has published books on urban data and related social practices. He also works as an advisor to the United Nations Development Programme.
Author photo courtesy of Northeastern University.

Environmental topics are popular with data-driven makers. A remarkable number of projects in the small but growing community deal with global warming, environmental pollution, resource extraction, and the injustices and inequalities involved in these issues. Formal design choices mirror this topical emphasis. Many physical representations of data integrate environmental media using the physical properties of water, light, and plants as narrative devices. Often, they invite us to engage with the physical context, and draw attention to the vast amount of information surrounding us. What could explain the ecological affinity that seems to abound in data physicalization practice?

In more than one way, physical data artifacts have what 2D data visualizations are missing. While data visualizations are often perceived as abstract and cerebral, physical representations of data afford a visceral experience, transforming data into tangible objects that appeal to all the senses.[1] By offering a multisensory and sometimes emotional experience outside the paradigm of visual rationality, physical representations of data promise to be useful for addressing the big issues of our time. Public apathy in the face of the unfolding climate catastrophe is often attributed to a discourse around climate data that is disconnected from everyday experience. While extreme weather events have become more frequent, it is difficult to connect them directly to the state of the climate, because the climate is a statistical concept. While data visualization can lucidly show statistical concepts, the method is less suited to expressing the countless relationships and interactions in which global warming manifests itself in the world,

◀
PREVIOUS PAGES
Solar Totems by Charles
Sowers.

from glacier volumes as physical forms of statistical aggregation to ocean sediments, tree rings, and countless other phenomena that climate scientists use as proxies for estimating current conditions and reconstructing past climates.

One may object here that I overstate my case. Data physicalization, as it is currently treated in the visualization community, is conceptually identical to data visualization—it takes a digital dataset and maps it to a lexicon of forms, except that these forms are no longer just flat. I believe that the conceptual model of mapping data to form is problematic for both visualization and physicalization, and that the latter makes these shortcomings particularly salient. Well-designed charts and maps are expected to define their mappings unambiguously in a legend, which is the key to decoding the representation. Scholars of critical cartography, however, have convincingly shown that this has very little to do with how most people make sense of and extract meaning from visualizations.[2] For data physicalizations, these mappings, already brittle for charts and maps, become an even more precarious affair. A designer may enjoy the wealth of physical variables at their disposal and encode them in nuanced ways. How much of this can then be decoded by the recipient, however, is a different question. There are no established conventions for physical instantiations of data that allow one to recognize a scatter plot or a line chart unless they resemble their 2D visualization counterparts. Without a shared formal language, the designer instead has to mobilize metaphors that connect to everyday knowledge and experiences in physical environments.

Equally important to the formal conventions of visualization is the relationship of a representation with the surrounding environment. A physical data display, whether intended or not, is always situated and contextual, establishing a relationship with its surrounding environment. A 2D chart is not only recognizable because it employs a familiar visual language, but also because it appears in the familiar context of a page, on a page clearly demarcated by its boundaries. Physical data objects usually don't have a neutralizing white border that distances them from their surroundings. Unlike the illuminated computer screen, a data sculpture shares the same light as its environment. It bears a relationship to the place where it is located; often its intended message is addressed to the people who live there and speaks to the issues they face. Designers and artists can reinforce this connection by choosing a material that is related to the phenomenon, such as melting ice, to embody a dataset about climate change. As Paul Dourish notes, the often thoughtlessly used word *context* is a complicated affair. It is not something that can be described, delineated, or represented in discrete terms, but something that emerges dynamically out of actions, and ever-changing relationships.[3] Developing a sensibility for such emerging relationships can mean switching from formulaic rules to a more bespoke approach that engages with the particularity of a situation.

1 Artist and educator Kelly Dobson calls for *data visceralization* instead of visualization, and exemplified the concept with a range of artworks. See the discussion in **Data Feminism**. Catherine D'Ignazio and Lauren F. Klein. 2020. MIT Press.

2 Designs on Signs/Myth and Meaning in Maps. Denis Wood and John Fels. 1986. In *Cartographica: The International Journal for Geographic Information and Geovisualization*. Volume 23, Issue 3.

3 What We Talk about When We Talk about Context. Paul Dourish. 2004. In *Personal and Ubiquitous Computing*. Volume 8, Issue 1. Springer.

——

Physical data objects are
not necessarily always
representations—sometimes
they merely present
themselves.

——

It is therefore possible to think about representing environmental data entirely in contextual terms. Visitors to the Austrian Alps can experience a physical representation of global warming by hiking the Pasterze Glacier trail. The Pasterze, Austria's biggest glacier, is rapidly disappearing; it has lost over half of its volume since 1850 and is currently receding at an annual rate of 10 to 20 meters. As a result, the trail grows in length every year. At the end of the trail, signposts mark the previous locations of the glacier's base over the past several decades (Figure 1). We can look at the glacier as a representation of data in several ways. First, the signposts establish a context of measurement that allows a comparison of the glacier to its historical extent. If visualization is ultimately all about comparison, as Andrew Gelman postulates,[4] performing this comparison here involves the entire body (and a sturdy pair of hiking boots). But the glacier is not a representation, it is data in physical form: a proxy of the local climate. Beyond its length and volume, it offers a rich source of information, containing records and traces of the past. The glacier cannot be moved and circulated, which is often considered a central aspect of data,[5] but it offers a situated context for climate models that can be experienced with the senses and bring us closer to the origins of its data.

◀

FIGURE 1

The Pasterze Glacier (Austria) with a sign indicating the past extent of the glacier's tongue. | Credit: Image courtesy Matija Zorn.

PHYSICALIZATIONS AS DATA ENVIRONMENTS

As shown in the example of the glacier trail, physical data objects are not necessarily always representations—sometimes, as embodiments and materializations of data, they merely present themselves.[6] The projects in this section all challenge the traditional representational model of visualization, which is based on an unambiguous mapping of data to form.

The temporary installation *Perpetual Plastic* by Liina Klauss, Moritz Stefaner, and Skye Morét addresses the environmental burden of plastic, focusing specifically on marine debris, which negatively affects the biosphere in many visible and invisible ways. Using marine trash collected from a beach in Bali, the artists created a diagram of the global state of plastic waste, the colorful plastic trash laid out on the same beach

4 Exploratory Data Analysis for Complex Models. Andrew Gelman. 2004. In *Journal of Computational and Graphical Statistics*. Volume 13, Issue 4. Taylor & Francis.

5 Visualisation and Cognition: Drawing Things Together. Bruno Latour. 1990. In *Representation in Scientific Practice*. Michael Lynch, Steve Woolgar (Editors). MIT Press.

6 I discuss ontological concepts of data in more detail in **What We Talk about When We Talk about Data Physicality**. Dietmar Offenhuber. 2020. In *IEEE Computer Graphics and Applications*. Volume 40, Issue 6. IEEE.

expressing the percentages discarded, recycled, incinerated, and reused. But the objects collected by the volunteers—slippers, cups, bottles, and fishing nets in various states of decay—are more than a representational medium, the "paint" used by the artists. They constitute a physical dataset that has been collected, categorized, and transformed just like any other data. This dataset can be analyzed in many ways and contains a wealth of material information that far exceeds what is encoded in the diagram.

Environmental physicalizations take advantage of their own physical qualities and their expressive potential.

Robert Cercós' *Dataponics* project uses a familiar data source, Fitbit physical activity data, to control the light and water supply to a house plant, effectively tying the livelihood of one organism to the activity of another. What may appear to be a straightforward example of data mapping is subverted by the agency and temporality of the plant, which does not always behave exactly as the data defines. Not being able to express short-term variations in the data set, the plant imposes its own temporality on the user. The representational relationship turns into a co-dependency, as the owner of the plant may wish to avoid seeing their plant suffer.

Charles Sowers' *Solar Totems* generate their own data by using a spherical lens to burn traces of sunlight into the inside of the trunks of hollowed-out trees. The device is a contemporary version of a historical scientific device to record the amount of sunlight over an extended period, which was described by its inventor in 1857 as a self-registering sundial.[7] The resulting record reflects environmental conditions, clouds and changing seasons, but also environmental events such as the occluded skies resulting from California wildfires. *Solar Totems* are a meditation on the nature of data in the most elemental sense—as marks, autographic records, and environmental patterns that differ from the traditional notion of data as textual artifacts.

7 On a New Self-Registering Sun-Dial. John Francis Campbell. 1857. In *Report of the Meteorological Society*. British Meteorological Society.

Finally, one of my own projects, *Dustmark*, examines the relationship between environmental phenomena and their measurement. Dust and particulate matter are an invisible form of pollution that causes significant harm, but can only be accurately measured with scientific instruments. But over longer periods, dust accumulates on all surfaces of the city, turning the city into a visualization of its own dust exposure. To make this ubiquitous patina legible requires visible points of reference, similar to the historical signs on the Pasterze glacier. Dustmarks are visual markers created by selective cleaning surfaces in the urban environment, drawing attention to the material basis of measurement.

An aspect shared by these examples of environmental physicalization is that they take advantage of their own physical qualities and their expressive potential.[8] They also emphasize and carefully stage different forms of autographic phenomena—physical traces that result from processes of self-inscription.[9] The projects take advantage of the fact that everything that happens in the environment inscribes itself into the world in countless ways. Every process leaves traces, and these traces can be used by visualization designers. While the public value of climate models and epidemiological predictions depends on their ability to aggregate a vast number of variables into a single meaningful number, convincing the public of their veracity may benefit from a second strategy: tracing the origins of data back to the physical and sensory phenomena to which they are causally connected.

This brings me back to the initial point: what makes physical representations of data such an attractive choice for conveying environmental concerns may have something to do with the inherently situated nature of physical data objects. Bluntly speaking, a 2D chart lives on a webpage or a magazine spread, while a data sculpture is perceived as part of its physical environment. For this reason, physicalizations resist complex data mappings but lend themselves to an approach that engages with their environment and its own material qualities. This relational quality resonates with the central idea of ecology: everything in the world is connected and forms a dynamic system.

8 See Dan Lockton's concept of qualitative displays: **Exploring Qualitative Displays and Interfaces**. Dan Lockton, Delanie Ricketts, Shruti Aditya Chowdhury, and Chang Hee Lee. 2017. In *Proceedings of the ACM Conference Extended Abstracts on Human Factors in Computing Systems*. Pages 1844–1852. ACM.

9 Data by Proxy – Material Traces as Autographic Visualizations. Dietmar Offenhuber. 2019. In *IEEE Transactions on Visualization and Computer Graphics*. Volume 26, Issue 1. IEEE.

Our data artwork presents a Sankey diagram of the fate of all plastic ever produced. It was installed right next to a river leading to the ocean on one of Bali's beaches. It was constructed from thousands of pieces of plastic debris found on nearby beaches.

PERPETUAL PLASTIC

Liina Klauss

Moritz Stefaner

Skye Morét

2019

Bali, Indonesia

Acknowledgments

Supported by the National Geographic and
Sky Ocean Ventures Ocean Plastic Innovation Challenge.

🔗 perpetual-plastic.net

Perpetual Plastic is a physical data sculpture made from beach debris, revealing the fate of all plastics ever produced. The situated, participatory data installation highlights the scope of the plastic problem and the transformation of plastic over its lifetime.

—

LIINA KLAUSS

is an artist and activist who has worked with marine debris in Asia since 2011.
(https://liinaklauss.com)

—

MORITZ STEFANER

is a self-employed data visualization expert / Truth & Beauty Operator.
(truth-and-beauty.net)

—

SKYE MORÉT

is a marine debris scientist and information design strategist.
(https://skyemoret.com)

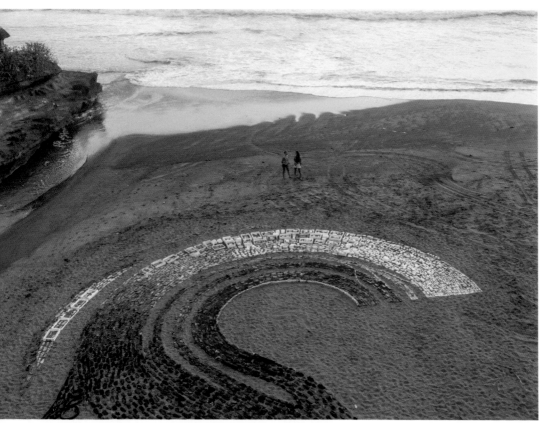

◄

FIGURE 1

With a diameter of 14m (46ft), and an even greater length, the diagram established a strong physical presence on the beach and created an intriguing juxtaposition with the natural scenery.

▼

FIGURE 2

The diagram was manually laid out by collecting and arranging 4,760 pieces of plastic trash.

1 Production, Use, and Fate of All Plastics Ever Made

Roland Geyer, Jenna R. Jambeck, and Kara Lavender Law. 2017. In *Science Advances*. Volume 3, Issue 7.

▼

FIGURE 3

Different streams in the diagram represent the relative amounts of plastic that have a specific lifecycle, from being discarded, recycled, incinerated, or still in use. The green recycled branch is connected to other streams, as, for example, plastic can be first recycled then ultimately discarded. The figures are derived from a scientific study by Roland Geyer and colleagues.'

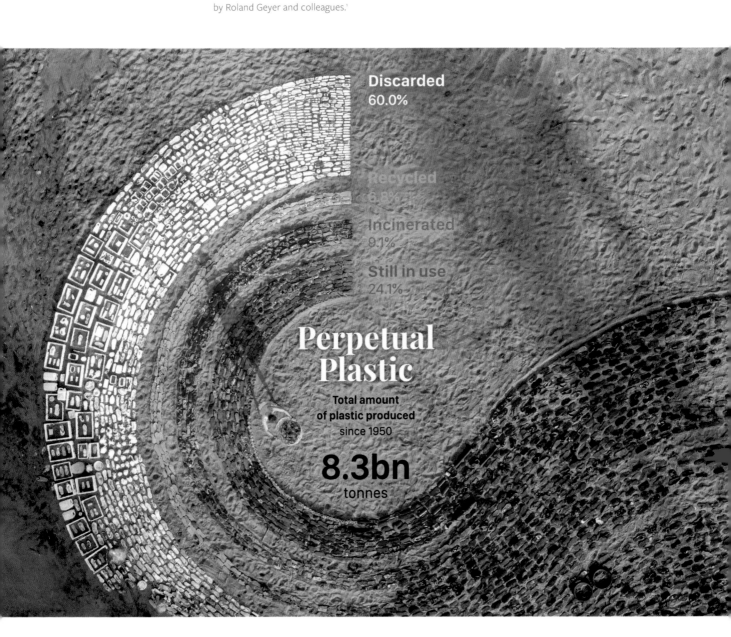

Discarded
60.0%

Recycled
8.8%

Incinerated
9.1%

Still in use
24.1%

Perpetual Plastic

Total amount of plastic produced since 1950

8.3bn
tonnes

PROJECT MOTIVATION AND INSPIRATION

From the early 1950s to 2015, 8.3 billion metric tons of plastic were produced for human consumption. To understand the environmental legacy of exponential plastic production, we visualized what happens to plastics after their first use. A physical data sculpture illustrates the fate of all plastic ever produced, located on a beach in Bali, and created from plastic trash from nearby beaches.

Our goal is to illustrate the scope of the plastic management problem as well as the transformation and final fate of plastic. Once plastic reaches the ocean, it is already too late to stop its diffusion. According to leading experts, the only effective solution is to "turn off the tap" and radically reduce plastic production. Our visualization focuses on an understanding of this global cycle of mismanagement.

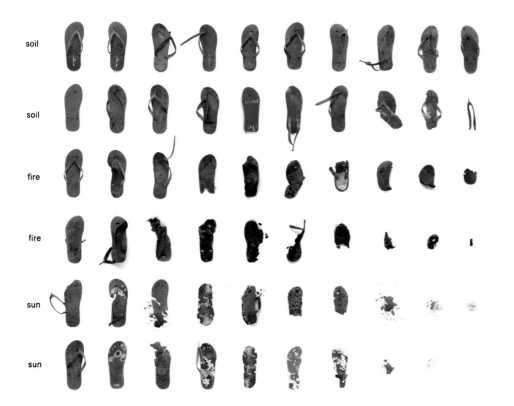

FIGURE 4

Media reports about ocean plastic encourage us to assume that most marine debris is large (flip flop size or bigger) when, in reality, plastic breaks down very quickly in the sun and waves—the vast majority of ocean plastic is smaller than 5mm in size.

PRACTICES AND PROCESSES

① Inspirations

▶

FIGURE 5

The original graphic from the scientific paper shows the amount and flow of plastic with figurative illustrations.

▶

FIGURE 6

Inspired by a graphic on "Our World in Data,"[1] we decided to redesign the graphic in the form of a Sankey diagram, to facilitate pattern recognition and introduce a flow/stream metaphor, fitting with the key role rivers play in transporting trash into the oceans.

▶

FIGURE 7

We further transformed the Sankey into a semi-circle version, to align better with the landscape and the overall project message.

1 https://ourworldindata.org/plastic-pollution#global-plastic-production-to-fate

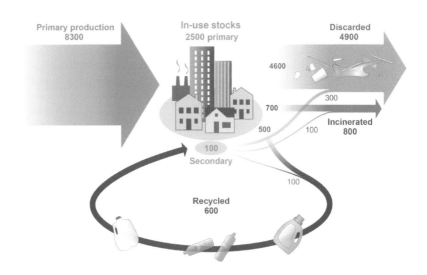

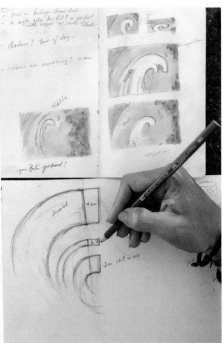

② Sketches

Various sketches, exploring size, positioning and integration into the environment. Size is calculated by the amount of marine debris collected. Debris consisted mainly of single-use plastic items and was collected in various beach clean-ups in the weeks leading up to the installation. A major factor in calculating physical dimensions is the space left between the single plastic items.

③ Location

Overlay on satellite imagery, for planning orientation and physical dimensions. As marine pollution usually accumulates on remote, not easily accessible beaches, it often goes unnoticed. The same was true for the installation. We fully relied on the final photo to get the message out to the public.

④

Guidelines

▲

FIGURE 8
Measuring and marking circular guidelines.

▶

FIGURE 9
Filling marked guidelines with debris material of the respective colors.

Arrangement and Placement

FIGURE 10

The space left between the single plastic items is a major factor in arriving at the final dimension of the installation. The data sculpture consists of over 4500 single-use plastic pieces. Each single piece was arranged and placed carefully to emphasize the whole over the parts.

▼

FIGURE 11

Over the course of 24 hours and with many helping hands, the final installation came together.

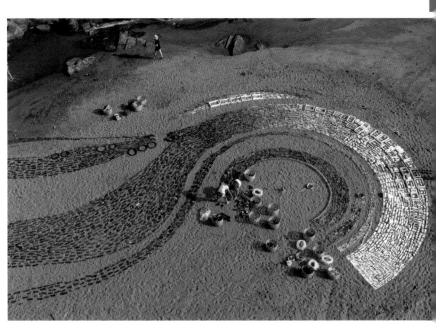

MATERIALS AND TOOLS

Trash and Debris Found on Beaches

▲▲

FIGURE 12

Living in Bali, Liina Klauss is constantly confronted with trash and debris found on beaches. In her art practice—under the motto of "Curating-the-Beach"—she transforms and reinterprets the material found. For *Perpetual Plastic* a total of thirty-two 100l baskets of trash were used.

▲

FIGURE 13

Volunteers helping to collect marine debris. They meet pollution hands-on, touching and being touched. The emotional response is usually overwhelmingness, shock and sadness. Through the art-making process this can shift into a sense of accomplishment and empowerment. This clean-up resulted in twenty-nine 100l rubbish-bags of plastic being removed from Mengening Beach in Bali.

▲

FIGURE 14

The basis for the trash sculpture is a growing stash of items found, sorted by color and size. The plastic items found intrinsically stay the same, but were put into a context-driven (color) system of order and belonging. Once they are part of a bigger picture, human perception changes from an ugly to an aesthetically pleasing experience.

▲

FIGURE 15

Through curation, the waste bin becomes a color palette. None of the items found is altered in any way, no paint, spraycan, or scissors are used. Solely by sorting the items by color we arrive at a diversified paintbox. Color sorting is a time-consuming process that also needs a skilled eye to discern the different tones.

REFLECTIONS

We deliberately chose to create a "data visceralization" from physical, known objects—not only because they were colorful and relatable, but also because they allowed us to encode data variables into a tangible, situated form, at human scale. The direct link to beach clean-up activities suggests immediate opportunities for action, turning the sculpture into a catalyst for engagement.

The location of the piece is not coincidental either—1,315 metric tons of plastic debris enter the ocean from Indonesia every single day, and rivers play a big role there. Without effective waste management, the only way to handle the vast amounts of single-use plastic waste in Bali is to either openly burn it or deposit it next to rivers so that the next rains will carry it "away."

On a final note, all flip-flops were reused in subsequent installations by Liina Klauss or recycled in collaboration with the footwear brand Indosole. Other recyclable materials have been handed over to the waste management company EcoBali. Non-recyclables like fishing nets and toothbrushes were deposited in a landfill.

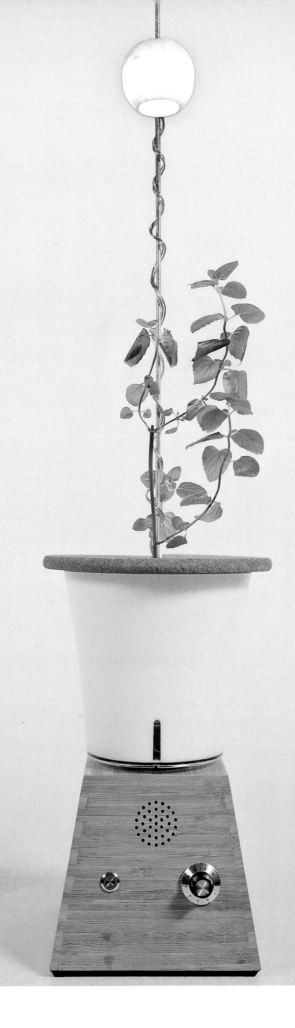

DATAPONICS: HUMAN-VEGETAL PLAY

Robert Cercós

2016

Acknowledgments

Adam Nash
Jeremy Yuille
William Goddard
Helmut Munz

Dataponics: Human-Vegetal Play maps human physical activity measured by a wearable device to the amount of light and water fed to a potted plant. The moisture that surrounds the plant's roots is measured, and plays different internet radio stations accordingly.

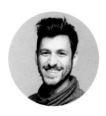

—

ROBERT CERCÓS

Ph.D., is a Chilean engineer, researcher and artist. He is the co-founder of Spike, a data innovation lab that addresses complex challenges in different fields through experimentation and machine learning techniques. His research explores the transformative power of playful interactions with data.

▶

FIGURE 1

The full dataponics system working on a pedestal in our design lab, just before going into an in-the-wild field study. | Credit: Jeremy Yuille.

PROJECT MOTIVATION AND INSPIRATION

▼

FIGURE 2

Couplings between self-quantified plant and human: for instance, if the player had more than zero steps over the last 30 minutes, the growing lights turned on; if the player walked 14 minutes in the last 30 minutes, the pump circulated the water for 14 minutes; if the hydroponic medium was dry, the music was old blues from the 1940s; if it was too humid, modern pop from the 2000s was played.

This project was born as an exploration of ways in which self-quantification could have significance beyond the self. Typical self-quantification data visualizations are centered in numbers, graphs, or forms of gamification which, in turn, elicit comparison and competition. Moreover, the "self" in self-quantification always refers to a "human self." I was inspired by the idea of extending the concept of self-quantification to non-human agents, for instance, plants or animals, and, at the same time, exploring the possibilities of coupling different quantified selves through data; in this case, a human and a plant. The main idea was to explore the affective dimension of self-quantification from unfamiliar, critical perspectives.

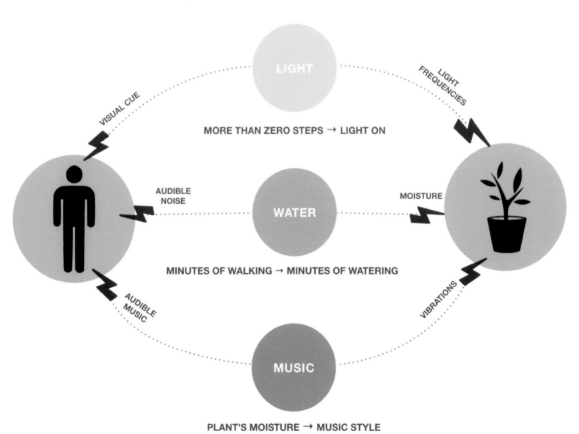

PRACTICES AND PROCESSES

Early Sketches and Proof of Concept

I started exploring different settings, types of plants, pots, and mediums in which an autonomous plant would be fully viable. Part of my early sketches include some elements of the final design: lights, humidity sensors, among others.

Prototypes

I built several prototypes using everyday elements like Tupperware and plastic buckets, testing hydroponic settings, nutrients, watering cycles, and other variables. I also built several versions of the watering mechanism and tested them with real plants, in the beginning without the connection to actual data. I explored different types of couplings

▼

FIGURE 3

Some references and early sketches.

▼▼

FIGURE 4

Early experimentation with different seeds.

◄▼

FIGURE 5

Early conceptual sketch of the whole system.

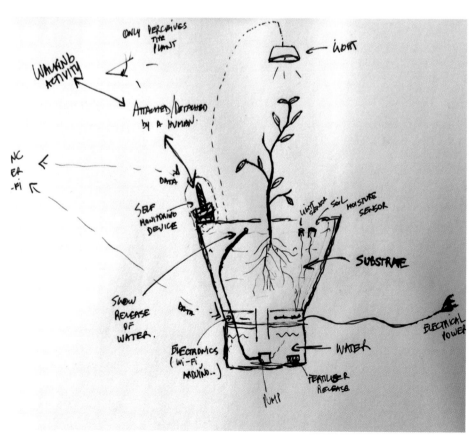

▶

FIGURE 6
Early prototype of the
electronics and watering system.

▼

FIGURE 7
Early prototype of the watering
system (using drops over soil).
Later I moved to an hydroponic
system that provided more
control.

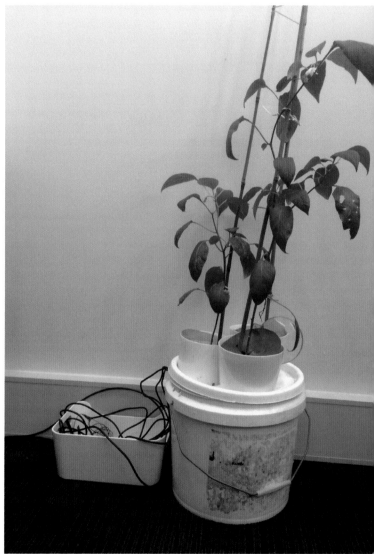

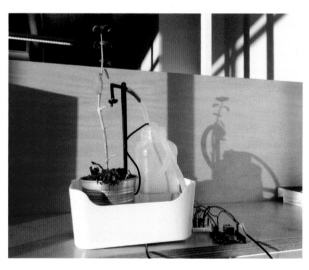

between the physical activity data and the watering and artificial light switches (rules like "if [something happens in the steps activity] then [something happens in dataponics]").

Fabrication

Once I got a viable pot in which plants would survive and tested possible couplings to the lights, watering, and sound, I built three versions of that pot—sitting atop a base encasing all the electronics. I tested them in the lab for 30 days to ensure reliability and fix any remaining technical bugs.

◀ ▲

FIGURES 8 - 9

The fabrication consisted of mixing and adapting the different components: pot, 3D printed light shade and support, electronics wooden box, controls.

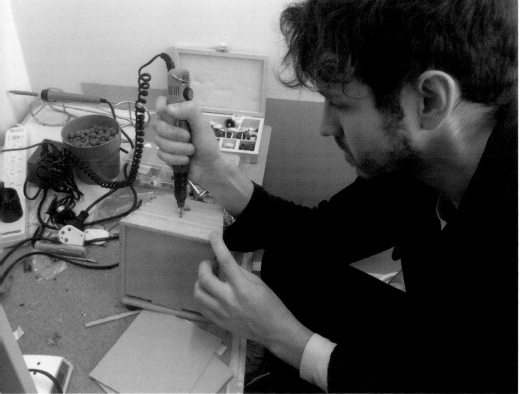

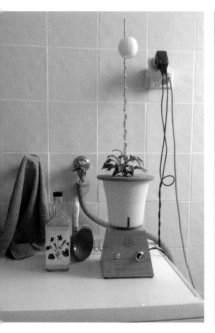

4

In-the-Wild Test

I found three volunteers who were willing to couple their Fitbit data to the plants. Each person chose a plant of their preference and received a set of materials (Figure 11) to document the whole process.

5

Documentation

▲

FIGURES 10 – 11

The dataponics system had to be able to autonomously work in-the-wild, only requiring wireless internet connectivity and electricity.

▶

FIGURE 12

Photo shoot of the final piece.

MATERIALS AND TOOLS

Plants, Seeds, Growing Medium
I tested different kinds of plants (tomato, chili, basil, mint, among others) and different growing mediums (soil and hydroponic).

3D Software and Printer
Blender to create models of the lamp, and MakerBot Replicator to 3D print the light shade.

Electronics
Arduino Yún (with USB, and WiFi), electronic boards, mini-USB sound card (for radio and sounds), LED lights, water pumps, other electronic elements (transistors, resistors, power transformers).

Software
Node.js over Heroku for the backend and API, Fitbit API for step counting data, and Arduino programming language for the device. The device called a cloud API every minute sending its current status, we uploaded Fitbit data and the API responded with what should happen to the plant: lights on/off, water on/off, which internet radio should play, etc.

Time-Lapse Videos[1]
For understanding plants' evolution with the different settings of water, light, and so on.

Wood, Dremel, Pots
For the fabrication of the final work.

1 https://youtu.be/57Wc2ekbRlQ

REFLECTIONS

The process from ideation to fabrication and finally, in-the-wild use was a very long one; more than a year of work. My first reflection is related to the influence that the natural speed of plants exerted on the project; planting a seed, getting a plant, putting it into a hydroponic pot, and so forth, sometimes took many months. This aspect was mostly beneficial (as I had plenty of time to think things through), but sometimes the slow speed caused some challenges. For instance, one time a plant died because of a pump failure and everything had to start again. By design, each plant received enough water and light to survive regardless of the step activity to avoid manipulative strategies of behavior change.

The idea of using self-quantification as a way of coupling selves of different nature (plants and humans) was surprising in many ways. In our in-the-wild study, this created a sense of depth and added significance to the act of self-measuring the number of daily steps. It also gave long-term feedback (plant's wellbeing) for an immediate action (walking), bringing the long-term effects of behavior to the present in a slow way.

The different couplings were a result of nearly one year of experimentation, in which I was trying to find something that was technically feasible and, at the same time, created some meaning in the player's experience. I mixed couplings between different aspects of activity (number of steps, time walking, length of sitting) to different perturbations (watering cycle, lights, sound). These created, in turn, perturbations to the player that were near the plant (pump noise, lights on/off, plant's health, music genres).

Finally, the project highlights an interesting design challenge: How should we design for growing bodies (both the plant and the human) that are continuously changing but at very different speeds?

Completed log showing one year of solar/
atmospheric data at the site. | Credit: Miles Epstein.

SOLAR TOTEMS

Charles Sowers

2017

Glen Canyon Park Recreation Center

Acknowledgments

Collection of the City and County of San Francisco, San Francisco Arts Commission

Ken Carter - Electronics

🔗 charlessowers.com/solartotems

Solar Totems is a sculptural installation that produces a 3-year archive of atmospheric conditions by focusing the sun's rays to burn daily lines into 3 successive upright logs. Passing clouds and periods of rain produce interruptions in the daily burn line.

—

CHARLES SOWERS

is an artist whose work presents actual physical phenomena that draw people into careful noticing and interaction. Drawing attention to the unnoticed or unseen is a dominant theme in his work, which blends aesthetics and information, often by setting up conditions that allow an external force to animate or complete the artwork.

Solar Totems is a sculpture composed of three 30-inch-diameter by 9-foot-tall old-growth redwood logs. The logs are installed upright in a triad arrangement on the open, south-facing plaza in front of the Glen Canyon Park Recreation Center. A solar-powered heliograph mechanism with a spherical lens is mounted on one of the logs. The sun's rays are focused by the lens to lightly burn into the wood. As the sun moves across the sky, the burn becomes a line, preserving a record of sunshine periodically broken by fog or cloudy skies. The lens is advanced a small distance each day to create a distinct daily line. Each log records one year of daily atmospheric conditions. When the yearly record is complete, the heliograph is moved to another log, leaving a sculptural archive of daily variations in sunlight that park visitors can use to compare regional weather patterns from year to year.

▼

FIGURE 1

Showing the installation at the beginning of the 3rd year—the apparatus is on the 3rd log.

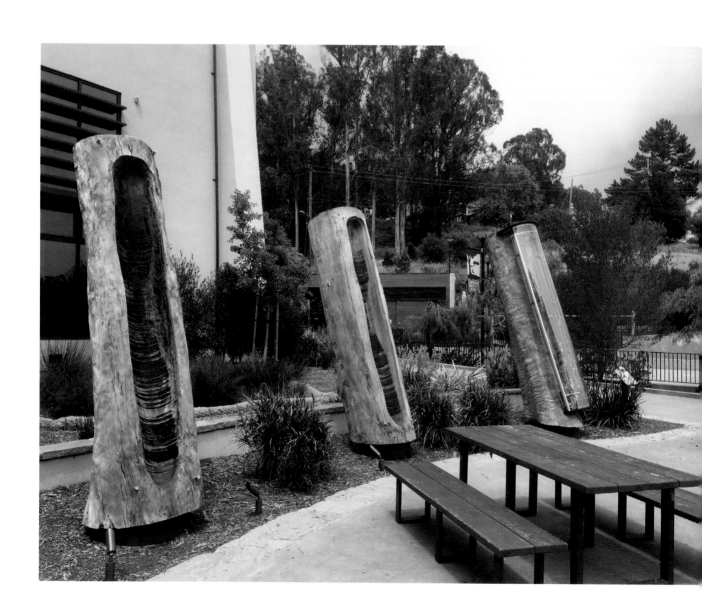

PROJECT MOTIVATION AND INSPIRATION

Solar Totems is inspired by 19th-century meteorological instruments that similarly burned a record of the relative proportions of clear or cloudy skies that occurred during the day. But unlike the traditional instruments that produced a separate burn record for each day, or blurred multiple-day records into one hard-to-read meta-pattern, the heliograph mechanism in *Solar Totems* writes a sequential solar text, day by day, line by line, like a written document. This stacked, linear arrangement of solar burn markings evokes letters, words, and sentences, linking solar script to manuscript, the traditional symbol of archived human knowledge from the cultural past.

▼
FIGURE 2
Closeup of the lens and the burn lines; several days show morning fog during San Francisco's October summer.

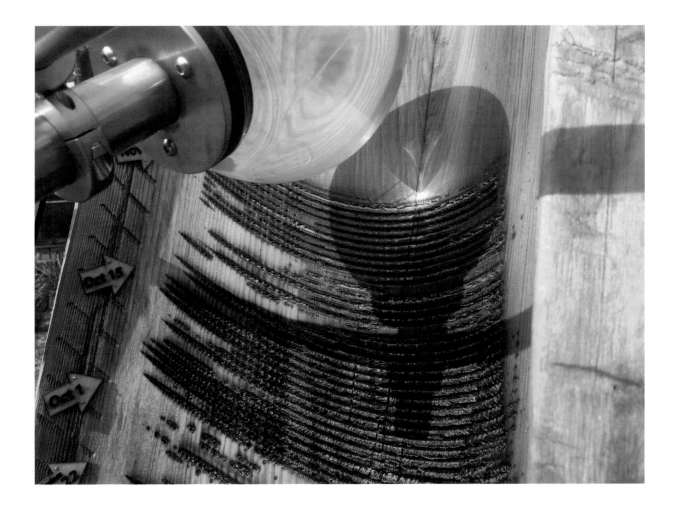

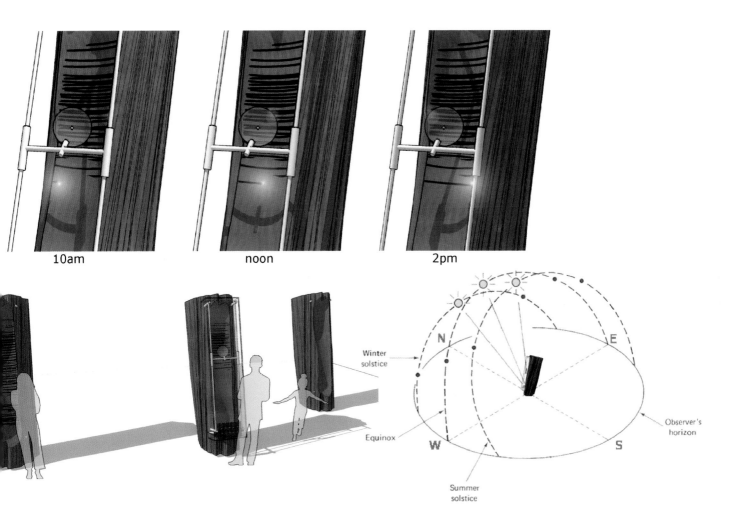

10am noon 2pm

Winter
solstice

Equinox

Summer
solstice

N

E

W

S

Observer's
horizon

▲
FIGURE 3
Diagrams showing how the
rays record the daily and yearly
progression of the sun.

PRACTICES AND PROCESSES

Ideation

I had been playing with this idea for many years. My first idea was to place a spherical lens in a carved stump. I learned that this was basically the same design as the early Campbell Sunshine recorder.

Apparatus Experiments

I did several experiments burning wood and also using stainless steel foil as the material for receiving the burns. Ultimately burning wood was more visceral and harkens back to childhood experiences with a magnifying glass.

③

Refining the Mechanism

I liked the symmetry of a fixed spherical lens where the only moving part is the earth. But a problem is that the burns overlap and are hard to discern as separate days. For a while, I thought there might be an optical way to separate the lines to make them distinct and readable. This turned out not to be possible, as the sun's path across the sky changes from day to day by less than its apparent diameter. This eventually led me to the idea of shifting the lens up a bit each day. My friend Ken Carter did some studies in Mathematica for me and we discovered that the lens would have to be shifted in and out over the course of a year to keep the lens in focus. However, I found that the alternative of carving a special surface that keeps the lens in focus throughout the year really appealed to me; the logic is encoded into the carving.

▼
FIGURE 4
First sketch of the idea.

▶
FIGURE 5
Using stainless steel foil to
receive the sun's burns.

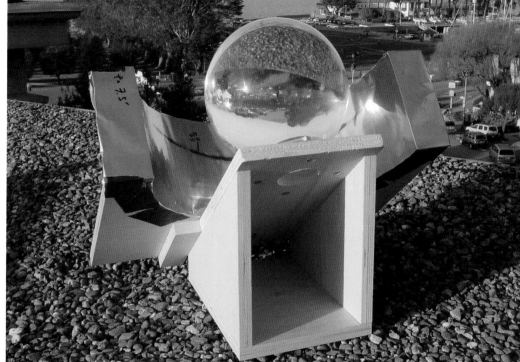

◀
FIGURE 6
I created a mock-up to
confirm the mechanism.

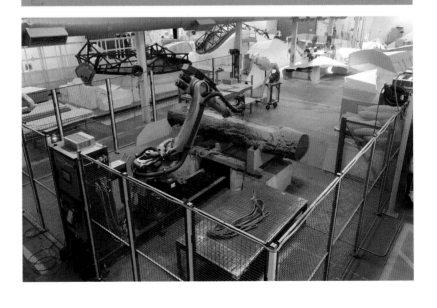

FIGURE 7

Closeup of case fit detail.

FIGURE 8

I used Grasshopper to generate the burn-through surface geometry.

▶

FIGURE 9

I used photogrammetry to capture the log geometry so that I could fit the heliograph and case to each log.

▶

FIGURE 10

Having the logs carved on a 6-axis machine.

④ Overcoming Problems

A major hurdle was the perception that the piece would be a fire hazard. Previously, whenever I had brought up the concept with clients, they always balked. This fear kept the project on a back burner for many years until I had the reasoning, design, and evidence that there is no fire hazard. My experiments had shown me that the burn is quite shallow and the build-up of charcoal in the burn insulates the rest of the wood. In fact, timber frame warehouses frequently survive fire because of this insulative effect of charcoal build-up. In addition, the sphere has a very tight focus; just a one-quarter inch out of focus and there is not enough heat to mark wood.

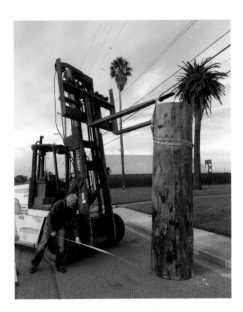

⑤ Fabricating and Installing the Logs

Finally, in 2016, I proposed the piece to the San Francisco Arts Commission and they accepted it. But I wasn't home free. I had to build it. There were many challenges in the fabrication and installation. First off, Mathematica wasn't cutting it for outputting files suitable for digital manufacturing, so I took my first dive into Grasshopper. It was quite a first project but I eventually got my geometry worked out. Then there was the issue of getting the carving and heliostat in the right place on the log to allow a cover to seal off the burn area so that people wouldn't be able to feed in any fuel (sticks, grass, or paper) to create a fire. Photogrammetry and some ingenuity helped me solve this and the issue of how to indicate the exact correct place and orientation for the carving. The main installation challenge was properly aligning the carved faces of the logs with the sun. For this, I went with a hybridized old technology: marking the shadow of a pole at the exact time of solar noon as determined from calculations on a NASA website. Unfortunately, the day of this important step was foggy with no sun. I had to try again the next day and it, too, was foggy; but there was a miraculous clearing at

◀

FIGURE 11

Setting up for photogrammetry.

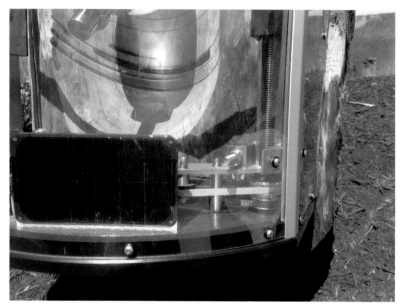

▲
FIGURE 12

The base of the advancement system with solar cells, motor, and the two screw threads on each side.

precisely solar noon and I was able to mark true solar south. The log's tilt was also a critical factor that was solved with age-old techniques.

(6) Designing the Lens Advancement

There was no power provided to the site so the lens-advancing motor had to be solar-powered and it needed to

work without fault or the record would be spoiled. Ken Carter designed a control system that used solar power to charge batteries, move the lens up one-quarter inch each night, and text us a confirmation that the move had proceeded without fail. On several occasions, Ken also remotely corrected failed moves via text commands and we jointly troubleshot these failures to eliminate them over the ensuing years.

●●●○○ AT&T 🛜 11:17 PM ✈ ⁂ 100% ▬

‹ **+1 (415) 373-2499** ⓘ

L̲e̲n̲s̲ ̲M̲o̲v̲e̲ ̲F̲i̲n̲
Time 42, 36,
43, 37
Current 70,
74, 73, 71

Today 8:03 PM

Day 160 –
20:03
Lens Move Fin
Time 43, 37,
42, 37
Current 64,
67, 74, 72

▲

FIGURE 13

The heliograph controller
sent nightly text messages
to confirm that the lens had
advanced.

MATERIALS AND TOOLS

Various Materials and Tools for Prototyping
I always do many experiments and mock-ups throughout the whole creation process to make sure my assumptions are correct and the piece will work. For example, I made some small, single day burning apparatus using a water-filled spherical wineglass and set these up to learn how mistakes in alignment affect the burn. I try to make these experiments as simple as possible; a laser cutter has helped my practice immeasurably for fast production of early mock-ups. Later mock-ups get more complicated.

Grasshopper
Grasshopper allowed me to generate the geometry of the burn trough and trace the sun's rays to avoid having the case shade the burn.

Autodesk Inventor
I do all my mechanical design in Inventor.

NASA/JPL Orbits and Ephemera Website
This website provided me with the data for Grasshopper to generate the carve geometry.

SketchUp
I use SketchUp for rough iterative design and also for generating proposal graphics.

Forklift for Installation
Handling 1.25-ton logs presented a bit of a challenge. A "grade-all" rough terrain forklift and some good rigging solved everything.

REFLECTIONS

Solar Totems turned out better than I expected. The monumental scale is more powerful than I imagined. They really are like totems or ritual architecture. The piece really gets people engaged in their location. Whenever I go on-site, people talk to me about how they like to check the *Solar Totems* every day. One woman even noticed how the trees on the ridge above are recorded in shadow at the end of the day.

I have overheard many people explain the logs to each other, people seemed to understand what was going on. With the heliostat now removed, I think it is less obvious to viewers what these monoliths are and what took place to mark them. I am still trying to figure out how to mark dates now that the recording is done.

It would be nice to be able to record more years. The first totem captured the 2017 solar eclipse. I wish the *Solar Totems* had been recording during the smoke blackout during the September 2020 California Wildfires. Like examining tree rings, it is interesting to map local, regional, and world events onto the recorded burns.

Dustmark above Konrad Adenauer Strasse,
Stuttgart. | Credit: Frank Kleinbach.

STAUBMARKE (DUSTMARK)

Dietmar Offenhuber

2018

Public space intervention, Stuttgart, Germany

Acknowledgments

Commissioned by Drehmoment Festival, KulturRegion Stuttgart.
In collaboration with luftdaten.info

🔗 offenhuber.net/project/staubmarke-dustmark

Staubmarke is an autographic visualization that makes urban pollution legible. Based on citizen science efforts to measure airborne particulate matter pollution, *Staubmarke* calls attention to the material nature of data and turns the surfaces of the city into a visualization.

—

DIETMAR OFFENHUBER

is an Associate Professor at Northeastern University in information design and urban affairs. He holds a Ph.D. in Urban Planning from MIT. His research focuses on the relationship between design, technology, and urban governance. Dietmar is the author of the award-winning monograph *Waste is Information* (MIT Press) and has published books on urban data and related social practices. He also works as an advisor to the United Nations Development Programme.
Author photo courtesy of Northeastern University.

▶

FIGURE 1

A dustmark close to Neue Staatsgalerie.

▼
FIGURE 2
Dustmark on St. Maria church.

PROJECT MOTIVATION AND INSPIRATION

Urban air pollution is an intensely political issue. Controversies about airborne particulate matter often converge on the interpretation of numerical sensor values and modalities of measurement, which are frequently disputed by parties with diverging interests. It doesn't help that the fine dust is invisible and its metrics of measurement are gross simplifications of a complex phenomenon. Dustmarks attempt to make legible the rich material dimension of dust pollution, which accumulates on all surfaces of the city. Placed around the locations of dust sensors, dustmarks allow a comparison of the digital sensor values with the accumulation of dust on the surface of the city, made legible through a visual reference pattern. Dustmarks are not driven by digital information but by material data: expressing material patterns of the environment. They add experiential context to digital data, inviting viewers to compare sensor values with the discolorations around the marks. The design of the patterns allows changes to be observed over time. As time progresses, the dustmarks will slowly fade, beginning with the most detailed patterns.

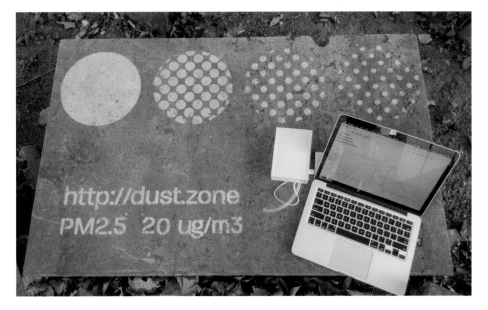

◄

FIGURE 3

Dustmark in front of Neue Staatsgalerie, with mobile dust sensor and laptop. The pattern is designed to allow observing changes over time. More intricate patterns will disappear first as new dust accumulates in the cleaned areas.

PRACTICES
AND PROCESSES

Dustmark uses the existing technique of *Reverse Graffiti*, which involves creating visual patterns by selectively cleaning surfaces (for example with a pressure washer and a metal stencil) rather than adding paint. Formally, the marks consist of four circles arranged in a row, alluding to the particulate matter samples collected for gravimetric measurement. The four circles form a scale of halftone patterns with decreasing density, supporting the sensory assessment of the dust patina by estimating local contrast and detail.

Location

We chose sites in public spaces in close proximity to sensor locations operated by the citizen-driven initiative luftdaten.info.

Reverse Graffiti

Using a pressure washer and a metal stencil, a reference pattern consisting of four circles with halftone patterns of decreasing density was applied. After experiments with different methods, we determined that untreated concrete surfaces work best for the process.

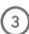

Website

The reverse graffiti also includes a link to the project website and shows the highest daily average value measured by the closest sensor from the luftdaten. info network of volunteers.

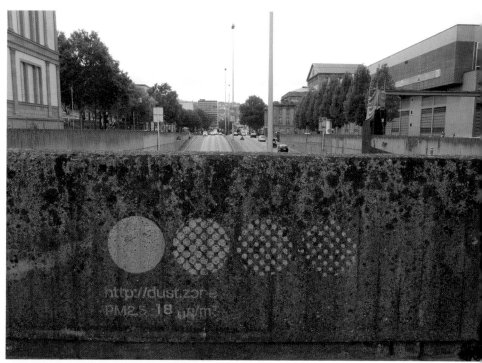

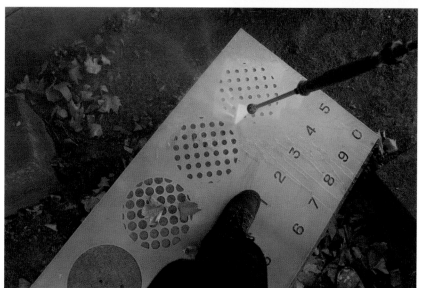

▲
FIGURE 4
A dustmark above Konrad
Adenauer Strasse, Stuttgart.

◀
FIGURES 5 - 6
Creating a dustmark using a
pressure washer and a stencil.

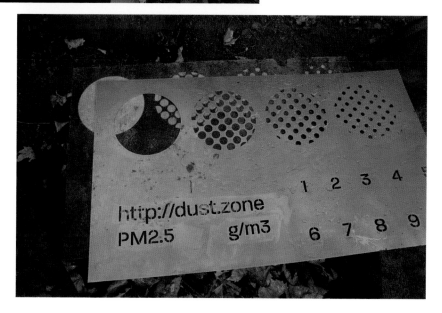

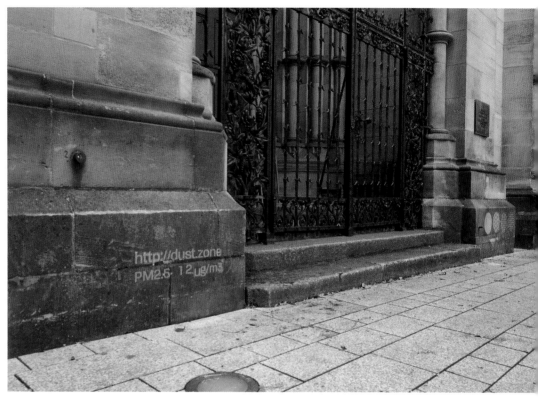

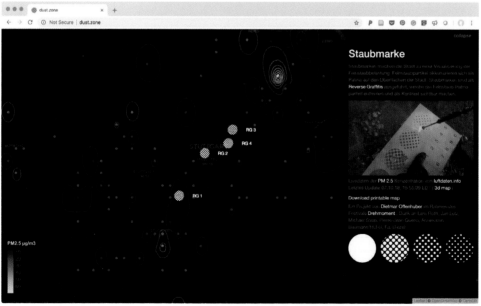

④ Visualization

The project website offers a real-time visualization of particulate matter concentrations measured around the dustmark locations and photos of the dustmarks over time.

⑤ Fading Patterns

Since the accumulation of dust is an ongoing process, dustmarks will slowly fade. The reference patterns are designed to allow an estimation of the rate of accumulation: the circle with the finest halftone pattern will disappear first, continuing until the whole graffiti is indistinguishable from its surroundings.

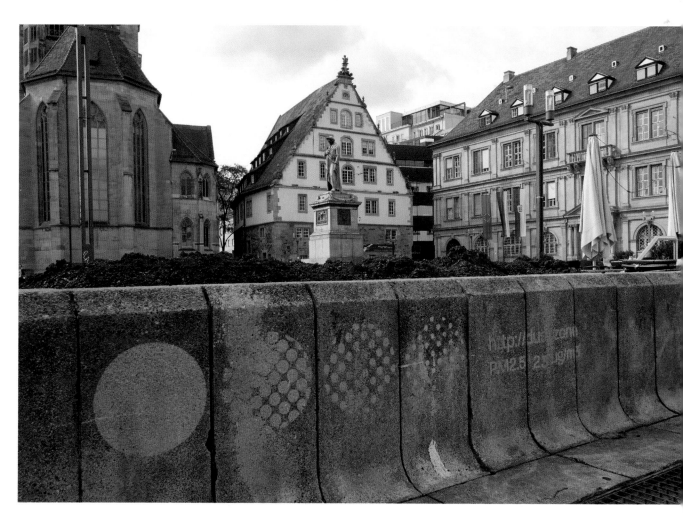

MATERIALS AND TOOLS

Nova SDS011 Particulate Matter Dust Sensor
A popular and fairly accurate low-cost air quality sensor that counts particles through optical scattering.

Stencil
Laser-cut sheet metal for applying the reverse graffiti.

Pressure Washer
Water, no cleaning agents.

Website
R-Shiny backend processing data from the luftdaten.info API.

REFLECTIONS

On examining a dustmark, viewers usually quickly notice that particulate matter is not the only substance accumulating on the walls and surfaces of the city, limiting the usefulness of dustmarks as accurate measures of particulate matter pollution. Provoking such critical reflections through the sensory experience of the dustmark is the goal of the project. Dust is a complex physical phenomenon, and the numerical values created by black-boxed sensors are simplifications that are based on many hidden assumptions. In this sense, the project addresses our tendency to naturalize data—to treat them as abstract information, decoupled from the material world. The project is ultimately about the limits of objectivity—just as the dustmarks offer no accurate representation of pollution exposure, the quantitative metrics are shaped by political debates and at the same time are only able to capture a limited aspect of the complex phenomenon of particulate matter.

CONCLUSION

There is a tendency in some corners of the design and maker communities to think of data-driven making exclusively in the context of digital fabrication. But, as we've tried to show in this book, making with data is about so much more than just CAD software, 3D printers, mills, and laser cutters. Creators can just as easily use craft approaches, leverage the collective effort of large groups of people, or even rely on environmental processes to create new data-driven experiences. The resulting pieces can range vastly in scale, from architectural interventions like *Orbacles* to small objects like *Dataseeds* that can be carried in a pocket. They can also serve a variety of different purposes—engaging people in discussions about urban planning, informing decisions in business meetings, or simply evoking emotion, reflection, and inspiration.

In crafting this book, we have sought to give creators an opportunity to showcase not just their final designs, but also the processes through which they transform abstract data into physical forms. For consistency, we have organized these processes into linear steps and also grouped the projects into five broad themes. However, the real-world experience of creating these projects is often more intricate, messy, and iterative than our linear descriptions might suggest. With that in mind, we encourage you to not fear messiness and experimentation in your own work, nor assume that this book captures all of the ways of giving physical form to data. There are as many different ways of making with data as there are approaches to art, craft, or design—and the examples we've collected here only scratch the surface!

Looking ahead, technical advances in robotics, fabrication, augmented reality, and related disciplines (maybe even true programmable matter) will continue to make it easier to create dynamic physical representations of data. Meanwhile, increasing data literacy and the growing accessibility of everyday data analysis tools could help an even wider range of people incorporate data into their creative practices, both technical and traditional. These developments will almost certainly create opportunities for new art pieces and experiences that reveal data, as well as new ways of representing data in the context of everyday life. The future holds immense potential for combining computation with craft, creating new experiences for creators, communities, and audiences. In that spirit, we hope you take inspiration from the creators we have gathered in this book (as well as the broader community of data-driven makers and visualizers) and explore opportunities for making with data in your own life. For those who wish to dive

deeper, the following pages contain a variety of additional references—including larger collections of examples along with key references from the growing academic literature on *data physicalization*. These references suggest a multitude of ways for artists and designers to incorporate data into their creation process, as well as opportunities for educators and everyday crafters to use accessible and expressive physical construction approaches to encourage learning, awareness, and personal exploration.

Remember, there is no single recipe for making with data. Rather there are a vast range of processes, tools, and approaches just waiting to be explored. So go forth, experiment with data in your own spaces and practices, and encourage others to do so! Try new ways of creating, and endeavor to use data to create something new! And as you do, document your process and share it—letting the world see not only what you're making with data, but *how* you're making it.

— SH, TN, LO, WW

RESOURCES

Books

Making Data: Materializing Digital Information.
Ian Gwilt (Editor). 2022. Bloomsbury Visual Arts. https://bloomsbury.com/us/making-data-9781350133235
A collection of reflections on the process giving form to data and the importance of physical representations, along with deeper case studies of several specific projects. The book includes contributions from Jason Alexander (*EMERGE*), Stephen Barrass (*Chemo Singing Bowls*), Daniel Keefe (*Orbacles*), Dietmar Offenhuber (*Dustmark*), Laura Perovich (*SeeBoat*), and Adrien Segal (*Snow Water Equivalent*).

Online Resources

Making with Data (Companion Website)
https://makingwithdata.org
The online companion to this book contains additional photos, video, and other content related to the projects documented here, as well as a collection of related projects. We welcome contributions and will continue to highlight diverse projects that showcase new and innovative approaches to making with data.

Data Physicalization Wiki
http://dataphys.org
http://dataphys.org/list
The excellent wiki maintained by Yvonne Jansen and Pierre Dragicevic houses a large and growing list of physical data artifacts and art pieces as well as a variety of other related resources.

Data Physicalization Workshops Series and Materials
https://data-physicalisation.github.io
Houses a variety of teaching resources that use physical representations of data to teach important visualization and data literacy concepts.

Academic Writing

Data Physicalization.
Pierre Dragicevic, Yvonne Jansen, and Andrew Vande Moere. 2021. In *Springer Handbook of Human Computer Interaction*. Jean Vanderdonckt, Philippe Palanque, Marco Winckler Springer (Editors).
A deep overview of the theory, practice, and state of data physicalization as a research domain.

Opportunities and Challenges for Data Physicalization.
Yvonne Jansen, Pierre Dragicevic, Petra Isenberg, Jason Alexander, Abhijit Karnik, Johan Kildal, Sriram Subramanian, and Kasper Hornbæk. 2015. In *Proceedings of the ACM Conference on Human Factors in Computing Systems (CHI '15)*. Pages 3227–3236. ACM.
Collects a variety of promising research directions and future challenges for research related to data physicalization.

Embodiment in Data Sculpture:
A Model of the Physical
Visualization of Information.
Jack Zhao and Andrew Vande Moere.
2008. In *Proceedings of the International*
Conference on Digital Interactive Media
in Entertainment and Arts (DIMEA '08).
Pages 343–350. ACM.
Introduces the notion of data sculpture and
highlights the tensions and relationships
between data-driven artistic practice and
more analytical approaches.

Data to Physicalization:
A Survey of the Physical Rendering
Process.
Hessam Djavaherpour, Faramarz
Samavati, Ali Mahdavi-Amiri, Fatemeh
Yazdanbakhsh, Samuel Huron, Richard
Levy, Yvonne Jansen, and Lora Oehlberg.
2021. In *Computer Graphics Forum.*
Volume 40, Issue 3 (June 2021). Wiley.
Examines the process of creating physical
representations of data through the lens
of rendering and examines the trade-offs
associated with a variety of different creation
methods.

Making Data Tangible:
A Cross-disciplinary Design Space
for Data Physicalization.
Sandra Bae, Clément Zheng, Mary Etta
West, Ellen Yi-Luen Do, Samuel Huron,
and Danielle Albers Szafir. *In Proceedings*
of the ACM Conference on Human Factors
in Computing Systems (CHI '22). **ACM.**
Explores, describes, and analyses the
variety of work and approaches to
physically representing data across the data
visualization, tangible user interaction, and
design communities.

Physecology: A Conceptual
Framework to Describe Data
Physicalizations in their Real-
World Context.
Kim Sauvé, Miriam Sturdee, and Steven
Houben. 2022. In *ACM Transactions on*
Computer-Human Interaction. **Volume 29,**
Issue 3, Article 27 (June 2022). ACM.
Broadens the context of physical
representations of data to consider the
contexts, environments, and settings in
which they appear.

ABOUT THE EDITORS

—

DR. SAMUEL HURON

is an information designer and associate professor in Design of Information Technologies in the Social and Economical Science department of Télécom Paris at the Institut Polytechnique de Paris, and part of the CNRS Institut Interdisciplinaire de l'Innovation. His research addresses how humans create visual and physical representations of abstract information to think, collaborate, learn, analyze, explore, and design new data representations, systems and information artefacts. He leads the design studio at Télécom Paris and he is part of the Interact and Diva teams. He worked as the lead designer of the research institute of the Pompidou Center. His approach is grounded in fifteen years of experience in interactive media industries where he worked with a broad range of civic, cultural, and corporate clients. Prior to his research career, he worked in new media art with projects including video art labels on art installations, video mixing, and live performances. For his Ph.D. on Constructive Visualization he was awarded the IEEE VGTC Pioneers' "Best Doctoral Dissertation Award". He is an alumnus of University of Calgary, ENSAD, INRIA, Université Panthéon Sorbonne.

Credit: Emmanuelle Marchadour.

—

DR. TILL NAGEL

is a Research Professor of Visual Analytics at the Mannheim University of Applied Sciences. His interests are in information visualization, interaction design and data literacy. He heads the Human Data Interaction Lab, which investigates new ways of supporting different target groups with interactive data representations. A major focus of his research is around the themes of urban data and mobility visualizations, and in the democratization of visualization tools. He was the general chair of the IEEE VIS Arts Program 2018 and 2019. He is a member of the VISAP steering committee, of the advisory board of the Mannheim Smart City initiative, and is an associated member of the Medical Faculty Mannheim of Heidelberg University. Dr. Nagel has a background in media and computer science, and received his Ph.D. at the Human Computer Interaction group at KU Leuven. He was a visiting scholar at the MIT Senseable City Lab in Boston and Singapore, a postdoctoral fellow at the FHP Urban Complexity Lab, and a guest professor at Burg Giebichenstein University of Arts and Design. His work has been exhibited at Venice Biennale of Architecture, Shanghai Design Exhibition, DMY Berlin, and featured in *The Guardian*, *Esquire*, *Süddeutsche Zeitung*, and many more.

Credit: Uta Diehl.

DR. LORA OEHLBERG

is an Associate Professor of Computer Science at the University of Calgary. Her research addresses how technology can better support creativity, collaboration, and curiosity in a range of domains, including interaction design, electronic fashion, improvised digital fabrication, physical data representations, improvised theatre, and healthcare innovation. She leads the Curio Lab, and is one of the faculty leaders of the Interactions Lab, a human-computer interaction research collective. She is currently the director of the Computational Media Design graduate program, and part of the University of Calgary's Makerspace community of practice group. In 2018 she was awarded a Peak Scholar of Entrepreneurship, Innovation, & Knowledge Engagement from the University of Calgary for her work in "People-Centred Technology for Creativity and Collaboration". She was an Inria Silicon Valley postdoctoral fellow with the InSitu group at Inria Saclay. She has a Ph.D. and MSc in Mechanical Engineering from the University of California at Berkeley, and a BSc in Mechanical Engineering from Stanford University.

Credit: Yvonne Jansen.

DR. WESLEY WILLETT

is an Associate Professor of Computer Science at the University of Calgary where he holds a Canada Research Chair in Visual Analytics. His interests span information visualization, social computing, new media, and human-computer interaction, and his research focuses on pairing data and interactivity to support collaboration, learning, and discovery. At the University of Calgary, Dr. Willett leads the Data Experience Lab and is a member of the Interactions Lab, the university's human-computer interaction research collective. He is also faculty in the Computational Media Design and Data Science programs, and was awarded the Faculty of Science's 2019 Excellence in Research Scholarship Award (Early Career). In 2019 he served as General Chair for IEEE VIS 2019, the premier academic conference for visualization and data analytics research.

Credit: Samuel Huron.

ACKNOWLEDGEMENTS

This book had its genesis at the 2018 Schloss Dagstuhl seminar on Data Physicalization (seminar #18441) organized by Jason Alexander, Petra Isenberg, Yvonne Jansen, Bernice E. Rogowitz, and Andrew Vande Moere. Our immense thanks go out to all of the organizers, attendees, and staff who facilitated the conversations that helped frame and motivate our work. In particular, we thank Denton Fredrickson for his contributions to the initial framing and structure of this collection of works.

We extend our deep appreciation to the colleagues and collaborators who provided support and insight throughout the creation of the book. Huge thanks to all of the authors and contributors, as well as to Elodie Maigné for the wonderful book design, and to Michael Hung for his tremendous help during the final organization and preparation of the manuscript. We also thank our editors and staff at Routledge, including Elliott Morsia, Randi Cohen, Simran Kaur, and Talitha Duncan-Todd, as well as AK Peters Visualization series editors Tamara Munzner and Alberto Cairo for their continued support. Thanks as well to Camille Beaudelaire, Nadieh Bremer, Fanny Chevalier, Benedikt Groß, Jon McCormack, Lisa Charlotte Muth, Sandra Rendgen, and Shirley Wu for their invaluable feedback, critique, and suggestions.

We also extend personal thanks to all of the members of our research teams—the Interactions Lab at the University of Calgary, the Human Data Interaction Lab at the Mannheim University of Applied Sciences, and the *Interact and Diva Team* of Télécom Paris, Institut Polytechnique de Paris. Finally, we thank all of the friends, colleagues, and family members—including but not limited to Aurelien Tabard, François Taddei, Alice Thudt, Jagoda Walny, and Tiffany Wun—for their encouragement and assistance throughout the process.

This work was supported in part by the Natural Sciences and Engineering Research Council of Canada (NSERC) [RGPIN 2016-04540], funding from the Canada Research Chairs Program, the Carl Zeiss Foundation, by the Economics and Social Sciences department of Télécom Paris and by French government funding managed by the National Research Agency under the Investments for the Future program (PIA) grant ANR-21-ESRE-0030 (CONTINUUM).

INDEX

#

100% [City] 103, 104, 106, 107, 146–161

3D

 bar chart 292

 model 178, 192, 194, 240

 modeling 48, 281, 308, 341

 object 196

 software 341

3D printing 22, 26, 118, 119, 172, 173, 180, 181, 183, 188, 190, 193, 194, 212, 213, 214, 216, 217, 219, 236, 239, 257, 259, 261, 295, 305, 339, 341

 metal 196

 selective laser sintering (SLS) 259, 261

A

abacus 14, 15, 19

abrasive disk 45

acoustic levitation 248

acoustics 186, 196

acrylic 114, 208, 209, 270, 274, 283

activity 117, 342

 data 274

 log 55

 mobility 137

 physical 180, 181, 275, 316, 334, 339

 situated 118

 step 342

 tracker 183, 269, 274

 visual 280

Adafruit 128, 130

Adobe

 Illustrator (software) 42, 48, 56, 60, 80, 84, 218

 Photoshop (software) 215, 218

aesthetic 34, 113, 117, 196, 256, 259, 260, 274, 275, 346

 aesthetically meaningful 267

 aesthetically pleasing 41, 128, 270, 275, 329

 "non-digital" 260

affordances 56, 72

 physical 106

age 151

age bracket 235, 240

aggregation 56, 100, 103, 260, 313, 317

air quality 255, 256, 368

air travel 278

AirFIELD 245, 247, 276–285

Alexander, Jason 248, 288

algorithm 204, 280

Altium Designer 308

aluminum 208, 282, 295

American Community Survey (ACS) 204

angle grinder 45

animation 280, 282, 283

 stop motion 259

annotate 260, 305

Anthropocene Footprints 74–85

anthropomorphizing 85

Antoni, Janine 34

Apple

 iPad 218

 Mac 218

application

 companion 306

 web 69, 71, 295

application programming interface (API) 341, 368

architecture 231

Arduino 130, 292, 295, 296

 mini 128, 129

 Yún 341

art 16, 22, 26, 97, 167, 203, 246

 data 97, 144, 209, 212, 248, 280

 kinetic 248

 programming 283

artifact 22

 physical 266

artificial intelligence (AI) 252

arts festival 225

artwork 169, 174, 209

 data 318

 dynamic 280, 284

assemblage system 118

Atlanta, Georgia, USA 277, 278, 280, 282

ATMELAVR Programmer 296

atmospheric conditions 346, 347

attention 91, 104, 117, 141, 143, 190, 259, 262, 346, 360

audience 34, 85, 104, 107, 127, 129, 131, 151, 156, 161, 169, 174, 241, 297

 non-specialist 241

auditorium 156

augmented reality (AR) 218, 266

Autodesk

 Fusion 360 (software) 208

 Inventor (software) 296, 355

autographic
> phenomena 317
> processes 24
> records 316
> visualization 360

automation 59, 69, 183, 258, 259

axis 41, 101, 288, 295, 296, 305, 307

B

bag 143

Bali, Indonesia 319–323, 328, 330

band 158

bandsaw 45, 48

Barcelona, Contemporary Art Fair of 167, 170

Barcelona, Spain 132, 136, 140

Barlow, Jamie 245, 278

Barrass, Stephen 181, 183, 186

Barry, Andrew 103

batch production 239

battery 305, 354

beach 315, 318, 321, 323, 325, 328, 330

behavior 342

bender
> pipe 92, 96
> sheet metal 230

Berlin, Germany 151, 153, 161

birds 225, 226, 229

birth 33

BitDrones (project) 248

blanket 34, 81
> baby 82
> temperature 34

Blender (software) 119, 215, 218, 341

blog 245, 246

blood pressure 184, 186, 188, 190, 193, 194

boat 101

bone
> Ishango 17, 18
> Lebombo 17, 18

book 158

booklet 155

Boston matrix 218

bracket 119
> fixing 171, 173

brass cleaner 95

Braunschweig, Germany 150

bungee cord 137, 143

bus/train station 140

C

C 308

C++ 283, 308

Cairn 103, 104, 108–120

calculation 19

calendar 18, 55, 56, 60, 79

call-and-response 209

Campbell, John Francis 316

CandyFab4000 (project) 178

card 261

cardboard 270

Carpendale, Sheelagh 30

Carter, Ken 350, 354

carving 44, 55, 352, 353, 355

casting 152, 155, 158

cause-and-effect diagram 218

census 79

Census Bureau 204

ceramic — see clay

Cercós, Robert 316, 334

chain reaction 152

charcoal 353

chart 313
> 2D 313, 317
> bar 83, 114, 248, 252, 260, 262, 288, 290, 291, 292, 295
> legend 143, 258, 259, 260, 313
> line 244, 245, 247, 305, 313
> physical 183, 244, 245, 247, 255, 261, 262, 297, 300, 309
> pie 137, 141, 252, 256, 257, 258, 259, 260, 262
> scatterplot 247, 305, 307, 313

chart noise 256

Chemo Singing Bowl 181, 183, 184–196

chemotherapy 186, 188, 190, 193

Cinder (software) 284

circumference 167, 193, 259

Citala (display manufacturer) 284

citizen science 100, 131, 132, 360

Cityscope (artwork) 225

civic engagement 107

civic questions 125

clay 55
> impression 18
> manipulation tools 60
> Mesopotamian clay token 17, 18, 30
> modeling 32
> slip 55, 59
> slip application 55, 59
> tablet 17, 18

cleaning 95, 172, 317, 364

agent 368
 clean-up 325, 328, 330
 of data 215, 262
client 137
climate change 222, 225, 313
climate data 231, 312
cloud 341
co-creating 107, 133
co-design 234
co-located setting 104
codependency 316
cognition 25, 241
collaboration 100, 168, 284, 309, 330
Cologne, Germany 153
Colombia 134, 140
color 220, 227, 329
 palette 329
 scheme 230
combination 118
Commoning 120
community 106, 124, 128, 130, 255, 262
 dissemination 142
 knowledge 130
 of activists 120
 of makers 120
 of practice 110
 visualization 313
comparison 34, 72, 85, 137, 141, 168, 183, 214, 260,
269, 270, 291, 307, 315, 336, 347, 363
compensation 158
competition 336
compromise 309
computer-aided design (CAD) 22, 48, 92, 96, 190,
 194, 195, 238
 KiCAD EDA (software) 296
 model 45, 217, 240
 OpenSCAD (software) 192, 193, 195
 Rhinoceros (software) 207, 227, 230, 283
 SolidWorks (software) 48, 208, 308
computer numerical control (CNC) 22, 48, 179,
 181
 6-axis machine 352
computer server 282, 295
concentration
 of ozone 245, 246
 of particulate matter 367
conductivity 125, 127
constraint 34, 67, 79, 114, 193, 262, 309
construction 16, 67, 101, 103, 106, 107, 113, 118, 215,
 230, 270, 272, 275, 292, 293, 297, 318
 asynchronous 104
 shared 104, 106

synchronous 104
 toy 33
context 66, 127, 168, 231, 241, 306
 contextual information 241, 313
 diverse 151
 -driven system 329
 education 236
 experiential 363
 fablab 120
 familiar 313
 home 270, 275
 situated 315
 usage 72
continuity 42
convention center 168
conversation 118, 134, 137, 144, 155
copper
 pipe 33, 92, 96
 wire 283
correlation 44, 72, 237
cost 66, 309
 effective 194
 housing costs 200, 204
 low- 71, 72, 127, 368
counting 18, 19
coupling 336, 337, 339, 342
COVID-19 141, 247
crime 91
criteria 152, 153
crochet 34
cross-device computing 266
Crossworks Studio 308
CSS (Cascading Style Sheets) 296
cultural change 91
curation 329
custom software 56, 60, 283
cutter
 laser 119, 143, 208, 240, 274, 296, 355
 paper 59, 60, 71
 thread 171, 173
 tubing 95
 vinyl 173
cutting 42, 59, 70, 80, 172, 181, 217, 295, 296
 curved shapes 48
 laser 118, 119, 140, 143, 207, 270, 272, 273, 274,
 295, 368
cycle
 Gartner hype 218
 global cycle of mismanagement 323
 menstrual 18
 watering 337

D

D3.js (software) 229, 230
dance 156
Dassé, Thierry 101, 110
data
 actuation 245
 analysis 110
 artifact 245, 247, 248, 256, 312
 bar 290
 categorical 103
 characterization 190
 collection 110, 113, 137, 316
 edibilization 25
 event 103
 income 200
 logging 128, 130
 manifestation 24
 mapping 56, 85, 184, 188, 194, 204, 209, 224,
 230, 260, 270, 272, 273, 275, 282, 313, 315, 316,
 317, 334, 356
 materialization 24
 modeling 219
 object 24, 237, 241, 269, 313, 314, 315, 317
 participatory 100
 personal 22, 52, 56, 120, 144, 183, 196, 266, 267,
 269, 275
 physicalization — see data physicalization
 pot 55
 processing 230
 public 22
 qualitative 103
 quantitative 103
 sculpture 24, 38, 76, 180, 181, 200, 212, 213, 218,
 218, 219, 267, 313, 317, 320, 323, 327
 selection 80
 sonification 24, 186, 188, 191, 196
 source 218
 story 25, 302
 subjective 103
 tabular 84
 tactility 24
 visceralization 330
 visualization — see visualization
Data Badges (project) 104, 106, 107
Data Feminism (book) 107, 313
Data Murals (project) 106
data physicalization 24, 66, 79, 85, 103, 183, 186,
 190, 193, 196, 215, 219, 225, 240, 241, 288, 313, 315
 design 266
 environmental 316, 317
 participatory 100, 107, 320
 practice 312
 reconfigurable 297
Data Strings 103, 162–174
Data That Feels Gravity 181, 210–219
database 261
Dataponics 316, 332–342
Dataseeds 183, 232–241
dataset
 dynamic physical 291
 one-dimensional 64, 67
death 32, 33, 342
 battle 92
 penalty 151
debris, marine 315, 318, 320, 325, 326, 328
decision-making 244
decision support landscape 212, 213, 214
Deltagraphs (software) 218
demographics 204
density 191, 364
design 127, 227, 230
 ambition 281
 challenge 137, 193, 256, 275, 342
 collective 225, 231
 content design 171
 critique session 269, 270
 data-driven 101
 "Design and Define" 138
 digital 42
 exploration 66, 72, 143
 human-centered 266
 interaction 172, 270, 295, 309
 lab 334
 mechanical 296
 participatory 106
 physical 292
 principle 114, 138, 270, 275
 printed circuit board (PCB) 296
 process 219
 sound 190
 space 72
 structural 296
 table 238
 user-centered 275
diagram 321, 322, 349
 Sankey 318, 324
diameter 82, 92, 96, 191, 281, 321, 347, 350
diary 255
direct data manipulation 297
directing 158
disc 280, 281, 282, 283
disease 91
dispenser 118

display
 axis 295
 digital 252
 light-emitting diode (LED) 208
 physical 247, 248
 physical data 313
 shape 248
 small 305
 "stand-around" 292
 tablet 295
Dobson, Kelly 313
documentation 118, 128, 155, 340
domestic 35
Domestic Data Streamers 101, 164
Dourish, Paul 313
Dragicevic, Pierre 244, 301
drawing 41
 digital 273
 line 92
 software 270, 274
dremel 341
drill 48, 92, 96
Duarte, Jose 100, 134
Dulake, Nick 183, 234
dust 305, 306, 307, 309, 317, 363
Dustmark 317, 358–368
dynamic
 data 291, 297
 line chart 305
 physical object 309
 scatterplots 307

E

EasyDataViz 100
ebonize 47, 48
eCLOUD (artwork) 285
EcoBali 330
economic data 212, 214
economy 76, 83
education 236
e-ink 259, 260
elastics 143
electromagnet 246, 247
electromechanical components 208
electronics 127, 128, 208, 259, 261, 272, 274, 275, 292, 305, 308, 338, 339, 341
 breadboard 341
 control 292
 hobbyist platforms 130
 power transformer 341
 resistor 341
 soldered 295
 transistor 341
email 55
EMERGE 248, 286–297
emissions 79, 80
 greenhouse gas 34, 76, 224
 low emission zones 133
 per capita 80
 total reported 83
emoto 181
empowerment 328
encoding 25, 34, 35, 50, 64, 65, 66, 67, 72, 76, 85, 100, 106, 107, 117, 118, 127, 140, 180, 181, 214, 245, 248, 288, 295, 313, 316, 330, 350
Endings 86–97, 178
energy 288
engagement 219
ensemble 155
environment 124, 125, 174, 231, 256, 267, 270, 305, 312, 313, 315, 323, 363
 physical 313, 317
 urban 317
Environment Canada 76, 84
environmental data 315
environmental media 312
epoxy 130
ethics 107
ethnic background 152
evolve 49, 128, 292, 295, 341
exhibition 97, 120, 172, 204
experience 16, 22, 70, 79, 80, 100, 113, 114, 151, 167, 172, 174, 196, 302, 315
 aesthetically pleasing 329
 childhood 350
 daily 34
 data 137, 248
 emotional 151, 312
 everyday 312, 313
 group 219
 hidden 61
 interactive 252
 intimate 40
 introspective 120
 multisensory 312
 personal 30, 269
 physical 30, 107
 player's 342
 playful 137
 sensory 26, 368
 shared 104
 social 128
 subjective 49

tactile 219
visceral 312
experiment 41, 56, 61, 168, 191, 193, 256, 259, 337, 342, 350, 353, 355, 364
Expertentheater 151
exploration 41, 49, 60, 83, 85, 167, 227, 231, 248, 305, 309, 325, 336, 337
 collaborative 309
 data 248
 shape 269, 270, 271, 273, 275
externalizing 103

F

fab lab 101, 110, 113
fabric 80
fabrication 26, 33, 41, 42, 45, 49, 81, 118, 293, 339, 341, 342, 353
 data-driven 26
 digital 22, 59, 241
 hand-made 241
 shop 228
Facebook 142
facilitator 106, 133, 172, 262
falsified 161
fatigue 284
feedback, long-term 342
Fekete, Jean-Daniel 301
Fels, John 313
fiber
 cotton 83
 silk 83
 synthetic 83
 wool 83
fidelity
 high- 270
 low- 118, 269, 270
field experts 130
field study, in-the-wild 334, 340, 342
Filbert, Heidi 35
filtering 56, 262
fire hazard 353
firing 55, 59
firmware 295
fishing line 92, 96
Fitbit 316, 340, 341
flashlight 156
FlightAware 282, 283
Floating Charts (project) 249
flow diagram 218
fluid dynamics 280, 282
foam 217, 259

foam-board 261
focus group 140
folding 33, 70, 230
Follmer, Sean 300
Fondation EDF, Paris 165, 167
forklift 355
form 215, 227, 237, 256, 262, 270, 275, 281, 283, 292, 297, 300, 313, 315, 317, 330
form-factor 127, 305
format 168
fountain 246
frame 228, 295, 307
framework, cabinet 45, 46
frequency 237
 of falls 234, 235
 of sound 191
funds 158
future 34, 80, 168, 196, 214, 224
 collective 125
 direction 72
 material use 231
 population 214
 predicted climate scenario 222

G

gallery 33, 35, 95, 203
gamification 336
Gaudí, Antoni 20
gear 270, 271, 274
Gelman, Andrew 315
gender 151, 152
generate debate 169
generative motion 282
geometry 248, 288, 353
 burn-trough surface geometry 352, 355
 log 352
Georgetown, Malaysia 157
glacier 315
Glass Apps 283
glass blowing 20
glazing 56, 59
Glen Canyon Park, San Francisco 347
global warming 312, 315
glue 45, 48, 103, 181, 217
 acrylic 207, 208
 hot glue 130
 silicone glue 130
Goods, Dan 245, 278
Google 92
 Docs 208
 Sheets 208

Gourlet, Pauline 101, 110

government 130, 152

graph 56, 88, 92, 95, 336, — see also chart, visualization

Grasshopper (software) 207, 227, 230, 283, 352, 353, 355

Greek risk measure 218

Greek wine cup 19

grid 152, 153

Gross Domestic Product (GDP) 247

Gross National Income (GNI) 214

growing medium 336, 341, 341

Gwangju, South Korea 146

Gwilt, Ian 183, 234

H

Hafermaas, Nik 245, 278

hand signals 156

handcraft 29, 273

handheld grinder 48

haptic 213, 219

haptics

 spatial 219

hardware 48, 262

Hardy, John 288

Hartsfield-Jackson International Airport 277, 278

Hayes, Sarah 33, 64

headphones 154

health 125, 188, 196

 plant 342

healthcare 234, 236

heatmap 218

heavy machinery 228

Hebbel Theater, Berlin 147, 151

height 245

heliograph controller 355

heliostat 353, 356

Heroku (software) 341

histogram 137, 141

home 35, 71, 113, 141, 144, 178, 267, 269, 270, 275

homicide rate 91

hoop 171, 172

Houben, Steven 245, 266

hourglass 20

household income 204

HTML 71, 296

Huron, Samuel 103, 373, 374

I

icon 18

ideation 230, 240, 292, 342, 350

Ijeoma, Ekene 181, 201

incentive 120

incising 55, 59

income 161, 305

income class 152

independence 155

Indosole 330

inFORM (project) 249

information olfactation 24

ink 33

Inkscape (software) 119, 173

Instagram 142

installation 26, 34, 88, 113, 131, 141, 164, 168, 169, 172, 174, 201, 203, 223, 225, 228, 229, 245, 246, 248, 262, 282, 284, 315, 318, 320, 325, 327, 330, 346, 347, 353, 355

instruction manual 104, 140, 141, 171

instrument 17

 19th-century meteorological 348

 musical 188, 190, 193, 196

 scientific 317

intangible 275

integration 118, 275

 home 275

 into daily life 56

 into the environment 325

interaction 85, 130, 172, 272, 275, 288, 312

 data 138

 device 140

 dynamic 292

 human-computer 297

 human-data 100, 266, 297

 physical 295, 300

 technique 295, 309

 user 72

interactive 291

 bar chart 288, 290, 295

 chart 297

 data experience 248

 physical chart 297, 309

 projected interactive display 295

 projection 230

 signage 256

 visualization 224, 300, 305

 website 229, 230

interdisciplinarity 103, 231, 297

interface

 peripheral 25

 physical 300

shape-changing 269, 288
 touch 302
 user 247, 248, 308, 309
Internet of Things (IoT) 288
Internet radio 334, 341
interpolation 204
interview 120, 155, 158, 269, 270
intuition 97, 128, 131, 209
inverse distance weighting (IDW) 204
invitation 49, 101, 152, 213, 214, 363
Ishii, Hiroshi 15
Isotype 21
iteration 41, 82, 83, 118, 127, 128, 131, 259, 274, 292, 355

J

Jansen, Yvonne 178, 290
JavaScript 69, 71, 296, 308
Jet Propulsion Laboratory (JPL) 355
joinery 48
joining 83
jointer 48
juxtaposition 321

K

KiCAD EDA (software) 296
kiln 60
Kimbell, Lucy 103
Kison, Markus 245
Klauss, Liina 315, 320
knitting 34
knotted 17, 79

L

label 45, 217, 259, 260, 295, 305
lamination 42, 48, 283
 stack 44, 48
laptop 363
laser engraving 117, 119
latex 245
Latour, Bruno 315
layout 42, 48, 95
Le Goc, Mathieu 247, 300
LEGO brick 32, 33
length 220, 227, 315, 321
lens, spherical 316, 347, 348, 350
Let's Play with Data 104, 106, 107, 132–145
lettuce 246
LibreOffice Calc (software) 195
Life in Clay 50–61

life-expectancy 91
light 107, 281, 312, 316, 334, 337, 339, 341, 342
 ambient 101
 color-changing 124
 growing 336
 shade 339, 341
 sunlight 316
 switch 339
light-emitting diode (LED) 125, 130, 292, 295
 color-changing 127
 controller 295
 diffusion 295
 illumination 292
 individually-addressable strip 128
Lindley, Siân 252
linear actuator 292, 295
linkage 292
liquid crystal display (LCD) 245, 280, 283, 284
live stream 280
location 325, 330, 364
 history 55, 56, 60
Lockton, Dan 317
LOOP 245, 247, 264–275

M

Madrid, Spain 132, 136
Madsen, Loren 33, 34, 35, 89, 178
magnet 114, 140, 143, 305
magnifying glass 217, 350
Maine, USA 122
maintenance 172, 284
MakerBot Replicator 341
manipulation 114
map 198, 245, 247, 313
 gradient 204, 205
 topographic 200, 205, 206, 207
marital status 151
marker 143
mask 34, 79, 84
Mathematica (software) 350, 353
matrix 21
measurement 80, 315, 317, 326, 334, 363, 368
 gravimetric 364
 self- 342
 snowpack 40, 42
mechanism 18, 178, 208, 241, 246, 256, 257, 259, 260, 270, 272, 275, 302, 350, 351
 "details-on-demand" 305
 heliograph 347, 348, 352
mediation tool 120
medium density fiberboard (MDF) 118, 140, 143

Melbourne, Australia 159
memento 183
memorabilia 106
Mental Landscapes 103, 107
mesh integrity 194
Meshlab (software) 218
metal 193, 228, 364
 3D printing 196
 hanger 173
 sheet 368
metaphor 83, 103, 188, 196, 203, 209, 234, 237, 241, 305, 313, 324
MG McGrath (company) 228
microcontroller 274, 292, 295, 296
 Adafruit 128, 130
 Advanced RISC Machines (ARM) 308
 Arduino — see Arduino
microphone 158
Microsoft
 Excel 48, 56, 60, 84, 92, 96, 193, 218
 PowerPoint 213, 308
 Research 252
milling 26, 48, 179
miniature 101
MINN_LAB Design Collective 183, 223
Minneapolis, Minnesota, USA 221, 225, 229
Minnesota, USA 220–224
minority 152
MIT Media Lab 15, 247, 247
mobility 133, 174
mockup 226, 227
modal synthesis 196
model 45, 194, 206, 219, 227, 240
 conceptual 313
 digital 227, 230
 Gaudí's hanging 20
 paper 256
 physical 17, 207, 238
 plan-relief 20
Morét, Skye 315, 320
motor 259, 274, 292, 295, 354
 servo 208, 244, 245, 246, 259, 261
 stepper 258, 259, 260, 261
mount 259, 282, 296
multiple choice 158
museum 113, 168, 203

N

Nagel, Till 374
nails 167
narrative 84, 89, 151, 196, 214, 312

National Aeronautics and Space Administration (NASA) 353, 355
National Water Quality Monitoring Council 130
nationality 151, 153
natural language processing 288
Natural Resources Conservation Service (NRCS) 41
neighborhood 101, 137, 255
newsletter 118
Node.js (software) 341
Norman Y. Mineta International Airport 285
notebook 255
nutrients 337
nylon 259, 261

O

Oehlberg, Lora 30, 373, 375
Of All the People in All the World (artwork) 32, 33
Offenhuber, Dietmar 312, 315, 317, 360
on-glaze pencil 56
online forums 130
online tutorial 130
OpenFrameworks (software) 308
OpenSCAD (software) 192, 193, 195
open-source content 117, 193, 308
opinion 101, 107, 169, 174
opportunity 34, 54, 66, 114, 151, 212, 213, 214, 269, 275, 330
optimization 281
Orbacles 183, 220–231
orientation 325, 353
origami 62–72, 273
outliers 214, 262

P

paint 118, 119, 171, 172, 181, 295, 316, 364
Panagiotidou, Georgia 100
panel 101, 133, 140
 e-ink 259, 261
 foam-board 259
 metal 140
 Plexiglas 119
 vanity 295
 wood 119
paper 21, 33, 96, 103, 156, 230, 256, 273, 305, 308
 adhesive 140, 143
 and pen 69, 84, 143
 crafting 66
 maquette 256
 origami 71

printer 64, 70, 71, 96, 143

transfer 59

parameters, sound 25, 190

passers-by 101, 140, 144

Pasterze Glacier, Austria 315, 317

patina 97, 317, 364

pattern recognition 324

Patuxent Bird Identification Infocenter 225

pebble 19

pedagogy 120

percentage 67, 201, 316

perception 49, 102, 144, 213, 329, 353

performance 34, 156, 161, 240, 255, 259, 295

issues 284

reliable 282

theater 148

Perin, Charles 300

Perovich, Laura 101, 124

Perpetual Plastic 315, 318–330

personalize 138, 183

perspective 49, 149, 281

citizen's 134

critical 336

maker 79

microscopic 158

viewer 79

pH 125, 127

photogrammetry 352, 353

photography 84, 142, 155, 203, 325, 367

long exposure 125, 130, 281

shoot 340

stop motion 259

physical bar chart 291, 292

Physical Bar Charts (project) 103

physical computing 266

physical data representation 22, 23, 178, 245, 269, 297, 312, 315, 317

physicalization — see data physicalization

pico projector 59

pictogram 21

piling 114

planer 48

plants 231, 312, 316, 334, 336, 337, 339, 340, 341, 342

plastic 194, 228, 273, 318, 320, 322, 323, 327

bucket 337

debris 330

flow 324

ocean 323

single-use 325, 327, 330

trash 321, 323

tray 230

waste 315

play 113, 137

plaza 347

Plexiglas 246

plotting 92, 209

plywood 42, 45, 46, 48, 272

PMQ Hong Kong 169, 171

political party 152

poll 107, 255, 256

pollution 88, 245, 246, 312, 317, 328

air 91, 95, 360, 363

airborne lead 91

dust 363

marine 325

particulate matter 317, 360, 363, 367, 368

source 127

sources 125

thermal 125

urban 360, 363

water 101, 103, 124, 125

polycarbonate 283

polyoxymethylene (POM) 274

population 32, 33, 67, 151, 152, 155, 161, 214, 247, 305

bird 222

position 325

Postography (artwork) 225

pot 337, 339, 341, 342

potter's wheel 55

poverty 91, 161

power supply 292

practice 22, 23, 34, 45, 66, 114, 118, 120, 142, 178, 209, 218, 219, 355

art 328

data 107

good 259

making 113

storytelling 302

traditional origami 70

precipitation 35, 40, 41, 45, 46, 49

prejudice 161

presence 275, 321

pressure washer 364, 365, 368

printed circuit board (PCB) 259, 282, 296

custom 292, 295, 305

printed guide 95

printer 96

inkjet 71

laser 71, 240

printing 56, 70, 92, 235, 241

block 21

privacy 107, 270, 275

probe 133

Processing (software) 229, 230

profession 152
profile 155
programmable matter 248
programme book 154
programming 127, 192, 248, 274, 282
 embedded software 308
 environment 194, 195
progression
 of the sun 349
 of time 363
projection 59, 228, 295
 screen 158
proof of concept 309, 337
proportion 42, 144, 161, 207, 247, 256, 305, 348
protective finish 47
prototype 126, 194, 213, 219, 230, 238, 240, 248, 256,
 259, 268, 269, 270, 272, 273, 282, 283, 292, 305,
 308, 309, 337, 338, 351, 355
 paper 256, 257
PSyBench (system) 246
psychological ownership 106
public 169, 231, 241, 317, 325
 participation 144
 space 101, 106, 137, 142, 144, 364
 transportation 137
Public Lab (community group) 125
Public Use Microdata Sample (PUMS) 204
Puja stick 189, 195, 196
Pulse (artwork) 245
pump 342
Purchasing Power Parity (PPP) 214
push button 208

Q

QGIS (software) 204, 208
questionnaire 155
quipu 30, 79, 85

R

R-Shiny (software) 368
radio 128
rapid eye movement (REM) 34
rate 196, 235
 annual 315
 fall 234
real time 124, 125, 172, 245, 246, 255, 278, 280, 282,
 283, 367
 plot 130
record 356
 activity 101
 autographic 316

burn 348
Campbell Sunshine recorder 350
 student 306
 sunshine 347
refine 56, 217, 230, 350
reflectivity 248
rehearsal 152, 155, 158, 161
relatable 80, 85, 168, 204, 330
relationship 155, 305, 307, 312, 313, 317
 representational 316
religious space 168
remote-controlled boat 124, 125, 127
rendering 205, 206, 217, 227, 295
representation 151
repurposed material 79, 83, 84
research through design 266
resetting 172
residence 151, 153
resonate 190, 194, 196, 317
restriction 161
reverse graffiti 364, 367, 368
reward 140
Rhinoceros (software) 207, 227, 230, 283
rice 32
rigging 282, 355
Rimini Protokoll 100, 149
robot 247, 252, 256, 300, 302, 305
rope 76, 81, 82, 83
rotor 248
roughness 219
rubber 260

S

safety equipment
 face shield 45
 hearing protection 45
 respirator 45
San Diego, California 150
San Jose, California, USA 285
sand 20
satellite imagery 325
Sau Paulo, Brazil 150
Sauvé, Kim 245, 266
scale 17, 20, 42, 48, 56, 80, 127, 137, 255, 270
 color 127
 full- 92
 human 80, 330
 large 21, 92, 137
 monumental 356
 scalability 309
scent 25

schema 218

Schweisfurth, Volker 181, 212

scientific data 231

scissors 60, 71, 84

screenshot 71, 142, 205

screw 172

 thread 354

screwdriver 172, 173

script 155, 158

sculpture 88, 114, 167, 214, 222, 224, 229, 280, 282,
 283, 284, 330, 346, 347

 dynamic 278

 trash 329

SD card 128, 129

sealing 130

SeeBoat 103, 106, 122–131

seeds 341

Segal, Adrien 33, 35, 38, 178

selection 56

selective laser sintering (SLS) 259, 261

self-inscription 317

self-propelled 305

self-quantification 342

sensing 305

sensor 133, 256, 259, 261, 363, 364

 conductivity 128

 custom-made 127

 dust 363

 humidity 337

 Nova SDS011 Particulate Matter Dust Sensor
 368

 pH 128

 temperature 128, 129

 thermal 257

 touch 305

 turbidity 128

 water quality 124, 125

sensor data 260

sentiment 245, 246

service

 3D printing service 194, 195

 board fabrication 130

 commercial 3D printing 217

sewing needle 84

sexual orientation 161

sgraffito 55, 59

shadow 281

shape 190

 -changing 72, 269, 288

 exploration 273, 274

 -shifting 262

Shapeways (company) 194, 195

shared ownership 101, 106

shell money 21

sight-impaired 85

silicone, clear 283

simulation 20, 93, 196, 224, 295

 flocking 229

situated 114, 118, 313, 315, 317, 320, 330

size 234, 240, 325, 329

sketch 41, 56, 60, 66, 84, 137, 143, 230, 237

 composite 84

 concept 226

 sketching tools 240

sketching 273, 281, 292, 308, 325, 337, 351

SketchUp (software) 218, 355

Skype call history 53

sled 45

sleep 34

slide 154

Slumber (artwork) 34

smartphone 146

SmartToken 305

smell 155, 248

SMS (short message service) 256

Snow Telemetry (SNOTEL) 41

Snow Water Equivalent 36–49, 178

social media 142, 143, 144, 218

solar

 cell 354

 eclipse 356

 power 347, 354

 script 348

Solar Totems 316, 344–356

soldering 295

SolidWorks (software) 48, 208, 308

song 156

sound 155, 194, 339

sound effects 158

souvenir 106

Sowers, Charles 316, 347

spline 188, 193, 194

spreadsheet 46, 48, 84, 193, 195, 205

square-tube 295

stage 100, 151, 158

 turntable 151

stain 55, 59, 272

 black 48

 water-based 48

stainless steel 191, 194

 foil 350, 351

stamping 95

Stan's Cafe (artist collective) 32, 33

statistics 33, 152, 212, 234, 255, 312

democratize 21

 healthcare 236

 socio-demographic 148

Staubmarke — see *Dustmark*

Stefaner, Moritz 181, 315, 320

stencil 59, 60, 364, 365, 368

step data 266, 336, 341

sticky note 305

stiffness 248

stitching 80, 83

STL (file type) 194

strap 114

street 138, 168

string 20, 79, 101, 103, 244

structure 259

 hidden 282

 support 295

studio 55, 56, 61, 95, 297

Stuttgart, Germany 358, 365

styrene 261

sugar 178

sun 346, 347, 353, 355

sundial 316

support 140, 339

surface 217, 295

 3D 248

 area 64, 235, 237, 238

 configurable 252

 horizontal 302

 surfaces of the city 317, 360, 363, 368

 untreated concrete 364

Sutherland, Ivan 248

Sweeney, David 252

sycamore seed 234, 237, 241

symbol 209

symmetry 350

T

table saw 45, 48

Tableau (software) 56, 60

tablet 295, 296, 306

tabletop 110, 113, 118, 120, 247, 248

Taher, Faisal 288

tally mark 17, 18

tangible 100, 110, 174, 213, 222, 225, 247, 302, 309, 312, 330

Tangible Media Group 247, 247

tape 130, 141, 143

 measuring 59, 84, 260, 261

taping 92

taste 248

taxes 79

Taylor, Alex 252

team 21, 114, 120, 136, 158, 204, 209, 284

teleprompter 158

temperature 35, 125, 127, 248

 air 41

template 45, 48, 92, 96, 143

Tenison Road Charts 245, 250–262

Tenison Road, Cambridge, UK 255–257, 262

test tiles 56

testing 118

text message 55, 256, 354, 355

textile 30, 80, 81, 82, 84

texture 248, 273

The Commons (park) 220, 225

theater 158

theater of experts 151

Thermal Fishing Bob 125

Thingiverse (website) 190

thread 84, 167, 171, 172, 173

threaded rods 282

throwing 55, 56

Thudt, Alice 30, 31, 35, 52

Tibetan singing bowl 186, 188

tile 32, 33

tilt 227

time 203, 275

time series 193, 260

timeline 152, 168, 179, 181, 193, 218

timescale 225

timing pulley 208

toggle clamps 45

token 17, 18, 21, 101, 104, 113, 114, 118, 302, 305

 dispenser 114, 117

 manipulation 302

Tokyo, Japan 100, 148

touchscreen 288, 290

traffic 255, 260, 280

 flight 278, 280, 282, 283

 patterns 256, 257

transaction 17, 18

transparency 281

Transparency International (organization) 218

trash 328

tree rings 313, 356

treemap 212, 215

trend 34, 40, 41, 307

tuning fork 191

Tupperware 337

turbidity 125, 127

Tversky, Barbara 14

Twitter 142, 179, 181, 256

U

United States Environmental Protection Agency 130
Universal Serial Bus (USB) 341
user experience (UX) 308
user testing 295

V

V-Pleat Data Origami 62–72
vacuum forming machine 230
value
 absolute 270
 as in **a numerical value** 69, 125, 127, 151, 171, 288, 290, 295, 305, 307, 363, 368
 as in **of relative or intrinsic importance** 33, 72, 113, 144, 241, 255, 309, 317
 data 17, 19, 34, 187, 188, 190, 191, 193, 239, 241
 of a currency 19, 245, 246
 sensory 219
Vande Moere, Andrew 100
variation 46, 80, 127, 141, 189, 192, 194, 316, 347
vector graphic 48, 59, 143
Velcro 140
video 141, 143, 156, 219
 time-lapse 341
video camera 158
Vidler, John 288
vinyl 171, 172
virtual reality (VR) 218
virtual workshop 141
visual
 contrast 47
 guideline 171
 mark 56
 reference pattern 363, 367
 story 106
Visual Studio (software) 296
visualization 24, 52, 60, 76, 85, 110, 128, 231, 244, 260, 262, 270, 273, 275, 291, 307, 312, 313, 317, 323, 360, 367 — see also **chart, diagram, graph**
 2D data visualization 312, 313
 3D data visualization 41, 256
 abstract 275
 analog 144
 autographic 360
 constructive 33
 data 30, 32, 137, 168
 dot-based 309
 input 103
 kit 137
 participative 168
 physical 245, 302
 self-quantification 336
 technique 218
 tool 167
visually impaired people 219
volume 315
volunteers 316, 328, 340, 364
voting 17, 19, 156
VR glasses 214

W

Wage Islands 181, 198–209
waste management 330
water 19, 40, 198, 200, 209, 312, 316, 334, 337, 341, 342, 368
 clock 19
 coastal 125
 -filled spherical wineglass 355
 hydroponic system 338, 342
 ink-dyed 208
 jet 245, 246
 quality 125, 127
 watering system 338, 339
wax sphere 127
wearable device 334
weather 34
Weather Report (artwork) 225
web browser 295
website 209, 224, 295, 317, 367, 368
weight 248
West, Mieka 30, 31, 34, 35, 76
wheel 260, 305
WiFi 341
wiki 118
Wikipedia (website) 218
Willett, Wesley 103, 375
wire 282, 292
wireless transmitter 305
Wizard-of-Oz prototyping 308
wood 114, 171, 208, 228, 270, 274, 341, 347, 353
 ash 47, 48
 beads 19
 box 339
 burning 350
 carved stump 350
 logs 353, 355
 old-growth redwood logs 346, 347
 pin 117
 protective wood finish 48
 rods 19, 21
 shop 48

solid 45, 48
tree trunks 316
Wood, Denis 313
woodworking 33, 45, 48
tools 230
worksheet 153
workshop 141, 228, 255
World Bank 214, 218
wrapping 81, 83
Wylie, Sara 125

X

XCode (software) 308
X-Mind (software) 218

Y

yarn 79, 83, 84
Yau, Nathan 183

Z

Zooids 247, 298–309